2-00

The Triumph of American Painting

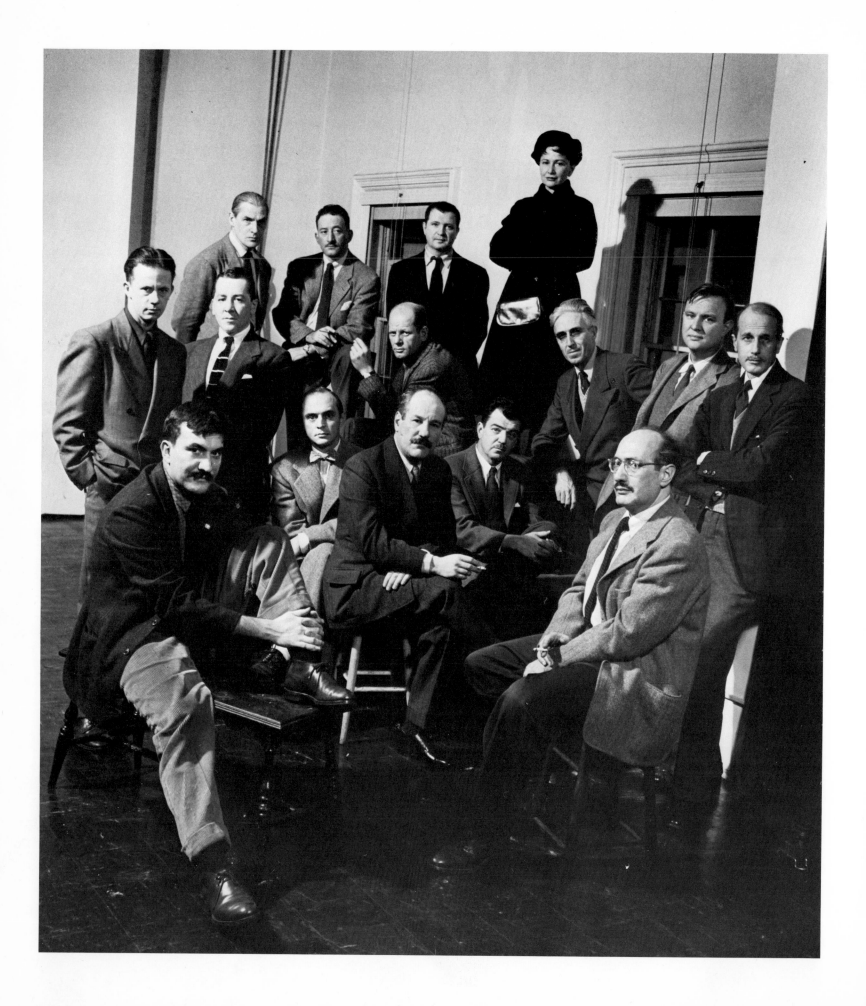

Abstract Expressionism

The Triumph of American Painting

Irving Sandler

Pall Mall Press · London

Pall Mall Press Limited
5 Cromwell Place, London, SW7

First published in Great Britain 1970

ISBN 0 269 02743 2

Printed and bound in Great Britain
by Jarrold & Sons Limited Norwich

To L. F. S.

C. H. S.

and to the memory of H. S.

Acknowledgments

THIS book owes its existence to the support, encouragement, advice, and assistance of many persons. My first debt is to those artists who generously submitted to interviews, engaged willingly in lengthy discussions, and searched hard to answer specific questions: L. Alcopley, Milton Avery, William Baziotes, Paul Brach, Ernest Briggs, James Brooks, Rosalind Browne, Fritz Bultman, Rudolph Burckhardt, Paul Burlin, Peter Busa, Nicholas Carone, Herman Cherry, Elaine de Kooning, Willem de Kooning, Burgoyne Diller, Friedel Dzubas, Jimmy Ernst, Herbert Ferber, John Ferren, Perle Fine, Louis Finkelstein, Helen Frankenthaler, Michael Goldberg, Robert Goodnough, Adolph Gottlieb, Balcomb Greene, Philip Guston, David Hare, Al Held, Hans Hofmann, Carl Holty, Harry Holtzman, Angelo Ippolito, Paul Jenkins, Aristodemis Kaldis, Howard Kanovitz, Allan Kaprow, Alex Katz, Robert Kaupelis, Franz Kline, Ibram Lassaw, Landis Lewitin, George McNeil, Nicholas Marsicano, Mercedes Matter, Joan Mitchell, Robert Motherwell, Barnett Newman, John Opper, Alfonso Ossorio, Raymond Parker, Phillip Pavia, Philip Pearlstein, Jackson Pollock, Lee Krasner Pollock, Richard Pousette-Dart, Ad Reinhardt, Milton Resnick, James Rosati, Mark Rothko, Ludwig Sander, Jon Schueler, Charles Seliger, Tony Smith, David Smith, Joseph Solman, Theodoros Stamos, William Turnbull, Jack Tworkov, Esteban Vicente, and Vaclav Vytlacil.

I also wish to thank those individuals in the other arts and my confreres in art history, art publishing, and in museum and gallery positions who have freely offered professional advice and shared information, recollections, and ideas with me: Lionel Abel, Lawrence Alloway, John Cage, Nicolas Calas, Leo Castelli, Howard Conant, Edwin Denby, David Ecker, Robert Goldwater, Clement Greenberg, Jerome Hausman, Thomas B. Hess, Philip Lieder, Douglas MacAgy, John Myers, E. A. Navaretta, Frank O'Hara, Barbara Rose, Harold Rosenberg, William Seitz, and Maurice Tuchman.

I am grateful as well to numerous collectors and museums for providing documentation of works in their collections, photographs, and the permission to reproduce them. For assistance in obtaining photographs, I am particularly indebted to Linda Loving of the Museum of Modern Art, Denny Judson of the Whitney Museum of American Art, and Betty Asher of the Los Angeles County Museum. In addition I wish to thank my wife Lucy Freeman Sandler for her constant encouragement and assistance; David Bell; Mary Solimena Kurtz of Praeger Publishers for her tireless efforts in editing my book and getting it into production; and my research assistants Barbara Cohen and Katherine Rosenbloom. Finally, I should like to express my gratitude to the John Simon Guggenheim Memorial Foundation for awarding me a fellowship in 1965 that was of great help in furthering my work on this book.

New York City IRVING SANDLER
September, 1970

Contents

Color Plates

Collection Whitney Museum of American Art, New York; Gift of Julien Levy for Maro and Natasha Gorky in Memory of Their Father. Photo Geoffrey Clements, New York.

3–8 Arshile Gorky. *Image in Xhorkom. ca.* 1936. Oil on canvas, 36 x 48 inches. Collection Mr. and Mrs. David Lloyd Kreeger, Washington, D.C. Photo courtesy M. Knoedler & Co., Inc., New York.

3–9 Arshile Gorky. *Enigmatic Combat. ca.* 1936. Oil on canvas, 35¾ x 48 inches. San Francisco Museum of Art, San Francisco, California; Gift of Miss Jeanne Reynal.

3–10 Wassily Kandinsky. *Picture with White Edge. No. 173.* 1913. Oil on canvas, 55⅜ x 79 inches. The Solomon R. Guggenheim Museum, New York.

3–11 Arshile Gorky. *Garden in Sochi I. ca.* 1940. Oil on canvas, 44¼ x 62¼ inches. Collection The Museum of Modern Art, New York; Purchase Fund and Gift of Mr. and Mrs. Wolfgang S. Schwabacher (by exchange).

3–12 Arshile Gorky. *Garden in Sochi II.* 1940–42. Oil on canvas, 25 x 29 inches. M. Knoedler & Co., Inc., New York. Photo Paulus Leeser.

3–13 Arshile Gorky. *Garden in Sochi III. ca.* 1943. Oil on canvas, 31 x 39 inches. Collection The Museum of Modern Art, New York. Photo Geoffrey Clements, New York.

3–14 Arshile Gorky. *The Liver is the Cock's Comb.* 1944. Oil on canvas, 72 x 98 inches. Albright-Knox Art Gallery, Buffalo, New York; Gift of Seymour H. Knox.

3–15 Arshile Gorky. *Diary of a Seducer.* 1945. Oil on canvas, 50 x 62 inches. Collection Mr. and Mrs. William A. M. Burden, New York. Photo courtesy The Museum of Modern Art, New York (Soichi Sunami).

3–16 Arshile Gorky. Study for *The Betrothal.* 1947. Pencil and wax crayon, 24 x 18½ inches. M. Knoedler & Co., Inc., New York.

3–17 Arshile Gorky. *Year After Year.* 1947. Oil on canvas, 34 x 39 inches. Collection Mr. and Mrs. Gifford Phillips, Santa Monica, California. Photo I. Serisawa, Los Angeles, California.

4–1 Adolph Gottlieb. *Pictograph.* 1946. Oil on canvas, 34 x 26 inches. Los Angeles County Museum of Art, Los Angeles, California; Gift of Burt Kleiner.

4–2 Mark Rothko. *Baptismal Scene.* 1945. Watercolor, 19⅞ x 14 inches. Collection Whitney Museum of American Art, New York. Photo Geoffrey Clements, New York.

4–3 Jackson Pollock. *Male and Female.* 1942. Oil on canvas, 73¼ x 49 inches. Collection Mrs. H. Gates Lloyd, Haverford, Pennsylvania. Photo courtesy The Metropolitan Museum of Art, New York (Alfred J. Wyatt).

4–4 William Baziotes. *The Web.* 1946. Oil on canvas, 30 x 32 inches. Estate of William

Baziotes. Photo courtesy Marlborough Gallery Inc., New York (O. E. Nelson).

4–5 Theodoros Stamos. *Ancestral Worship.* 1947. Pastel, gouache, and ink, 17½ x 23⅜ inches. Collection Whitney Museum of American Art, New York. Photo N. Daphnis, New York.

4–6 Hans Hofmann. *Idolatress I.* 1944. Oil and aqueous media on upsom board, 60⅛ x 40⅛ inches. Collection University Art Museum, Berkeley, California; Gift of the artist.

4–7 Clyfford Still. *1945.* 1945. Oil on canvas, 91 x 68 inches. Marlborough Gallery Inc., New York.

5–1 William Baziotes. *Untitled. ca.* 1938–40. Watercolor, pencil, and gouache on paper, 14 x 10 inches. Estate of William Baziotes. Photo courtesy Marlborough Gallery Inc., New York (O. E. Nelson).

5–2 William Baziotes. *The Butterflies of Leonardo da Vinci.* 1942. Duco enamel on canvas, 19 x 23 inches. Estate of William Baziotes. Photo courtesy Marlborough Gallery Inc., New York.

5–3 William Baziotes. *The Parachutists.* 1944. Duco on canvas, 30 x 40 inches. Estate of William Baziotes. Photo courtesy Marlborough Gallery Inc., New York (O. E. Nelson).

5–4 William Baziotes. *The Balcony.* 1944. Oil on canvas, 36 x 42 inches. Collection Wright Ludington, Santa Barbara, California. Photo Karl Obert, Santa Barbara, California.

5–5 William Baziotes. *Cyclops.* 1947. Oil on canvas, 48 x 40 inches. Courtesy of The Art Institute of Chicago, Chicago, Illinois.

5–6 William Baziotes. *The Flesh Eaters.* 1952. Oil on canvas, 60 x 71⅝ inches. Estate of William Baziotes. Photo courtesy Marlborough Gallery Inc., New York (O. E. Nelson).

5–7 William Baziotes. *Dawn.* 1962. Oil on canvas, 40 x 50 inches. Estate of William Baziotes. Photo courtesy Marlborough Gallery Inc., New York (O. E. Nelson).

7–1 Chaim Soutine. *Gnarled Trees. ca.* 1921. Oil on canvas, 38 x 25 inches. Collection Mr. and Mrs. Ralph F. Colin, New York. Photo Soichi Sunami, New York.

8–1 Thomas Hart Benton. *Ballad of the Jealous Lover of Lone Green Valley.* 1934. Oil on panel, 52½ x 41¼ inches. University of Kansas Museum of Art, Lawrence, Kansas.

8–2 Jackson Pollock. *Seascape.* 1934. Oil on canvas, 12 x 16 inches. Collection Mrs. Lee Krasner Pollock, New York. Photo courtesy Marlborough Gallery Inc., New York (O. E. Nelson).

8–3 Jackson Pollock. *Painting. ca.* 1938. Oil on canvas, 22 x 50 inches. Collection Mrs. Lee Krasner Pollock, New York. Photo courtesy Marlborough Gallery Inc., New York (O. E. Nelson).

8-4 Jackson Pollock. *Guardians of the Secret.* 1943. Oil on canvas, 48⅜ x 75¼ inches. San Francisco Museum of Art, San Francisco, California; Albert M. Bender Bequest.

8-5 Jackson Pollock. *Moon Woman Cuts the Circle.* 1943. Oil on canvas, 43 x 41 inches. Marlborough Gallery Inc., New York.

8-6 Jackson Pollock. *Gothic.* 1944. Oil on canvas, 84½ x 56⅛ inches. Collection Mrs. Lee Krasner Pollock, New York. Photo courtesy Marlborough Gallery Inc., New York.

8-7 Jackson Pollock. *Sounds in the Grass: Shimmering Substance.* 1946. Oil on canvas, 30⅛ x 24¼ inches. Collection The Museum of Modern Art, New York. Photo Geoffrey Clements, New York.

8-8 Jackson Pollock. *Cathedral.* 1947. Enamel and aluminum paint on canvas, 71½ x 35⅟₁₆ inches. Dallas Museum of Fine Arts, Dallas, Texas; Gift of Mr. and Mrs. Bernard J. Reis, New York.

8-9 Joan Miró. *The Poetess,* from *Constellations* series. 1940. Gouache on paper, 15 x 18 inches. Collection Mr. and Mrs. Ralph F. Colin, New York. Photo Soichi Sunami, New York.

8-10 Jackson Pollock. *Convergence.* 1952. Oil on canvas, 93½ x 155 inches. Albright-Knox Art Gallery, Buffalo, New York; Gift of Seymour H. Knox.

8-11 Piet Mondrian. *Composition* V. 1914. Oil on canvas, 21⅝ x 33⅝ inches. Collection The Museum of Modern Art, New York; Sidney and Harriet Janis Collection.

8-12 Jackson Pollock. *Autumn Rhythm.* 1950. Oil on canvas, 105 x 207 inches. The Metropolitan Museum of Art, New York; George A. Hearn Fund, 1957.

8-13 Jackson Pollock. *Number 23 (Frogman).* 1951. Oil on canvas, 58½ x 47 inches. Courtesy of the Martha Jackson Gallery, Inc., New York. Photo Geoffrey Clements, New York.

8-14 Jackson Pollock. *Number 14.* 1951. Duco on canvas, 57⅞ x 105⅞ inches. Collection Mrs. Lee Krasner Pollock, New York. Photo courtesy Marlborough Gallery Inc., New York (O. E. Nelson).

8-15 Jackson Pollock. *Echo.* 1951. Oil on canvas, 91⅞ x 86 inches. Collection The Museum of Modern Art, New York; Acquired through the Lillie P. Bliss Bequest and the Mr. and Mrs. David Rockefeller Fund. Photo Hans Namuth.

8-16 Jackson Pollock. *Portrait and a Dream.* 1953. Enamel on canvas, 58¼ x 134½ inches. Dallas Museum of Fine Arts, Dallas, Texas; Gift of Mr. and Mrs. Algur H. Meadows and the Meadows Foundation, Inc.

8-17 Jackson Pollock. *Easter and the Totem.* 1953. Oil on canvas, 82⅛ x 57⅞ inches. Collection Mrs. Lee Krasner Pollock, New York. Photo courtesy Marlborough Gallery Inc., New York (Geoffrey Clements).

9-1 Willem de Kooning. *Standing Man. ca.* 1942. Oil on canvas, 41⅛ x 34⅛ inches. Courtesy Wadsworth Atheneum, Hartford, Connecticut; Ella Gallup Sumner and Mary Catlin Sumner Collection. Photo E. Irving Blomstrann, New Britain, Connecticut.

9-2 Willem de Kooning. *Queen of Hearts.* 1943–46. Oil and charcoal on composition board, 46 x 27½ inches. Joseph H. Hirshhorn Foundation.

9-3 Willem de Kooning. *Untitled Painting. ca.* 1942. Oil on masonite, 46 x 46 inches. Private Collection, New York. Photo Rudolph Burckhardt, New York.

9-4 Willem de Kooning. *The Marshes. ca.* 1945. Charcoal and oil on composition board, 32 x 23⅞ inches. Collection University Art Museum, Berkeley, California; Gift of Julian J. and Joachim Jean Aberbach, New York. Photo Ron Chamberlain, Berkeley, California.

9-5 Willem de Kooning. Backdrop for *Labyrinth.* 1946. Calcimine and charcoal on canvas, 202 x 204 inches. Collection Allan Stone Gallery, New York.

9-6 Arshile Gorky. *Portrait of Master Bill. ca.* 1937. Oil on canvas, 39½ x 52 inches. M. Knoedler & Co., Inc., New York.

9-7 Willem de Kooning. *Dark Pond.* 1948. Oil on masonite, 46½ x 55½ inches. Collection Mr. and Mrs. Richard L. Weisman, New York.

9-8 Pablo Picasso. *Nude Figure. ca.* 1910. Oil on canvas, 38½ x 30 inches. Albright-Knox Art Gallery, Buffalo, New York.

9-9 Marcel Duchamp. *The King and Queen Surrounded by Swift Nudes.* 1912. Oil on canvas, 45⅛ x 50¾ inches. Philadelphia Museum of Art, Philadelphia, Pennsylvania; Louise and Walter Arensberg Collection.

9-10 Willem de Kooning. *Ashville.* 1949. Oil on canvas, 25⅝ x 31⅞ inches. The Phillips Collection, Washington, D.C.

9-11 Willem de Kooning. *Attic.* 1949. Oil and tempera on canvas, 61⅜ x 80¼ inches. Collection Mrs. Albert H. Newman, Chicago, Illinois. Photo Rudolph Burckhardt, New York.

9-12 Willem de Kooning. *Woman I.* 1950–52. Oil on canvas, 75⅝ x 58 inches. Collection The Museum of Modern Art, New York.

9-13 Willem de Kooning. *Woman and Bicycle.* 1952–53. Oil on canvas, 76½ x 49 inches. Collection Whitney Museum of American Art, New York. Photo Geoffrey Clements, New York.

9-14 Willem de Kooning. *Woman VI.* 1953. Oil and enamel on canvas, 68½ x 58½ inches. Museum of Art, Carnegie Institute, Pittsburgh, Pennsylvania.

9-15 Willem de Kooning. *Gotham News.* 1955–56. Oil, enamel, and charcoal on canvas, 69½ x 79¾ inches. Albright-Knox Art Gallery, Buffalo, New York; Gift of Seymour H. Knox.

9-16 Willem de Kooning. *Door to the River.*

1960. Oil on canvas, 80 x 70 inches. Collection Whitney Museum of American Art, New York; Gift of the Friends of the Whitney Museum of American Art (and purchase). Photo Geoffrey Clements, New York.

9–17 Willem de Kooning. *Woman Acabonic.* 1966. Oil on paper mounted on canvas, 80½ x 36 inches. Collection Whitney Museum of American Art, New York; Gift of Mrs. Bernard Gimbel. Photo Geoffrey Clements, New York.

10–1 Hans Hofmann. *Still Life, Yellow Table in Green.* 1936. Oil on plywood, 60 x 44½ inches. Estate of Hans Hofmann. Photo Geoffrey Clements, New York.

10–2 Hans Hofmann. *Black Demon. ca.* 1944. Oil on canvas, 31 x 48½ inches. Addison Gallery of American Art, Phillips Academy, Andover, Massachusetts.

10–3 Hans Hofmann. *Ecstasy.* 1947. Oil on canvas, 68 x 60 inches. Collection University Art Museum, Berkeley, California; Gift of the artist. Photo Ron Chamberlain, Berkeley, California.

10–4 Hans Hofmann. *Effervescence.* 1944. Oil, india ink, casein, and enamel on plywood panel, 54⅜ x 35⅞ inches. Collection University Art Museum, Berkeley, California; Gift of the artist.

10–5 Hans Hofmann. *The Third Hand.* 1947. Oil on canvas, 60⅛ x 40 inches. Collection University Art Museum, Berkeley, California; Gift of the artist. Photo Ron Chamberlain, Berkeley, California.

10–6 Hans Hofmann. *Blue Rhythm.* 1950. Oil on canvas, 48 x 36 inches. Courtesy of The Art Institute of Chicago, Chicago, Illinois; Gift of the Society for Contemporary American Art.

10–7 Hans Hofmann. *Capriccioso.* 1956. Oil on canvas, 52 x 60¹⁄₁₆ inches. Norman Mackenzie Art Gallery, University of Saskatchewan, Regina Campus, Saskatoon, Canada. Photo André Emmerich Gallery, New York.

10–8 Hans Hofmann. *Blue Balance.* 1949. Oil on canvas, 30 x 38 inches. New York University Art Collection, New York; Gift of Harry Pinkerson. Photo O. E. Nelson, New York.

10–9 Hans Hofmann. *Combinable Wall I and II.* 1961. Oil on canvas, 84½ x 112½ inches over-all (I: 84½ x 60¼ inches; II: 84½ x 52¼ inches). Collection University Art Museum, Berkeley, California; Gift of the artist. Photo Ron Chamberlain, Berkeley, California.

10–10 Hans Hofmann. *Sparks.* 1957. Oil on canvas, 60 x 48 inches. Collection Mr. and Mrs. Theodore N. Law, Houston, Texas. Photo André Emmerich Gallery Inc., New York (Malcolm Varon).

10–11 Hans Hofmann. *Agrigento.* 1961. Oil on canvas, 84 x 72 inches. Collection University Art Museum, Berkeley, California; Gift of the artist.

11–1 Henri Matisse. *Dance.* 1909. Oil on canvas, 102⅝ x 153⅝ inches. Collection The Museum of Modern Art, New York; Gift of Governor Nelson A. Rockefeller in Honor of Alfred H. Barr, Jr. Photo Eric Pollitzer, Garden City Park, New York.

11–2 Milton Avery. *White Sea.* 1947. Oil on canvas, 30 x 40 inches. Collection Mr. and Mrs. Warren Brandt, New York. Photo Walter Rosenblum, Long Island City, New York.

11–3 Joan Miró. *Painting (Fratellini).* 1927. Oil on canvas, 51 x 38 inches. Philadelphia Museum of Art, Philadelphia, Pennsylvania; A. E. Gallatin Collection.

11–4 Jackson Pollock. *Mural.* 1943. Oil on canvas, 95¾ x 237½ inches. The University of Iowa Museum of Art, Iowa City, Iowa; Gift of Peggy Guggenheim.

12–1 Clyfford Still. *Self-Portrait.* 1945. Oil on canvas, 71 x 42 inches. San Francisco Museum of Art, San Francisco, California; Gift of Peggy Guggenheim.

12–2 Clyfford Still. *Fear.* 1945. Oil on paper, 24½ x 18½ inches. Collection Betty Parsons, New York. Photo Dan Lenore.

12–3 Clyfford Still. *Number 6.* 1945–46. Oil on canvas, 42⅜ x 33⅝ inches. Collection. Whitney Museum of American Art, New York; Promised gift of B. H. Friedman. Photo Geoffrey Clements, New York.

12–4 Clyfford Still. *1946-E.* 1946. Oil on canvas, 53½ x 45 inches. Marlborough Gallery Inc., New York. Photo O. E. Nelson, New York.

12–5 Clyfford Still. *1948.* 1948. Oil on canvas, 69 x 61 inches. Marlborough Gallery Inc., New York. Photo O. E. Nelson, New York.

12–6 Clyfford Still. *1949-G.* 1949. Oil on canvas, 90½ x 69 inches. Marlborough Inc., New York. Photo O. E. Nelson, New York.

12–7 Clyfford Still. *Painting.* 1951. Oil on canvas, 94 x 82 inches. Collection The Museum of Modern Art, New York; Blanchette Rockefeller Fund.

12–8 Clyfford Still. *1954.* 1954. Oil on canvas, 113½ x 156 inches. Albright-Knox Art Gallery, Buffalo, New York; Gift of Seymour H. Knox.

12–9 Clyfford Still. *Painting.* 1957. Oil on canvas, 16¹⁄₁₆ x 10¼ inches. Öffentliche Kunstsammlung Basel, Basel, Switzerland.

12–10 Clyfford Still. *1960.* 1960. Oil on canvas, 108 x 92 inches. Marlborough Gallery Inc., Photo O. E. Nelson, New York.

12–11 Clyfford Still. *1962-D.* 1962. Oil on canvas, 113½ x 146½ inches. Marlborough Gallery Inc., New York. Photo O. E. Nelson, New York.

12–12 Clyfford Still. *1964.* 1964. Oil on canvas, 114½ x 160 inches. Marlborough Gallery Inc., New York. Photo O. E. Nelson, New York.

13–1 Mark Rothko. *Geologic Reverie. ca.* 1946. Watercolor and gouache, 21¾ x 29¾ inches. Los Angeles County Museum of

Art, Los Angeles, California; Gift of Mrs. Marion H. Pike.

13-2 Mark Rothko. *Vessels of Magic.* 1947. Watercolor, 38¾ x 25¾ inches. Courtesy of The Brooklyn Museum, Brooklyn, New York.

13-3 Mark Rothko. *Number 26.* 1947. Oil on canvas, 33¾ x 45¼ inches. Collection Betty Parsons, New York. Photo Geoffrey Clements, New York.

13-4 Mark Rothko. *Number 18.* 1949. Oil on canvas, 67¼ x 56 inches. Collection The Museum of Modern Art, New York; Gift of Mrs. John D. Rockefeller III.

13-5 Mark Rothko. *Mauve Intersection (Number 12).* 1948. Oil on canvas stretched over braced composition board, 58 x 64 inches. The Phillips Collection, Washington, D.C.

13-6 Mark Rothko. *Number 24.* 1949. Oil on canvas, 88½ x 57½ inches. Collection Joseph H. Hirshhorn.

13-7 Mark Rothko. *Number 10.* 1950. Oil on canvas, 90⅜ x 57⅛ inches. Collection The Museum of Modern Art, New York; Gift of Philip Johnson. Photo Geoffrey Clements, New York.

13-8 Mark Rothko. *Untitled.* 1951. Oil on canvas, 93½ x 56¾ inches. Collection Mr. and Mrs. Gifford Phillips, Santa Monica, California.

13-9 Mark Rothko. *Four Darks in Red.* 1958. Oil on canvas, 102 x 116¼ inches. Collection Whitney Museum of American Art, New York; Gift of the Friends of the Whitney Museum of American Art, the Charles Simon Fund, Samuel A. Seaver, and Mr. and Mrs. Eugene Schwartz. Photo Geoffrey Clements, New York.

14-1 Barnett Newman. *The Death of Euclid.* 1947. Oil on canvas, 16 x 20 inches. Collection Betty Parsons, New York. Photo Dan Lenore.

14-2 Barnett Newman. *The Euclidian Abyss.* 1946–47. Oil and crayon on fabric, 28 x 22 inches. Collection Mr. and Mrs. Burton Tremaine, Meriden, Connecticut. Photo copyright 1951 the Miller Company, Meriden, Connecticut.

14-3 Barnett Newman. *Abraham.* 1949. Oil on canvas, 82¾ x 34½ inches. Collection The Museum of Modern Art, New York; Philip Johnson Fund.

14-4 Barnett Newman. *Covenant.* 1949. Oil on canvas, 48 x 60 inches. Joseph H. Hirshhorn Collection. Photo Eric Pollitzer, Garden City Park, New York.

14-5 Piet Mondrian. *Composition with Blue Square II.* 1936–42. Oil on canvas, 24½ x 23⅞ inches. Collection The Museum of Modern Art, New York; Sidney and Harriet Janis Collection. Photo Geoffrey Clements, New York.

14-6 Henri Matisse. *The Red Studio.* 1911. Oil on canvas, 71¼ x 86¼ inches. Collection The Museum of Modern Art, New York; Mrs. Simon Guggenheim Fund.

14-7 Barnett Newman. *Tertia* 1964. Oil on canvas, 78 x 35 inches. Nationalmuseum, Stockholm, Sweden. Photo copyright Nationalmuseum, Stockholm, Sweden.

15-1 Adolph Gottlieb. *Voyager's Return.* 1946. Oil on canvas, 37⅞ x 29⅞ inches. Collection The Museum of Modern Art, New York; Gift of Mr. and Mrs. Roy Neuberger.

15-2 Adolph Gottlieb. *The Sea Chest.* 1942. Oil on canvas, 26 x 34 inches. The Solomon R. Guggenheim Museum, New York.

15-3 Adolph Gottlieb. *Quest.* 1948. Oil on canvas, 30 x 38 inches. New York University Art Collection, New York; Gift of Mr. and Mrs. Samuel Kootz. Photo Charles Uht, New York.

15-4 Joaquín Torres-García. *Composition.* 1929. Oil on canvas, 32 x 39½ inches. Philadelphia Museum of Art, Philadelphia, Pennsylvania; A. E. Gallatin Collection.

15-5 Adolph Gottlieb. *Unstill Life.* 1952. Oil on canvas, 36 x 48 inches. Collection Whitney Museum of American Art, New York; Gift of Mr. and Mrs. Alfred Jaretzki. Photo Geoffrey Clements, New York.

15-6 Adolph Gottlieb. *Frozen Sounds II.* 1952. Oil on canvas, 36 x 48 inches. Albright-Knox Art Gallery, Buffalo, New York; Gift of Seymour H. Knox.

15-7 Adolph Gottlieb. *Blue at Night.* 1957. Oil on canvas, 42 x 60 inches. Virginia Museum of Fine Arts, Richmond, Virginia.

15-8 Adolph Gottlieb. *Circular.* 1960. Oil on canvas, 90 x 72 inches. New York University Art Collection, New York. Photo Geoffrey Clements, New York.

15-9 Adolph Gottlieb. *Rolling II.* 1961. Oil on canvas, 72⅝ x 90⅝ inches. Los Angeles County Museum of Art, Los Angeles, California; Estate of David E. Bright.

15-10 Adolph Gottlieb. *Rising.* 1962. Oil on canvas, 72⅛ x 48 inches. Brandeis University Art Collection, Waltham, Massachusetts; Gevirtz-Mnuchin Purchase Fund. Photo Eric Pollitzer, Garden City Park, New York.

15-11 Adolph Gottlieb. *Scale.* 1964. Oil on canvas, 60 x 48 inches. Marlborough Gallery Inc., New York. Photo Rudolph Burckhardt, New York.

16-1 Robert Motherwell. *Mallarmé's Swan.* 1944. College using gouache, crayon, and paper on cardboard, 43½ x 35½ inches. Contemporary Collection of The Cleveland Museum of Art, Cleveland, Ohio.

16-2 Robert Motherwell. *The Little Spanish Prison.* 1941. Oil on canvas, 27¼ x 17 inches. Collection of the artist; Promised gift to The Museum of Modern Art, New York. Photo courtesy The Museum of Modern Art, New York (Soichi Sunami).

16-3 Robert Motherwell. *Pancho Villa, Dead and Alive.* 1943. Gouache and oil with collage on cardboard, 28 x 35⅞ inches. Collection The Museum of Modern Art, New York.

16-4 Robert Motherwell. *Emperor of China.*

1947. Oil on masonite, 37 x 29 inches. Chrysler Art Museum, Provincetown, Massachusetts.

16–5 Robert Motherwell. *The Voyage.* 1949. Oil and tempera on paper mounted on composition board, 48 x 94 inches. Collection The Museum of Modern Art, New York; Gift of Mrs. John D. Rockefeller III.

16–6 Robert Motherwell. *At Five in the Afternoon.* 1949. Casein on cardboard, 15 x 20 inches. Collection of the artist. Photo Soichi Sunami, New York.

16–7 Robert Motherwell. *Elegy to the Spanish Republic XXXIV.* 1953–54. Oil on canvas, 80 x 100 inches. Albright-Knox Art Gallery, Buffalo, New York; Gift of Seymour H. Knox.

16–8 Robert Motherwell. *Iberia No. 18.* 1958. Oil on canvas board, 5⅛ x 7⅛ inches. Collection of the artist. Photo Peter A. Juley & Son, New York.

16–9 Robert Motherwell. *Beside the Sea No. 5.* 1962. Oil on rag paper, 29 x 23 inches. Collection of the artist. Photo Peter A. Juley & Son, New York.

16–10 Robert Motherwell. *Black on White.* 1961. Oil on canvas, 78¾ x 163¼ inches. The Museum of Fine Arts, Houston, Texas. Photo Hickey & Robertson, Houston, Texas.

18–1 Ad Reinhardt. *Untitled.* 1939. Paper collage, 7 x 9½ inches. Collection Mrs. Rita Reinhardt, New York.

18–2 Ad Reinhardt. *Untitled.* 1940. Paper collage, 15¼ x 13 inches. Collection Mrs. Rita Reinhardt, New York.

18–3 Ad Reinhardt. *Number 18.* 1949. Oil on canvas, 40 x 60 inches. Collection Whitney Museum of American Art, New York. Photo Oliver Baker, New York.

18–4 Ad Reinhardt. *Number 111.* 1949. Oil on canvas, 60 x 40⅛ inches. Collection Mrs. Rita Reinhardt, New York; Promised gift to The Museum of Modern Art, New York.

18–5 Ad Reinhardt. *Untitled.* 1950. Oil on canvas, 30½ x 40½ inches. Collection Mrs. Rita Reinhardt, New York.

18–6 Ad Reinhardt. *Untitled.* 1950. Gouache, 27½ x 40½ inches. Marlborough Gallery Inc., New York. Photo Aaron Siskind.

18–7 Ad Reinhardt. *Blue-Green.* 1950. Oil on canvas, 80 x 50 inches. Marlborough Gallery Inc., New York. Photo Oliver Baker, New York.

18–8 Ad Reinhardt. *Number 15.* 1952. Oil on canvas, 108¼ x 40¼ inches. Albright-Knox Gallery, Buffalo, New York; Gift of Seymour H. Knox.

18–9 Ad Reinhardt. *Abstract Painting: Red.* 1952. Oil on canvas, 108 x 40 inches. Collection Mr. and Mrs. Gifford Phillips, Santa Monica, California. Photo Frank J. Thomas, Los Angeles, California.

19–1 James Brooks. *Leonardo da Vinci.* Detail of *Flight.* Mural for Marine Terminal, La Guardia Airport, New York; destroyed. 1938–42. Casein glyptol emulsion on canvas,

12′ 3 x 235′ over-all; detailed 12′ 3 x 18′. Photo New York City Works Progress Administration.

19–2 James Brooks. *Dialogue.* 1947. Oil on fiberboard, 36 x 48 inches. Collection of the artist.

19–3 James Brooks. *K-1953.* 1953. Oil on canvas, 40 x 88 inches. Collection of the artist.

19–4 James Brooks. *Bozrah.* 1965. Oil on canvas, 60 x 54 inches. Collection Mr. and Mrs. Julian Eisenstein, Washington, D.C.

19–5 James Brooks. *Floxurn.* 1955. Oil on canvas, 64 x 59 inches. Collection of the artist. Photo Oliver Baker, New York.

19–6 James Brooks. *Sull.* 1961. Oil on canvas, 78 x 92 inches. Collection Winston H. Price, Baltimore, Maryland.

19–7 Bradley Walker Tomlin. *Burial.* 1943. Oil on canvas, 30 x 44 inches. The Metropolitan Museum of Art, New York; George A. Hearn Fund, 1943.

19–8 Bradley Walker Tomlin. *Arrangement. ca.* 1944. Oil on canvas, 44⅛ x 30⅛ inches. Collection Krannert Art Museum, University of Illinois, Champaign, Illinois.

19–9 Bradley Walker Tomlin. *Tension by Moonlight.* 1948. Oil on canvas, 32 x 44 inches. Betty Parsons Gallery, New York. Photo Geoffrey Clements, New York.

19–10 Bradley Walker Tomlin. *Number 10-A.* 1949. Oil on canvas, 46 x 31 inches. Collection Dustin Rice, New York. Photo Rudolph Burckhardt, New York.

19–11 Bradley Walker Tomlin. *Number 20.* 1949. Oil on canvas, 86 x 80¼ inches. Collection The Museum of Modern Art, New York; Gift of Philip Johnson.

19–12 Bradley Walker Tomlin. *Number 5.* 1949. Oil on canvas, 69⅞ x 37⅞ inches. Private Collection, New York. Photo Charles Uht, New York.

19–13 Bradley Walker Tomlin. *Number 10.* 1952–53. Oil on canvas, 72 x 102½ inches. Munson-Williams-Proctor Institute, Utica, New York.

19–14 Bradley Walker Tomlin. *Number 5.* 1952. Oil on canvas, 79 x 45 inches. Collection Betty Parsons, New York. Photo Geoffrey Clements, New York.

19–15 Franz Kline. *Seated Woman Doing Needlework.* 1945. Pencil on paper, 9½ x 9¾ inches. Estate of Franz Kline. Photo courtesy Marlborough Gallery Inc., New York.

19–16 Franz Kline. *Man on Horse. ca.* 1944. Ink on paper, 9⅞ x 7½ inches. Estate of Franz Kline. Photo courtesy Marlborough Gallery Inc., New York (Eric Pollitzer).

19–17 Franz Kline. *Untitled. ca.* 1950. Ink on paper, 21 x 18 inches. Estate of Franz Kline. Photo courtesy Marlborough Gallery Inc., New York (Eric Pollitzer).

19–18 Franz Kline. *Untitled. ca.* 1950. Oil on telephone paper, 11 x 9 inches. Estate of Franz Kline. Photo courtesy Marlborough Gallery Inc., New York (Eric Pollitzer).

19–19 Franz Kline. *Chief.* 1950. Oil on canvas,

58⅜ x 73½ inches. Collection The Museum of Modern Art, New York; Gift of Mr. and Mrs. David M. Solinger.

19–20 Franz Kline. *Cardinal*. 1950. Oil on canvas, 77⅝ x 56¾ inches. Collection George and Elinor Poindexter, New York. Photo Rudolph Burckhardt, New York.

19–21 Franz Kline. *Pennsylvania*. 1954. Oil on canvas, 45 x 63 inches. Collection George and Elinor Poindexter, New York. Photo Edward Meneeley, New York.

19–22 Franz Kline. *The Bridge*. 1955. Oil on canvas, 80 x 52¾ inches. Munson-Williams-Proctor Institute, Utica, New York.

19–23 Franz Kline. *Accent Grave*. 1955. Oil on canvas, 75¼ x 51¾ inches. The Cleveland Museum of Art, Cleveland, Ohio; Anonymous gift.

19–24 Franz Kline. *Mahoning*. 1956. Oil on canvas, 80 x 100 inches. Collection Whitney Museum of American Art, New York; Gift of the Friends of the Whitney Museum of American Art. Photo Geoffrey Clements, New York.

19–25 Franz Kline. *Siegfried*. 1958. Oil on canvas, 103 x 81 inches. Museum of Art, Carnegie Institute, Pittsburgh, Pennsylvania; Gift of Friends of the Department of Fine Arts.

19–26 Philip Guston. *Martial Memory*. 1941. Oil on canvas, 39¾ x 31½ inches. City Art Museum of St. Louis, St. Louis, Missouri.

19–27 Philip Guston. *If This Be Not I*. 1945. Oil on canvas, 41½ x 54½ inches. Collection Washington University Gallery of Art, St. Louis, Missouri.

19–28 Philip Guston. *Porch No. 2*. 1947. Oil on canvas, 62½ x 43⅛ inches. Munson-Williams-Proctor Institute, Utica, New York.

19–29 Philip Guston. *The Tormentors*. 1947–48. Oil on canvas, 40¾ x 60⅛ inches. Collection of the artist. Photo courtesy Marlborough Gallery Inc., New York.

19–30 Philip Guston. *Review*. 1948–49. Oil on canvas, 39⅜ x 59 inches. Collection of the artist; on loan to The Solomon R. Guggenheim Museum, New York. Photo courtesy Marlborough Gallery Inc., New York.

19–31 Philip Guston. *White Painting No. 1*. 1951. Oil on canvas, 58 x 62 inches. Private Collection, Los Angeles, California.

19–32 Philip Guston. *Zone*. 1954. Oil on canvas, 46 x 48⅛ inches. Collection Mr. and Mrs. Ben Heller, New York. Photo Oliver Baker, New York.

19–33 Philip Guston. *The Room*. 1954–55. Oil on canvas, 71⅞ x 60 inches. Los Angeles County Museum of Art, Los Angeles, California; Contemporary Art Council Fund.

19–34 Philip Guston. *Untitled*. 1958. Oil on canvas, 64 x 75⅛ inches. Collection of the artist; on loan to The Solomon R. Guggenheim Museum, New York.

19–35 Philip Guston. *Looking*. 1964. Oil on canvas, 68 x 80 inches. Collection of the artist. Photo courtesy Marlborough Gallery Inc., New York (Eric Pollitzer).

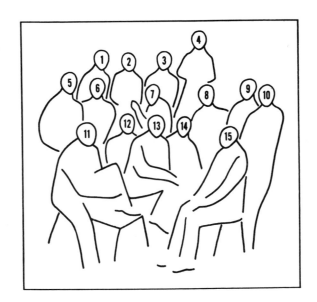

FRONTISPIECE: Nina Leen, LIFE Magazine © Time Inc. The photograph, which appeared in LIFE Magazine's issue of January 15, 1951, represents the so-called Irascibles: **1.** Willem de Kooning; **2.** Adolph Gottlieb; **3.** Ad Reinhardt; **4.** Hedda Sterne; **5.** Richard Pousette-Dart; **6.** William Baziotes; **7.** Jackson Pollock; **8.** Clyfford Still; **9.** Robert Motherwell; **10.** Bradley Walker Tomlin; **11.** Theodoros Stamos; **12.** Jimmy Ernst; **13.** Barnett Newman; **14.** James Brooks; **15.** Mark Rothko.

I have the loftiest idea, and the most passionate one, of art. Much too lofty to agree to subject it to anything. Much too passionate to want to divorce it from anything.

Albert Camus,
Notebooks 1942–1951

Introduction

CONVERSATIONS and interviews with dozens of artists have supplied much of the basic material for this history of Abstract Expressionism. First-hand contacts with most of the leading figures of the movement have, hopefully, made it possible for this book to reflect "the sympathy of a man who stands in the midst and sees like one within, not like one without, like a native, not like an alien," to cite Woodrow Wilson's conception of the historian's role.

The recollections of the artists, corroborated by other available documents, including formal statements, public letters, records of meetings, symposia, and lectures, reveal their artistic intentions. Knowledge of the aims and beliefs of the Abstract Expressionists is of prime importance, for it illuminates the actual evolution of their styles.

In response to World War II and the intellectual climate generated by it, the future Abstract Expressionists came to believe that they faced a crisis in subject matter. Prevailing ideologies—socialist, nationalist, and Utopian—and the styles identified with them—Social Realism, Regionalism, and geometric abstraction—lost credibility in their eyes. Unwilling to continue known directions or to accept any other dogma, the Abstract Expressionists turned to their own private visions and insights in an anxious search for new values. The urgent need for meanings that felt truer to their experience gave rise to new ways of seeing—to formal innovations.

The broader attributes of this process of stylistic change have been ignored by formalist writers on art, whose point of view came to dominate art criticism during the 1960's. These writers narrowed their interpretation to formal problems, avoiding any analysis of content. Their underlying premise was that advanced artists conceive new styles by rejecting recently established styles that have become outworn through overuse. The implication here is that the artistic vanguard is motivated primarily by formalist considerations. To be sure, the Abstract Expressionists schooled themselves in older styles, assimilating the traditions of modern art more thoroughly than artists of their generation elsewhere in the world. In so doing, they were able to avoid repeating visually exhausted ideas and to venture in fresh directions. However, their preoccupation was with investing forms with meanings that relate to the whole of human experience, and any critical approach that does not consider these meanings is misleading.

Philip Guston, in a seemingly paradoxical remark made during the 1950's, underscored the contrasting attitudes of formalist criticism and Abstract Expressionism, stating that in the future some artists would be looked upon as great formalists but that those who set out to be formalists would be dismissed entirely. Indeed, this book deals with artists' intentions precisely in order to capture the embryonic period in the development of their styles —before they were assimilated into art history—the time when, in Eugène Ionesco's words, artists are

. . . aware that a particular way of saying things is worn out and that a new way must be sought; or that the old exhausted idiom, the old forms must be exploded, because they have grown incapable of containing the new things that have to be said.

So what we first notice about new works of art is that they are quite distinct from those that came before (providing of course, that the artists have been adventurous and not just dull and imitative). Later these differences become less marked, and then it is above all their resemblance with much older works and a certain common identity that may be most noticeable; everyone feels more at home with them and in the end they are integrated into the history of art and literature.[a]

A statement by Mark Rothko sums up the Abstract Expressionists' antipathy to formalist aesthetics: "I would sooner confer anthropomorphic attributes upon a stone than dehumanize the slightest possibility of consciousness."[b] Formalists have countered by asserting that statements concerning content and artistic intentions are too subjective to be dealt with objectively. Nevertheless, poetic insights, no matter how private, can be true revelations and can be checked against the evidence on the picture surface, verified, as it were, or at least made comprehensible. The remarks of an artist, when they correspond to visual "facts," can also be valuable in suggesting ways of experiencing his work and understanding how it came into being. The ultimate test, however, is the work itself. It must convince one that it embodies the meanings that the artist (or anyone else) attributes to it, else any discourse concerning content is irrelevant.

The term "Abstract Expressionism" is used in this book mainly for the sake of convenience. It has an advantage over such names as "New York School," "action painting," and "American-type painting" because it has remained in the public mind and because it has been favored by critics and historians. As early as 1929, Alfred H. Barr, Jr., applied the term to Kandinsky's early improvisations.[c] In 1946, Robert Coates of the New Yorker used it to characterize the paintings of a number of American artists.[d] The name was popularized in a series of panel discussions held in 1952 at the Club and organized by the Abstract Expressionists—ironically, the artists it was supposed to refer to, many of whom participated in the symposia, repudiated it. Their reason was a valid one, for they believed that they did not constitute a movement. Moreover, as Rothko said, they feared that "to classify is to embalm. Real identity is incompatible with schools and categories except by mutilation."[e]

This book focuses on the milieu in which the Abstract Expressionists flourished from roughly 1942 to 1952; their ideas and how they developed; and on a close analysis of the works of fifteen artists, who were singled out for discussion in depth because they had evolved distinctive styles by 1952 and because they had been generally recognized by their fellow artists as significant. The terminal date of 1952 was selected because by that time, the main tendencies in Abstract Expressionism had been established and accepted, at least by the artists themselves.

There is a widely held notion that when the events of the 1940's are fully researched, certain "truths" will be established. Indeed, many persons who kindly contributed information to this study have expressed the hope that it would "set the record straight." Most will be disappointed, for what they really desired was not so much a record of events as the assertion that certain events were more significant than others. Yet different artists' assessments of "significant" events were so varied and even contradictory that it soon became

clear that there was not one "truth" but many, each determined by the vantage point from which an artist viewed developments. I, of course, have made my own assessment, and much as I hope it approximates the "facts" by incorporating numerous versions of the events, I recognize that the interpretation is mine alone.

The most difficult "fact" to determine is who painted what first. It is generally assumed that if artist A worked prior to artist B in a certain style, then artist A influenced artist B, and that A is a leader and B a follower. This is frequently true, but it also may happen that artists A and B were friends who exchanged ideas, or that artist B was tending in a direction similar to artist A before seeing his pictures, or that artist B, responding to the same stimuli in art and in the world at large, developed independently of artist A. The latter theory is known as "multiple discovery." Sociologist Robert Merton has written that in science (and, I believe, in art), the multiple is far more common than the single discovery, for "particular discoveries . . . become highly probable when, first, prerequisite kinds of knowledge have accumulated in man's storehouse of culture and, second, when the attention . . . becomes focused on particular problems; focused either by changing social needs, by developments internal to science, or by both." Merton does not minimize the role of the individual innovator but stresses that his activities do not occur "apart from the environing structure of values, of social relations and of socially induced foci of attention." [1]

To be sure, the most significant qualities in an artist's work—those that embody its artistic identity—issue from an individual's solitary efforts. Yet, his personal style does not spring Athena-like from his forehead; there are external factors that shape it. The Abstract Expressionists in fact formed a loose community, meeting frequently in each other's studios and homes, and in certain restaurants, bars, and galleries. They followed each other's work closely, establishing what Robert Motherwell called an underlying network of awareness, in which everyone knew who was painting what and why. The Abstract Expressionists also shared an enthusiasm for modern ideas and a Romantic outlook on life. Mutual awareness, mutual interests and attitudes gave rise tacitly to a common culture. Yet there was never a consensus concerning its attributes—except negatively, for the Abstract Expressionists were generally agreed as to what elements in past styles were no longer viable, that is, as to what they did *not* want to paint.

Perhaps the strongest cultural bond was a common aesthetic evolution: the rejection of existing realist and geometric tendencies, the attraction to Surrealist content and the technique of automatism, and—during the late 1940's and early 1950's—the achievement of new styles that could no longer be subsumed under existing labels. At first, it was difficult to determine sub-tendencies in Abstract Expressionism. Around 1949, however, it grew increasingly apparent that there were two main trends, gesture painting and color-field painting. The elucidation of these tendencies, in both art historical and socio-cultural terms, has been the purpose of this study.

Notes

a. Eugène Ionesco, *Notes and Counter Notes: Writings on the Theater* (New York: Grove Press, 1964), p. 247.

b. Mark Rothko, "Personal Statement," in catalogue of an exhibition, "A Painting Prophecy—1950," David Porter Gallery, Washington, D.C., May 14–July 7, 1945, n.p.

c. William C. Seitz, "Abstract Expressionist Painting in America" (Ph.D. dissertation, Princeton University, 1955), p. 448.

d. Robert M. Coates, "The Art Galleries," *New Yorker*, XXII, No. 7 (March 30, 1946), 83.

e. Mark Rothko, "Letter to the Editor," *Art News*, LVI, No. 8 (December, 1957), p. 6.

f. Robert K. Merton, "The Role of Genius in Science," *Temple University Alumni Review*, XIV, No. 3 (April, 1962).

DURING the 1930's, when most of the Abstract Expressionists began their painting careers, the prevailing aesthetic viewpoints were being shaped by economic, political, and social calamities: at home, by the Great Depression ushered in by the stock market crash of 1929; abroad, by Hitler's rise to power, the Spanish Civil War, the Moscow trials, the Nazi-Soviet Non-aggression Pact, and, in 1939 by the outbreak of World War II. Above all, the breakdown of the economy affected artists as it did millions of other Americans who found themselves unemployed or dispossessed. The Depression and the steps taken to recover from it generated "epidemics of faith or despair," one historian recalled, "the ever-present sense of the closeness of violence, and even, in the first years of the decade at least, the occasional abrupt conviction that perhaps tomorrow, for good or bad, barricades might rise on all the Main Streets across the land." [1]

Responding to the temper of the times, artists on the whole chose to work in socially oriented styles. The Regionalists, whose leaders were Thomas Hart Benton, Grant Wood (*Fig. 1-1*), and John Steuart Curry, embraced a rightist, isolationist ideology. Recoiling from the crushing events of the present, they sought to recapture in their paintings America's agrarian past. The Social Realists, among them William Gropper and Ben Shahn (*Fig. 1-2*), were motivated by Marxist dogmas and depicted the condition of workers engaged in a class struggle. Both groups continued earlier directions in American painting, but these assumed a new urgency during the Depression.

In New York, where the future Abstract Expressionists gravitated, most artists were leftist. Their social consciousness was intensified by the actions they had to take on their own behalf. Always on the margins of society, they were in worse straits in the 1930's than in the past. A number of them joined together in 1933 as the Unemployed Artists' Group, later called the Artists' Union, to pressure the national government for subsidies. The Roosevelt Administration was responsive to the plight of unemployed artists and re-solved to create work for as many as needed it. Prior to the New Deal, federal agencies would decide to commission specific public decorations and would select artists, generally of some reputation, to execute them. During the Depression, however, the government's emphasis shifted from a desire for works of art to a concern for the artists' need to work.

In December, 1933, Roosevelt set up the Public Works of Art Project. During the five months of its existence, it hired 3,749 artists, who produced 15,633 works of art for public institutions.[2] Encouraged by the success of this program but aware that it did not assist enough artists, the New Deal ex-tended its relief activities and, in August, 1935, transferred them to the newly organized Federal Art Project (simply called the Project) under the Works Progress Administration (WPA).[3] Unlike its predecessor, which supported artists who could show proof of professional accomplishments, the Project did not demand evidence of artistic qualifications, thus making younger and lesser-known painters and sculptors eligible for financial aid. Within a year, the Project was employing some 5,500 needy artists, teachers, craftsmen, photographers, designers, and researchers.[4] They received an average of $95 monthly, in return for which they were required to work 96 hours or—if in the easel division—to submit periodically pictures painted in any style in their own studios.[5] The remaining time was their own.

The Project played a vital role in the development of American art by paying artists to paint, thereby enabling them to devote their energies to art with little distraction. Such younger painters as Arshile Gorky, Jackson

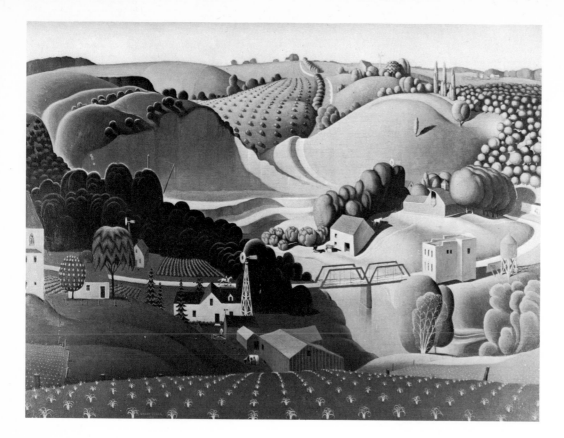

1-1 Grant Wood. *Stone City, Iowa.* 1930.
Joslyn Art Museum, Omaha, Nebraska.

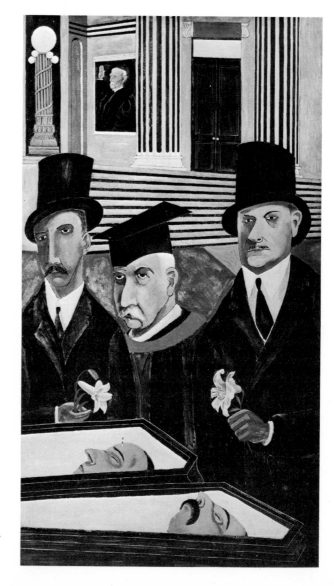

1-2 Ben Shahn. *The Passion of Sacco and Vanzetti.* 1931–32.
Collection Whitney Museum of American Art, New York;
Gift of Edith and Milton Lowenthal in Memory of Juliana Force.

Pollock, Willem de Kooning, William Baziotes, Mark Rothko, Adolph Gottlieb, Philip Guston, and James Brooks could experiment freely and at a leisurely pace during their formative years. The opportunity to concentrate on painting altered the attitude of a number of artists toward a career in art. De Kooning, for example, had only painted in his spare time before his employment by the WPA in 1935–36. After a year on the Project (until Congress passed a law barring aliens), he decided to do odd jobs on the side. His mode of living remained the same, but art became his vocation rather than his avocation.

The dedication of artists to art was deepened by a change in their social position. The very existence of the Project was partly responsible for this, since it indicated that the national government recognized the artists' worth to society. The Depression also upgraded the social standing of artists, at least in their own eyes. In a society whose business was business, artistic creation was suspect as an unmanly and frivolous evasion of reality. Artists who did not cater to the tastes of a philistine public generally escaped into self-imposed isolation, Bohemia, or expatriation. But after the collapse of the economy, artists could shake their feelings of social inadequacy, for the American Dream was proven bankrupt; by default, the artists' opinion of their vocation rose. Moreover, the Social Realists could identify with radical and labor groups that were growing in power and status. Some felt that at last they might find a place in the mainstream instead of on the fringe of American society—no longer isolated and ineffectual but workers among workers, whose job it would be to depict and to help realize the destiny of their comrades.

Many artists believed that the New Deal was inaugurating a cultural renaissance. Holger Cahill, the director of the Project, had said that its aim would be "to work toward an integration of the arts with the daily life of the community." [6] In fact, the WPA established 103 community art centers, which were visited by more than 8 million people.[7] Nevertheless, Cahill's hope was illusory, for while the centers probably contributed to the development of a new audience for art, the Project itself did not

> as has sometimes been suggested, really convey—either to the artists . . . or to the public, which on the whole endured rather than enjoyed the little it saw of its post-office and hospital decorations—the impression that art had suddenly become essential to American society. . . . More important, the experience of the depression years suggested to the artists that however marginal an afterthought art was to others it was essential to them.[8]

A by-product of the Project experience, and that which proved its most lasting legacy, was the art community it gave rise to, particularly in New York. Unlike earlier American artists, who tended to be loners, the WPA employees were thrown together of necessity. Daily meetings on the job encouraged contacts that cut across aesthetic positions and produced a constant exchange of ideas, generating a sense of community similar to that in the Paris cafés. However, the emergence of an artists' community in New York was disadvantageous in one respect: It lent itself to manipulation by the Communist Party, which was the mainspring of radical activities, and which attracted intellectuals because it presumed to have explanations for the existing crisis and offered plans to rid society of poverty, injustice, and war. Few artists were card-carrying members, but a great many were sympathizers who joined front organizations, particularly ones opposed to Fascism. In 1936, for

example, more than 400 artists met in the First American Artists' Congress Against War and Fascism, held in New York. The Congress was convened to demand increased public aid to artists, to protest censorship and other attacks on civil liberties, and to condemn Fascism in Italy and Germany.

Given the artists' social consciousness, it was natural for them to respond to calls for social action. But the Communists and their fellow travelers pressured artists to participate in such causes as the Artists' Congress at the expense of their creative work, and those who refused were subjected to abuse. Indicative of this kind of pressure but atypical in its graciousness was a remark made by Stuart Davis (a non-Communist who was an initiator of the Artists' Congress and other protest groups) to justify the break with his friend Arshile Gorky:

> In the early part of 1934 the economic situation for artists became so bad that they were forced to look around for ways and means to save themselves. They were shoved together by mutual distress, and artist organizations of one kind or another began to form as a natural result. I was in these things from the beginning and so was Gorky. I took the business as seriously as the serious situation demanded and devoted much time to the organizational work. Gorky was less intense about it and still wanted to play.[9]

By "play" Davis meant "paint."

The Communists pressured artists not only to devote full time and energy to politics but also to adopt a Social Realist position. They used such meetings as the Artists' Congress to promote this attitude, even though the Congress was supposed to be nonpartisan in aesthetic matters and was joined by artists who worked in every existing style. The culminative effect of the speeches was to advance Social Realism and to repudiate modernist tendencies, which were deemed ivory-tower escapism, bourgeois decadence, and worse. To the Communist Party, art was a weapon in the class struggle, subservient to politics. Its function was propagandistic, to incite the masses to revolution. Its subject matter had to be what proletarian novelist Mike Gold termed "the suffering of the hungry, persecuted and heroic millions," and its form an easily understood figuration.[10] To convey its message as forcibly as possible, art had to be executed in an aggressive, declamatory manner, painted on a large scale, and placed where it could be widely seen—all factors that favored the use of mural paintings in public sites.

American leftist artists took as their models the Mexican social revolutionaries, who were quite well known and admired in this country. From 1936 to 1937, David Siqueiros (*Fig. 1-3*) lived in New York, where he founded an experimental workshop. José Clemente Orozco executed a mural for the New School of Social Research in 1930–31 and in 1932–34 for Dartmouth College, which was visited by a number of New York artists (*Fig. 1-4*); Diego Rivera was given a large exhibition at the Museum of Modern Art in 1931–32. The latter, in 1933, painted a mural for Rockefeller Center.[11] Angered by a portrait of Lenin in Rivera's mural, the Rockefeller family ordered it covered over. This act provoked widespread controversy, and the publicity dramatized the propagandistic value of mural decoration.

For the "Paint Proletarian" motto of the Social Realists, the Regionalists substituted "Paint American." Politically, the two tendencies were opposed —one looking forward to violent social upheavals that would lead to an international workers' utopia (*Fig. 1-5*), the other looking back to the verities of

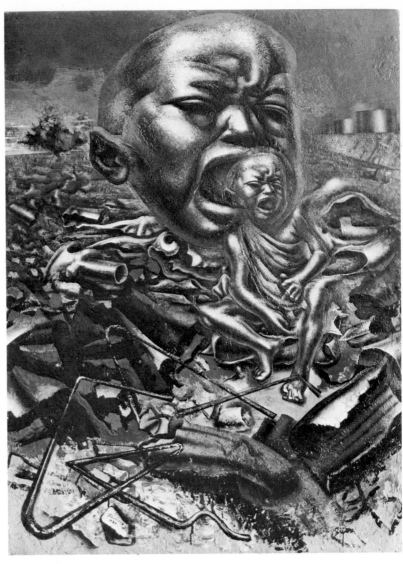

1–3 David Alfaro Siqueiros. *Echo of a Scream*. 1937.
Collection The Museum of Modern Art, New York;
Gift of Edward M. M. Warburg.

1–4 José Clemente Orozco. *Gods of the Modern World*. Panel 12 of the series
 on the Epic of America. 1932–34.
Baker Library, Dartmouth College, Hanover, New Hampshire.

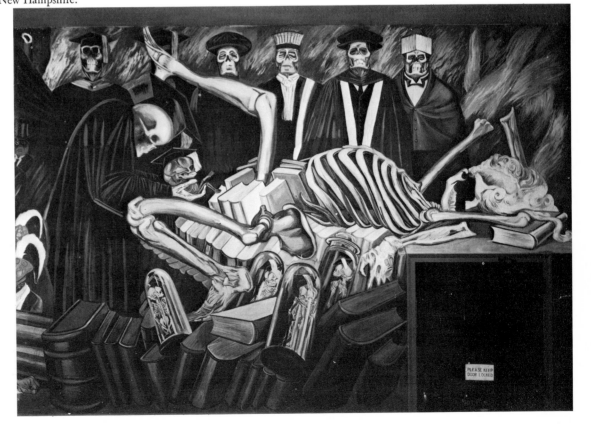

a rural Golden Age (*Fig. 1-6*). However, they appealed to artists in related ways, for each offered an ideological haven: Marxism or nationalism. Social Realism and Regionalism were also akin in their aesthetics. Despite the differences in subject matter—urban factory laborers in the one and farmers and townsmen in the other—they both employed similar illustrational techniques aimed at communicating with a mass audience. Furthermore, the proletarians and patriots shared a hatred of high-brow aestheticism and reviled as either un-American or enemies of the working class artists who looked to European modernism.

Notwithstanding the pressures from the militant left and right, a growing number of young artists experimented with avant-garde styles. They began to realize that American realist pictures of the 1930's could not rival modern European paintings and that what was good for political causes was not necessarily good for art. And they found it increasingly difficult to make excuses for "a poor art for poor people"—as Gorky caustically reproached Social Realism—just because its intentions were noble.[12]

The "hard-boiled" pose of the Social Realists and Regionalists became mildly irritating rather than threatening to the emerging American vanguard. This anti-aesthetic stance denied European modernism outright on ideological grounds and tried to make a virtue of provincialism and lack of taste; thus, it led to paintings of distressing triteness, affectedly crude rather than strong, and devoid of formal interest. Stuart Davis (*Fig. 1-7*) recognized this when he attacked the popular Regionalist John Steuart Curry (*Fig. 1-8*) in 1935:

1–5 William Gropper. *Hostages.* c. 1937.
Collection of The Newark Museum, Newark, New Jersey;
Sophronia Anderson Bequest, 1944.

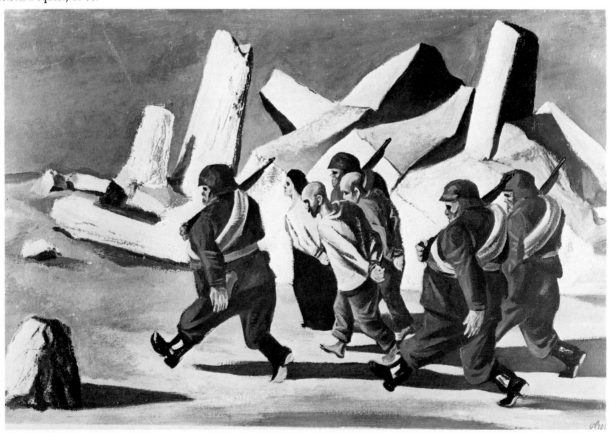

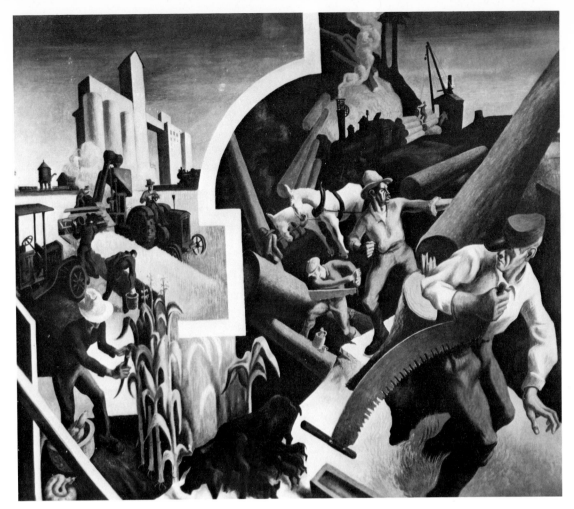

1–6 Thomas Hart Benton. *Agriculture and Lumbering.* Detail. 1931.
The New School for Social Research, New York.

> How can a man who paints as though no laboratory work had ever
> been done in painting, who wilfully or through ignorance ignores the
> discoveries of Monet, Seurat, Cézanne and Picasso and proceeds as
> though painting were a jolly lark for amateurs, to be exhibited in coun-
> try fairs, how can a man with this mental attitude be considered an
> asset to the development of American painting? [13]

The rejection of realist styles by the new vanguard was speeded by a growing
disillusionment with the leftist and rightist rationales that supported them. By
the middle of the 1930's, both positions had begun to decay from within and
to lose their power to engage intellectuals, while the motives of their
advocates began to appear less and less noble.

In a decade of widespread farm foreclosures and monopolization, the Region-
alist conception of America as a paradise of independent small farmers and
townsmen came to seem an incredible fantasy. As America's outlook turned
global, Regionalism—the aesthetic counterpart of the America First movement
—lost its pertinence. Its leading exponents also held ugly anti-urban chauvin-
istic prejudices that alienated many artists. Marxism, too, proved increasingly
irrelevant as the New Deal's recovery programs took effect and unions grew in
power. When it became clear that capitalism would survive and that labor
organizations were pragmatic and middle-class, revolutionary goals became
unreal. Furthermore, the idealism of Communist leaders at home and abroad
became suspect. Internationally minded leftists were dismayed by the opportu-
nistic nationalism revealed by the Soviet regime in the Moscow trials of 1936–
38 and by the cynical repression of all non-Stalinists. The final blow was struck
by the Nazi-Soviet Nonaggression Pact of 1939. Even those who had grown

11

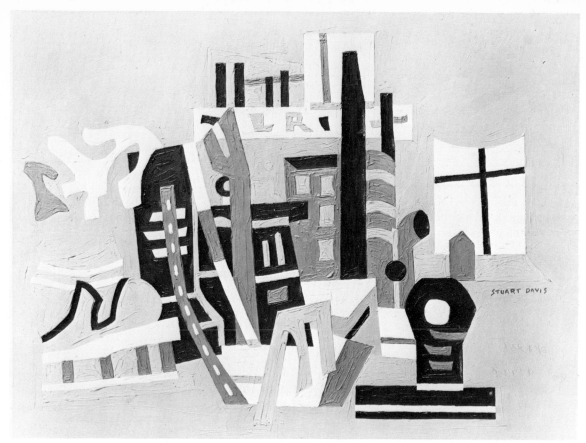

1–7 Stuart Davis. *New York Waterfront.* 1938.
Albright-Knox Art Gallery, Buffalo, New York.

skeptical of the Party but who remained loyal because of anti-Fascist senti-
ment drew back in disgust; the Artists' Congress broke up over a resolution
in support of the pact. It became obvious that the Russian Revolution
had been betrayed, and that Communism had degenerated into Stalinism.
Artists also fled the Party (and political activities in general) because of the
excessive demands made on their time. More significantly, however, they
found the hardening of the Party's artistic line repugnant and rebelled against
the self-abasement demanded by the Communists' insistence on treating art
as strictly a propagandistic tool.

More than anything else, artists were disaffected by the triteness of Social
Realist mannerisms—the banal illustration, the heavy-handed mimicry of
the murals of Orozco, Rivera, and Siqueiros, or of political cartoons—and
by the dishonesty of their subject matter—bloated capitalists protected by
vicious policemen beating noble strikers and emaciated women and children.
These stereotypes did not correspond to actual people and their concrete
feelings; they were the spurious issue of abstract formulas, "the soap-box
speaking instead of the man," as Balcomb Greene, a spokesman for abstract
art, scoffed.[14] In the name of truth and feeling, artists turned to "direct
sensual experience," which, asserted the abstract sculptor Ibram Lassaw in
1938, "is more real than living in the midst of symbols, slogans, worn-out
plots, clichés—more real than political-oratorical art." [15]

Although vanguard artists began to deny politics a role in art, the artist's
social responsibility was to remain a troublesome issue, one often debated
during the following two decades. Artists increasingly recognized that
if they were to renew art they would have to rely on their own experi-
ences and embody these in contemporary forms. First, however, they would
have to overcome provincialism and master the traditions of modern art,
channeling all of their energies to this pursuit. Aware that the international
center of art was in Paris, a small number of New York artists began a trans-

atlantic dialogue with living masters abroad and steeped themselves in the rich heritage of modern painting. Of inestimable help were the modern paintings being amassed by local museums. The Museum of Modern Art, which opened in 1929 under the direction of Alfred H. Barr, Jr., soon assembled the finest single collection of modern art in the world, including numerous master-works by Pablo Picasso. It also mounted major loan exhibitions: the inaugural was "Cézanne, Gauguin, Seurat, van Gogh," followed by a large survey of the School of Paris. Other shows valuable to vanguard artists were "Cubism and Abstract Art" (1936), "Fantastic Art, Dada, Surrealism" (1936–37), "Bauhaus 1919–28" (1938–39) and retrospectives of Henri Matisse, Henri de Toulouse-Lautrec, Fernand Léger, Vincent van Gogh, and Picasso.

From 1927 to 1943, Albert Gallatin's Museum of Living Art was housed in the library of New York University, where it was accessible to local artists, most of whom lived in the vicinity. It was here that many first saw the works of the avant-garde Europeans. Gallatin's orientation was to Paul Cézanne, Georges Seurat, and their progeny: Picasso, Georges Braque, Léger, and Juan Gris. Of special interest was the selection of Neoplasticist and Con-structivist canvases by Piet Mondrian, Georges Vantongerloo, Theo van Doesburg, Naum Gabo, and El Lissitzky. Because of its concentration of abstract works, the Gallatin collection was more important in the artistic development of many local artists than the Museum of Modern Art. The Museum of Non-Objective Painting (later The Solomon R. Guggenheim Museum) opened in 1939, but its collection, including the largest single group of Wassily Kandinsky's paintings, had been exhibited in 1936, 1937, and 1938.

1–8 John Steuart Curry. *Baptism in Kansas*. 1928.
Collection Whitney Museum of American Art, New York.

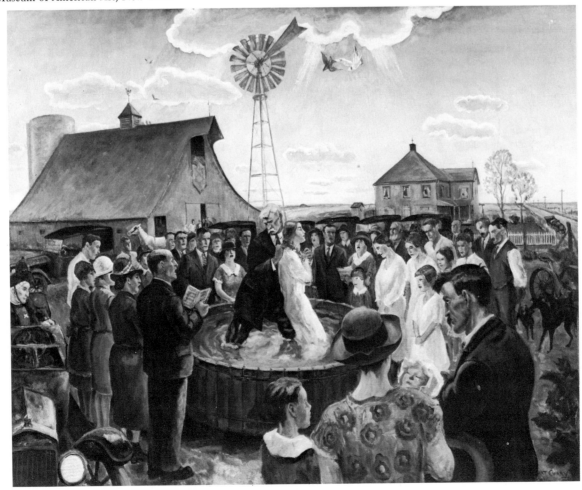

The Société Anonyme, founded in 1920 by Katherine Dreier and Marcel Duchamp to promote the study of modern art and ideas in America, organized almost 100 shows, as well as lectures and symposia, prior to 1943, the year its holdings were given to Yale University. To keep up with recent trends abroad, vanguard artists studied the latest French art magazines, particularly the *Cahiers d'Art*.

Some artists in New York assimilated the intellectual justifications for modernist art in the classes of Hans Hofmann, who began to teach there in 1932; some studied the writings of other vanguard artists and critics. Léger's aesthetics, for example, were summarized in *Art Front*, the organ of the Artists' Union, in 1935:

> During the past fifty years the entire effort of artists has consisted of a struggle to free themselves from certain old bonds.
> In painting, the strongest restraint has been that of subject-matter upon composition, imposed by the Italian Renaissance.
> This effort toward freedom began with the Impressionists and has continued to express itself until our own day.
> The Impressionists freed color—we have carried their attempt forward and have freed form and design.
> Subject matter being at last done for, we were free.[16]

Léger's point of view appealed to those New York artists who in rejecting Social Realism and Regionalism were drawn to diametrically opposed tendencies, which were nonobjective, structural, and concerned with formal values. Particularly attractive were the geometric variants of Cubism—Neoplasticism, Constructivism, and the Bauhaus style—which appealed to artists because they were avant-garde, favored by those European abstract artists of the 1930's who formed *the Cercle et Carré, Art Concret,* and *Abstraction-Création* groups, and because they lent themselves to logical analysis; Neoplasticism even offered a ready-made system of rules. Geometric abstraction was preferred to Surrealism (then personified by Dali), which despite its modern Freudian content was literary and illusionistic, thus making it unacceptable to American modernists.

By the mid-1930's New York artists had adopted abstraction in sufficient numbers to constitute a sub-scene, but few local galleries would show their works and museums ignored or rejected them. In 1935, however, there seemed to be some hope for recognition: The Whitney Museum, which generally featured realists, announced a show of abstract art by Americans, but the result was disappointing to the vanguard. George L. K. Morris, an abstract painter and critic for *Partisan Review*, lamented the "dearth of genuine abstractions; most of the artists chosen had become stalled in various ill-digested ferments of impressionism, expressionism and half-hearted cubism." [17] Moreover, the Whitney exhibition focused on artists of an older generation, with roughly a third of its participants having exhibited in the 1913 Armory Show.[18]

It is a commonly accepted notion that the Americans disposed to abstract styles in the 1930's were heavily influenced by the veterans of the Armory Show. In fact, the younger artists who were not old enough to have seen the show questioned the radicalism of their elders. They believed that the participants in the Armory Show, even at their most nonobjective, had abstracted from nature at the expense of strictly pictorial values. The return of most of the older generation to tame realist or semiabstract styles

like Precisionism during the 1920's or earlier was further proof to their juniors that they had not grasped the radical implications of nonrepresentational art. Thus, America's abstract art of the 1930's found most of its models abroad rather than at home—although the young abstractionists were impressed by the canvases of John Marin, Stuart Davis, Milton Avery, and Jan Matulka. The art of this decade has been generally dismissed as inferior by critics who consider only the glut of shoddy Social Realist and Regionalist illustrations and of imitative geometric abstractions. But to overlook the best of 1930's painting, including that of such traditionalists as Edward Hopper and Edwin Dickinson, is to misjudge the level at which the future Abstract Expressionists began.

In 1936, the Museum of Modern Art surveyed the history of Cubist and abstract art in an extensive exhibition. This show and its catalogue by Alfred H. Barr, Jr., were important in assembling before young abstract artists the visual sources and traditions out of which their own new styles were emerging.[19] Yet the show neglected current abstract tendencies and left out Americans, presumably because the Whitney Museum had covered them the year before but more likely because the Museum of Modern Art was interested primarily in European masters.[20] Abstract artists realized that if their works and ideas were to be more fully presented to the public they themselves would have to do it. In the spring of 1935, shortly after the Whitney's show of American abstraction, a number of them gathered in Ibram Lassaw's studio to plan an exhibition. The group organized itself into the American Abstract Artists (AAA) in the fall of 1936, and in the following spring held a show consisting of thirty-nine artists, the first of a series that continue to this day.[21] The group also promoted abstract art by publishing illustrated pamphlets to accompany its shows, stressing the fact that "fine abstract art does not invalidate past representational art, rather, in a form which is uniquely the reflex of our time, it possesses the same qualities as historical art; [that] 'abstract art' is an unfortunate misnomer—it is actually the most concrete of art styles; and finally, [that] abstract art is the most legitimate and authentic expression of contemporary international culture."[22]

Although they gathered initially to arrange a group show, the abstract artists continued to meet to exchange ideas about art. An issue that was argued again and again concerned the merits of "pure" as against "subject matter" abstraction: Did the introduction of imagery—the expression of things—into a picture detract from the expressiveness of the picture as an object in itself? After 1937, the consensus was that it did, but the matter of degree was troublesome and factions arose. Acrimonious debates resulted, particularly over the admission of new members, and certain applicants who had more in common with the AAA than with any other group were rejected because their painting was not deemed abstract enough.

Although the AAA supported abstract art in general, the majority of its members, following Parisian nonobjective painters, favored geometric Cubist styles, employing cleanly edged forms in flat colors thoughtfully knit together and contained within the picture limits (*Fig. 1-9*). The spokesmen of the AAA—George L. K. Morris, Balcomb Greene, and Carl Holty—painted in this vein, considering geometric abstraction the latest stage to which modern art had progressed. Discussing the innovations of Cézanne, Seurat, and their Cubist successors, Morris wrote in 1938: "These vital steps have proved a direction, and not as we were once informed, the end of a road and an era. . . . the path has been cleared for later artists who are finding for

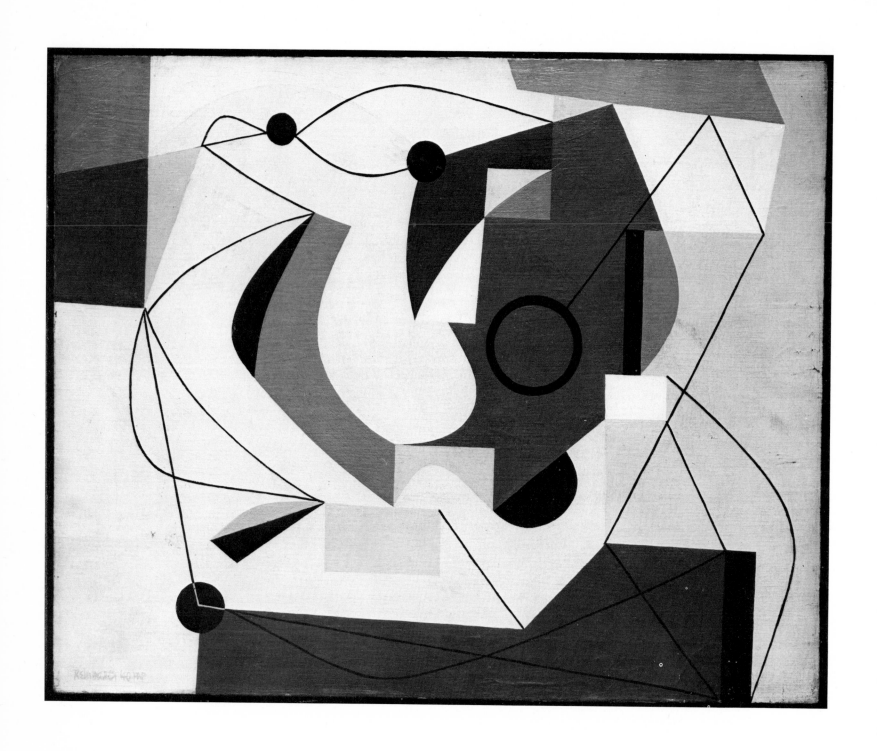

1–9 Ad Reinhardt. *Untitled.* 1940.
New York University Art Collection, New York;
Gift of Jacob Ornstein.

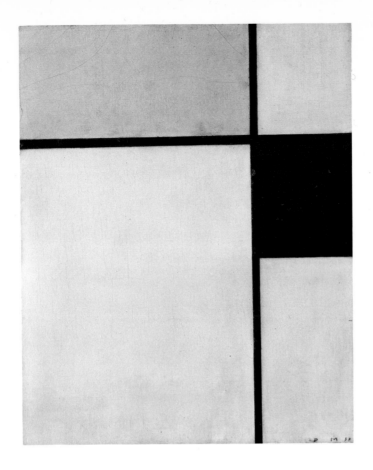

1–10 Piet Mondrian. *Composition with Blue and Yellow*. 1932.
Philadelphia Museum of Art, Philadelphia, Pennsylvania;
A. E. Gallatin Collection.

themselves that they must strip art inward to those very bones from which all cultures take their life. The ground is clear, and it remains for them to construct the foundations anew." [23] Morris reiterated this point the following year: "American abstract art has been free to concentrate upon the structural properties of esthetics, until its works have become things that can be looked at, complete in themselves, and not merely impressionistic counterfeits of nature." [24]

On the whole, American geometric painters chose to limit their discourse to formal matters. Most conceived of a picture as a self-contained entity, the internal ordering of whose parts was its own end. When they did generalize about the content of their works, the key words in their rhetoric were "purity," "essentials," and "universals." As the editors of the catalogue for the 1938 AAA show wrote: "To understand abstract art is . . . no more a problem than understanding any and all art. And this depends upon the ability of the individual to perceive essentials, to perceive that which is called universally significant." [25] A few proclaimed geometric abstraction as the harbinger of a brave new world to be guided by rational principles discoverable in art. The artist would stand beside the architect and the designer, humbly and anonymously, in the service of a suprapersonal ideal. These grandiose utopian visions—alternatives to Marxism and nationalism—gave sustenance even to those abstract artists who remained silent on such issues.[26]

Committed to a program of nonobjectivity, the AAA rejected Impressionism, Expressionism, and Surrealism. Its chief targets were the Surrealists, who constituted the most active and best-organized anti-abstraction group in Paris. The AAA disapproved of Surrealism and Expressionism not only in their figurative forms but in their abstract manifestations as well, so intense was its proclivity for a purely structural art, and its denial of "literature," figuration, and illusionism.[27]

The strongest influence upon AAA thinking was the Neoplasticism of Mondrian (*Fig. 1-10*). It was he who had carried Cubism into abstraction,

17

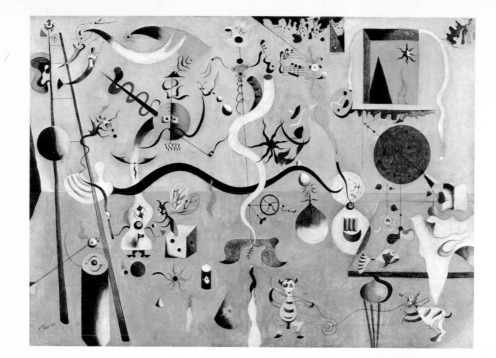

1–11 Joan Miró. *Carnival of Harlequin*. 1924–25.
Albright-Knox Art Gallery, Buffalo, New York.

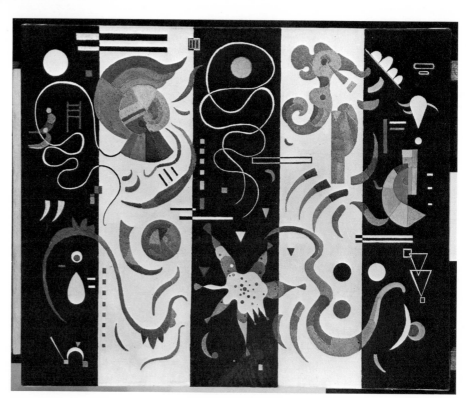

1–12 Wassily Kandinsky. *No. 609*. 1934.
The Solomon R. Guggenheim Museum, New York City.

had developed a system of rules that could be applied to the painting of a modern picture, and had formulated a rationale, at once utopian and universal, for his art. Mondrian's aesthetics were therefore congenial to those Americans who were striving to master the inner workings of abstract structure and to justify their efforts in this direction. Most of the AAA's membership experimented with Neoplastic ideas at one time during their careers.[28] Indeed, during the 1930's, Mondrian's painting was probably better understood and appreciated by a larger group of artists in America than anywhere else in the world.

However, most geometric painters did not limit themselves to the rectangular forms and primary colors of Neoplasticism. They introduced abstract organic forms derived from Picasso, Paul Klee, Hans Arp, and particularly Joan Miró (*Fig. 1-11*). AAA members were not interested in the fantasy evoked by such forms or in the spontaneous techniques used to create them but employed biomorphism to climb out of the Cubist box, as Holty put it.

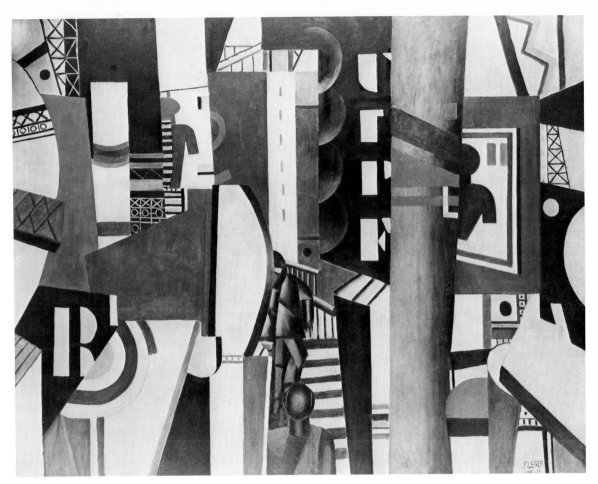

1–13 Fernand Léger. *The City*. 1919.
Philadelphia Museum of Art, Philadelphia, Pennsylvania;
A. E. Gallatin Collection.

They also adapted Kandinsky's geometric symbols (*Fig. 1-12*) and Léger's machine-like images (*Fig. 1-13*) to broaden the vocabulary of nonobjective art.[29]

Intent on keeping abreast of the European avant-garde, the AAA produced work that was largely derivative and eclectic. They were often attacked for this, and to counter criticism, tried to make a virtue of imitation.[30] Toward the end of the 1930's, the vanguard artists began to feel that geometricism was too limited in range. The more ambitious thought it meaningless to continue turning out pallid copies of European models indefinitely. Furthermore, Abstract Cubism struck them increasingly as an overrefined, academic vein—as stultifying as Social Realism and Regionalism. Geometric abstraction had become too easy, too boring to generate much enthusiasm; any deft artist could "make" a good Cubist picture. Although the formal lessons learned from Cubism were not forgotten, fresh moves toward a new subjective art seemed necessary; but the prejudice of the members of the AAA against non-structural styles had become so ingrained that it inhibited them from probing in the direction of Abstract Surrealism or Abstract Expressionism. Nevertheless, the geometric abstractionists continued to paint and to exhibit, remaining a strong force on the New York art scene.

Derivativeness was in large part accountable for the AAA's decline. Other contributing factors were internal dissension and the disruption caused by World War II, during which many artists joined the armed forces or went to work in defense plants. More important, the AAA had achieved its main ends by making a strong case for abstraction, by encouraging many artists to venture in that direction, and by focusing attention on vital aesthetic issues, which it publicized far beyond the limits of its own membership. The AAA's shows and pamphlets also cultivated an appreciation for abstract art in

enough people to provide a wide audience and buying market (in 1944, more than half of the annual exhibition was sold). Museums also began to accord abstract artists recognition by exhibiting them and purchasing their works. Success stimulated the opening of new galleries, and when the number of these increased enough, the AAA's initial reason for being—to provide a showcase for American abstract works—vanished.

The last year that the AAA played a dramatic role in American art was 1940. Its members mounted a large show at the New York World's Fair. They also picketed the Museum of Modern Art for its neglect of American abstract art, distributing a leaflet of devastating wit composed by Ad Reinhardt.[31] Further-more, the AAA published a booklet denouncing leading art critics, ridiculing them simply by quoting from their writings. These protests were to prove precedents for similar activities in the future.

None of the innovators of Abstract Expressionism belonged to the AAA, although those who lived in downtown New York—where the AAA's func-tions were centered—were friends of its members and followed its activities closely. They also shared in its main purpose: to enter the mainstream of modern art. But they objected to the AAA's narrowness and refused to limit themselves to nonobjectivism. Modernist artists not in the AAA formed three loose groups: one called "The Ten," numbered Mark Rothko and Adolph Gottlieb among its founders; another centered around Hans Hofmann and his school; the third, including Davis, Gorky, De Kooning, John Graham, and David Smith, met casually in various Greenwich Village locales.

Picasso was the living painter most admired by the two latter groups; they were heavily in debt to his work, particularly to such pictures as the *Girl Before a Mirror* (1932; *Fig.* 1-14), acquired by the Museum of Modern Art in 1938. Clement Greenberg recalled that "Picasso's arabescal manner of the early and middle thirties, with its heavy, flat cloisonnéd colors, was an obsessive influence from 1936 until after 1940, and even later.[32] His more geometric *The Studio* (1927–28; *Fig.* 3-5), acquired by the same museum in 1935, also made a strong impression.

Picasso's method of composing provided the basis for the teachings of Hans Hofmann, the most important teacher of modern art in America.[33] Almost half of the AAA's charter members had studied with him. Young artists learned of him from their contemporaries and from teachers who had at-tended his internationally famous school in Munich during the 1920's. Hof-mann's theories about modern painting were acquired at first hand when he lived in Paris from 1904 to 1914, and his skill in imparting the principles of Picasso's drawing and Henri Matisse's color was unrivaled. In brief, he taught that an artist must take into account simultaneously three factors: nature and its laws; the artist's personality, spiritual intuition, and imagination; and the medium and its inherent laws. The painter was to begin by visualizing volumes and voids in nature, then to translate them into planes of color in accord with the nature of the picture surface, that is, by flattening solids and filling voids. The planes were to be organized into "complexes"; the total effect of a picture issued from the interrelationship of the complexes, which are always more significant than the elements themselves.[34] What makes the relations consequential is the sense of volume, or plasticity, with which the planes are reinvested while remaining flat. Hofmann's teaching also provided modernist artists, including many of the founders of Abstract Expressionism, with a new artistic vocabulary, and it also influenced leading critics, notably Clement Greenberg and Harold Rosenberg.[35]

Hofmann focused on the mechanics of painting in his classes, but these

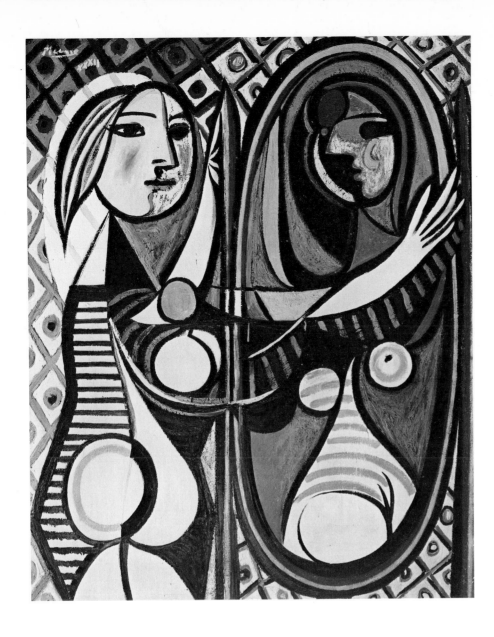

1–14 Pablo Picasso. *Girl Before a Mirror*. 1932.
Collection The Museum of Modern Art, New York;
Gift of Mrs. Simon Guggenheim.

were only the means of realizing spiritual syntheses. To him the process of
achieving "suggested volume" was a dialectical one. In 1932, Hofmann wrote
that "the relation of two given realities always produces a higher, a purely
spiritual third. The spiritual third manifests itself as pure effect. . . . The
quality of the work originates in this transposition of reality into the purely
spiritual." [36] The third dimension in painting also simulates "life" generated
by the pulsating movements of flat forms—a kind of breathing effect. He
wrote that a form "that does not owe its existence to a perception of move-
ment is . . . spiritless and inert. The form is the shell of life." [37] In his
emphasis on the spiritual in art, Hofmann resembled Kandinsky and Mon-
drian, although he ignored their radical social aspirations, stressing instead
the self-sufficiency of art. Hofmann's aesthetic dogmas appealed to the
ideology-prone artists of the decade who had grown disenchanted with politics.

Graham, Davis, Gorky, De Kooning, and Smith did not constitute a formal
group like the AAA, but they met often enough to keep abreast of each
other's views about art. There was no leader among them; Davis was the
best known, but Graham played the greater intellectual role. The latter's
status was enhanced by his variegated career as an artist, connoisseur, polemi-
cist, mystic, dandy, and cosmopolite.[38] In 1937, Graham published a book on
aesthetics entitled *System and Dialectics of Art*, which was widely read by van-
guard artists. Based on a Socratic method of question and answer, this small
volume is chaotically organized, contradictory, repetitive, and poorly written
in Russianized English, yet it is full of brilliant and provocative insights that

1–15 John Graham. *White Pipe.*
1930.
New York University Art Collection,
New York; Gift of Dorothy Paris.

reflect much of what Graham's friends, particularly Gorky and De Kooning,
were thinking at the time.

Graham asserted that art should reveal the essence of things and therefore
be abstracted from nature (*Fig. 1–15*)—in other words, that it should be
figurative like Picasso's.[39] However, this revelation could not be achieved by
copying visual reality ("if nothing else, it is too easy") but by translating
solids and voids into "pure" flat forms and composing these planes into self-
contained entities. Graham's insistence that all meaning in art had to be
expressed "in terms of pure form" led him to maintain that the "aim of
painting as of any pure art is to exploit its *legitimate assets* which are limit-
less without encroaching upon the domain of the other arts. Thus painting
that resorts to literature, sculpture, etc., to improve itself is a decadent art."[40]
In the process of revealing the essence of nature through pure form, draw-
ing became more essential than color: "*Color is an attribute of form and
acquires significance only after it occupies a definite portion of space.*"[41]
Graham considered his approach radical, since it repudiated outworn
methods. "*Revolution is the change of methods and not of the subject matter.
The change of methods means the change of forms.*"[42] Graham's attitude
was close to Hofmann's, both points of view reinforcing each other in the
minds of young artists (the two men had known each other in Europe and
maintained contact in America). Many of Graham's ideas—his insistence on
purity, the primacy of design—were also shared by the AAA. In fact, despite
his reservations concerning nonobjective art, Graham was sympathetic to
the AAA's orientation to geometric abstraction. He praised Neoplasticism
for its "attempt to find formal bases for a new plastic art, a new classicism
. . . Mondrian had the vision and heart to start anew."[43]

Graham differed from Hofmann and most members of the AAA in his
interest in Jung and Freud—in his belief that artists had to "re-establish a
lost contact with the unconscious (actively by producing works of art and
passively by contemplating works of art), with the primordial racial past

. . . in order to bring to the conscious mind the throbbing events of the unconscious mind." [44] It was Graham who most likely introduced Gorky to Freudian thinking. He also helped to bring Jung's theories to the attention of Rothko and Gottlieb; his influence in this direction was to be strongest on Jackson Pollock. Given his interest in tapping unconscious imagery, it is natural that Graham in his book should have stressed the importance of automatic writing and directed Gorky, De Kooning, Rothko, Gottlieb, and Pollock to that Surrealist technique. [45] However, Graham was unfavorably inclined toward Surrealism's penchant for literary symbolism, illusionism, and for disregarding pictorial structure. Graham valued the free gesture for its ability to convey personality directly. "Gesture, like voice, reflects different emotions . . . The gesture of the artist is his line, it falls and rises and vibrates differently whenever it speaks of different matter. . . . The handwriting must be authentic, and not faked . . . [not] conscientious but honest and free." [46] This concern with spontaneous gesture disposed him, as it did Pollock (who would carry it to an unprecedented extreme) and his other friends, to a painterly style of drawing.

Although Picasso's influence on American modernist art of the 1930's was stronger than Matisse's, the "color magician's" ideas were sufficiently known. Hofmann called attention to them in his classes; Greenberg recalled that "you could learn more about Matisse's color from Hofmann than from Matisse himself." [47] Milton Avery (Fig. 1–16) played the greatest role in transmitting the French master's approach to young artists, particularly to his friends Rothko and Gottlieb (Fig. 1–17). In 1935, the latter two helped organize The Ten, a group of independents, a majority of whom painted representational images in a loose, flat manner, but who were sympathetic enough to abstraction to include members of the AAA. [48] The group's central position was, as one critic wrote, "an attempt to combine a social consciousness with [an] abstract, expressionistic heritage, thus saving art from being mere propaganda on the one hand, or mere formalism on the other." [49]

On the whole, The Ten were favorably disposed to modern European art, particularly that of Matisse, Picasso, Chaim Soutine, and Georges Rouault. Its members also admired Albert Pinkham Ryder above all other American artists; of their elders, they favored Milton Avery, who was seen as combining the color concepts of Matisse with Ryder's brooding expressionism. The antiprovincial stance of the group was evident in a show entitled "The Ten: Whitney Dissenters," organized in 1938. It was held to protest the Whitney's sponsorship of "an American art that is determined by non-esthetic standards —geographic, ethical, moral or narrative—depending upon the various lexicographers who bestow the term. In the battle of words the symbol of the silo is in ascendancy in our Whitney museums of modern American art. The Ten reminds us that the nomenclature is arbitrary and narrow." [50] The group disbanded around 1940, but the Expressionist bent that it fostered was to grow in importance during the following decade.

As a result of the activities of various museums, the AAA, Hofmann's school, The Ten, Graham, Avery, and other charismatic figures, the vanguard in New York became the most knowledgeable in the world. It did not turn away from Parisian art but assimilated it. [51] However, much as local modernists talked the language of the School of Paris, their accent was different. Some writers attributed this deviation to their Americanness, but more likely it depended on the European artists they chose to emulate. [52] The Americans looked to artists who lived in France but who, for the most part, were not much appreciated there, notably Mondrian and Kandinsky. The works of

23

1–16 Milton Avery. *Sea Gulls, Gaspé*. 1938.
Addison Gallery of American Art, Phillips Academy, Andover, Massachusetts.

1–17 Adolph Gottlieb. *Sun Deck*. 1936.
Collection University of Maryland Department of Art, College Park, Maryland.

both were available in large numbers to local artists, and their writings were also well known. Georges Mathieu, a leading abstract painter in Paris after World War II, alleged that until 1945 he had never heard of either of these masters and that in their knowledge of geometric abstraction "a certain American public can be said . . . to have been fifteen to twenty years in advance of the corresponding French public." [53] Indeed, by 1940, as Clement Greenberg wrote, New York "had caught up with Paris as Paris had not yet caught up with herself, and a group of relatively obscure American artists already possessed the fullest painting culture of their time." [54] Never before had this occurred in American art.

1. Walter B. Rideout, *The Radical Novel in the United States, 1900–1954* (Cambridge, Mass.: Harvard University Press, 1956), p. 2.

2. Francis V. O'Connor, catalogue of an exhibition, "Federal Art Patronage, 1933 to 1943," University of Maryland Art Gallery, College Park, Md., 1966, p. 11.

3. The Federal Art Project, directed by Holger Cahill, was separate from the Treasury Department's Section of Painting and Sculpture, established late in 1934 and headed by Edward Bruce, who had supervised the Public Works of Art Project. The Section was financed by the allocation of 1 per cent of the construction costs of federal buildings. Artists generally competed for the mural commissions or were selected by committees of experts. In 1939, this program became the Section of Fine Arts of the Public Buildings Administration under the Federal Works Agency. Both the Project and the Section were terminated in the spring of 1943.

4. Dorothy C. Miller, in *The United States Government Art Projects* (New York: Museum of Modern Art, Department of Circulating Exhibitions), a brief, mimeographed summary excerpted from annual articles on painting and sculpture that she prepared for *Collier's Yearbook*, 1935–43, reported on page 13 that as of October, 1941, the Project's production figures were more than 2,250 murals, including frescoes, mosaics, and photomurals, more than 85,150 paintings allocated on permanent loan to public institutions, some 13,198 sculptures for public buildings, and 239,727 fine prints from 12,581 original designs.

5. There was discrimination against abstract artists on the Project, but Burgoyne Diller, who headed the mural project in New York, was an abstract painter, and he encouraged other modernists and tried to find commissions for them.

6. O'Connor, "Federal Art Patronage," p. 29.

7. Miller, *The United States Government Art Projects*, pp. 14, 17.

8. Robert Goldwater, "Reflections on the New York School," *Quadrum*, No. 8 (1960), 20.

9. Stuart Davis, "Arshile Gorky in the 1930's: A Personal Recollection," *Magazine of Art*, XLIV, No. 2 (February, 1951), 58.

10. Daniel Aaron, *Writers on the Left* (New York: Harcourt, Brace & World, 1961), p. 208.

11. Orozco also painted murals for Pomona College (1930); Rivera, for the San Francisco Stock Ex-

1 Notes

change (1930) and the Detroit Art Institute (1932); and Siqueiros, for the Chouinard School of Art in Los Angeles (1932).

12. In a conversation with the author, January 29, 1968, Rosalind Browne recalled that the speech by Gorky was delivered at an Artists' Congress meeting in the spring of 1936.

13. Stuart Davis, "The New York American Scene in Art," *Art Front*, I, No. 3 (February, 1935), 6.

14. Balcomb Greene, "Expression as Production," catalogue of an exhibition, "American Abstract Artists," Section XI, New York, 1938, n.p.

15. Ibram Lassaw, "On Inventing Our Own Art," catalogue of an exhibition, "American Abstract Artists," Section VIII, New York, 1938, n.p.

16. Fernand Léger, "The New Realism," *Art Front*, II, No. 8 (December, 1935), 10. (A lecture delivered at the Museum of Modern Art.)

17. George L. K. Morris, in Introduction to catalogue of an exhibition "American Abstract Artists," Section II, New York, 1939, n.p.

18. George McNeil, "American Abstractionists Venerable at Twenty," *Art News*, LV, No. 3 (May, 1956), 34. McNeil also wrote: "The Whitney's genuine 1936 outlook was shown at its Third Biennial Exhibition of Contemporary Painting when only ten of the 123 artists could be considered abstract, even with a liberal allowance—Joseph Stella, Niles Spencer, Stuart Davis, Arshile Gorky, Arthur Dove, Louis Shanker, Theodore Roszak, Jan Matulka, John Marin and Charles Sheeler."

19. Alfred H. Barr, Jr., *Cubism and Abstract Art* (New York: Museum of Modern Art, 1936).

20. In 1937, the Museum of Modern Art refused a request of the American Abstract Artists to hold their annual exhibition there.

21. The thirty-nine artists in the First Annual Exhibition of the AAA in 1937 were: Josef Albers, Rosalind Bengelsdorf, Ilya Bolotowsky, Harry Bowden, Byron Browne, Jeanne Carles, George Cavallon, A. N. Christie, Anne Cohen, Burgoyne Diller, Werner Drewes, Herzl Emmanuel, Robert Foster, Balcomb Greene, Gertrude Greene, Hananiah Harari, Harry Holtzman, Carl Holty, Ray Kaiser, Frederick P. Kann, Paul Kelpe, M. Kennedy, Leo Lances, Ibram Lassaw, Agnes Lyall, George McNeil, Alice Mason, George L. K. Morris, John Opper, Ralph Rosenborg, Louis Schanker, Charles Shaw, Esphyr Slobodkina, Albert Swinden, R. D. Turnbull, Vaclav Vytlacil, Rudolph Weisenborn, Frederick Whiteman, and Wilfred Zogbaum. In 1937, the AAA exhibition was held at the Squibb Galleries, New York; attendance was 1,500. There was also a show at Columbia University that year.

In 1938, the Annual was held at the American Fine Arts Gallery, New York; attendance was 7,000. The show was circulated by the College Art Association to the Henry Arts Center, University of Washington, Seattle; the Palace of Legion of Honor, San Francisco; the William Rockhill Nelson Museum, Kansas City; and the Art Institute, Milwaukee. Other New York shows that year were held at the Contemporary Art Center, Y.M.H.A., and the Municipal Art Galleries. The Third Annual, 1939, was at the Riverside Museum, New York; it traveled to Beloit College, Beloit, Wisconsin. A group close to the AAA, the Concretionists, held a show at New York University in 1936. Organized by Albert Gallatin, it consisted of Gallatin, Charles Biederman, Alexander Calder, John Ferren, George L. K. Morris, and Charles Shaw.

22. McNeil, "American Abstractionists Venerable at Twenty," p. 65.

23. George L. K. Morris, "The Quest for an Abstract Tradition," catalogue of an exhibition, "American Abstract Artists," Section II, New York, 1938, n.p.

24. Morris, in Introduction to catalogue of an exhibition "American Abstract Artists," Section IV, New York, 1939, n.p. Morris also wrote: "There are discernible two main currents that might be claimed as a starting-point for many individual artists. Foremost is that French tradition which became grounded upon Cubism and has reached America through several different channels. It recurs in the geometric forms that predominate on the one hand, and in the curved, self-contained shapes that have grown through Braque, Arp and Miró on the other. A second current might be said to stem from German abstraction as typified by the Bauhaus and its teaching heritage. Here again we are met with a divided concept—the open pictures of Klee and early Kandinsky on the one hand, and on the other a movement toward closed integration that has influenced the art of today most strongly through Constructivism. Both the Constructivists and the Dutch Stijl group have taught Americans much with their emphasis upon exactness in the absorption of form by color, contour and tone."

25. The Editors, in Introduction to catalogue of an exhibition, "American Abstract Artists," New York, 1938, n.p.

26. Balcomb Greene believed abstraction to be Social Realist art on a higher level. In "Differences Over Léger," *Art Front*, II, No. 2 (January, 1936), 9, he wrote: "The complete revolutionist . . . [will] welcome a new art. . . . The objection of some revolutionaries, only 'political' and therefore incompletely mature, that all creative activity must be specific agitation, is becoming less insistent. The people in revolt are being integrated."

27. Harry Holtzman, "Attitude and Means," catalogue of an exhibition, "American Abstract Artists," Section V, New York, 1938, n.p., typified an anti-Expressionist and anti-Surrealist bias when he attacked "the solipsist [who] would have the means become a merely egotistic function. It is characteristic of the particularized attitude to comprehend the object (painting, sculpture, construction) as an individualistic symbol . . . The particularized attitude is in opposition to the comprehension . . . of universal meaning."

Alice Mason, "Concerning Plastic Significance," catalogue of an exhibition, "American Abstract Artists," Section VI, New York, 1938, n.p., wrote: "The surrealists . . . still use their materials as props for narrative; they find a source of wonder in dreams, in automatism and in the subconscious, and depict this feeling academically by the extraordinary placing of objects and the unusual scale of them. Not working plastically, they seek to record such things as nostalgia, dreamlike fancies and incongruous shapes

that have no part at all with abstract art. We look for nothing mystical or dreamlike but the magic in the work itself." The use of automatism and incongruous shapes could yield an abstract art but not the kind Miss Mason would be in sympathy with, for she would still object to its disregard for plasticity.

28. Several Americans became all-out disciples of Mondrian. Harry Holtzman, for example, was so stunned by three of Mondrian's canvases that he saw in the Gallatin Collection in 1933 that he looked up the Dutch painter in Paris the following year and returned to America to proselytize for Neoplasticism. Shortly after, Holtzman was active in the formation of the AAA.

29. The paintings of Léger were of special interest in part because he was the only French master to visit America during the 1930's—in 1931, 1936, and 1938. Although he spoke no English, he worked for several weeks in 1936 with a number of New Yorkers, including De Kooning, on a WPA project to paint murals for the French Line pier. Léger was also esteemed by the vanguard here because his pictures, though not nonobjective, were akin in appearance and in spirit to geometric abstractions, and because he was a leftist who wanted his works to reach the masses. Jean Helion, whose painting was heavily in debt to Léger, was also influential in America, where he lived from 1936 to 1940. He had been a founder of the *Art Concret* and *Abstraction-Création* groups in Paris and a contributor to their magazines. In 1936, he wrote the introduction to the catalogue of the Gallatin Collection and lectured to the AAA, befriending many of its members. Abstract artists also had a high regard for Russian Constructivism and for the Bauhaus. Josef Albers, a teacher at the Bauhaus, and Werner Drewes, who had studied there, were early members of the AAA. In 1940, the group invited Walter Gropius, Marcel Breuer, and other architects to exhibit models in its annual show.

30. Morris, in Introduction to catalogue of an exhibition "American Abstract Artists," Section IV, New York, 1939, n.p.

31. McNeil, "American Abstractionists Venerable at Twenty," p. 65. McNeil wrote: "Ad Reinhardt, our genial Aretino of the art world, reached for his scissors and montaged a series of bizarre type-faces. 'How Modern Is the Museum of Modern Art?'; 'in 1939 the Museum professed to show ART IN OUR TIME—whose time Sargent, Homer, LaFarge, and Harnett?'; and 'What is this—a three ring circus?' were some of the captions."

32. Clement Greenberg, "New York Painting Only Yesterday," *Art News*, LVI, No. 4 (Summer, 1956), 84.

33. In 1915, Hofmann opened his School of Fine Arts in Munich. He closed it in 1932. In the summer of 1930, he taught at the University of California, Berkeley, and in the spring of 1931, at the Chouinard School of Art, Los Angeles, and again at Berkeley in the summer. In the winter of 1932, Hofmann taught at the Art Students League, New York, and in the summer of 1933, at the Thurn School of Art, Gloucester, Massachusetts. In the autumn of that year, he opened a school on Madison Avenue in New York; in the summer of 1934, he taught again at the Thurn School, and in October, he opened the Hans Hofmann School of Fine Arts at 137 East 57th Street, New York. The school was moved to 52 West Ninth Street in 1936, and in 1938, to 52 West Eighth Street. In the summer of 1935, he opened a summer school in Provincetown, Massachusetts. Hofmann closed the New York and Provincetown schools in 1958.

34. William C. Seitz, *Hans Hofmann* (New York: Museum of Modern Art, 1963), p. 47.

35. Hofmann's conception of painting as "push and pull" anticipates Rosenberg's "Action Painting." Clement Greenberg, in "Art," *The Nation*, CLX, No. 16 (April 21, 1945), 469, wrote: "Hans Hofmann is in all probability the most important art teacher of our time. . . . He has, at least in my opinion, grasped the issues at stake better than did Roger Fry and better than Mondrian, Kandinsky, Lhote, Ozenfant, and all the others who have tried to 'explicate' the recent revolution in painting. . . . this writer . . . owes more to the initial illumination received from Hofmann's lectures than to any other source. . . . I find the same quality in Hofmann's painting that I find in his words—both are completely relevant. His painting is all painting . . . asserting that painting exists first of all in its medium and must there resolve itself before going on to do anything else."

36. Hans Hofmann, "Plastic Creation," *The League*, V, No. 2 (New York: Art Students League, Winter, 1932–33), 14.

37. *Ibid.*, p. 22.

38. Thomas B. Hess, "John Graham, 1881–1961," *Art News*, LX, No. 5 (September, 1961), 46.

39. Graham not only lionized Picasso but, by 1937, in *System and Dialectics of Art* (New York: Delphic Studios, 1937), pp. 75–76, had singled out for acclaim Davis, Milton Avery, Max Weber, Matulka, De Kooning, Smith, and Gorky, commenting that "Some are just as good and some are better than the leading artists of the same generation in Europe." He was probably the first to praise publicly De Kooning, Smith, and Jackson Pollock (whom he befriended in the late 1930's).

40. *Ibid.*, p. 23.

41. *Ibid.*, p. 53.

42. *Ibid.*, p. 97.

43. *Ibid.*, p. 33.

44. *Ibid.*, p. 15.

45. The New York vanguard learned about automatic drawing and painting from sources other than Graham's book, that is, from reproductions of pictures by Masson and Miró that were featured repeatedly in *Cahiers d'Art*. However, they rarely practiced automatism in the 1930's.

46. Graham, *System and Dialectics of Art*, p. 88.

47. Clement Greenberg, "New York Painting Only Yesterday," p. 84.

48. The others in The Ten were Ben-Zion, Ilya Bolotowsky, Louis Harris, Jacob Kufeld, Schanker, Joseph Solman, and Tschacbasov, a total of nine,

for the group was unable to decide on a tenth. Tschacbasov dropped out in 1936 and was replaced by Lee Gatch for a year. In 1938, Kufeld left and Graham, Earl Kerkam, and Ralph Rosenborg joined. Carl Knaths and Liberte were invited as guests in a show of the group in 1939. The Ten began to come together in 1935 and met frequently, for periods of time, as often as once a week. Their first exhibition was at the Montross Gallery in December, 1935. In the 1936–37 season, they were shown again at the Montross Gallery, and at the Galerie Bonaparte in Paris. In May, 1937, the group exhibited at the Georgette Passedoit Gallery; in November, 1938, under the heading of "The Ten Whitney Dissenters," at the Mercury Gallery, and, later in the year, at the Passedoit Gallery. The last show was in October, 1939, at the Bonestall Gallery.

49. Herbert Lawrence, "The Ten," *Art Front*, II, No. 3 (February, 1936), 12.

50. Catalogue of an exhibition, "The Ten: Whitney Dissenters," New York, November, 1938. In a conversation with the author, June 29, 1967, Joseph Solman recalled that the statement was written by Rothko and Bernard Braddon of the Mercury Gallery.

51. Greenberg, "New York Painting Only Yesterday," p. 86.

52. Morris, in Introduction to catalogue of an exhibition "American Abstract Artists," Section IV, New York, 1939, n.p.: "There are marks of foreign influence upon American abstract art and there are works, moreover, that continue definitely established European traditions. Yet anyone who knows America can see that the tone and color contrasts are quite native, that the culminative rhythmic organization resounds from an accent which could have originated in America alone." But Morris does not specify what these "native" characteristics are.

53. Georges Mathieu, mimeographed document, "Declaration to the Abstract Avant-Garde Painters," (A Letter to Twenty-Five American Artists), April, 1952, n.p. (The "Declaration" was read at the Club, November 21, 1952.)

54. Greenberg, "New York Painting Only Yesterday," p. 85.

POLITICAL events strongly influenced the development of American art in the early 1940's as they had during the preceding decade. America's entry into World War II provided Social Realists and Regionalists with a new cause, and they quickly organized themselves into the Artists for Victory.[1] But despite the exertions on their behalf by museums and art magazines, retrogressive styles could not be revived, for academic illustration, no matter how patriotic, had become aesthetically irrelevant. Much as modernist artists supported the war effort, their response to the war was more complex than a desire for an Allied victory. They sensed that victory would not significantly change man's lot. Indeed, the war gave rise to an outlook far different from that of abstract artists of the 1930's. It threw into sharp relief the dark side of man as inherent to his being; human irrationality could never again be dismissed as a passing aberration. The after-effects of the war—the possibility of atomic holocaust, the Cold War—aggravated the anxious awareness of man's vulnerability and of his tragic condition.

In the face of these terrible events, every sustaining norm became more problematical than ever before. World War I and the pervasive corruption of postwar society had provoked a crisis mentality in the Dadaists, who, in their indignation and despair, were motivated to subvert every established convention of society and its culture, which they blamed for the débacle. Reacting against reason, which they believed to be the mainspring of Western culture, the Dadaists glorified irrationality. As artists, they aimed most of their abuse at art, but their iconoclastic outrages against aesthetic values could not be repeated for long. They soon faced an essential dilemma, as Motherwell perceived: "how to express oneself without art when all means of expression are potentially artistic."[2] The Dadaists could take two courses: they could stop producing works, as Duchamp did, for they would inevitably lapse into art; or they could transform their negative purposes into positive ones, as those who became the Surrealists did. The Surrealists continued to embrace Dada's irrationality but wedded it to Freudian and Marxist rationality, both of which became dogmas of faith.

The Russian Revolution gave rationalism a renewed popularity as intellectuals began once more to think of reason as adequate to shape a new society and of man as perfectible. This attitude accounts for the upsurge of Neoplasticism, Constructivism, and the Bauhaus after the war. The dark side of man was ignored by those artists who hopefully designed messianic blueprints. They did not, of course, deny the existence of irrational and idiosyncratic traits but suppressed all signs of them in their art and aspired to extract and refine from experience the universal and the eternal.

Such optimism crumbled with World War II. It was no longer possible to disregard what Henry James called "the imagination of disaster." The ideologies that engaged intellectuals during the 1920's and 1930's were proven to be abstract schemes that did not account for man's behavior, and intellectuals in growing numbers refused to accept any pre-established formula, whether Marxist, nationalist, Freudian, or Utopian. American modernist artists had earlier repudiated Social Realism and Regionalism; after the advent of the war, many rejected Neoplasticism, Constructivism, and the Bauhaus, because the conception of man's nature and condition posited by these styles had lost its relevance.

Instead of embracing cosmic constructs that sheltered them from the realities of existence, the Abstract Expressionists began to rely on their own particular experiences and visions, which they painted as directly as they could.

They refused to set limits on the emotional content of their painting, no matter how indecorous, and acknowledged ambiguity and irrationality as factors inherent in human nature. Motherwell remarked that their

> response to modern life . . . [was] rebellious, individualistic, unconventional, sensitive, irritable . . . this attitude arose from a feeling of being ill at ease in the universe . . . Nothing as drastic an innovation as [their] abstract art could have come into existence, save as the consequence of a most profound, relentless, unquenchable need. The need is for felt experience—intense, immediate, direct, subtle, unified, warm, vivid, rhythmic.[3]

An earlier statement by Motherwell, made in 1942, is also indicative of this point of view. In it, he acclaimed Mondrian above all other geometric abstractionists but questioned his "loss of contact with historical reality; or more concretely, loss of the sense of the most insistent needs (and thus of the most insistent values) of a given time . . . when men were ravenous for the *human* . . . Mondrian failed, with his restricted means, to express enough of the felt quality to deeply interest us."[4] Desiring the "human," the personal, and the subjective, the Abstract Expressionists reacted against the social visions identified with Neoplasticism, Russian Constructivism, and particularly the Bauhaus—the dreams of men as smoothly functioning cogs in a social machine—and they repudiated the glorification of technology and its artifacts by these movements.[5] Indeed, the Abstract Expressionists rejected any pictorial element that evoked the machine-made: impersonal, polished surfaces from which all signs of the artist's hand had been eliminated; precisely lined closed forms that looked as if they were ruled with the help of such mechanical devices as the T-square and French curve; synergetic, streamlined compositions, and "un-psychological" colors. Instead, they experimented with unstable, indeterminate, dynamic, open, and "unfinished" forms—directly exploiting the expressiveness of the painting medium to suggest the particular creative action of the artist, his active presence and temperament.

Acutely conscious of their own irrationality, the Abstract Expressionists could not believe that their actions were predictable, like a machine's, and so they welcomed the unpremeditated in painting. The awareness of an extreme dissociation of past, present, and future gave rise to a mixture of perplexity and hopefulness, anxiety and elation. The loss of a conception of man's perfectibility prompted a pessimistic attitude, for the acceptance of his fallibility, of his future as uncertain and temporal, generated a tragic view of life. Yet the Abstract Expressionists did not succumb to a total cynicism, for they refused to deny any of the traditional human and aesthetic aspirations. Recognizing, however, that existing traditions could not be extended with credibility, they accepted as authentic guides only their own changeable experiences and intuitions, which resulted in a growth of self-confidence and a reliance on the free judgments of the individual.

Despite the ardor with which they prized individuality, the Abstract Expressionists hoped that their private statements would tap inner sources common to all men and so become communicable, or intrasubjective. In this, they were not as indifferent to social aims as their stress on individuality would imply. All in all, the Abstract Expressionists assumed a romantic point of view, which may be contrasted with the classicistic or "geometric" attitude, as defined by Jacques Barzun:

. . . the geometrician works in a closed universe, limited by his own axioms and definitions; the romanticist works in an open universe limited by concrete imperfections—imperfections which have not all been charted, which may change and which need not be the same for all men. . . . Classicism is therefore stability within known limits; romanticism is expansion within limits known and unknown.[6]

There are significant differences, however, between the Abstract Expressionists and the nineteenth-century romantics. The latter recorded their responses to nature, while the Abstract Expressionists tried to expose directly, in the process of painting, the changeable facts of their creative experience. In so doing, they seized upon the fundamental Romantic impulse.

Unwilling to accept existing ideologies and the styles they gave rise to, the Abstract Expressionists faced what they referred to repeatedly as "a crisis in subject matter." As the phrase indicates, their preoccupation was with meaning—with what to paint, rather than with how to paint. Indeed, their objection to geometric painting was based on their belief that it had become too much a matter of making pictures whose end was composition for its own sake. As Gottlieb said in 1943: "It is generally felt today that this emphasis on the mechanics of picture-making has been carried far enough." [7] Their urgent need for new themes led Gorky, Pollock, Gottlieb, Rothko, and Baziotes to re-evaluate Surrealism. Having generally ignored it during the 1930's, they were now drawn to its stress on meaning, at once human and irrational. However, the New York artists were unimpressed with Surrealist paintings, which, with the exception of Miró's and, to a lesser extent, André Masson's, they found lacking in artistic qualities. But the Surrealist turn of mind remained largely unknown until World War II. When Paris fell to the Nazis in 1940, the center of global art was suddenly cut off from the rest of the world. Leading Parisian artists, many of them Surrealists, fled to America, adding to the number who had been emigrating since 1939. The more prominent were André Breton, Marc Chagall, Salvador Dali, Max Ernst, Léger, Jacques Lipchitz, Masson, Matta, Mondrian, Amédée Ozenfant, Kurt Seligmann, Yves Tanguy, Tchelitchew, and Ossip Zadkine. Thus, by an act of war, New York became the international art capital.

The awareness of being at the center of the international art scene instilled in American modernists a sense of confidence that was to encourage them to stop imitating imported styles. To American artists during the 1930's, the School of Paris had been the vital source of world art; yet by studying it at an ocean's remove, they continued to feel that they were in an artistic backwater. After the arrival of the Europeans, however, New Yorkers felt less provincial. To see, occasionally to talk to Léger, Mondrian, or Breton in the flesh was to join the School of Paris with an intimacy impossible earlier and to become heir to a succession of revolutionary masters that stretched back for more than a century.[8]

The life style of the Surrealists-in-exile set an example for the local vanguard. As Robert Goldwater wrote, they were

> international in character, "bohemian" in a self-confident, intensive fashion possible (after so many depressing years), to none of the New York artists, living *as if* they had no money worries . . . [yet they] had this in common with the artists who had experienced the W.P.A.: they too existed on the margin of society . . . Moreover, as the latest issue of a long line of romantics, they accepted this situation as a condition of creativity, and made of it a positive virtue . . . Artists of considerable

reputation, they transmitted a sense of being at (or simply of being) the artistic center. . . . New York was at the head of the procession, there was nowhere else to look for standards or models. The conviction of the European group of the importance of art even in the midst of cataclysm, for all that it was partly expressed through annoying poses, was sincere and contagious. It was a proper accompaniment of their Surrealism, with its reliance upon the intuitive promptings of creation, and its trust in the subconscious impulse as the best artistic guide; it was a point of view that the American *avant garde* of the time . . . had not yet experienced.[9]

The enforced isolation of Paris prompted some artists and writers here to call for an independent American art. The appeal that generated the widest and longest controversy was contained in a letter by Samuel Kootz to *The New York Times* in the summer of 1941. Kootz had long been an internationalist in his aesthetic outlook: In a book entitled *Modern American Painters* (1930) and in a letter of 1931 to *The New York Times*, he had condemned attacks on modern French art and acclaimed those American modernists who followed the masters abroad.[10] However, in his letter to the *Times* of a decade later, Kootz asserted that artists here had been separated from Paris by the war and could no longer look to it for fresh ideas. The future of art probably lay in America, and yet, "I have not seen one painter veer from his established course. I have not seen one attempt to experiment, to realize a. new method of painting. . . . Isn't there a *new* way to reveal your ideas, American painters? . . . Anyhow, now's the time to experiment. . . . God knows you've had a long rest." [11] The art critic of the *Times*, Edward Alden Jewell, called the letter "a truly shattering bomb," and dozens of artists wrote in to challenge Kootz, declaring that a new experimental art was indeed being produced in America, but that, unfortunately, it was not being shown in the galleries. In response to their letters, Jewell suggested that artists "come out of their studios and organize. Let them form an exhibiting organization and, in some readily accessible place, prove it to Mr. Kootz that the picture he drew of American art today is far too black." [12] Jewell's appeal led to the formation of a so-called Bombshell Group, which in the spring of 1942 held an exhibition at the Riverside Museum of more than 200 works by fifty-five of its members.[13]

Kootz had nothing to do with the organization of this group or with the Riverside show and asserted that he was "unable to find outstanding inspiration or talent in a single painter in the group." [14] But he had begun to visit studios prior to the show, and when the R. H. Macy department store invited him to arrange an exhibition in 1942, he selected 179 paintings by seventy-two artists, including Davis, Avery, Morris, Holty, Graham, Matulka, Gorky, Rothko, Gottlieb, and nearly every other modernist painter in New York. Jewell, who had earlier attacked Kootz for caricaturing American art, was disappointed with the Macy's display because few of the participants were unknown. Kootz, on the other hand, was elated, claiming to have found what he was seeking.

Kootz did articulate an urge on the part of artists here for a new and independent American art, an urge that was to grow stronger as the decade progressed. However, at the time of the Macy's show it was premature, since none of the artists represented—and they included the most venturesome in New York—had as yet rejected their allegiance to European styles. Kootz misjudged the situation; because he disliked Surrealism, he ignored the role the emigrés were beginning to play in American art.

Many of the artists in the Macy's show disagreed with Kootz's assessment. They were members of the Federation of Modern Painters and Sculptors, organized in opposition to the Artists' Congress by artists interested more in aesthetic values than in political action. In 1943, the Federation strongly affirmed a globalist position.

> This country has been greatly enriched both by the influx of many great European artists, some of whom we are proud to have as members of the Federation, and by the growing vitality of our native talent. . . . As a nation we are now being forced to outgrow our narrow political isolationism. Now that America is recognized as the center where art and artists of all the world meet, it is time for us to accept cultural values on a truly global plane.[15]

The most active European artists at the time were the French Surrealists. Possessing a highly developed sense of group identity, a flair for promotion, a knack for generating excitement and for attracting patrons, they made their presence strongly felt on the New York art scene, particularly after Breton, the spokesman of the movement, arrived from Paris in 1941.[16] In the fall of 1942, André Breton was instrumental in organizing the "First Papers of Surrealism," a show held at the Reid mansion on Madison Avenue. (The title was meant to suggest an immigrant's first citizenship papers.) Duchamp crisscrossed sixteen miles of white string throughout the gallery space to produce a labyrinthine setting. This maze attracted immediate public attention, but what proved more interesting to local artists was the show itself, which included nearly every major artist oriented toward Surrealism.[17]

At the same time that the "First Papers of Surrealism" show was held, Peggy Guggenheim, then the wife of Max Ernst, opened her Art of This Century Gallery, which featured abstract and Surrealist art; the gallery's interior, designed by Frederick Kiesler, was a remarkable Surrealist environment. It soon became a focal point of emigré activities and a meeting place for European and New York artists.[18] Miss Guggenheim's assistant from 1942 to 1944 was Howard Putzel, who befriended many young Americans who were employing automatism to create biomorphic abstractions and introduced them to Miss Guggenheim.[19] In the spring of 1942, the gallery presented an "Exhibition of Collage," which included Pollock, William Baziotes, Robert Motherwell, Gerome Kamrowski, and Ad Reinhardt, and, in the following year, a "Spring Salon," again featuring works by Pollock, Motherwell, and Baziotes. Putzel advised Miss Guggenheim to put Pollock under contract and to represent Rothko. Ultimately, the gallery gave Pollock, Hofmann, Baziotes, Motherwell, Rothko, Clyfford Still, and Richard Pousette-Dart their first one-man shows. Miss Guggenheim's and Putzel's promotion and encouragement of these then little-known artists was of inestimable importance in their careers.

Only a handful of Americans—David Hare, Motherwell, Baziotes, Gorky, Peter Busa, Kamrowski—actually became intimate with the Surrealists. Surrealism was a way of life; its adherents were concerned with the quality of the life lived by their fellows and so were prone to form coteries. Some Americans who would have been acceptable to them were not interested in joining the Surrealist clique; disillusioned with programs of any sort, especially political ones, they could think of no reason to associate with a group and to become embroiled in its internecine feuds, and rivalries. Chauvinism, condescension, and jealousy on both sides also kept local and emigré artists apart. The European stance of the artist-aristocrat was quite different from that of the ex-WPA proletarian. The emigré thought of himself as more sophisti-

2–1 Salvador Dali. *The Persistence of Memory*. 1931.
Collection The Museum of Modern Art, New York.

cated and acted generally as if America were a provincial land, patronizing even what he liked. Breton's refusal to learn English was symptomatic of this attitude, and it kept him at a distance from most Americans. Moreover, the fact that the Surrealists were looking for disciples did not endear them to the American vanguard, who had been artists for too long to assume subservient positions, particularly in relation to other artists whom they did not esteem.

Above all, many Americans objected to the kind of Surrealism favored by Breton and his circle. Breton was heavily influenced by psychoanalytic procedures, in which matter drawn from the preconscious is given oral form. This led him to believe that such imagery was essentially verbal.[20] To be acceptable, therefore, pictorial themes had to be transposable into language. Thus, Breton dismissed nonobjective art out of hand, speaking of it as formalist and inhuman. However, he rejected the mere imitation of visual reality as trivial and instead insisted that artists plumb their subjects from preconscious sources, presenting them as "hand-painted dream photographs," in Dali's words, or as symbols of inner states of mind (*Fig. 2-1*).[21] Because these symbols tended to be abstract, Breton assented to a degree of abstraction and consequently admired the works of Miró, Masson, Arp, Matta, and Gorky. Nevertheless, the artists he usually championed were the more figurative, illusionistic, and academic of the Surrealists, such as Dali, René Magritte, and Paul Delvaux.

This aspect of Surrealism did not interest the New York vanguard. During the Depression decade, they had had to struggle against Social Realism and Regionalism, and they were not now about to accept what they deemed merely another brand of retrogressive painting. Clement Greenberg expressed his dissatisfaction with conventional Surrealism thus: "The subject matter is

2–2 Roberto Matta. *Prescience.* 1939.
Courtesy Wadsworth Atheneum, Hartford, Connecticut;
Ella Gallup Sumner and Mary Catlin Sumner Collection.

different, but the result is the same that the nineteenth-century academic artist sought. . . . where all the problems have been solved only academicism is possible." [22] Greenberg asked whether the Surrealist image provoked "a new way of seeing as well as new things to be seen. For such painters as Miró, Arp, Masson and Picasso, it certainly does. But not for Ernst, Dali . . . [There is] no fundamental change in the conventions of painting as established by the Renaissance. . . . new anecdotes to illustrate . . . promoted the rehabilitation of academic art under a new literary disguise." [23] In a dual retrospective of works by Miró and Dali at the Museum of Modern Art in 1941–42, the museum unwittingly offered local artists a choice between the two tendencies in Surrealism.

Breton's bias against abstraction did not go unchallenged even within the movement. Matta (*Fig. 2-2*) questioned it, and on grounds that Breton himself had established in the first Surrealist manifesto (1924). In it, he had defined Surrealism as "Pure psychic automatism, by which it is intended to express, verbally, in writing, or by other means, the real process of thought. Thought's dictation, in the absence of all control exercised by the reason and outside all aesthetic or moral preoccupation." [24] Automatism had been widely practiced during the early days of Surrealism, but it was abandoned for what Breton termed the "reasoning stage," particularly during the 1930's. Matta called for a return to the earlier emphasis. He maintained that automatism was Surrealism's most liberating innovation, for it enabled the unconscious mind to speak spontaneously, and that it should not be curbed by a too rigorous insistence upon figuration. In 1942, Wolfgang Paalen, who had emigrated to Mexico, took a similar position. In the first issue of his magazine *Dyn* (on sale in New York), he wrote:

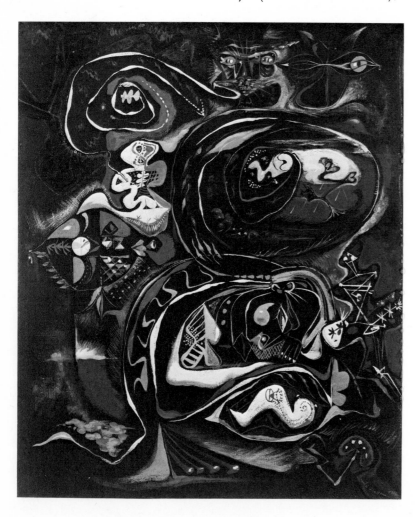

2–3 André Masson. *Meditation on an Oak Leaf.* 1942.
Collection The Museum of Modern Art, New York.

36

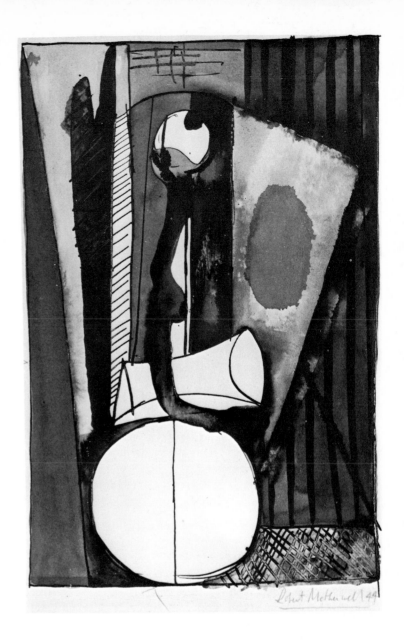

2–4 Robert Motherwell. *Drawing.* 1944.
Whereabouts unknown.

Salvador Dali has . . . never made paintings which could be qualified
as automatic. This point has to be clearly established, because his de-
fenders pretend that his academic style does not matter since he uses
it as a means to relate automatically experienced images [of dreams].
But it is precisely for this reason that his painting instead of being auto-
matic is simply an academic copy of a previously terminated psychologi-
cal experience. . . . the true value of the artistic image does not
depend upon its capacity to *represent*, but upon its capacity to *prefigure*,
i.e., upon its capacity to express potentially a *new order* of things. In
order to distinguish between reactionary and revolutionary painting, it is
enough to distinguish between what I shall call the *representative image*
and the *prefigurative image*.[25]

Abstract automatism was the largely unexplored direction in Surrealist
painting, as Matta pointed out. Of the younger Surrealists, Matta had begun
to experiment with it only in 1937, and Paalen, even later (in 1939 he was
still painting in an academic manner). Its freshness and its tendency to ab-
straction and biomorphism appealed to the New Yorkers. Organic forms—
as opposed to geometric ones—suggested anthropomorphic sources, inner
and outer life in all of its rich, changeable, and ambiguous variety, and so
pointed to a humanist content.

Even before they had met Matta, Gorky, Pollock, and Baziotes were aware
of automatism as a technique, although they did not practice it much during
the 1930's. It was Matta who was influential in promoting automatism and

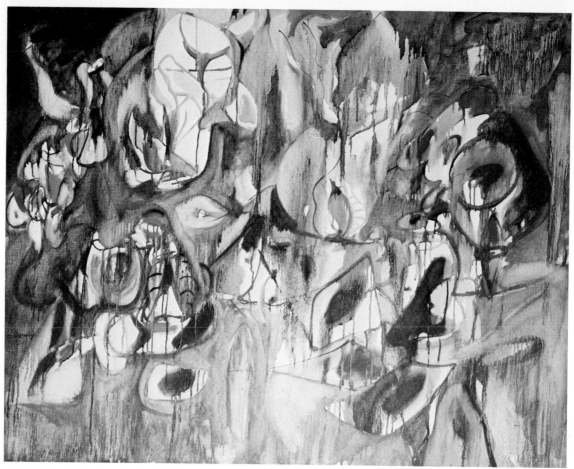

2–5 Arshile Gorky. *One Year the Milkweed.* 1944.
M. Knoedler & Co., Inc., New York.

who, more than any of the other Surrealists, made himself available to young New Yorkers. A keen intellectual and scintillating conversationalist, he was able to focus attention on issues, to crystallize and dramatize them verbally. Matta appealed to a number of local artists for support in what he deemed an attempt to renew Surrealism and to save it from becoming an academy. He organized a group—consisting of Motherwell, Baziotes, Pollock, Kamrowski, and Busa—to explore the possibilities of automatism and perhaps to challenge Breton's leadership.[26] The artists met at his home about a half-dozen times in the winter of 1941–42, but the group soon disbanded. The New Yorkers resented Matta's attempt to dominate them, to be a "pope" like Breton. Furthermore, they did not see the need to organize for any purpose and became suspicious of Matta's anti-aesthetic bias and his negative attitude toward the tradition of modern art, which were shared by the Surrealists as a whole. Unlike the early twentieth-century styles of Fauvism and Cubism, Surrealism (like Dada) had not evolved directly from the artistic movements immediately preceding it but from philosophical, psychological, and political premises. Breton, for example, responded more to ideological concepts than to painterly values, and he wrote almost exclusively about ideas. The Americans were also absorbed with the content of their pictures, but they were concerned with aesthetic values as well. This made them uneasy with the orthodox Surrealists, as it did Masson (*Fig. 2-3*), who, in 1946, wrote: "The surrealist movement is essentially a literary movement. . . . In literature the surrealists are as insistent on the exact word as Boileau; but when it comes to painting they are very liberal in matters of structure. The spiritual directors of surrealist painting are not of the profession."[27] Overly preoccupied with extra-aesthetic matters, the orthodox

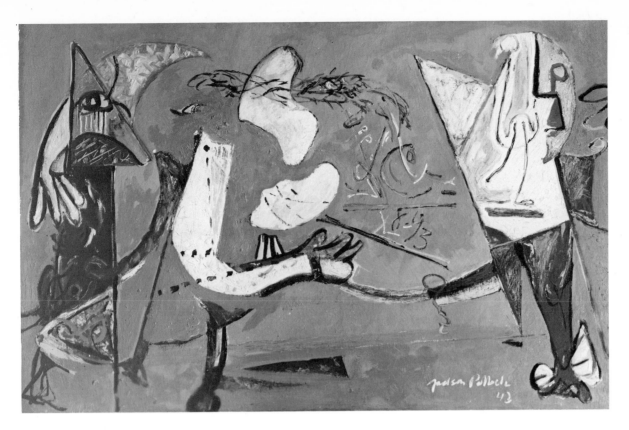

2–6 Jackson Pollock. *Search for a Symbol*. 1943.
Collection Mrs. Lee Krasner Pollock, New York.

2–7 William Baziotes. *Untitled*. c. 1942–43.
Estate of William Baziotes.

Surrealists were indifferent, indeed hostile, to modern art and its evolution. As Masson recalled: "The admirable achievement of Seurat, Matisse and the Cubists was counted as nothing. Their exalted conception of space and their discovery of essentially pictorial means were treated as a burdensome legacy which had to be thrown overboard." [28]

The Surrealist movement aimed to revolutionize man and society. Compared to this aspiration, or even as a means of furthering it, the creation of works of art seemed a "lamentable expedient," in Breton's words.[29] Artists concerned with art for art's sake—with quality in art and with its traditions—who willingly suffered the tedium of creation, were ridiculed as "producers," "men with a profession," and worse. Matta more than other Surrealists distrusted a concern for formal values, for he reasoned that to depict irrational impulses one had to spurn picture-making. The state of being possessed —of being controlled by preconscious forces—was incompatible with the act of possessing, of being under control. Masterliness, after all, required mastery. Matta certainly understood that automatism could never be "pure," that pictures had to be consciously organized to some degree, but he minimized the role of the artist as maker.

The New Yorkers did not consider automatism sufficient in itself. Their point of view was reflected by Paalen:

> automatism . . . can be no more than incantatory *technique*, and not creative expression. . . . the kaleidoscopic flow of the painter, emancipated in automatism, [is] nothing but raw material . . . in order that there may be a poem or a painting language must become articulate. The everflow multicolored sauce or the verbal inflation finally becomes as boring . . . as the petty algebra of rectangular plastic purism.[30]

40

Masson agreed: "Only so much as can be reabsorbed esthetically from that which the automatic approach provides should be ulitized. For art has an authentic value of its own which is not replaced by psychiatric interest." [31]

Motherwell (*Fig. 2-4*) was close to Matta and had adopted the practice of automatism. During the summer of 1941, he visited Mexico with Matta, met Paalen there, and stayed on through the fall and early winter to work with him. At this time Motherwell began to modify his ideas. In an article of 1944, he changed the Surrealist term "psychic automatism" to "plastic automatism." "Plastic automatism . . . as employed by modern masters, like Masson, Miró and Picasso, is actually very little a question of the unconscious. It is much more a plastic weapon with which to invent new forms. As such it is one of the twentieth century's greatest formal inventions." [32] Gorky (*Fig. 2-5*), Hofmann, Pollock (*Fig. 2-6*), De Kooning, Baziotes (*Fig. 2-7*), Rothko (*Fig. 2-8*), and Gottlieb (*Fig. 2-9*) were also occupied with "plastic" qualities; they wanted to employ automatism—to arrive at their forms freely and directly— but at the same time they desired to cultivate the pictorial values threatened by this technique—the structural cogency and painterly finesse that they admired in the works of Picasso, Matisse, Mondrian, and Miró. For it was from these and other modern masters that the New Yorkers derived their awareness of quality in art, their conception of a modern picture and of how it should project. Strongly "panel-conscious," they would not accept the deep illusionistic space favored by Matta and Dali.[33] They realized that if a picture were painted in a banal manner it could never have a sense of the marvelous, which was the fundamental reason for being of Surrealist art— indeed, of all art.

2–9 Adolph Gottlieb. *The Hunter.* 1947.
Marlborough Gallery Inc., New York.

2 Notes

1. The Artists for Victory, Inc., was organized early in 1942. It consisted of twenty-three societies, with a membership of some 10,000 nationally and 3,000 to 4,000 in New York. The purpose of the organization was to further the war effort. In a sense, it attempted privately to continue the Federal Art Project. In August, 1942, it held a "National War Poster Competition" at the Museum of Modern Art, and from December 7, 1941, to February 23, 1943, a juried show—the high point of its activities—at the Metropolitan Museum for which 14,000 entries were submitted; 532 paintings, 305 sculptures, and 581 prints accepted; and $52,000 distributed in prizes. An issue of *Art News* (January 1–14, 1943) was devoted to the show. In June, 1944, the organization held an exhibition of war murals, and, in October, 1944, a show entitled "Portrait of America" at the Metropolitan Museum. Although there were abstract artists in the Artists for Victory, most of its members were realists.
2. Robert Motherwell, ed., Introduction to *The Dada Painters and Poets* (New York: Wittenborn, Schultz, 1951), p. XVII.
3. Robert Motherwell, "Symposium: What Abstract Art Means to Me," *Museum of Modern Art Bulletin*, XVIII, No. 3 (Spring, 1951), 12.
4. Robert Motherwell, "Notes on Mondrian and Chirico," *VVV*, No. 1 (June 1942), 59.
5. At its most extreme, the Abstract Expressionist antipathy to the Bauhaus was articulated by Clyfford Still. See Benjamin J. Townsend, "An Interview with Clyfford Still," *Gallery Notes*, XXIV, No. 2 (Buffalo, N.Y.: Albright-Knox Art Gallery, Summer, 1961), 13.
6. Jacques Barzun, *Classic, Romantic and Modern* (New York: Anchor Books; Doubleday, 1961), pp. 40–41.
7. *The Portrait and the Modern Artist*, mimeographed script of a broadcast by Adolph Gottlieb and Mark Rothko on "Art in New York," H. Stix, director, WNYC, New York, October 13, 1943, p. 3.
8. Robert Goldwater, "Reflections on the New York School," *Quadrum*, No. 8 (1960), 24.
9. *Ibid.*, p. 24.
10. Samuel Kootz, "America über Alles," letter to *The New York Times*, December 20, 1931, sec. 8, p. 11. In the Foreword to his *Modern American Painters* (New York: Brewer & Warren, 1930), p. ii, Kootz disapproved of the imitation of French art, much as it was "the breeding ground for all that has been most significant in modern painting." He also rejected formalism, typified for him by geometric abstraction, which he termed antihuman, sterile, and hermetic, although he admired Mondrian. Instead, he called for artists here to paint emotional visions of American life while taking into account a fundamental aesthetic order.
11. Samuel Kootz, letter to *The New York Times*, in Edward Alden Jewell, "The Problem of 'Seeing,'" *The New York Times*, August 10, 1941, sec. 9, p. 7.
12. Edward Alden Jewell, "Challenge and Answer," *The New York Times*, August 31, 1941, sec. 9, p. 7.
13. The initial meeting of the Bombshell Group was at the New School for Social Research on November 23, 1941. Later, its members met at a recreation center, 51 West Tenth Street, which they called the Bomb Shelter. In 1943, the Bombshell Group changed its name to the League of Present Day Artists, which is still in existence.
14. Samuel Kootz, *New Frontiers in American Painting* (New York: Hastings House, 1943), p. 60.
15. Edward Alden Jewell, "End-of-the-Season Melange," *The New York Times*, June 6, 1943, sec. 2, p. 9.
16. The Surrealists broadcast their ideas in such magazines as *View*, which devoted special issues to Ernst, Tanguy, and Duchamp, and *VVV*, the quasi-official organ of the movement; influenced important galleries, such as Julien Levy and Pierre Matisse, which had existed earlier as Surrealist showplaces; and initiated influential exhibitions.
17. Among the artists in the "First Papers of Surrealism" show were Arp, Hans Bellmer, Oscar Dominguez, Picasso, Delvaux, Magritte, Alberto Giacometti, Meret Oppenheim, Henry Moore, Chagall, Esteban Francés, Gordon Onslow-Ford, Klee, Hedda Sterne, David Hare, Breton, Leonora Carrington, Jimmy Ernst, Max Ernst, Brauner, Hirshfield, Miró, Seligmann, De Chirico, Duchamp, Matta, Tanguy, Masson, Kay Sage, Calder, Wifredo Lam, Kiesler, Motherwell, and Baziotes.
18. Alfred H. Barr, Jr., in an introduction written in 1956 to Peggy Guggenheim, *Confessions of an Art Addict* (New York: Macmillan, 1960), pp. 13–14, wrote that "*Art of This Century* immediately became the centre of the vanguard. Under the influence of Duchamp, Ernst and Breton, the surrealist tradition was strong but never exclusive. The great abstract painter, Piet Mondrian, was also welcome and took an active part as a member of the juries which chose the recurrent group shows of young American artists. In the first 'Spring Salon,' 1943, three young painters stood out: William Baziotes, Robert Motherwell and Jackson Pollock. Within a year all three were launched by the gallery with one-man shows. . . . Then, again with remarkable prescience, *Art of This Century* gave shows to Mark Rothko, Clyfford Still and others."
19. Putzel's role in the 1940's has been largely forgotten. He was born in Allenhurst, New Jersey, and at an early age moved with his family to San Francisco. There, he later wrote music and art criticism, and opened a gallery that featured modern European art. In 1935, with the help of Duchamp, Putzel organized a show of Kandinsky's watercolors. Other of his exhibitions were borrowed from the Matisse Gallery in New York. Subsequently, he moved his gallery to Hollywood and gave Tanguy a show, his first in that city. Putzel was introduced to Rothko by Buffie Johnson in Los Angeles. In 1938, he traveled to Paris, where he met Peggy Guggenheim and purchased art for her on a commission basis.

Guggenheim, *Confessions of an Art Addict*, p. 69, wrote: "Putzel first became known to me in the winter of 1938 . . . At that time he sent me some Tanguy paintings that he had exhibited out there and that were to be included in my Tanguy show. I met him a few months later in Paris . . . He immediately took me in hand and escorted me, or rather forced me to accompany him, to all the

artists' studios in Paris. He also made me buy innumerable things that I didn't want, but he found me many paintings that I did need, and usually ones of the highest quality." Putzel returned to New York in 1940 and in 1942 became Guggenheim's assistant at the Art of This Century Gallery. In the fall of 1944, Putzel left her gallery and opened his own, the 67 Gallery. Had he not died soon after (1945), he would have represented Pollock, Gottlieb, Rothko, and Hofmann, who were his friends.

20. David Hare, interviewed by the author, June 2, 1964.

21. William Rubin, *Dada, Surrealism and Their Heritage* (New York: Museum of Modern Art, 1968), p. 40.

22. Clement Greenberg, "Surrealist Painting," *The Nation*, CLIX, No. 7 (August 12, 1944), 193.

23. Clement Greenberg, "Surrealist Painting," *The Nation*, CLIX, No. 8 (August 19, 1944), 219–20.

24. André Breton, *What is Surrealism?*, David Gascoyne, trans. (London: Faber & Faber, 1936), p. 59.

25. Wolfgang Paalen, "The New Image," Robert Motherwell, trans., *Dyn*, No. 1 (April–May, 1942), 9.

26. Matta, in an interview with Max Kozloff, *Artforum*, IV, No. 1 (September, 1965), 25, said: "What interested me was to see if everybody could apply the system that to me was fascinating at the time, to use morphology about my psychic responses to life. And everyone would invent their own morphology, and express this question. I tried to infect them with this idea, as something very good, something in which they could find wealth in their own terms." Matta probably had the idea of forming a group to experiment with automatism as early as 1940, for Gordon Onslow-Ford, a friend and great admirer of Matta, in "The Painter Looks Within Himself," *London Bulletin*, Nos. 18, 19, 20 (June, 1940), 31, wrote: "In this realm of scientific poetry there lies a philosophy, and we hope to start a bureau of analytical research to study the most important creations of the century in co-ordination with all branches of science. Painters who join our research will be able to play their part in the formation of a new world." Onslow-Ford also promoted automatism in New York. In 1940, he was invited to America by the Society for the Preservation of European Culture, organized by Kay Sage, a painter and the wife of Tanguy. The Society arranged for Onslow-Ford to lecture at the New School for Social Research in the winter of 1941. He quickly became a force in the New York art scene. In his lectures, he promoted the idea broached in his article: that an exploitation of the possibilities of automatism opened up by Matta's "psychological morphologies" was the most fruitful direction in which the Surrealists could venture. To accompany his talks, he asked Howard Putzel to arrange a series of exhibitions of works by leading Surrealists. Among the artists in Putzel's shows at the New School were Arp, Brauner, De Chirico, Delvaux, Dominguez, Ernst, Francés, Hayter, Magritte, Matta, Miró, Henry Moore, Onslow-Ford, Paalen, Seligmann, and Tanguy. Before Breton came to New York in 1941, Onslow-Ford also gathered around him many of the artists, European and American, here disposed to Surrealism.

27. André Masson, "Eleven Europeans in America," *Museum of Modern Art Bulletin*, XIII, Nos. 4–5 (1946), 4.

28. André Masson, "Painting as a Wager," *Yale French Studies*, No. 31 (1964), 124.

29. William Rubin, "Toward a Critical Framework: 1. Notes on Surrealism and Fantasy Art," *Artforum*, V, No. 1 (September, 1966), 36.

30. Wolfgang Paalen, "The New Image," in *Form and Sense* (New York: Wittenborn, Schultz, 1945), p. 34. (This essay was written in 1941.)

31. Masson, "Eleven Europeans in America," p. 4.

32. Robert Motherwell, "The Modern Painter's World," *Dyn*, No. 6 (November, 1944), 13.

33. William C. Seitz, "Abstract Expressionist Painting in America" (Ph.D dissertation, Princeton University, 1955), p. 110.

3 Arshile Gorky
(1904–48)

THE evolution of Arshile Gorky's painting typifies the change in the sensibility of American vanguard artists from the 1930's to the 1940's, the shift from Abstract Cubism to Abstract Surrealism. He was, indeed, as Willem de Kooning called him, "a Geiger counter of art." [1] During the first fifteen years of his career, Gorky tried to master these divergent streams and to merge them successfully. Then, in the last six years of his life—he died in 1948 at the age of forty-four—he achieved an independent artistic identity, becoming the first American to paint pictures that did not look like provincial adaptations of European styles.

Prior to 1942, Gorky deduced his art from art itself, which he considered a language to be learned. Paintings in museums, illustrations in art books, the *Cahiers d'Art* and other art magazines were his primers. Art was for Gorky what Marxism was for the Social Realists and nationalism for the Regionalists—but with a difference, for to Gorky the issues were aesthetic. He believed that to create an art worthy of the museums—and this was his primary aim at that time—he must first study existing masterworks, using them as his models, much as an apprentice in a Renaissance workshop. He considered such living painters as Picasso, Miró, Matisse, and Léger the newest masters before most of his contemporaries acknowledged them as such. In imitating them, he adopted an academic method, but built into it the potential of a vanguard art by choosing radical artists for his guides. Gorky's emulation of the School of Paris during the 1920's and 1930's was self-effacing; yet he was not at all humble in his choice of mentors. Indeed, he was self-assured to the point of arrogance, and with justification, for he possessed the taste and the intelligence to sense viable directions in art. As early as 1926, at the age of twenty-two, Gorky announced that Picasso and Matisse "are greater artists than the old masters. Cézanne is the greatest artist, shall I say, that has lived." [2] And five years later, he asked rhetorically: "Has there in six centuries been better art than Cubism?" [3]

Motivated by his desire to assimiliate the history of modern art, Gorky began at the beginning. By 1925, he was painting Impressionist pictures; then he "progressed" to Cézanne (*Fig. 3-1*) and Synthetic Cubism (*Fig. 3-2*). By the age of twenty-five, he was abreast of the most advanced painting in America. Gorky clearly understood the classicizing nature of Cubism. In 1931, he wrote of Stuart Davis, whom he had met two years earlier, that his painting exist in a

> cool and intellectual world where all human emotions are disciplined upon rectangular proportions. . . . where all dreams evaporate and logic plays its greatest victory . . . This man, this American, this pioneer, this modest painter, who never disarranges his age, who works to perfect his motives, who renders—clear, more definite, more and more decided —new forms and new objects. He chooses new rules to discipline his emotions. . . . expresses his constructive attitude toward his successive experiences. . . . Oh, what clarity! One is he, and one of but few, who realizes his canvas as a rectangular shape with two dimensional surface plane. Therefore, he forbids himself to poke bumps and holes upon that potential surface. This man, Stuart Davis, works upon that platform where are working the giant painters of this century—Picasso, Léger, Kandinsky, Juan Gris. [4]

In his pictures of 1929–34, Gorky painted clearly edged planes derived mainly from still lifes executed in the 1920's by Picasso, Braque, and Gris (*I*, p. 82). However, Gorky's early Cubist canvases cannot be mistaken for his European

3–1 Arshile Gorky. *Still Life*. 1927.
M. Knoedler & Co., Inc., New York.

3–2 Arshile Gorky. *Still Life*. 1929.
M. Knoedler & Co., Inc., New York.

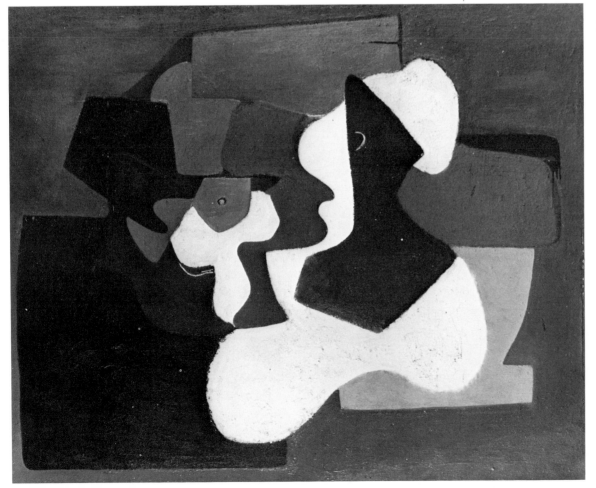

3–3 Arshile Gorky. Study for *Nighttime, Enigma and Nostalgia*. c. 1931–32.
M. Knoedler & Co., Inc., New York.

prototypes, his being more organic, abstract, and ambiguous in the manner of Miró and Masson.[5] A boomerang shape might be a palette, an eye, or a breast —anticipating his later composites of natural organisms. Other elements are also personal and precursive, or at least seem so in retrospect: the obsessively recurrent boot and sleeve shapes and the massing of planes in the centers of the pictures along implied horizontal axes. Furthermore, the mysterious darkness that pervades the *Nighttime, Enigma, and Nostalgia* series (*Fig. 3-3*) that occupied Gorky in the early 1930's has little precedence in works by Picasso, Braque, Gris, Miró, or by their American followers. Holger Cahill very early perceived the unique quality in Gorky's painting; in 1934, he wrote that it struck a "note of intellectual fantasy which is very rare in the plastic art of this country."[6]

However, Gorky did not at that time persist in trying to fuse Synthetic Cubist structure with Surrealist atmosphere and biomorphism. From 1934 to 1936, he turned away temporarily from the direction forged in his *Nighttime, Enigma, and Nostalgia* pictures and geometricized his design, influenced most likely by those friends who were later to organize the American Abstract Artists and by reproductions of works by the *Abstraction-Création* group in Paris.[7] Gorky's *Organization* (*ca.* 1934–36; *Fig. 3-4*), his major canvas of the period and one that was often exhibited and reproduced, looks more derivative than his earlier works generally, and was largely based on Picasso's *The Studio* (1927–28; *Fig. 3-5*). Even more imitative of Picasso's style was the *Composition with Head* (*ca.* 1935; *Fig. 3-6*). Through this and other works, Gorky came to be widely considered (and ridiculed) as a "masterly apprentice" and as the "Picasso of Washington Square."[8] He made no attempt to disavow such characterizations. Instead, he seemed to glory in them, as exemplified by an anecdote told by Harold Rosenberg: "When, in '37, some important paintings [by Picasso] arrived in New York in which the Spaniard had allowed the paint to drip, artists at the exhibition found a chance for their usual game of kidding Gorky. 'Just when you've gotten Picasso's clean edge,' one said in mock sympathy, 'he starts to run over.' 'If he drips, I drip,' replied Gorky proudly."[9]

Nevertheless, the assertion that Gorky was merely a slavish imitator who was indifferent to originality or who deliberately rejected it is exaggerated and not borne out by most of his pictures. Even *Organization*, close as it is to Picasso's *The Studio*, verges toward Neoplasticism, suggesting that Gorky viewed Picasso through the eyes of Mondrian.[10] More often than not, Gorky combined motifs and ideas from several sources, redesigning the compositions and reshaping the forms he borrowed. In fact, he was far more eclectic and inventive than simply imitative, and this difference is significant. Gorky's departures from the modern masters are too pronounced to have been caused by insufficient knowledge. Rather, they resulted from a conscious attempt to master two disparate traditions—Cubism and Surrealism; to discover what was fresh and viable in both; to synthesize them and at the same time to find his own artistic identity. His approach is also reflected in his tastes in art history. Ingres and Uccello were his favorites;[11] he admired the consummate draftsmanship of their classical compositions, as did the Cubists, and was attracted to Ingres' obsessive sexuality and to Uccello's juxtaposition of incongruous spaces, as were the Surrealists.

Why then did an artist of Gorky's intelligence and ambition revert at times from a creative eclecticism to being a mere copyist? Some writers have suggested that there were deep psychological motivations for his abnegation of

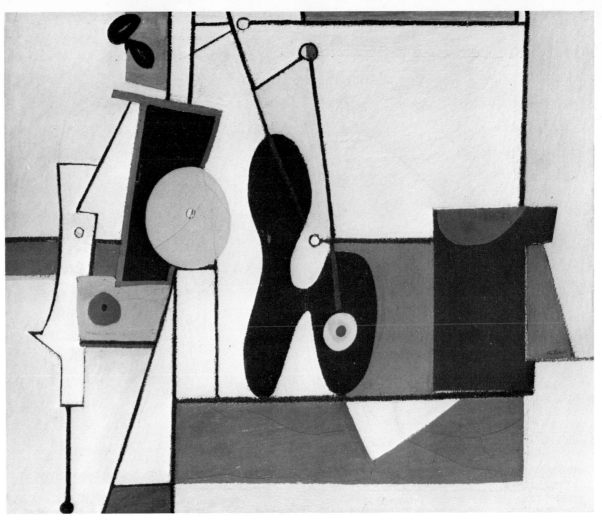

3–4 Arshile Gorky. *Organization*. c. 1934–36.
M. Knoedler & Co., Inc., New York.

personality. For example, Gorky's dealer, Julien Levy, called him a "camouflaged man," commenting that the painter changed his name from Vosdanig Adoian to Arshile Gorky, copied the poet Paul Éluard in some of his love letters, and organized a class on camouflage during World War II.[12] However, there is no necessary connection between these acts and his painting. Explanations having little to do with Gorky's development as an artist are more credible—and far simpler. An Armenian immigrant who had difficulty speaking English, he may have passed off the love letters of others as his own to impress girl friends; he may have changed his name to make it sound more artistic, as many immigrants did to Americanize theirs; and he may merely have wanted to teach camouflage as his contribution to the war effort.

Gorky's dramatization of himself in the face of ridicule as an imitator of Parisian masters appears to have been a life posture paralleling a deliberate artistic strategy that, although seemingly provincial, actually underlined his fear of provincialism. In fact, Gorky looked for guidance to the School of Paris no more than the American Abstract Artists and other modernist painters in New York. But unlike them, he acknowledged his debts frankly and refused to conceal his dependency by cultivating some readily apparent stylistic deviation, as Stuart Davis had Americanized French Cubism by substituting commercial gadgets for its studio paraphernalia and vivid billboard colors for its restrained palette. Had he so desired, Gorky could have followed the example of Davis, who had achieved a personal variant of Cubism.

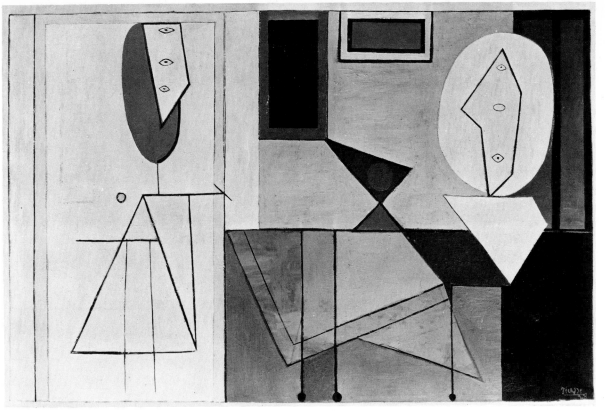

3–5 Pablo Picasso. *The Studio*. 1927–28.
Collection The Museum of Modern Art, New York;
Gift of Walter P. Chrysler, Jr.

3–6 Arshile Gorky. *Composition with Head*. c. 1935.
M. Knoedler & Co., Inc., New York.

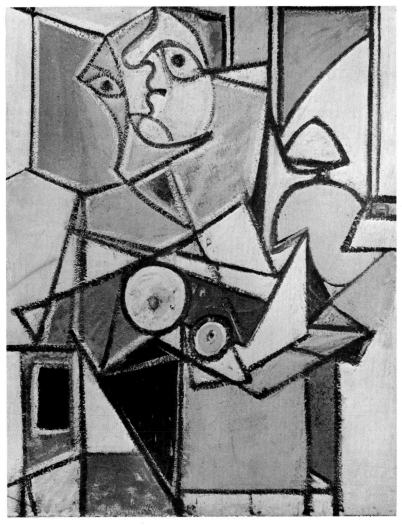

49

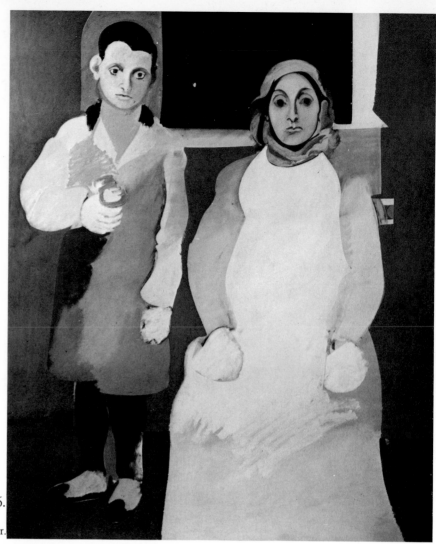

3–7 Arshile Gorky. *The Artist and His Mother.* 1926–c. 1936.
Collection Whitney Museum of American Art, New York;
Gift of Julien Levy for Maro and Natasha Gorky in Memory of Their Father.

Gorky's *Nighttime, Enigma, and Nostalgia* pictures pointed the way to a distinctive style; had he continued them, however, he would have been "original" only in the most obvious way. He appeared to have sensed that Davis's painting, no matter how brilliant, was insular and minor, and so refused to exploit an incipient style of his own, to make a career of it, and in the end to be trapped in it. This was a sign of greater self-criticism, of admitting more readily than his contemporaries the derivative nature of his style and of American art in general. Gorky's self-abnegation was paradoxically a sign of enormous ambition. He would not be known simply as a second-rate Cubist with Surrealist leanings. When he made his bid for artistic identity, it would be a fresh and major step. Until then, he would venture provisionally into eclecticism, and when it seemed to him that he was not ready to show his face at all, he would wear the imposing masks of Picasso and Miró. Behind them, he would test various possibilities in an effort to recognize the new ones that would fulfill his ambition.

While working on the nearly nonobjective *Organization*, Gorky was also painting portraits and semi-abstract murals for the Newark Airport (a Project commission)—indications of his wide range of interests at the time. Entitled *Aviation, Evolution of Forms under Aerodynamic Limitations*, the Newark panels, which were made up of composites of abstracted airplane parts, had a social message. But Gorky avoided the retrogressive mannerisms of the Social Realists, the Regionalists, and the Mexican muralists. Characteristically, he turned for models to such modernists as Davis and Léger. Gorky's portraits of the 1930's also exhibit a variety of influences: Picasso, Miró,

Ingres, Cézanne. The most imposing of his works in this genre is the *Artist and His Mother* (1926–*ca.* 1936; *Fig. 3-7*). It was based on an old photograph, but Gorky simplified and flattened the figure into overlapping and interpenetrating planes. This double portrait anticipates his abstractions of the 1940's, its floating planes being thinly and loosely painted—"unfinished" looking, unlike most of Gorky's other works of the 1930's, which are tightly knit and heavily pigmented.

Around 1936, Gorky abandoned figuration and geometry in favor of biomorphic abstraction, as in the *Image in Xhorkom* series (*ca.* 1936; *Fig. 3-8*). Motivated apparently by a desire to create a poetic effect without sacrificing structural properties, he emulated Miró more than ever before, for that Cubist-oriented Surrealist master earlier had held similar aims. Gorky's desire for plasticity is evident in the paint-encrusted planes of the *Image in Xhorkom* canvases. Although they seem vehemently executed—Expressionist in feeling—the overworked surfaces indicate a preoccupation with exactness of placement and tones. The rich pigmentation also indicates Picasso's continuing influence; it is closer to the latter's "white" painting of the late 1920's and to his *Girl Before a Mirror* (*Fig. 1-14*) than to Miró's thinly coated canvases. Gorky's *Enigmatic Combat* (*ca.* 1936; *Fig. 3-9*) is, in pattern and texture, even more reminiscent of the *Girl Before a Mirror*, although its image is abstract and disintegrated, suggesting the influence of Masson's *Combats* (1932–35).[13] *Enigmatic Combat* also recalls Gorky's earlier *Nighttime, Enigma, and Nostalgia* series, revealing his concern with his own artistic identity. Indeed, around 1937, Gorky had achieved a considerable independence of image and composition.

Still, the artist was not ready to make his leap into originality. Around

3–8 Arshile Gorky. *Image in Xhorkom.* c. 1936.
Collection Mr. and Mrs. David Lloyd Kreeger, Washington, D.C.

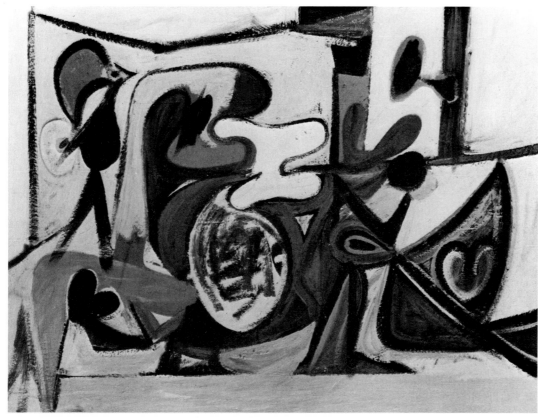

1941–42, he submitted to the influence of Kandinsky's early improvisations (*Fig. 3–10*) and Matta's automatist paintings of 1938–42 (*Fig. 2-2*).[14] Gorky was already loosening his design, but he had ventured only tentatively in this direction. Kandinsky (with whom Gorky falsely claimed to have studied for three months in 1920) and Matta showed him the way to a more spontaneous and poetic abstraction—to an "idea of the canvas as a field of prodigious excitement, unloosed energies."[15] But Gorky approached these mentors differently than he had Picasso and Miró. He freely adapted their ideas to his own ends, without concern for how they realized them in their own paintings. Matta was younger than Gorky and far less experienced as an artist; Kandinsky around 1920, had abandoned the earlier improvisational style that had come to interest Gorky and, in any case, had not developed it fully enough to inhibit subsequent extensions by others. Moreover, Kandinsky's automatist pictures had been largely overlooked, even by the Surrealists.[16] Gorky was thus the first to recognize their viability.

Gorky's increasing independence was abetted by the stance of Matta and Breton, who became his close friends, and of other Surrealists in New York during World War II. The emigrés quickly admitted him into their milieu, and such acceptance was invaluable to him, for he had long wished to join the School of Paris. During the 1930's, he could make contact with it only by emulating the look of European masterworks, for these were all that were available to him. In the next decade, he could, through personal interaction, partake of the creative spirit that gave rise to the art he revered. The Surrealists gave Gorky the confidence to rely on his own intuition, insights, and experiences. They also helped him accept, as Julien Levy wrote, "that his most secret doodling could be very central. He found his fantasy legitimized,

3–9 Arshile Gorky. *Enigmatic Combat.* c. 1936.
San Francisco Museum of Art, San Francisco, California;
Gift of Miss Jeanne Reynal.

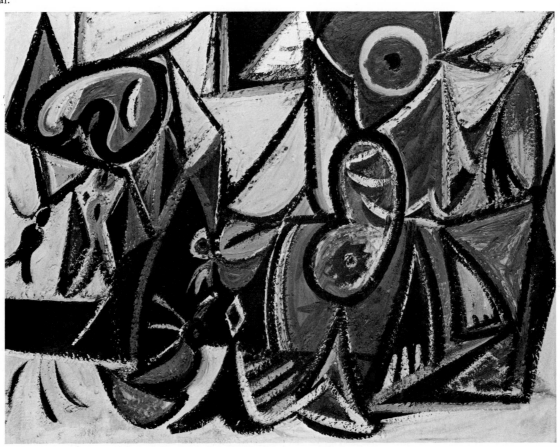

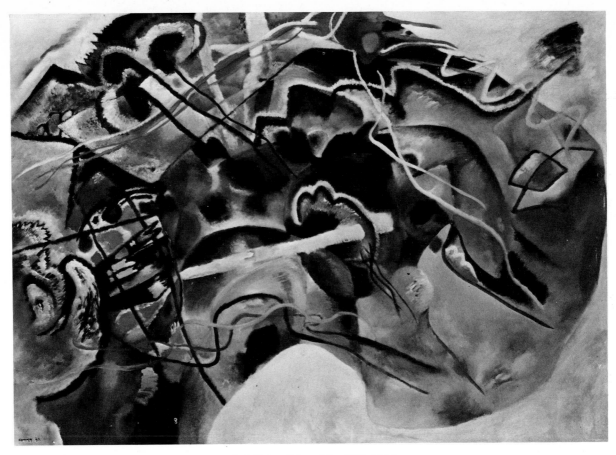

3–10 Wassily Kandinsky. *Picture with White Edge, No. 173. 1913.*
The Solomon R. Guggenheim Museum, New York City.

3–11 Arshile Gorky. *Garden in Sochi I.* c. 1940.
Collection The Museum of Modern Art, New York;
Purchase Fund and Gift of Mr. and Mrs. Wolfgang S. Schwabacher (by exchange).

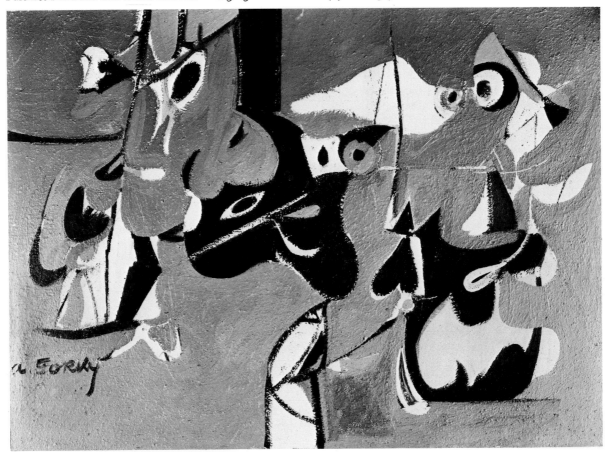

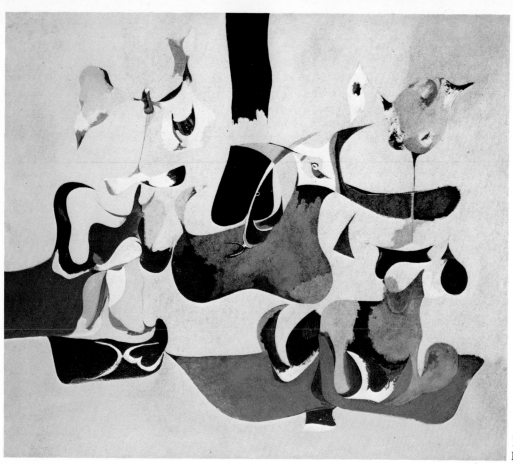

3–12 Arshile Gorky. *Garden in Sochi II*. 1940–42. M. Knoedler & Co., Inc., New York.

and discovered that his hidden emotional confusions were not only not shameful but were the mainsprings for his personal statement, and that what he had thought had been his work had been just practice, and what had been his play was closer to his art." [17]

Gorky's final leap to originality can be traced in his three versions of the *Garden in Sochi* (*ca.* 1940–42/43), as William Rubin has observed.[18] The imagery in the first (*Fig. 3-11*) was influenced by Miró, but there are clear departures. In Miró's painting, precisely edged, paper-thin planes are silhouetted against flat grounds. Gorky's backgrounds are located in front of the images, pushed forward by brushing the ground colors over the forms, instead of the forms being outlined against the ground. The shapes are only partly defined by the brushed edges of the field and float clear of them in indeterminate but shallow depth. The pigmentation is heavier than in Miró's canvases, causing Gorky's picture to look dense, but there is air in the apertures through which the images appear. *Garden in Sochi II* (*Fig. 3-12*) derives more from Miró than the first. Responsible, perhaps, for Gorky's move from eclecticism to imitation was the large Miró retrospective held at the Museum of Modern Art in 1941. But this less original second version was to be a necessary step toward his own personal style, for Gorky eliminated the heavy impasto and keyed up the color.

With *Garden in Sochi III* (*Fig. 3-13*) and with *Pirate 1*, completed just before it in 1942, Gorky announced his mature style, in which he detached drawing from color. The lines meander as if spontaneously doodled, and the fluid forms are suggested rather than defined. They are still reminiscent of Miró's, but by loosening them in the manner of Matta, Gorky became independent of both sources. Instead of superimposing coats of color on a more or less fixed composition to produce opaque surfaces, Gorky painted flowing, often semitransparent areas of brilliant color, allowing them to spill freely

54

over the canvas. These flaring plumes bear little relationship to the precise, gridlike planes of Synthetic Cubist compositions, although vestiges of such architectonic structures remain, even in his freest improvisations. There is also a more pronounced suggestion of depth and atmosphere, produced by the looser brush-handling and the slight modeling of forms. This move toward illusionism was anticipated, of course, by Kandinsky and Matta, but Gorky avoided their deep space. Indeed, his conception of a modern picture as a flat object was too ingrained for him to do otherwise. Gorky's limited illusionism opened up fresh possibilities in American abstract painting—and in his own, for as Meyer Schapiro wrote, he "discovered an atmosphere suited for the objects of modern fantasy . . . the vague, unstable image-space of the day-dreaming mind." [19]

In the *Pirate* and *Garden in Sochi* series, Gorky invented a unique imagery —composites of opulent, pliant, softly rounded forms and bristling, hard projections. Instead of looking to art for subject matter as he had in the past, Gorky now looked to nature. He spent the summer of 1942 in Connecticut and the one following on a Virginia farm, drawing close-up views of flowers, grasses, and other organisms; when back in his studio in the winter, he painted from these sketches. According to his friend Elaine de Kooning, herself a painter, Gorky

> found in the contours of weeds and foliage, a fantastic terrain, pitted
> with bright craters of color which he let swim isolated on the white

3–13 Arshile Gorky. *Garden in Sochi III.* c. 1943.
Collection The Museum of Modern Art, New York.

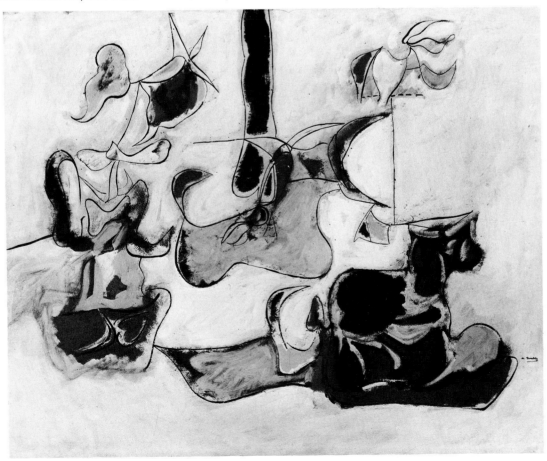

55

paper while a labyrinthine pencil line, never stopping, created dizzy, tilted perspectives that catapulted the horizons to the top of the page. Then he focused more minutely, staring down into the hearts of flowers to come up with magnified stamens and pistils, aggressive as weapons, with petals like arching claws, leaves like pointed teeth and stems like spears.[20]

Gorky drew from nature not to imitate her, but to interpret his own psychic state—remembered experiences, fears, sexual desires—which he allowed to alter freely the shapes of what he saw and their relations to each other.[21] In 1945, Breton wrote that Gorky was "of all the surrealist artists, the only one who maintains a direct contact with nature—sits down to paint *before her*." His aim was to use the unlimited play of analogies and sensations that nature provides "as springboards . . . in fathoming certain profound states of mind . . . [to] leap beyond the ordinary and the known." [22]

Called "hybrids" by Breton, Gorky's visceral amalgams of natural phenomena constituted imaginary landscapes that are also table-tops, echoing his earlier Cubist still lifes. By integrating motifs from diverse sources, Gorky followed the Surrealist practice of "putting nature out of place" to suggest irrational and startling juxtapositions. Indeed, his desire for this kind of cryptic lyricism led him to use ambiguous motifs that lend themselves to multiple connotations and to immerse them in an atmosphere that invites reverie. Central to Gorky's poetry, as to Surrealism in general, was the drama of sex, which was projected in the interaction of erotic signs: softly rounded and yielding shapes and pudenda-like crevices that evoke a warm, tender voluptuousness, and hard, bony thorn- and claw-like protuberances that suggest hostile, even cruel, phallic aggression (*Fig. 3-14*).

Gorky's images were influenced by Matta's *Psychological Morphologies*, or *Inscapes*. But Matta's mechanomorphic inventions inhabited a science-fiction fantasy world devoid of warmth, most unlike Gorky's dream of nature. Gorky's hybrids also differ from Miró's shorthand symbols in that they are more abstract and allude more to inner organs—liver, heart, lungs—than to external phenomena. Although not as pronounced as in his earlier pictures, Gorky continued in later years to draw on paintings he admired, incorporating details from them into his works. His *Diary of a Seducer* (Fig. 3-15), was, according to Ethel Schwabacher, related to Ingres' *Odalisque* at the Metropolitan Museum, and, in Elaine de Kooning's view, to David's *Mars Disarmed by Venus*, an illustration of which Gorky had seen on the cover of a magazine.[23] However, such differences in the interpretation of the same painting by two of the artist's close friends indicate the extent of Gorky's departures from his sources.

Gorky's invention of "hybrids" may, as he himself said, have been prompted in part by the Armenian church decoration he saw as a child. His one-time student and biographer, Ethel Schwabacher, remarked that this art was a palimpsest of Babylonian, Sumerian, Byzantine, Syrian, and Persian murals, embellished with grotesque composites of human and animal figures.[24] Freud related such images to those that appear in dreams. He wrote of "certain constituents of the content of dreams which are peculiar to them and are not found in waking ideation. What I have in mind are 'collective' and 'composite figures' and the strange 'composite structures,' which are creations not unlike the composite animals invented by the folk imagination of the Orient." [25]

Gorky suggested the kind of poetry he wanted his paintings to evoke in a statement he made in 1942 about the *Garden in Sochi* series:

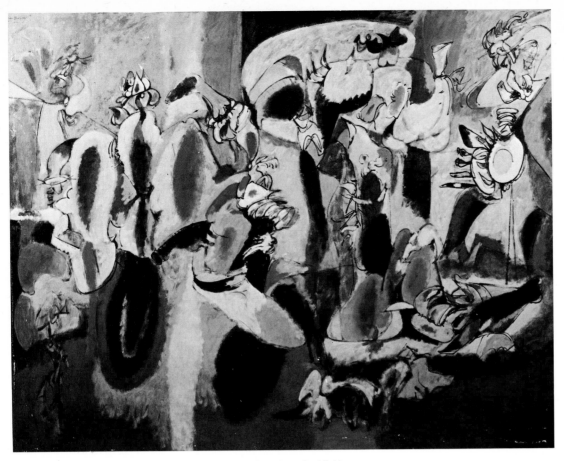

3–14 Arshile Gorky. *The Liver is the Cock's Comb.* 1944.
Albright-Knox Art Gallery, Buffalo, New York;
Gift of Seymour H. Knox.

3–15 Arshile Gorky. *Diary of a Seducer.* 1945.
Collection Mr. and Mrs. William A. M. Burden, New York.

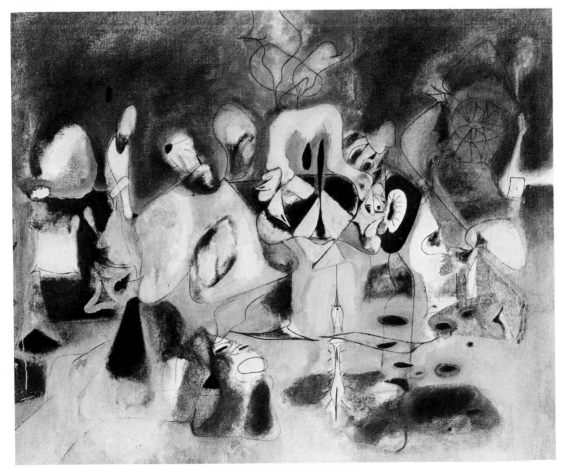

About 194 feet away from our house on the road to the spring, my father had a little garden with a few apple trees which had retired from giving fruit. There was a ground constantly in shade where grew incalculable amounts of wild carrots, and porcupines had made their nests. There was a blue rock half-buried in the black earth with a few patches of moss placed here and there like fallen clouds. But from where came all the shadows in constant battle like the lancers of Paolo Uccello's painting? This garden was identified as the Garden of Wish Fulfillment and often I had seen my mother and other village women opening their bosoms and taking their soft and dependent breasts in their hands to rub them on the rock. Above all this stood an enormous tree all bleached under the sun, the rain, the cold, and deprived of leaves. This was the Holy Tree. I myself do not know why this tree was holy but I had witnessed many people, whoever did pass by, that would tear voluntarily a strip of their clothes and attach this to the tree. Thus through many years of the same act, like a veritable parade of banners under the pressure of wind all these personal inscriptions of signatures, very softly to my inno-cent ear used to give echo to the sh-h-h-sh-h of silver leaves of the poplars.[26]

Gorky's abstractions did not illustrate any particular scene or autobiographi-cal event, as the quote suggests.[27] (Unlike Miró or Chagall, he refrained from using symbols that alluded directly to the folklore or landscape of his native

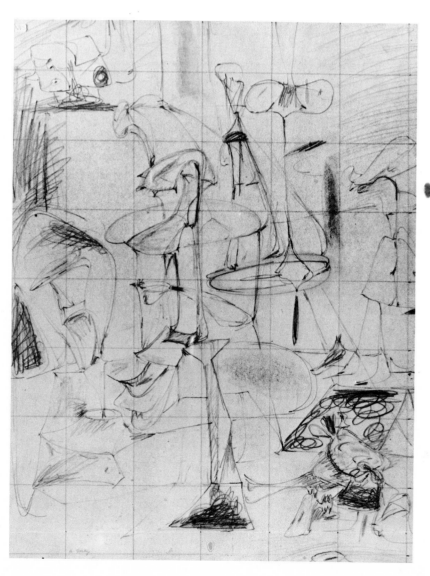

3–16 Arshile Gorky. Study for *The Betrothal*.
1947.
M. Knoedler & Co., Inc., New York.

land.) His verbal description is meant rather to add another dimension to the painting, like the titles of most Surrealist pictures. His words evoke the mood of reverie and earthiness conveyed by the *Garden in Sochi* pictures and can be considered a key to their poetic content, just as his earlier remarks on Stuart Davis, far different in tenor, provide a key to his classicizing Cubist pictures of the 1930's.

However, Gorky to the end remained within the classical tradition. Drawing has always been the primary pictorial means of classicizing artists, and Gorky was essentially a draftsman—like his heroes Ingres and Picasso. In his canvases of the 1930's, he determined the design first and treated color as an attribute of form. Moreover, no matter how spontaneous his later pictures look, there is no sacrifice of control, of the precision of touch and line, and of the ideal of the masterpiece. Gorky's style changed, but not his need to render more definite new forms and new objects, to choose new rules to discipline his emotions. The new "rule" that Gorky devised to realize freedom and perfection at the same time was to work in series. Instead of overpainting—one painting on top of another on the same canvas—as he did in his 1930's works he selected a quick sketch and deliberately developed its theme in successive works, each of which retained the freshness of the first sketch (*Fig. 3-16; II*, p. 83). Thus, Gorky could give free rein to the unexpected and the unordered and convey the impression that his imagery issued directly from unconscious impulses. At the same time, he could refine it, testing every edge and tone for its felt value and structural function, and be as virtuoso as an old master. Miss Schwabacher's characterization of Gorky as "the Ingres of the unconscious" was indeed an apt one, for he made a grand style of automatism.[28]

3–17 Arshile Gorky. *Year After Year.* 1947.
Collection Mr. and Mrs. Gifford Phillips, Santa Monica, California.

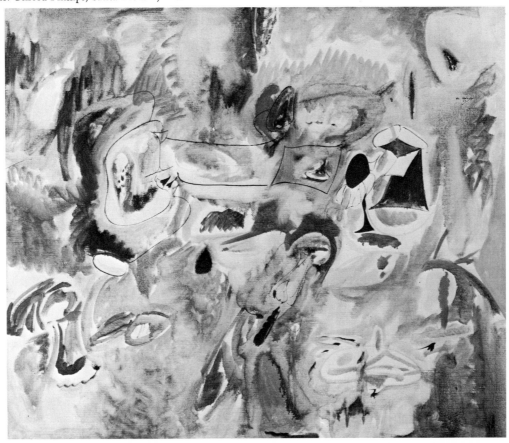

Questions have been raised as to whether Gorky should be considered a late Surrealist or an early Abstract Expressionist. The Surrealists themselves accepted him as one of theirs, and for good reason, for his imagery had the reference to nature, the obsessive sexuality, and the mood of poetic reverie they valued greatly. Gorky did, however, differ from the Surrealists generally (but not from Matta) because of the extreme to which he carried abstraction and spontaneity, anticipating Pollock's "drip" paintings, which were exhibited the year Gorky died. Yet, even at their freest, Gorky's improvisations —*Year After Year* (1947; *Fig. 3-17*)—when compared to the pictures of Pollock and other pioneer Abstract Expressionists do not abandon the realm of the familiar or extend known ideas to the point where they seem radical and new. All in all, Gorky was a synthesizer rather than an innovator. He remains a transitional figure, but a crucial one, for, as Adolph Gottlieb wrote, he recognized that "the vital task was a wedding of abstraction and surrealism. Out of these opposites something new could emerge, and Gorky's work is part of the evidence that this is true." [29]

3 Notes

1. Harold Rosenberg, *Arshile Gorky: The Man, The Time, The Idea* (New York: Horizon Press, 1962), p. 25.
2. Arshile Gorky, in the *New York Evening Post*, September 15, 1926, p. 17.
3. *Ibid.*
4. Arshile Gorky, "Stuart Davis," *Creative Art*, IX, No. 3 (September, 1931), 213.
5. Taking his cues from Miró, Masson, and Klee, Gorky experimented with automatism in the early 1930's, but, except for some drawings, little that seems spontaneous remains in the finished oils.
6. Holger Cahill, catalogue of an exhibition, "Arshile Gorky," Mellon Galleries, Philadelphia, February 2–15, 1934, n.p.
7. Gorky attended a few initial meetings of the American Abstract Artists but did not join or exhibit with the group. He may have been invited to join the *Abstraction-Création* group in 1932. A reproduction of a painting by Gorky appeared in the *Cahiers d'Art*, Nos. 1 and 2 (Paris, 1938), 63, so he got to be known in Paris. Perhaps John Graham introduced his work there.
8. Meyer Schapiro, in Introduction to Ethel Schwabacher, *Arshile Gorky* (New York: Macmillan, 1957), p. 11, and Rosenberg, *Arshile Gorky*, p. 66.
9. Rosenberg, *Arshile Gorky*, p. 66. Gorky's attitude was close to that of Graham, who so adulated Picasso that he believed that all painting that postdated the Cubist pioneer's bore his imprint. Pictures that did not openly reveal that debt were either dishonest or unintelligent. His veneration of Picasso raised trouble-

some questions, because he did prize uniqueness ("rarity") and surprise (produced by "the injection into the world of a new idea"). However, if, as Graham insisted, Picasso "has painted everything and better [than anyone else], he has exhausted all pictorial sources." What else then could an artist do but copy the omnipotent master?

10. Ethel Schwabacher, *Arshile Gorky*, p. 56, wrote: "Gorky frequently looked at . . . the work of one master through the eyes of another. He had seen Ingres and Cézanne through the eyes of Picasso, then Picasso and Klee through the eyes of Miró. Still later, he was to see Duchamp through the eyes of Matta."

11. In his studio on Union Square in New York, Gorky hung a full-sized photostat of Ingres' *Self-Portrait at the Age of Twenty-four*, which was on view at the Metropolitan Museum, and a reproduction of Uccello's *Rout of San Romano*.

12. Julien Levy, in Foreword to William C. Seitz, *Arshile Gorky* (New York: Museum of Modern Art, 1962), p. 7.

13. Rosenberg, *Arshile Gorky*, pp. 76–82, and William Rubin, "Arshile Gorky, Surrealism and the New American Painting," *Art International*, VII, No. 2 (February 25, 1963), 29.

14. Gorky was also influenced by the organic images of Tanguy and Duchamp.

15. Schapiro, in Introduction to Schwabacher, *Arshile Gorky*, pp. 12–13.

16. Kandinsky was rarely included in shows organized by the Surrealist emigrés in the early 1940's.

17. Levy, in Foreword to Seitz, *Arshile Gorky*, p. 8.

18. My analysis follows that of Rubin, "Arshile Gorky, Surrealism and the New American Painting," p. 29. Rubin used the internal evidence of style to determine Gorky's evolution from 1940 to 1942.

19. Schapiro, in Introduction to Schwabacher, *Arshile Gorky*, p. 13.

20. Elaine de Kooning, "Gorky: Painter of His Own Legend," *Art News*, XLIX, No. 9 (January, 1951), 64.

21. Seitz, *Arshile Gorky*, p. 29.

22. André Breton, "The Eye Spring Arshile Gorky," Introduction to the catalogue of the Arshile Gorky exhibition at the Julien Levy Gallery, New York, March, 1945. Rubin, "Arshile Gorky, Surrealism and The New American Painting," pp. 35–36, pointed out that Gorky's approach to nature was entirely different from Matta's: "Matta began unpremeditatedly spreading washes of color . . . and then 'provoked' the image, which became more particularized, more illustrative as he proceeded. In contrast, the drawings [from nature] that constituted Gorky's starting points are more illustrative than the paintings that derived from them. . . . the elements [in the paintings] became less literal, more abstract."

23. Schwabacher, *Arshile Gorky*, p. 126, and Elaine de Kooning, "Gorky," p. 65.

24. Schwabacher, *Arshile Gorky*, p. 26.

25. Sigmund Freud, quoted in Schwabacher, *Arshile Gorky*, pp. 125–26.

26. A statement by the artist written in June 1942, at the request of Dorothy Miller, about the painting *Garden in Sochi*, which the Museum of Modern Art had just acquired. From the Collections Archives, the Museum of Modern Art, New York, and reprinted with its permission. There is an element of irony, Surrealist in spirit, in the super-accuracy of remembered facts, that is, "about 194 feet."

27. Occasionally, Gorky did draw on specific experiences. In January, 1946, about twenty-seven of his paintings were destroyed by fire. The smoldering reds in *Agony* were probably prompted by the fire.

28. Schwabacher, in Foreword to *Arshile Gorky*, p. 17.

29. Adolph Gottlieb, in Introduction to catalogue of an exhibition, "Selected Paintings by the Late Arshile Gorky," Kootz Gallery, New York, March 28–April 24, 1950, p. 1.

4 The Myth-Makers

LIKE Gorky, a number of other New York painters—Gottlieb, Rothko, Pollock, Motherwell, and Baziotes—re-evaluated Surrealism and began to experiment with automatism around 1941 or 1942 but used this technique for different ends. Unlike Gorky, all except Motherwell were attracted to ancient myths and primitive art and employed automatism to reveal what they believed to be universal symbols that inhabited the inner mind. Gottlieb and Rothko, who began to paint myth-inspired pictures around 1942, made their thoughts known in 1943 in a radio broadcast and in a letter to *The New York Times* (on which Barnett Newman collaborated).[1] The letter, which commanded widespread attention, was written in response to a review of their work by the *Times* critic Edward Alden Jewell, in which he said he was left in a "dense mood of befuddlement."[2]

In the letter, the three artists stated:

> To us, art is an adventure into an unknown world . . . of the imagination [which] is fancy-free and violently opposed to common sense. . . .
> It is a widely accepted notion among painters that it does not matter what one paints as long as it is well painted. This is the essence of academism. There is no such thing as good painting about nothing. We assert that the subject is crucial.[3]

These ideas were inspired by Surrealism, but Gottlieb, Rothko, and Newman diverged from the Surrealist position when they asserted that the themes that interested them "are concerned with primitive myths and symbols that continue to have meaning today . . . only that subject matter is valid which is tragic and timeless. That is why we profess kinship with primitive and archaic art."[4] The three painters had been attracted to primitive art in the 1930's, although it did not then influence their pictures. Gottlieb, for example, began to collect it in 1935. He and Rothko had been Expressionists and as such were favorably disposed toward archaic cultures. They and their associates in The Ten followed with great interest the many articles on ancient art in the *Cahiers d'Art* and saw the Museum of Modern Art's shows on "African Negro Art" (1935), "Prehistoric Rock Pictures in Europe and Africa" (1937), "Twenty Centuries of Mexican Art" (1940), "Indian Art of the United States" (1941), and "Ancestral Sources of Modern Painting" (1941). Gottlieb's and Rothko's interest in primitive art and myth was also stimulated by Jung's conception of the collective unconscious and its role in the creation of art.

The New Yorkers' inclination toward Jungian thinking contrasted with the Freudian orientation of the Surrealists-in-exile, who generally illustrated dreams, hallucinations, and other such psychological experiences. The Surrealists did appreciate primitive art enough to collect it, but with the exception of Masson and Wifredo Lam, they spurned myth-making in their own work.[5] Their opposition to what they termed "escapism through myths" was set forth in an editorial in *View*, April, 1943: "It has been suggested . . . that the role of the artist consists in creating new myths. But the progressive forces of history have always followed an opposite trend. . . . We [support] the infinitely more advanced because more human interpretation of motivations which Freud has given us. . . . we are against myths . . . be they pagan or Christian."[6]

Gottlieb (*Fig. 4-1*) disagreed with this stand, asserting that

> for us [him and Rothko] it is not enough to illustrate dreams. While modern art got its first impetus through discovering the forms of primitive art, we feel that its true significance lies not merely in formal ar-

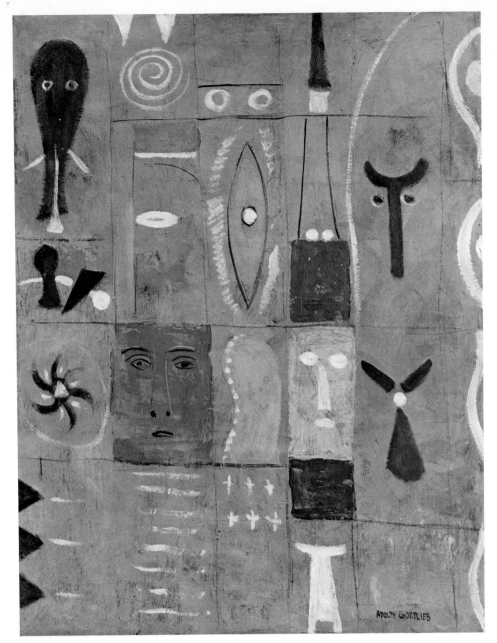

4-1 Adolph Gottlieb. *Pictograph*. 1946.
Los Angeles County Museum of Art, Los Angeles, California;
Gift of Burt Kleiner.

rangement, but in the spiritual meaning underlying all archaic works.
. . . That these demonic and brutal images fascinate us today is
not because they are exotic, nor do they make us nostalgic for a past
which seems enchanting because of its remoteness. On the contrary, it
is the immediacy of their images that draws us irresistibly to the fancies
and superstitions, the fables of savages and the strange beliefs that were
so vividly articulated by primitive man.[7]

Rothko's point of view was similar. He explained that he turned to the myths
of antiquity, as in *Baptismal Scene* (*Fig. 4-2*),

because they are the eternal symbols upon which we must fall back to
express basic psychological ideas. They are the symbols of man's
primitive fears and motivations, no matter in which land or what time,
changing only in detail but never in substance, be they Greek, Aztec,
Icelandic or Egyptian. And our modern psychology finds them persisting
still in our dreams, our vernacular and our art, for all the changes in the
outward conditions of life.[8]

In their desire to create a "tragic and timeless" art, Gottlieb and Rothko
refused to submit to the ideological limitations imposed by Surrealism. Sum-

63

ming up that position, Lionel Abel wrote in a manifesto in the first issue of *VVV* that "we reject the lie of an 'open universe' in which everything is possible, and we support those doctrines which indicate how man's acts are circumscribed. Thus we support Historical Materialism in the social field, and Freudian analysis in psychology. Armed with these perspectives we are prepared to deal with all forms of transcendentalism." [9]

Underlying the cosmic aspirations of the myth-makers of the 1940's was a pervading pessimism quite unlike the optimism inherent in Freudian psychotherapy and Marxist revolutionary action. Gottlieb and Rothko attributed their new attitude to World War II. The former said:

> If we profess kinship to the art of primitive man, it is because the feelings they expressed have a particular pertinence today. In times of violence, personal predilections for niceties of color and form seem irrelevant. All primitive expression reveals the constant awareness of powerful forces, the immediate presence of terror and fear, a recognition of the brutality of the natural world as well as the eternal insecurities of life. That these feelings are being experienced by many people throughout the world today is an unfortunate fact and to us an art that glosses over or evades these feelings is superficial and meaningless. That is why we insist on subject matter, a subject matter that embraces these feelings and permits them to be expressed.[10]

Rothko agreed:

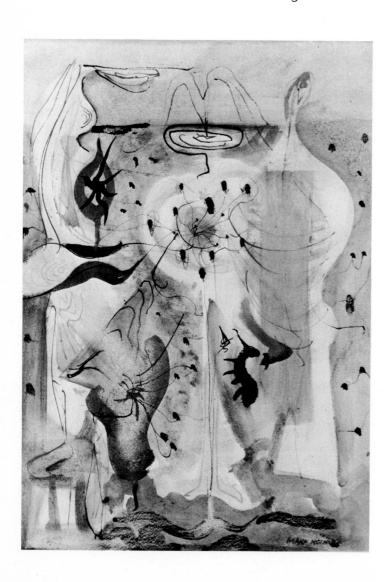

4–2 Mark Rothko. *Baptismal Scene*. 1945.
Collection Whitney Museum of American Art, New York.

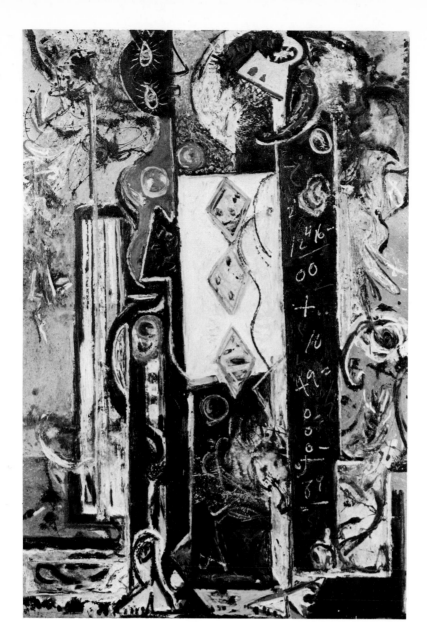

4–3 Jackson Pollock. *Male and Female*. 1942.
Collection Mrs. H. Gates Lloyd, Haverford, Pennsylvania.

Those who think that the world is more gentle and graceful than the primeval and predatory passions from which these myths sprang are either not aware of reality or do not wish to see it in art. The myth holds us, therefore, not through its romantic flavor, not through the remembrance of the beauty of some bygone age, not through the possibilities of fantasy, but because it expresses to us something real and existing in ourselves, as it was to those who first stumbled upon the symbols to give them life.[11]

The role of primitive myth-maker was also assumed by Pollock, who was in Jungian analysis. He gave the pictures in his first two shows (1943 and 1944) such titles as *Male and Female* (Fig. 4-3), *Guardians of the Secret*, *She Wolf*, *Moon Woman Cuts the Circle*, *Totem Lesson*, and *Night Ceremony*. In 1944, he wrote:

I have always been very impressed with the plastic qualities of American Indian art. The Indians have the true painter's approach in their capacity to get hold of appropriate images, and in their understanding of what constitutes painterly subject-matter. Their color is essentially Western, their vision has the basic universality of all real art. Some people find references to American Indian art and calligraphy in parts of my pictures. That wasn't intentional; probably was the result of early memories and enthusiasms.[12]

4–4 William Baziotes. *The Web*. 1946.
Estate of William Baziotes.

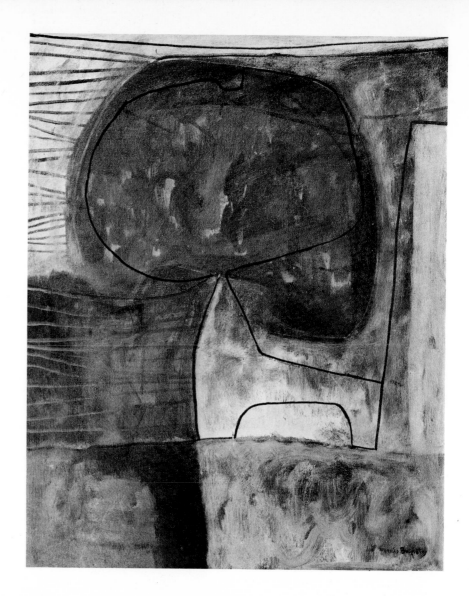

4–5 Theodoros Stamos. *Ancestral Worship*. 1947.
Collection Whitney Museum of American Art, New York.

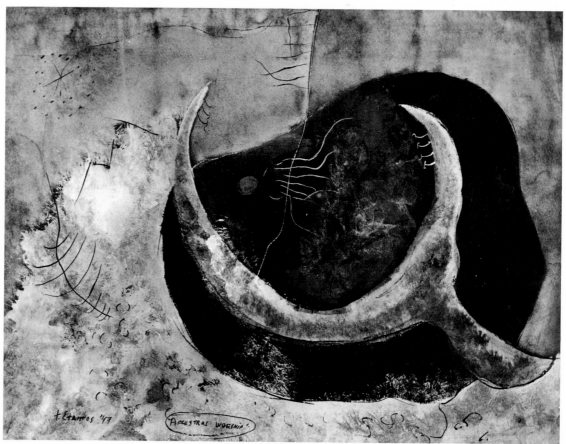

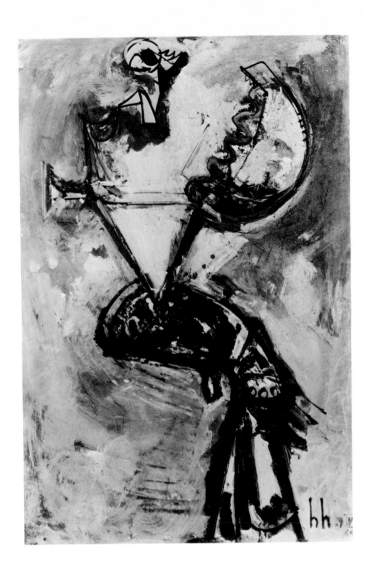

4-6 Hans Hofmann. *Idolatress I.* 1944.
Collection University Art Museum, Berkeley, California;
Gift of the artist.

Like Pollock, Baziotes, Stamos, and Hofmann invented mythic figures and
gave their canvases mythic titles (*Figs. 4-4, 4-5, 4-6*). Independently, Clyfford
Still (*Fig. 4-7*) did the same. In the introduction to the catalogue of Still's
first show at the Art of This Century Gallery early in 1946, Rothko wrote:

> It is significant that Still, working out West and alone, has arrived at
> pictorial conclusions so allied to those of the small band of Myth
> Makers who have emerged here during the war. The fact that his is a
> completely new facet of this idea, using unprecedented forms and com-
> pletely personal methods, attests further to the vitality of this move-
> ment. Bypassing the current preoccupation with genre and the nuances
> of formal arrangements, Still expresses the tragic-religious drama which
> is generic to all Myths at all times, no matter where they occur.
> He is creating new counterparts to replace the old mythological
> hybrids who have lost their pertinence in the intervening centuries.
> For me, Still's pictorial dramas are an extension of the Greek Perse-
> phone Myth. As he himself has expressed it, his paintings are "of the
> Earth, the Damned and of the Recreated." [13]

Judging by the titles of many of their pictures, Gottlieb, Rothko, Pollock,
and Baziotes were as interested in Greco-Roman myths—particularly those
dealing with primitive sexuality and brute force—as in the American Indian
and other preliterate cultures. They did not actually copy Greco-Roman art
but tried instead to create new forms analogous in spirit to the old.[14] As

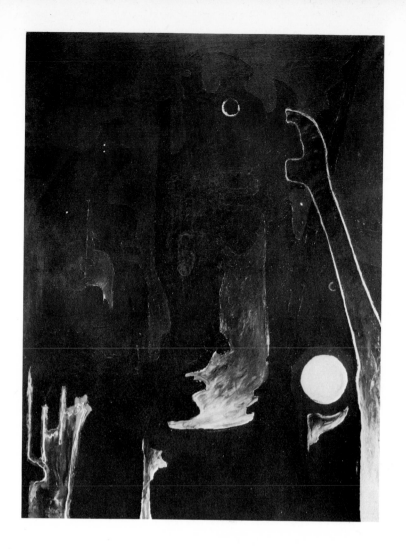

4–7 Clyfford Still. *1945.* 1945.
Marlborough Gallery Inc., New York.

Rothko said: "Our presentation of these myths, however, must be on our own terms, which are at once more primitive and more modern than the myths themselves—more primitive because we seek the primeval and atavistic roots of the idea rather than their graceful classical versions: more modern than the myths themselves because we must redescribe their implications through our own experience." [15]

Although their pictures contained allusions to primitive symbols, the desire for a truly modern mythic art led Gottlieb and Rothko to adopt abstraction. They were also aware that the art of many aboriginal peoples was abstract, as Newman wrote about the paintings of the Northwest Coast Indians: "Here, then, among a group of several peoples the dominant aesthetic tradition was abstract. They depicted their mythological gods and totemic monsters in abstract symbols, using organic shapes, without regard to the contours of appearance." [16] The urge to be simultaneously modern and primitive also disposed the three myth-makers, as they wrote in their letter to the *Times,* to "favor the simple expression of the complex thought. We are for the large shape because it has the impact of the unequivocal. We wish to re-assert the picture plane. We are for flat forms because they destroy illusion and reveal truth." [17] The simple form has as a rule been thought of as archaic by modern primitivizers, for simplicity tends to be equated with truth and to be valued for its own sake; [18] a flat form, because it is nonillusionistic, was conceived of as modern. Automatism was the initial method employed by the myth-makers to arrive at their images. But since it tended to yield intricate linear patterns whose overlapping elements produced an illusionistic space that conflicted with their desire for simplicity and flatness, it was later abandoned.

Implicit in this predilection for archaic art was a questioning of European traditions, including modern ones. In the introduction to the catalogue for "The Ten: Whitney Dissenters" exhibit of 1938, the group asserted that it strove to "see objects and events as though for the first time, free from the accretions of habit and divorced from the conventions of a thousand years of painting." [19] During the early 1940's, the myth-makers' criticism of Western culture was ambivalent, for they often selected Greco-Roman legends as subjects and acknowledged their debt to the School of Paris as well. But by 1946 their antipathy to Western art had sharpened, and they increasingly prized "the many primitive art traditions," because they stood apart "as authentic aesthetic accomplishments that flourished without benefit of European history," as Newman wrote in the catalogue of a show of Northwest Coast Indian painting that he arranged in 1946 at the Betty Parsons Gallery.[20] Earlier, in 1944, for a show at the Wakefield Gallery entitled "Pre-Columbian Stone Sculpture," he wrote: "While we transcend time and place to participate in the spiritual life of a forgotten people, their art by the same magic illuminates the work of our time. . . . So great is the reciprocal power of this art that while giving us greater understanding of the people who produced it, it gives meaning to the strivings of our own artists." [21]

The idea of creating an art "without benefit of European history" was to grow even stronger in time. In part, the rejection of European traditions stemmed from the belief that a concern with the finite particulars of history denied the kind of timeless content the myth-makers were seeking. It also arose from a desire for originality and for a native American art—one reason perhaps for their preoccupation with indigenous Eskimo, pre-Columbian, and Northwest Indian art. A certain nationalistic spirit pervaded this kind of thinking (and was carried to extremes by Still), although the myth-makers abhorred Regionalist painting among other styles current at that time, as they asserted in their letter to the *Times*.[22]

The *Times* letter contained many of the premises that would prompt new departures in the painting of Rothko, Newman, and Gottlieb. Changes in their attitude toward content brought with it changes in their styles. The idea that art is an adventure into an unknown world inclined them to experiment with new images. That this unknown world was found in timeless universal myths disposed them to transcend the particular, to reach beyond the familiar world and traditional art. Repudiating conventional ways of seeing, they asserted: "It is our function as artists to make the spectator see the world our way—not his way." [23]

More important, much as the letter emphasized content, it announced the stylistic direction their painting would eventually take, even to the point of anticipating their formal developments. In the letter, Gottlieb, Rothko, and Newman condemned "pictures for over the mantle," yet they did not paint works of enormous size until later. Moreover, although they believed in 1943 that their forms were abstract, large, simple, and flat, these adjectives apply more accurately to their canvases after 1949—that is, after they had abandoned the automatist technique. The three artists did not follow a conscious program, but, in retrospect, it is clear that they extended their ideas concerning content until they arrived at new and original images.

4 Notes

1. Adolph Gottlieb and Mark Rothko, *The Portrait of the Modern Artist,* mimeographed script of a broadcast on "Art in New York," H. Stix, director, WNYC, New York, October 13, 1943, p. 4. Adolph Gottlieb and Mark Rothko (in collaboration with Barnett Newman), "Letter to the Editor," *The New York Times,* June 13, 1943, sec. 2, p. 9.

2. Edward Alden Jewell, "End-of-the-Season Melange," *The New York Times,* June 6, 1943, sec. 2, p. 9. The circumstances that led to the letter are as follows. In the summer of 1943, the fifty-five members of the Federation of Modern Painters and Sculptors held their third annual exhibition at the Wildenstein Gallery. In a statement, the group announced that America had become the center of world art and demanded that art here be accepted on a "truly global plane." In a review of the show in *The New York Times,* Jewell, tongue in cheek, suggested that the new art be called "globalism," but admitted that it confused him. Gottlieb, who was active in the Federation, phoned him to ask if he and his friends could write an explanation, and Jewell agreed. The preamble to the letter to the *Times* was framed by Newman, the points by Gottlieb, with the exception of the last one, which was Rothko's idea. It was signed by Rothko and Gottlieb, but not by Newman, because he was not a member of the Federation.

3. Gottlieb and Rothko (in collaboration with Newman), "Letter to the Editor." The conception of a "crisis of subject matter" was best summed up by Wolfgang Paalen in the introduction to the catalogue of his show at the Art of This Century Gallery, New York, April 17–May 12, 1945 (although he was ambivalent to myth-making): "The plastic analysis of the subject-matter (cubism), which has led to arbitrary deformations in the degeneration of cubism; the poetical revelation of the subject by unexpected juxtapositions (surrealism), which has led to literary academicism; the renunciation of subject-matter (purist abstractivism), which finally reduced panting to simple plays of optic equilibrium—these are principal aspects of the crisis of subject. It shows that now it is no longer a question of experimenting how to paint, but finding *what* to paint. The problem is no longer to invent new techniques but to find new themes."

4. *Ibid.*

5. The Surrealists' interest in primitive art is apparent in the *First Papers of Surrealism,* New York, 1942. On the flyleaf of the catalogue to the show appears a statement titled "Primitive Art," unsigned, but probably written by Breton: "Surrealism is only trying to rejoin the most durable traditions of mankind. Among the primitive peoples art always goes beyond what is conventionally and arbitrarily called the 'real.' The natives of the Northwest Pacific coast, the Pueblos, New Guinea, New Ireland, the Marquesas, among others, had made *objets* which Surrealists particularly appreciate (Collections Max Ernst, C. Levy Strauss, André Breton, Pierre Matisse, Carlbach, Segredakis)." However, Breton was unsymathetic to the possibilities of a contemporary mythic art.

In the first three issues of *Dyn,* Wolfgang Paalen reproduced primitive objects, particularly those of the Haida, Bella-Bella, Bella-Coola, Kwakiutl, and Nootka Indians, and wrote texts in French about them. But in his major articles, which appeared in English and French, he did not discuss the ways in which modern artists could use the form and content of archaic art. Indeed, Paalen believed that primitive man was in the childhood stage of psychological development. Hence, adult artists of today could find their works interesting but not useful, a point of view attacked by Newman in the catalogue of a show of pre-Columbian stone sculpture at the Wakefield Gallery, May 16–June 5, 1944. He deplored the identification of the "primitive" with the "child-like" as "condescending" and claimed that primitive masterpieces are "the best any man can do."

Paalen, in Introduction to *Dyn* (Amerindian Number—Spring 1944, No. 4–5, n.p.), changed his attitude, writing that "art can reunite us with our prehistoric past . . . this is the moment to integrate the enormous treasure of Amerindian forms into the consciousness of modern art. . . . This integration would be the negation of all exoticism . . . the abolition of interior frontiers . . . a universal art [which] will help in the shaping of the new, the indispensible world-consciousness." The change in *Dyn's* policy occurred after Gottlieb, Rothko, and Newman articulated their position. They probably influenced Paalen, who had met them in New York. But, unlike them, he said nothing about the modern artist's use of primitive art then, and continued to attack what he called "sham mythologies," as in the introduction to the catalogue to his show at the Art of This Century Gallery, April 17–May 12, 1945.

6. "The Point of *View*—An Editorial," *View,* No. 1, Series III (April, 1943), 5.

7. Gottlieb and Rothko, *The Portrait of the Modern Artist,* n.p.

8. *Ibid.*

9. Lionel Abel, "It is Time to Pick the Iron Rose," *VVV,* No. 1 (June, 1942), 2.

10. Gottlieb and Rothko, *The Portrait of the Modern Artist,* n.p.

11. *Ibid.*

12. Jackson Pollock, "Jackson Pollock" *Arts and Architecture,* LXI, No. 2 (February, 1944), 14. (Answers to a questionnaire.)

13. Mark Rothko, in Introduction to catalogue of the Clyfford Still exhibition at the Art of This Century Gallery, New York, February 12–March 2, 1946, n.p.

14. Mark Rothko, in a letter to *The New York Times,* July 8, 1945, sec. 2, p. 2x, wrote: "If there are resemblances between archaic forms and our own symbols, it is not because we are consciously derived from them but rather because we are concerned with similiar states of consciousness and relationship to the world. With such an objective we must have inevitably hit upon a parallel condition for conceiving and creating our forms. . . . [Our abstractions] are finding a pictorial equivalent for man's new knowledge and consciousness of his more complex inner self."

15. Gottlieb and Rothko, *The Portrait of the Modern Artist,* n.p.

16. Barnett Newman, in Introduction to catalogue

of an exhibition, "Northwest Coast Indian Painting," Betty Parsons Gallery, New York, September 30–October 19, 1946, n.p.

17. Gottlieb and Rothko (in collaboration with Newman), "Letter to the Editor."

18. In a sense, the American myth-makers continued the attitude of Gauguin, Ensor, Munch, and the German Expressionists. Robert Goldwater, *Primitivism in Modern Art* (New York: Vintage Books; Random House, 1967), p. 120, wrote that "the chief characteristic of the primitivism of these artists is a tendency to call all the refined and complicated aspects of the world about them superficial and unimportant. . . . Their main interest lies in the bases of human character and conduct, and these they conceive as violent and somewhat unpleasant, attempting to express them by simplifications of form and contrasts of color. The 'expressionist' character of their art . . . lies in the thoroughness and narrowness of this interest."

19. Catalogue of an exhibition, "The Ten: Whitney Dissenters," New York, November, 1938. The denial of European culture had many precedents in Europe, beginning with Gauguin. For example, in 1902, Klee had written: "I want to be as though newborn, knowing absolutely nothing about Europe, ignoring poets and fashions, to be almost primitive." Quoted in Goldwater, *Primitivism in Modern Art*, p. 199.

20. Newman, "Northwest Coast Indian Painting," n.p.

21. Barnett Newman, catalogue of an exhibition, "Pre-Columbian Stone Sculpture," Wakefield Gallery, New York, May 16–June 5, 1944, n.p.

22. Gottlieb and Rothko (in collaboration with Newman), "Letter to the Editor."

23. *Ibid.*

5 William Baziotes
(1912–63)

AROUND 1941, William Baziotes began to use the automatist technique to paint biomorphic abstractions with a mythic content. He stressed the primacy of subject matter, thinking of his pictures as "mirrors" that reflected the strange and demonic side of his personality. Occasionally, he was more specific, attributing symbolic meanings to his forms and colors. The painting entitled *Cyclops* (1947) refers to the fearsome one-eyed giant of Greek mythology, but it was also suggested by a rhinoceros that the artist saw at the Bronx Zoo, imagining it to be the living kin of primordial and legendary beasts. Baziotes did, as he put it, refer to "flora, fauna and beings" to bring forth "those strange memories and psychic feelings that mystify and fascinate." [1] But far more vital in summoning up the fantastic imagery of his inner world was the use of automatism. As he wrote in 1947: "Each beginning suggests something. Once I sense the suggestion, I begin to paint intuitively. The suggestion then becomes a phantom that must be caught and made real." [2]

As important to Baziotes as his mythic subject matter was the art of the museums, whose masterliness he tried to emulate. He admired "plasticity" wherever he saw it, but there were other qualities that gripped him even more in the works of certain artists. Of Picasso, he said: "Well, I looked at Picasso [in his retrospective at the Museum of Modern Art in 1939] until I could smell his armpits and the cigarette smoke on his breath. Finally, in front of one picture—a bone figure on a beach—I got it. I saw that the figure was not his real subject. The plasticity wasn't either—although the plasticity was great. No. Picasso had uncovered a feverishness in himself and is painting it—a feverishness of death and beauty." [3]

Baziotes was attracted to fantastic subject matter early in his career. From 1938 to around 1940, he painted in the exotic colors of Persian miniatures a series of bizarre figural improvisations that owed much to Miró, Klee, and particularly Picasso (*Fig. 5-1*). In the spring of 1940, Baziotes met Matta and was stimulated by his idea that abstraction need not be devoid of content but could embody psychic meanings. However, like Gorky, he was unsympathetic to Matta's anti-aesthetic bias, which held that the recording of irrational impulses was incompatible with the rationality of picture-making. After 1941, Baziotes' work became increasingly automatist, organic, and abstract, akin to Matta's *Psychological Morphologies*, or *Inscapes*. The Surrealists-in-exile quickly accepted Baziotes, and two of his canvases—one of them *The Butterflies of Leonardo da Vinci* (1942; *Fig. 5-2*)—were included in the International Surrealist Exhibition held in New York that year.

During this period, Baziotes' painting was complicated and amorphous—lacking surface tension and strong, articulated design. Desirous of capturing these qualities in his canvases, he resumed experimentation with Synthetic Cubism, as in *The Parachutists* (*Fig. 5-3*) and *Balcony* (*Fig. 5-4*), both painted in 1944. The latter was, for Baziotes, the germinal picture: an all-over linear web, it is at once spontaneous and composed. Baziotes achieved the sense of structure that he desired in these pictures but not the kind of imagery. *Balcony*, with its organic, abstract shapes that were softly brushed so as to appear liquid signaled a new direction for his stylistic development. However, he did not find the subjects that stimulated him to paint his best pictures until around 1946, at which time he reduced the number and enlarged the size of his shapes to make the images more specific and less active, as in *Dwarf* (1947; *III*, p. 86). Instead of drawing a linear grid, Baziotes spread colors on the canvas and, in the process, determined their contours, which are bluntly drawn, broken, or blurred in places—entirely unlike Miró's

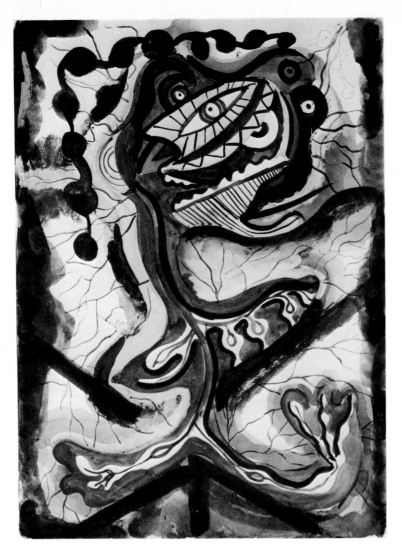

5–1 William Baziotes. *Untitled.* c. 1938–40.
Estate of William Baziotes.

5–2 William Baziotes. *The Butterflies of Leonardo
da Vinci.* 1942.
Estate of William Baziotes.

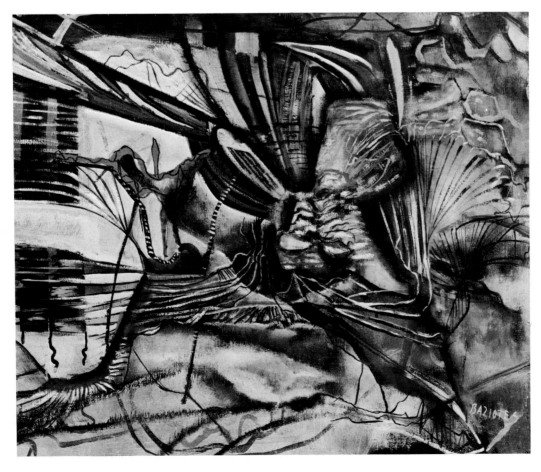

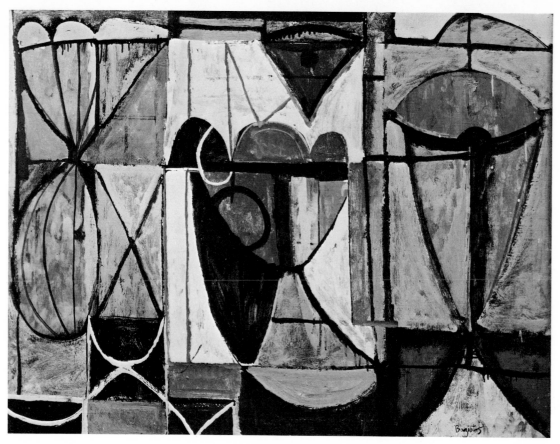

5–3 William Baziotes. *The Parachutists*. 1944.
Estate of William Baziotes.

crisp, hard edges or Gorky's and Matta's swift-flowing calligraphy. Baziotes differed from them also in that his loosely painted surfaces suggest a viscid fluid—reminiscent of Klee—that impedes all activity. Indeed, his shapes, swollen and ungainly, seem inert and unable to move in this environment.

There is in Baziotes' painting none of Miró's debonair irony, Gorky's erotic reverie, or Matta's space-age fantasy. Instead, it conjures up a state of suspended animation. The dappled brushwork, though subtly nuanced, appears stabbed or scrubbed, as if the artist reluctantly, at times impatiently, came out of a trance to paint such a hypnotic state. One has the sense with Baziotes that each painting has taken shape slowly, growing passively from within itself. Inhabiting this dream world are clumsy and deformed monsters, some suggesting amputated torsos and maimed creatures. These images are suggested by doodle-like configurations—a circle within a circle, pinwheel, or zigzag—that turn color areas into a cyclops (*Fig. 5-5*); flesh eaters (Fig. 5-6); a dwarf or a haunted nocturnal landscape. Baziotes' subjects are immersed—shrouded—in a dark yet phosphorescent aquatic substance. The sense of water at night is also evoked by the colors he favored: greens, blues, and purples.

Baziotes was one of several Americans (including Rothko, Gottlieb, and Theodoros Stamos) who in the mid-1940's were fascinated by underwater life. Their portrayal of a submarine world of the artist's imagination reflected an extreme reaction, probably unintentional, to the rational approach that dominated European art, especially geometric abstraction. It may be that in a deeper sense the mythic prototypes of Rothko, Gottlieb, Stamos, and particularly Baziotes—for his painting is the most passive—are Narcissus, Orpheus, and Dionysus. Herbert Marcuse wrote that these figures are the antagonists of the gods of willful behavior and reason, and stand for a

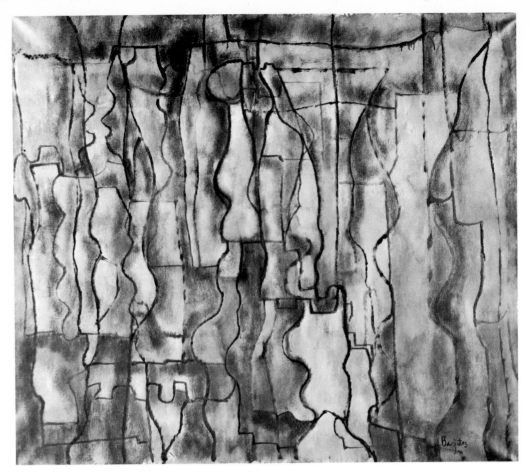

5–4 William Baziotes. *The Balcony.* 1944.
Collection Wright Ludington, Santa Barbara, California.

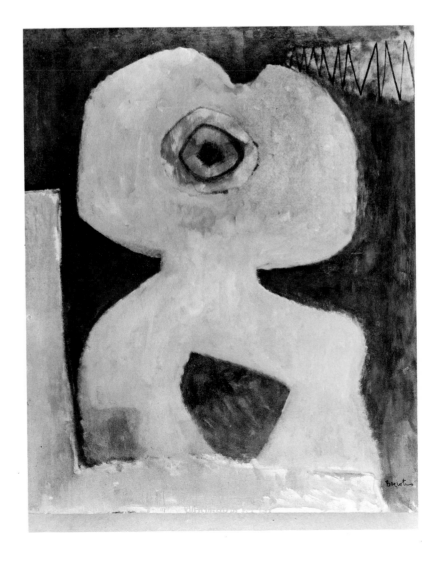

5–5 William Baziotes. *Cyclops.* 1947.
Courtesy of The Art Institute of Chicago, Chicago,
Illinois.

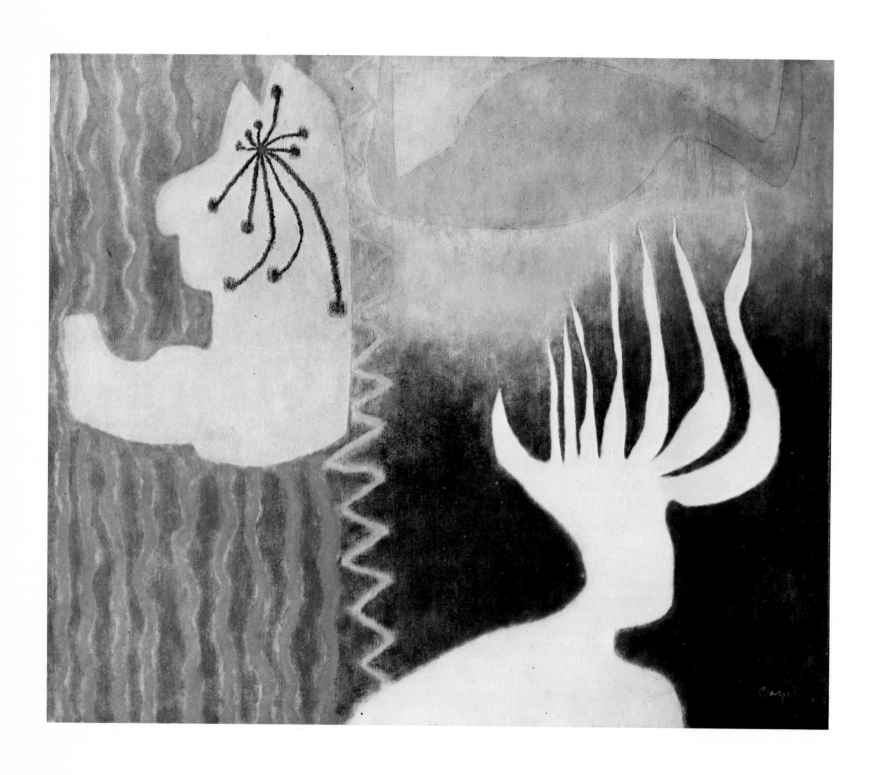

5–6 William Baziotes. *The Flesh Eaters*. 1952.
Estate of William Baziotes.

different manner of being. "They have not become the culture-heroes of the Western World: theirs is . . . the voice which does not command but sings . . . the deed which is peace and ends the labor of conquest; the liberation from time which unites man with god, man with nature." [4]

Miró's canvases showed Baziotes how he could use automatism while still retaining painterly values. In the 1930's, Miró came to rely increasingly on the process of painting, remarking that "rather than setting out to paint something, I begin painting and as I paint the picture begins to assert itself, or suggest itself under my brush. . . . The first stage is free, unconscious; but after that the picture is controlled throughout in keeping with the desire for disciplined work which I have felt from the beginning." [5]

Not only did each of Baziotes' pictures develop in this way, but his career as a whole can be divided into the two successive stages of which Miró spoke. In the 1940's, his work was at its freest. After 1950, a change in emphasis occurred; his painting became tighter, polished, more calculated—he now labored from six months to a year on a canvas (*Fig. 5-7*). Baziotes' desire for stillness accounted in part for the change; he took care to suppress abrupt transitions in brushwork, color, and texture. Equally significant, however, was the fact that his classicizing disposition came to the fore. Baziotes became increasingly concerned with the definition of form rather than with the spread of color, and he edged his forms precisely and sharpened his meandering lines. At the same time, his imagery changed. Instead of painting shapes that suggested creatures, he invented protocreatures, the kin of boneless unicellular organisms—protozoa, amoeboids, coelenterates, and hydrazoa. These spare,

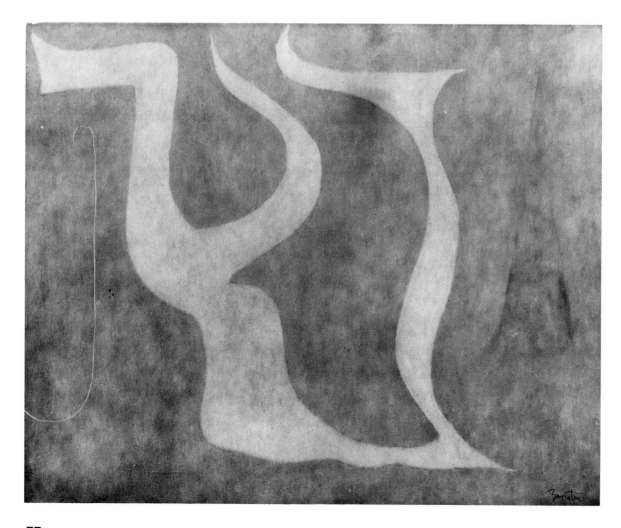

5-7 William Baziotes. *Dawn.*
 1962.
Estate of William Baziotes.

77

sinuous, quivering growths are like pale, shimmering jelly, and they are of the same consistency as the stuff in which they drift. The entire surface emits a uniform but pulsating cool light. There is a loss of freshness and surprise in the late works, but what does not change is the tranquillity and hypnotic mystery that distinguishes all of Baziotes' work.

Baziotes influenced the development of Abstract Expressionism in that he was among the first of the vanguard artists to create an original variant of Abstract Surrealism. Yet, like Gorky, he himself cannot rightfully be numbered among the Abstract Expressionists, as he often is.[6] His painting evolved counter to theirs in the late 1940's and in the 1950's; at a time when they were becoming more venturesome, he closed off and refined his painting. Moreover, unlike the pioneer Abstract Expressionists who innovated extreme nonfigurative styles, Baziotes (even more than Gorky) retained the mood of fantasy and the references to image and symbol that they eliminated, and so remained close to Surrealism.

5 Notes

1. William Baziotes, catalogue of an exhibition, "The Magical Worlds of Redon, Klee, Baziotes," Contemporary Arts Museum, Houston, Texas, January 24–February 17, 1957, n.p.

2. William Baziotes, "I Cannot Evolve Any Concrete Theory," *Possibilities 1*, No. 1 (Winter, 1947–48), 2.

3. Rudi Blesh, *Modern Art USA* (New York: Alfred A. Knopf, 1956), pp. 268–69.

4. Herbert Marcuse, *Eros and Civilization* (Boston: Beacon Press, 1955), p. 162.

5. Joan Miró, quoted in James Johnson Sweeney, "Miró," *Art News Annual*, XXIII (1954), 187.

6. Baziotes was included in "The New American Painting" show at the Museum of Modern Art, 1958; the "American Abstract Expressionists and Imagists" show at the Solomon R. Guggenheim Museum, 1961, and the "New York School" show at the Los Angeles County Museum, 1965.

AFTER 1943, the New Yorkers who were venturing into automatist and biomorphic abstraction—among them Baziotes, Gottlieb, Hofmann, Motherwell, Pollock, and Rothko—became increasingly familiar with each other's work and often exhibited together. (The exception was Gorky, who had largely removed himself from his American contemporaries.) This resulted in a loose community based on mutual understanding and respect. Personal interactions were of great importance, for they gave rise to an aesthetic climate in which innovation and extreme positions were accepted and encouraged. Except for Gottlieb, all these artists were given exhibitions at the Art of This Century Gallery from the end of 1943 to the beginning of 1945. Their works were also shown at the 67 Gallery, which was opened in the winter of 1944 by Howard Putzel, who by then had left the employ of Peggy Guggenheim. Putzel's first show, entitled "Forty American Moderns," included canvases by Avery, Baziotes, Stuart Davis, Gottlieb, Morris Graves, Hofmann, Matta, Motherwell, Pollock, Richard Pousette-Dart, Rothko, and Mark Tobey. The choice is a tribute to the remarkable taste of Putzel, who in the early 1940's had the kind of discerning eye for artists of promise that John Graham had had in the previous decade.

A few writers—notably James Johnson Sweeney, Sidney Janis, Samuel Kootz, Clement Greenberg of *Partisan Review* and *The Nation*, and Manny Farber of the *New Republic*—also recognized the gifts of some of the Americans. Sweeney's admiration for Pollock led him to write the preface to the painter's first show in 1943. In it he asserted:

> Pollock's talent is volcanic. It has fire. It is unpredictable. It is undisciplined. It spills itself out in a mineral prodigality not yet crystallized. It is lavish, explosive, untidy. But young painters, particularly Americans, tend to be too careful of opinion. . . . What we need is more young men who paint from inner impulsion [sic] without an ear to what the critic or spectator may feel—painters who will risk spoiling a canvas to say something in their own way. Pollock is one.[1]

In the same year, Greenberg also acclaimed Pollock: "*Conflict* and *Wounded Animal* . . . are among the strongest abstract paintings I have seen yet by an American. . . . Pollock has gone through the influences of Miró, Picasso, Mexican painting, and what not, and has come out on the other side at the age of thirty-one, painting mostly with his own brush."[2] In 1945, Greenberg was even more laudatory: "Jackson Pollock's second one-man show . . . establishes him, in my opinion, as the strongest painter of his generation and perhaps the greatest one to appear since Miró."[3] Greenberg also hailed Baziotes and Motherwell in 1944, commenting "that the future of American painting depends on what [they] . . . and only a comparatively few others do from now on"; in 1945, he called Hofmann's painting "completely relevant. His painting is all painting."[4]

Motherwell, writing in *Partisan Review* in 1944, asserted:

> Certain individuals represent a young generation's artistic chances. There are never many such individuals in a single field, such as painting—perhaps a hundred to begin with. The hazards inherent in man's many relations with reality are so great—there is disease and premature death; hunger and alcoholism and frustration; the historical moment may turn wrong for painters: it most often does; the young artist may betray himself, consciously or not, or may be betrayed—the hazards are so great that not more than five out of a whole young generation are able to develop to the end. And for the most part it is the painting of

mature men which is best. The importance of the one-man show of young Jackson Pollock . . . lies just in this, that he represents one of the younger generation's chances.[5]

In 1944, Sidney Janis wrote a book entitled *Abstract and Surrealist Art in America* and organized a show at the Mortimer Brandt Gallery of fifty of the artists he discussed. In his text, Janis considered abstraction and Surrealism to be the two major trends in contemporary painting. He deemed these directions

> antithetic . . . allied to undercurrents of opposing traditions which have persisted for centuries and which, though radically changed, continue today. One may be regarded as romantic, and in general follows from fauvism through expressionism, joining in the formation of the surrealist stream. It may be emotional, intuitive, spontaneous, subjective, unconscious. The other, following the classic line, stems from cubism . . . to abstract art and is for the most part intellectual, disciplined, architectonic, objective, conscious.[6]

However, Janis went on to say:

> Though abstraction and surrealism are considered countermovements in twentieth-century painting, there is in certain painters a fusion of elements from each. American painters particularly have a strong inclination to develop interchanging ideas which may fit into either tradition, though there are purists in both categories who adhere to basic premises and moreover insist that it is impossible to do otherwise. Apparently the schism between the factions is not as unsurmountable as their members believe. That abstract painters are able to bridge the gap to surrealism is indicated in the work of [Rothko, Gottlieb and Gorky]. It is also true that the opposite takes place. Motherwell, formerly a member of the surrealist circle, still retains surrealist ideas while approaching pure abstraction.[7]

Janis was not alone in noting this tendency. The introduction to the catalogue of Rothko's show at the Art of This Century Gallery in 1945 stated that his "painting is not easily classified. It occupies a middle ground between abstraction and surrealism." [8]

Janis pointed to a "merging of abstract and expressionist streams" by citing the works of Hofmann and Pollock, among others.[9] A year earlier, Kootz in *New Frontiers In American Painting* had written that one could determine the future of art "if he knew the ultimate potential of Abstraction and Expressionism." [10] Robert M. Coates of the *New Yorker* observed in 1945:

> There's a style of painting gaining ground in this country which is neither Abstract nor Surrealist, though it has suggestions of both, while the way the paint is applied—usually in a pretty free-swinging, spattery fashion, with only vague hints at subject matter—is suggestive of the methods of Expressionism. I feel that some new name will have to be coined for it, but at the moment I can't think of any. Jackson Pollock . . . and William Baziotes are of this school.[11]

Taking his cue from Coates's inability to find a term for the new style in American painting, Putzel organized a show entitled "A Problem for Critics" in the spring of 1945, in which works by Arp, Gorky, Gottlieb, Hofmann, Masson, Miró, Picasso, Pollock, and Rothko were included.[12] In a press release published by Jewell in *The New York Times*, Putzel asked critics to try to invent a name for what he called this "new metamorphism" in

American art. According to Putzel, it was related to totemic, early Mediterranean, and other archaic images (although not directly based on any of these), and its forerunners were Arp, Miró, and Picasso, to a degree. In these masters:

> the new "ism" finds its most effective support among American painters. The closeness of . . . resemblance to pre-Columbian expressions indigenous to this hemisphere is an incidental factor. What counts is that painters, however respectful, are unimpressed with any idea of becoming "another Picasso" or "another Miró," and that their works indicate genuine talent, enthusiasm and originality. I believe we see real American painting beginning now.[13]

New York critics responded to Putzel's request for comments on his show, although none came up with a new stylistic term. Most were unsympathetic but recognized, as Coates wrote, that a

> new school of painting is developing in this country. It is small as yet, no bigger than a baby's fist, but it is noticeable if you get around to the galleries much. It partakes a little of Surrealism and still more of Expressionism, and although its main current is still muddy and its direction obscure, one can make out bits of Hans Arp and Joan Miró floating in it, together with large chunks of Picasso and occasional fragments of such more recondite influences as the ancient Byzantine painters and mosaicists and the African Negro sculptors. It is more emotional than logical in expression, and you may not like it (I don't either, entirely), but it can't escape attention.[14]

The most serious appraisal of Putzel's show was by Clement Greenberg in *The Nation*. He recognized the importance of the new tendency and the promise of some of the artists: "One or two . . . have accepted just enough of surrealist cross-fertilization to free themselves from the strangling personal influence of the Cubist and post-Cubist masters. Yet, they have not abandoned the direction these masters charted. . . . They advance their art by painterly means without relaxing the concentration and high impassiveness of true modern style."[15] However, Greenberg disagreed with Putzel's assertion that the forerunners of the "new metamorphism" were Arp and Miró. These artists, "despite their desire to restore 'poetry' to modern painting, continue the flattening-out, abstracting, 'purifying' process of cubism. And their influence, moreover, was strong in abstract painting long before the new turn came. No, that owes its impulse to surrealist 'biomorphism' . . . [which] restoring the third dimension, gave the elements of abstract painting the look of organic substances."[16] Putzel countered in a supplementary statement, published in *The New York Times*. He wrote that Arp

> used a kind of automatism: a deliberate start from a formless field of emotion or "inspiration," which he worked toward, but not into, direct resemblance to recognizably familiar things. It seems to me that Arp is a forerunner of, for example, Adolph Gottlieb, Hans Hofmann, Jackson Pollock and Mark Rothko, who also work away from direct resemblances. The new direction offers the possibility of considerable variety and also extension, and that constitutes a part of its inherent strength.[17]

Greenberg was sympathetic to Putzel's show but with strong reservations. Above all, he questioned the emergence of illusionism, of "images, no longer locked to the surface in flat profile."[18] Greenberg's ambivalence issued from

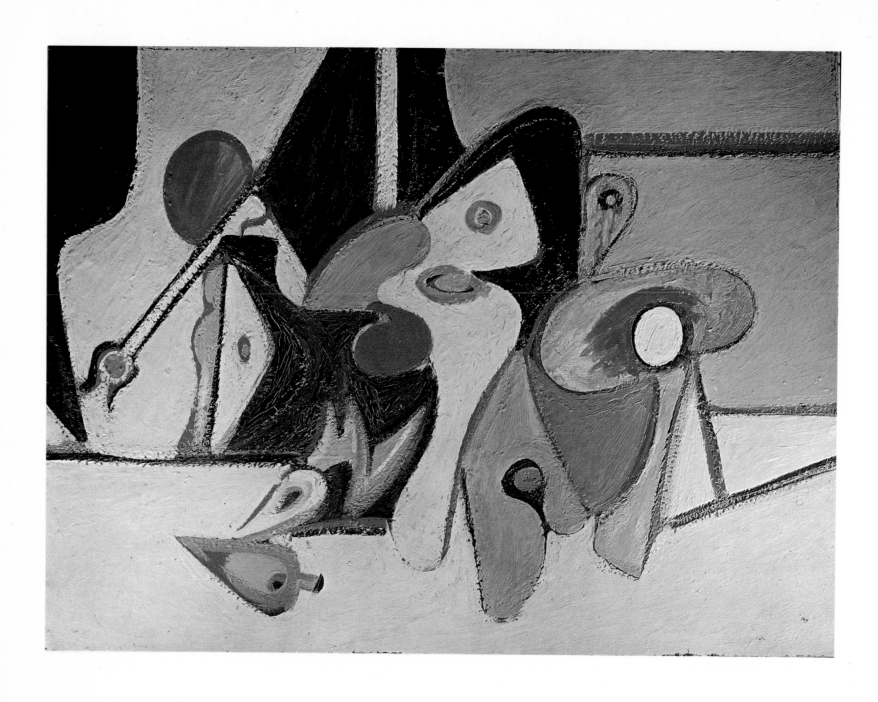

I Arshile Gorky. *Composition*. 1932–33.
Collection Mr. and Mrs. I. Donald Grossman, New York.

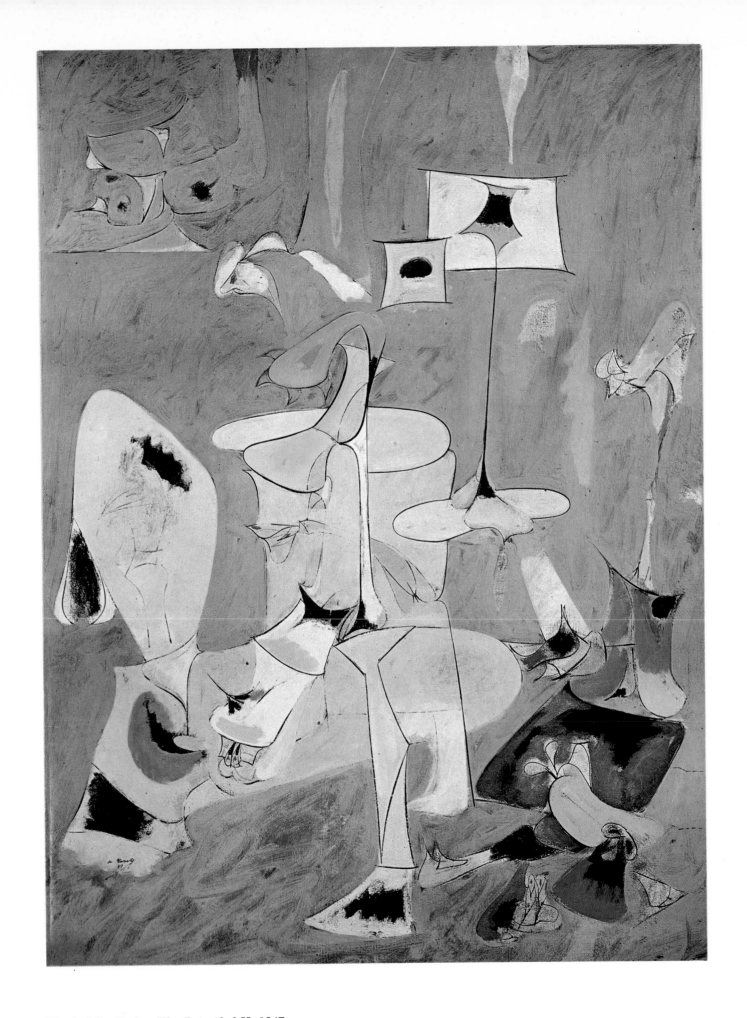

II Arshile Gorky. *The Betrothal II*. 1947.
Collection Whitney Museum of American Art, New York.

his belief that there existed in each of the arts an urge to dissociate itself from the others—to tend toward purity. He asserted:

> Purity in art consists in the acceptance, willing acceptance, of the limitations of the medium of the specific art. . . . The purely plastic or abstract qualities of the work of art are the only ones that count. Emphasize the medium and its difficulties, and at once the purely plastic, the proper, values of visual art come to the fore. Overpower the medium to the point where all sense or resistance disappears, and the adventitious uses of art become important.[19]

Therefore, as Greenberg saw it, "The history of avant-garde painting is that of a progressive surrender to the resistance of its medium; which resistance consists chiefly in the flat picture plane's denial of efforts to 'hole through' it for realistic perspectival space. . . . Painting abandons chiaroscuro and shaded modeling. . . . Primary colors . . . replace tones and tonality." [20] Greenberg attributed deeper meaning to the nonillusionistic surface and asserted that "in a period in which illusions of every kind are being destroyed the illusionist methods of art must also be renounced. . . . Let painting confine itself to the disposition pure and simple of color and line, and not intrigue us by associations with things we can experience more authentically elsewhere." [21] Greenberg did not mean that reductionist abstraction need lack inner drama or rhythm, for if it did, it degenerated into decoration: "It is the task of the abstract artist to satisfy this requirement with the limited means at his disposal. He cannot resort to the means of the past, for they have been made stale by overuse, and to take them up again would be to rob his art of its originality and real excitement." [22] Greenberg exhorted artists to rid art of expendable conventions, of borrowings from other arts, in order to arrive at progressively purer stages, each of which was avant-garde in its time. He considered this process, which he called self-criticism, inexorable and controlled by a kind of art historical determinism.[23]

During the 1940's, Greenberg favored a Cubist aesthetic. He called for an impassive abstract art, "governed by the structural or formal or 'physical' preoccupations that are supposed to exhaust the intentions of cubism and its inheritors." [24] His point of view was influenced by that of the American Abstract Artists, and at first he naturally found in their works its fullest embodiment. In 1942, he acclaimed the AAA's sixth annual exhibition, because it "could tell us most about the probable future of abstract art in this country." [25] Given his predilection for Cubist abstraction, Greenberg was hostile to Surrealism. As late as 1945, he wrote of Gorky's shift from the influence of Picasso and Miró to that of Kandinsky and Matta:

> This new turn does not of itself make Gorky's painting necessarily better or worse. But coming at this moment in the development of painting, it does make his work less serious and less powerful. . . . For the problems involved in Kandinsky's earlier abstract paintings were solved by Kandinsky himself, while the problems of "biomorphism" were never really problems of modern painting, having been dealt with before impressionism and consigned since Odilon Redon to the academic basement. What this means is that Gorky has at last taken the easy way out.[26]

Although Greenberg was certain about the direction art should take, he grew increasingly bored with the Cubist-inspired painting he saw. At first, he tried to apologize for it: "While the American abstract movement has been no less

chained to its origins abroad than the rest of our art, and has produced its own share of pallid, imitative work, abstractionists are as a group more conscious of their shortcomings in this respect and less comfortable about them." [27] In time, he became increasingly critical, claiming that Cubist abstraction had become arid.[28] Reluctantly, Greenberg began to re-evaluate Abstract Surrealism, despite its "swing back towards 'poetry' and 'imagination,' the signs of which are a return to elements of representation, smudged contour lines and the third dimension," and to think of it as a positive force. By 1944, he had overcome his doubts, even to the extent of endorsing automatism, writing that

> the reliance upon the unconscious and the accidental serves to lift inhibitions which prevent the artist from surrendering, as he needs to, to his medium. In such surrender lies one of the particular advantages of modern art. Surrealism, under this aspect and only under this, culminates the process which has in the last seventy years restored painting to itself and enabled the modern artist to rival the achievements of the past.[29]

The acceptance of painterly abstraction prompted Greenberg slowly and with changes of mind to turn against the American Abstract Artists. In 1945, he remarked: "The ninth annual exhibition of the American Abstract Artists . . . suffers from a lack . . . of strong personalities. . . . Some of the animation that comes with surrealism is needed." [30] The following year, he reversed his opinion, declaring that the AAA annual

> asserts a higher level than any other group show of contemporary art that I have seen this year. . . . What most markedly characterizes the group as a whole is the effort to continue and develop the premises inherent in cubism, in the face of all the currents that have flowed so fast in the opposite direction these past ten years or so. In some instances the fidelity to cubism goes so far as to render an artist's work nothing more than a series of pastiches. . . . In other instances cubism is a constricting influence that rationalizes the artist's failure to exert his temperament and search his emotions—which is to misabuse cubism, for it was originally and above all a vehicle of emotion.

In this last statement, Greenberg began to change the emphasis in his conception of the uses of Cubism. Instead of being a style to develop, Cubism is considered "a creative discipline, a force infusing style into the works of those —and especially those—who seek expression primarily. It is a means, not of inhibiting emotion, but of controlling and so exploiting it." [31] In 1947, Greenberg finally repudiated the AAA once and for all. Of its annual that year, he wrote: "Here the hand of the past descends more heavily because none of the thirty-seven artists represented can quite boast a temperament. . . . nowhere does [vitality] break through the canonical modes of the School of Paris to assert a new independent personality—or an idea." [32]

Greenberg worried about the AAA for a half-dozen years after it had ceased to be a force in the evolution of vanguard art, because he yearned for an impassive, rational art. In 1947, he wrote: "The art of no country can live and perpetuate itself exclusively on spasmodic feeling, high spirits and the infinite subdivision of sensibility." He called for "the development of a bland, large, balanced, Apollonian art. . . . The task facing culture in America is to create a *milieu* that will produce such an art . . . and free us (at last!) from the obsession with extreme situations and states of mind. We have had

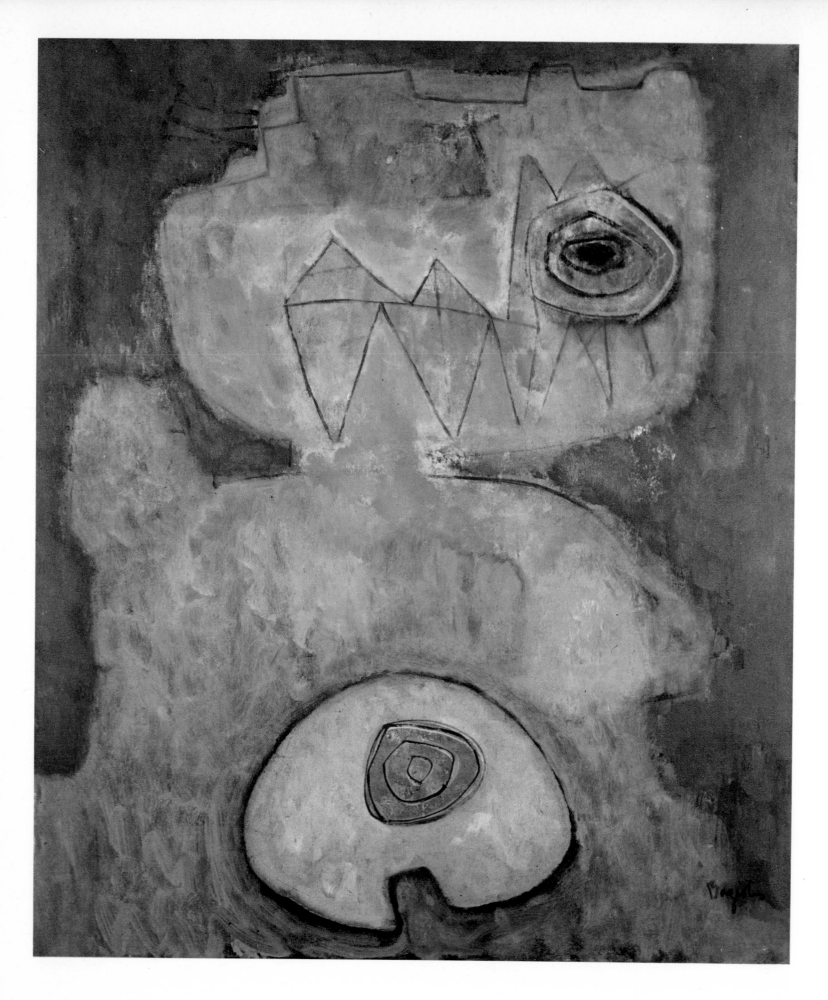

III William Baziotes. *Dwarf*. 1947.
Collection The Museum of Modern Art, New York;
A. Conger Goodyear Fund.

IV Jackson Pollock. *Pasiphae*. 1943.
Collection Mrs. Lee Krasner Pollock, New York.

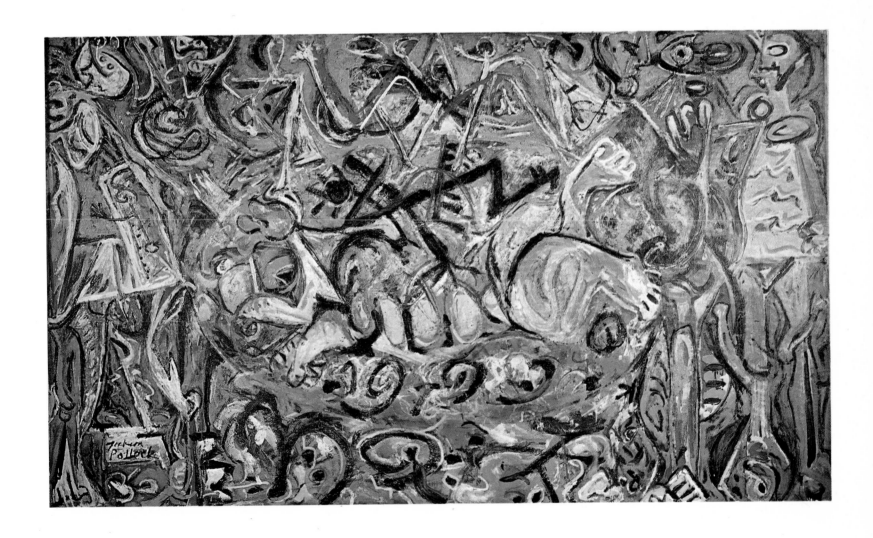

enough of the wild artist—he has by now been converted into one of the standard self-protective myths of our society: if art is wild it must be irrelevant." [33] This attitude prompted Greenberg to be ambivalent at times even about Pollock, maintaining that the painter's "gothicness," "stridency," and "paranoia" "narrowed" his art.[34]

Nevertheless, Greenberg was among the first to champion the Abstract Expressionists. This he did primarily on the basis of his taste, even though his conception of art was antithetical to theirs. At a time when they were preoccupied with romantic "subject matter," he adopted a classical formalist approach that they considered of little pertinence to their intention. The conflict in points of view is clear in Greenberg's review of Gottlieb's 1947 show:

> Gottlieb is perhaps the leading exponent of a new indigenous school of symbolism which includes among others Mark Rothko, Clyfford Still and Barnett Benedict Newman. The "symbols" Gottlieb puts into his canvases have no explicit meaning but derive, supposedly, from the artist's unconscious and speak to the same faculty in the spectator, calling up, presumably, racial memories, archetypes, archaic but constant responses. Hence the archaeological flavor, which in Gottlieb's painting seems to come from North American Indian art and affects design and color as much as content. I myself would question the importance this school attributes to the symbolical or "metaphysical" content of its art; there is something half-baked and revivalist, in a familiar American way, about it.

Yet Greenberg did not allow his aesthetics to cloud his eye. He concluded that "as long as this symbolism serves to stimulate ambitious and serious painting, differences of ideology may be left aside for the time being. The test is in the art, not in the program." [35]

6 Notes

1. James Johnson Sweeney, in Introduction to catalogue of an exhibition, "Jackson Pollock," Art of This Century Gallery, New York, November 9–27, 1943, n.p.

2. Clement Greenberg, "Art," *The Nation*, CLVII, No. 22 (November 27, 1943), 621.

3. Clement Greenberg, "Art," *The Nation*, CLX, No. 14 (April 7, 1945), 397.

4. Clement Greenberg, "Art," *The Nation*, CLIX, No. 20 (November 11, 1944), 599, and "Art," *The Nation*, CLX, No. 16 (April 21, 1945), 469.

5. Robert Motherwell, "Painter's Objects," *Partisan Review*, XI, No. 1 (Winter, 1944), 97.

6. Sidney Janis, *Abstract and Surrealist Art in America* (New York: Reynal & Hitchcock, 1944), p. 2.

7. *Ibid.*, p. 89.

8. Introduction to catalogue of an exhibition, "Mark Rothko," Art of This Century Gallery, New York, January 9–February 4, 1945, n.p. Manny Farber, in "The Art of Contrast," *The New Republic*, CXI, No. 20 (November 13, 1944), 626, remarked that Motherwell is "preponderantly interested in abstraction and surrealism."

9. Janis, *Abstract and Surrealist Art in America*, p. 50.

10. Samuel M. Kootz, *New Frontiers in American Painting*, (New York: Hastings House, 1943), p. 60.

11. Robert M. Coates, "Assorted Moderns," *New Yorker*, XX, No. 45 (December 23, 1944), 51.

12. Prior to Putzel's show, David Porter, a friend of Guggenheim and Putzel, both of whom advised him, arranged a show entitled "A Painting Prophecy—1950" at the David Porter Gallery in Washington, D.C. (February, 1945). In the Foreword to the catalogue, Porter announced that the purpose of his exhibition was "to suggest the existence of an active group of artists in this country who . . . may be forming a . . . new kind of painting." As he saw it, the new art was "a unique blending of . . . Romantic and Abstract Painting. This union of a highly poetic and personal art with a kind of painting which has for so many years been expressed by inventions in pure line, form and color indicates that we may be experiencing a revolutionary synthesis in American Painting." Porter called for a new criticism "to properly evaluate and understand the ultimate significance of this Personal Symbolism." Taking his cue from the artists who were occupied with "subject matter," Porter also remarked: "Since the personal symbol is so much the private concern of the artist's imagination, it is likely that the road to comprehension lies more directly through analysis of the picture content rather than through study of its form."

13. Howard Putzel, "A Problem for Critics," statement accompanying an exhibition, printed in Edward Alden Jewell, "Toward Abstract or Away," *The New York Times*, July 1, 1945, sec. 2, p. 2.

14. Robert M. Coates, "The Art Galleries," *New Yorker*, XXI, No. 15 (May 26, 1945), 68. Edward Alden Jewell, "Toward Abstract or Away," did not think that a new "ism" had developed. He did allow that "Much recent abstraction is markedly expressionist in character. This type is encountered again and again. To it belongs work by Jackson Pollock . . . Mr. Putzel's 'problem for critics' has stimulated considerable controversy and may well occasion more."

15. Clement Greenberg, "Art," *The Nation*, CLX, No. 23 (June 9, 1945), 657.

16. *Ibid*., pp. 657, 659.

17. Putzel, "A Problem for Critics," (press release).

18. Clement Greenberg, "Art," *The Nation*, CLX, No. 23 (June 9, 1945), 657.

19. Clement Greenberg, "Towards a Newer Laocoon," *Partisan Review*, VII, No. 4 (July–August, 1940), 305. In this, his first major article on art, Greenberg asserted that in each of the arts there existed an urge to disassociate itself from the others —to become *pure*. Purism was "the terminus of a salutory reaction against the mistakes of painting and sculpture in the past several centuries" (p. 296). The primary "mistake" was the emphasis on literary subject matter, which led to a denial of medium. Greenberg took his cues from Wölfflin, Roger Fry, Clive Bell, the geometric abstractionists, and, perhaps, from Hofmann, who had written in *Fortnightly*, Sept. 11, 1931: "The difference between the arts arises because of the difference in the nature of the mediums of expression. . . . Each means of expression has its own order of being. . . . The key to understanding lies in the appreciation of the limitations, qualities and possibilities [of each]" (reprinted in Hofmann, *Search for the Real*, Cambridge, Mass., 1967, p. 57).

20. *Ibid*., p. 307.

21. Clement Greenberg, "Abstract Art," *The Nation*, CLVIII, No. 16 (April 15, 1944), 451.

22. Clement Greenberg, "Art," *The Nation*, CLII, No. 16 (April 19, 1941), 482.

23. Fairfield Porter, in a letter to *Partisan Review*, VIII, No. 1 (January–February, 1941), 77, attacked the determinism in the thinking of Greenberg at the very beginning of his career. "Your [*Partisan Review*'s] art criticism is sectarian and academic. . . . [Greenberg] seems to say in 'Towards a Newer Laocoon' that History justifies the latest fashion. He confuses the arts of painting and history. . . . Perhaps the unifying attitude of the magazine is that everything exists for History's sake."

24. Clement Greenberg, "Art," *The Nation*, CLX, No. 23 (June 9, 1945), 657.

25. Clement Greenberg, "Art," *The Nation*, CLIV, No. 18 (May 2, 1942), 526.

26. Clement Greenberg, "Art," *The Nation*, CLX, No. 12 (March 24, 1945), 343.

27. Clement Greenberg, "Art," *The Nation*, CLIV, No. 18 (May 2, 1942), 526.

28. Clement Greenberg, "Art," *The Nation*, CLX, No. 23 (June 9, 1945), 657.

29. Clement Greenberg, "Surrealist Painting," *The Nation*, CLIX, No. 7 (August 12, 1944), 193.

30. Clement Greenberg, "Art," *The Nation*, CLX, No. 14 (April 7, 1945), 397.

31. Clement Greenberg, "Art," *The Nation*, CLXII, No. 15 (April 13, 1946), 444.

32. Clement Greenberg, "Art," *The Nation*, CLXIV, No. 18 (May 3, 1947), 525.

33. Clement Greenberg, "The Present Prospects of American Painting," *Horizon*, No. 93–94 (October, 1947), 27–28.

34. *Ibid*., p. 26.

35. Clement Greenberg, "Art," *The Nation*, CLXV, No. 23 (December 6, 1947), 630.

V Jackson Pollock. *One (Number 31, 1950)*. 1950.
Collection The Museum of Modern Art, New York;
Gift of Sidney Janis.

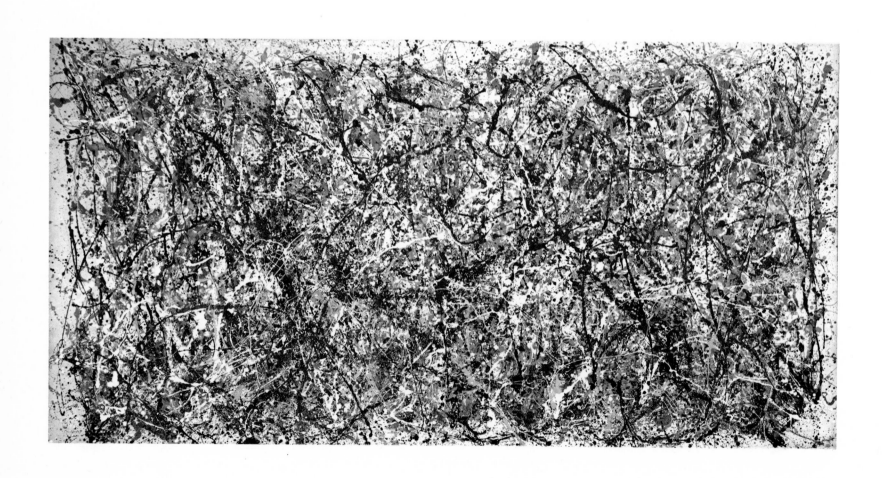

VI Willem de Kooning. *Pink Angel.* c. 1947.
Collection Mr. and Mrs. Frederick R. Weisman, Beverly Hills, California.

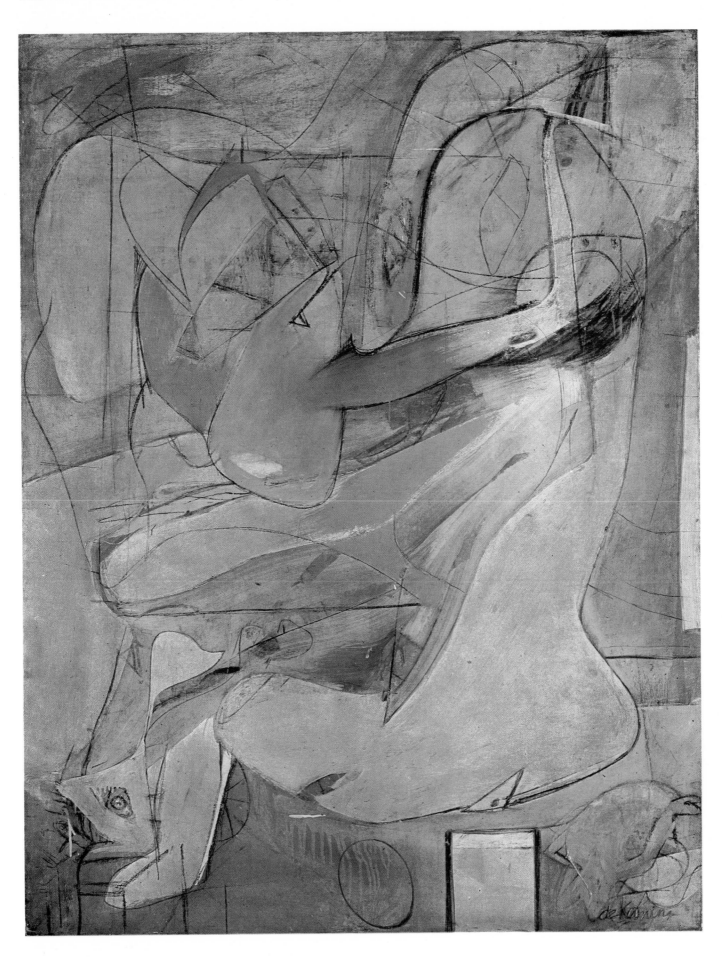

7 The Gesture Painters

IT was to be expected that Putzel and Greenberg should have sensed any changes in vanguard trends, since both men followed them closely and with sympathy. But when such popular critics as Jewell and Coates (who were not really attuned to contemporary developments) wrote about them seriously, it can be surmised that the art-conscious public began to express a curiosity about the new art. By 1945—much earlier than is generally supposed—a considerable number of people, certainly the readers of the art columns in *The New York Times* and the *New Yorker*, were aware of the new directions in American art.

However, it was not until after 1947 that the Abstract Expressionists began to arrive at independent, mature styles that could no longer be subsumed under existing categories. They addressed themselves to a difficult formal problem: If they eliminated representation and refused to design clearly articulated structures in the Cubist manner, how were they to avoid formlessness and create coherent paintings? Such artists as Pollock, De Kooning, and Hofmann, who were disposed to automatism and Expressionism, evolved one answer. Each in his own way would build an open field of free gestures, every detail of which would be painted with equal intensity. In 1948, Greenberg sensed that the challenge had become to order an expressive field without distinct shapes, "now that the closed-form canon—the canon of the profiled, circumscribed shape—as established by Matisse, Picasso, Mondrian, and Miró seems less and less able to incorporate contemporary feeling. This canon has not been broken with altogether, but it would seem that the possibility of originality and greatness for the generation of artists now under fifty depends on such a break." [1]

A picture composed of open, interpenetrating shapes tends to form an over-all field, or a total "mass image," as George McNeil called it, since "no single object or shape stands out from the total energy impact." [2] In contrast to the Synthetic Cubist image, whose distinct planes seem deliberately pieced together, balanced and contained within the picture limits, the mass image, composed of open and mobile painterly marks, appears to be impulsive and dynamic, and to expand beyond the framing edges.

The New York artists striving in this direction—it may be called gesture painting to differentiate it from other tendencies in Abstract Expressionism—believed that their painting had contemporary significance beyond its physical attributes. Their discussions about art centered on what was expressed—on connections with their experience—rather than on formal matters. De Kooning declared:

> Painting isn't just the visual thing that reaches your retina—it's what is behind it and in it. I'm not interested in "abstracting" or taking things out or reducing painting to design, form, line and color. I paint this way because I can keep putting more and more things in it—drama, anger, pain, love, a figure, a horse, my ideas about space. Through your eyes it again becomes an emotion or an idea. It doesn't matter if it's different from mine as long as it comes from the painting which has its own integrity and intensity. [3]

De Kooning here reversed Maurice Denis' famous dictum: "Remember that a picture—before being a battle horse or nude woman, or some anecdote—is essentially a flat surface covered with colors in a certain order." De Kooning did not deny the art-for-art's sake attitude implied in Denis' statement, but it was not as important to him as the meaning inherent in painting.

Motherwell also stressed the primacy of content, which for him was the expression of "reality as felt." In 1945, he wrote about his *Auto-Portrait*:

> Its feeling content happens to be just how I feel to myself . . . expressed as directly and cleanly and relevantly as I can communicate the concrete felt pattern of my senses. How I feel is not how I look; naturally then I have not represented my visage. This is the justification for the non-representational means employed in this work. Non-representation for its own sake is no more, though no less interesting than representation for itself. There simply happens to be certain problems of expression which representational means cannot solve.[4]

Motherwell considered the medium of painting all-important, for it brought feeling and thought into being. In 1944, he wrote that "since [Pollock's] painting is his thought's medium, the resolution must grow out of the process of his painting itself."[5] Hofmann's point of view was similar. In 1941, he insisted that every painting had to at once be plastic and psychologically motivated—a metaphor for the artist's temperament.[6]

The gesture painters refused to preconceive particular meanings, regarding the process of painting as an intense, unpremeditated search for the images of their creative experiences. They believed that if, during the direct process of painting, they followed the dictates of their passions, the content would finally emerge. Franz Kline remarked that "if you meant it enough when you did it, it will mean that much."[7] All painting involves this kind of direct seeking, but the gesture painters relied on it ("risked" was the word they often used) more than earlier artists, for whom it tended to be a secondary aim—subservient to didactic, formal, or other considerations. In their desire for total involvement with the act of painting, the gesture painters spurned conceptual designing, and for that reason turned against Cubism, whose primary goal they believed to be picture-making. This prompted them to favor the painterly gesture that appears to be lacking in artifice. The gesture painters also valued directness because it led to a sense of immediacy: their mass images, painted on an increasingly larger scale, produce a forceful impact on the viewer.

In 1947, the year he executed his first gestural "drip" paintings, Pollock wrote of the importance of directness to him, commenting that he preferred to work on the floor, to "feel nearer, more a part of the painting, since this way I can walk around it, work from the four sides and literally be *in* the painting."[8] He went on to say that he tried to work without preconceptions, to be as free as he could.

Pollock's point of view was shared by other contemporaries. In 1947, Motherwell wrote: "I begin a painting with a series of mistakes. The painting comes out of the correction of mistakes by feeling. . . . Ultimate unifications come about through modulation of the surface by innumerable trials and errors. The final picture is the process arrested at the moment when what I was looking for flashes into view."[9] Baziotes' thinking in that year was close to Motherwell's:

> I cannot evolve any concrete theory about painting. What happens on the canvas is unpredictable and surprising to me. . . . There is no particular system I follow when I begin a painting. Each painting has its own way of evolving. One may start with a few color areas on the canvas; another with a myriad of lines; and perhaps another with a profusion of colors. . . . As I work, or when the painting is finished, the subject reveals itself.[10]

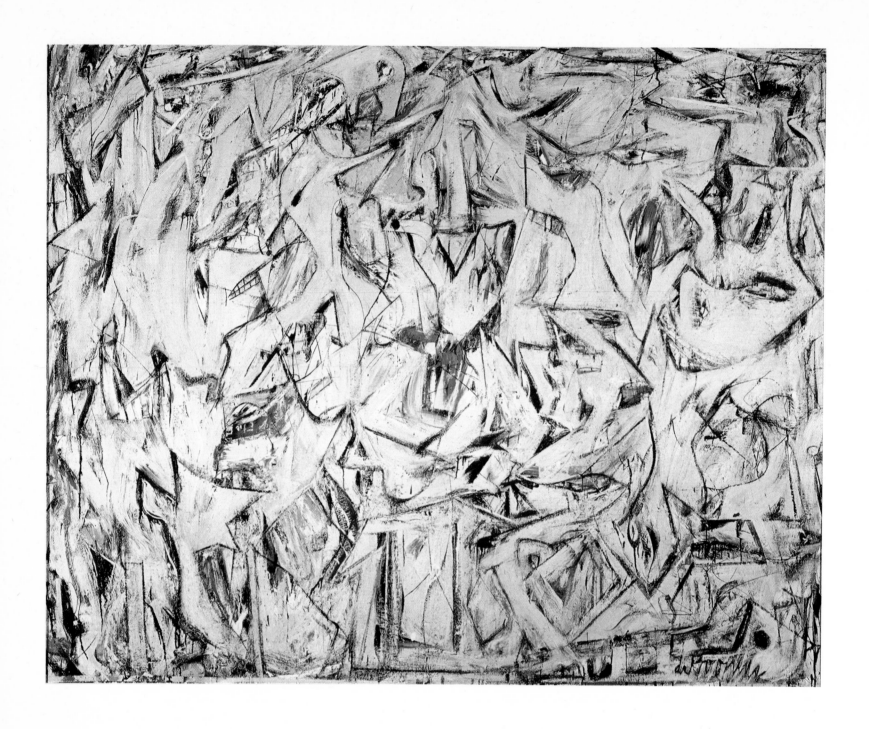

VII Willem de Kooning. *Excavation*. 1950.
Courtesy of The Art Institute of Chicago, Chicago, Illinois;
Gift of Edgar Kaufmann, Jr.

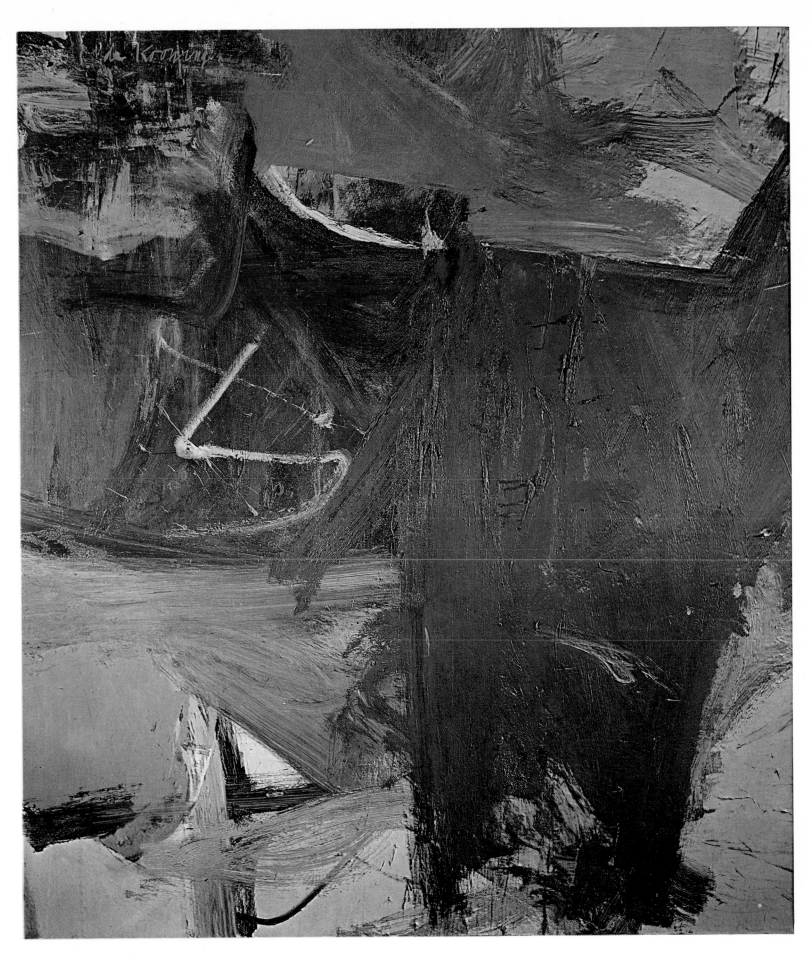

VIII Willem de Kooning. *Parc Rosenberg.* 1957.
Collection Mr. and Mrs. I. Donald Grossman, New York.

95

A similar view was advanced in the introductory statement of the magazine *Possibilities 1*. Its editors, Motherwell and Harold Rosenberg, wrote:

> This is a magazine of artists and writers who "practice" in their work their own experience without seeking to transcend it in academic, group or political formulas. Such practice implies the belief that through conversion of energy something valid may come out, whatever situation one is forced to begin with. The question of what will emerge is left open. One functions in an attitude of expectancy. As Juan Gris said: "you are lost the instant you know what the result will be." [11]

Motherwell summed up these ideas at the end of 1950:

> The process of painting then is conceived of as an adventure, without preconceived ideas on the part of persons of intelligence, sensibility and passion. Fidelity to what occurs between oneself and the canvas, no matter how unexpected, becomes central. . . .The major decisions in the process of painting are on the grounds of truth, not taste. . . . no artist ends up with the style he expected to have when he began . . . it is only by giving oneself up completely to the painting medium that one finds oneself and one's own style.[12]

Much as he valued the role of the unconscious in painting, Motherwell's emphasis was on decision-making, on consciously shaping forms. Similarly, Rosenberg maintained that gesture painting (which he termed action painting) had "extracted the element of decision inherent in all art," and had elevated it to a primary principle.[13] To him, the creator's decision-making was a "moral" activity, although it was detached from moral or aesthetic certainties.

The emphasis placed on decision-making by the gesture painters diverged sharply from that of the Surrealist automatists, who called for abandoning themselves to chance, even though they did not do so wholly in practice. Both groups believed that by painting spontaneously they could tap what William James had called "invasive experiences"—the upsurge of subliminal energies into the conscious mind.[14] Therefore, acts of will that might dam the flow of imagination would have to be suspended.[15] Nevertheless, the gesture painters rejected the Surrealist notion that the unconscious was a reservoir of images possessed of the profoundest truths about man, and that when such images were revealed—and they could only be disclosed accidentally—they divulged meaning automatically and infallibly. The gesture painters refused to accept free-associational images without first submitting them to the process of willed action, which implied a struggle to choose. They attempted to make compulsive choices; suspension of will was helpful in order to gain access to primary sources of energy that might otherwise be blocked, but chance effects did not ultimately count for much, for the artist himself chose to accept, reject, or modify them. Even Pollock, whose "drip" paintings looked far more spontaneous than any Surrealist works, insisted on this element of choice: "it seems to be possible to control the flow of the paint, to a great extent . . . I don't use the accident—'cause I deny the accident." [16]

George McNeil summarized the attitude toward spontaneity held by such gesture painters as De Kooning, Hofmann, Brooks, Kline, and Guston:

> When the hacking begins to slow and finally stop, when conscious building of color masses or extensions of movement, in short, known and sophisticated approaches, ceases to force the painting on, I react

by spontaneously striking lines or colors into the dead structure to enliven or resuscitate it. Here intuition works exclusively to shake up or dislocate known relations into an unknown which facilitates further re-working. Spontaneous cutting-through or cutting-into negates or should negate consciously processed relating, and helps counter the designing which enfeebles abstract painting. Thus conscious, continued ordering towards expressiveness alternates with spontaneous, subliminal "destructions" which, enigmatically, are the most constructive steps in painting.[17]

The gesture painters on the whole believed that when painting is deeply felt by the artist, its felt quality is communicable and can be experienced by the sensitive viewer as "real" or "moral"—and as aesthetically valid, for a fully felt shape or color was deemed formally correct. Therefore, the primary content of gesture painting was thought to be the "confession" of the artist's particular creative experiences—the embodiment of his unique artistic temperament.

At the core of an artist's creative actions is a unifying quality—his personality. The gesture painters, however, did not consider it a fixed or static essence. Instead, they thought of personality as subject to constant modification by new and unpremeditated experiences. The gesture painter came to accept as authentic only his own passions, thoughts, anxieties, and sensual experiences. Rosenberg maintained that for artists committed to Marxism, psychoanalysis, or science, the truth was already in existence outside the artist's own experience, but that painting as "a way of experiencing . . . means getting along without the guidance of generalizations, which is the most difficult thing in the world." [18] Later, Rosenberg stressed this point more strongly, asserting that an artist who accepted this premise is "fatally aware that only what he constructs himself will ever be real to him." [19]

The gesture painters conceived of a picture as a step in a changing progression of experiences. Painting had to be continually renewed, for if an artist lapsed into habit, decided on a style and exploited it, he would lose contact with his mutable being. Hence, to stop searching at any point—to make a manner of style—was deemed a failure of nerve. Indeed, the unfixed and unfinished quality of the shapes that the gesture painters favored seemed to symbolize the free personality in perpetual metamorphosis, in a state of becoming. This point was elaborated by Meyer Schapiro:

> The consciousness of the personal and spontaneous . . . stimulates the artist to invent devices of handling, processing, surfacing, which confer to the utmost degree the aspect of the freely made. Hence the importance of the mark, the stroke, the brush, the drip, the quality of the substance of the paint itself, and the surface of the canvas as a texture and field of operation—all signs of the artist's active presence. . . . The impulse . . . becomes tangible and definite on the surface of a canvas through the painted mark. We see, as it were, the track of emotion, its obstruction, persistence or extinction.[20]

But the spontaneous is not all, for, as Schapiro continued:

> these elements of impulse which seem at first so aimless on the canvas are built up into a whole . . . The artist today creates an order out of unordered variable elements to a greater degree than the artist of the past . . . The order is created before your eyes and its law is nowhere explicit. . . . This power of the artist's hand to deliver constantly elements of so-called chance or accident, which nevertheless belong to

a well-defined personal class of forms and groupings, is submitted to critical control by the artist who is alert to the rightness or wrongness of the elements delivered spontaneously, and accepts or rejects them.[21]

The strongly Existentialist tenor of Schapiro's remarks reveals how profoundly French Existentialist thinking—introduced into America soon after World War II—had replaced Freudian and Jungian dogmas as an intellectual frame of reference. To be sure, the Abstract Expressionists were not philosophers and they did not illustrate philosophical ideas in their painting. Yet they could not help being affected by the intellectual climate of the time. As De Kooning said: "We weren't influenced directly by Existentialism, but it was in the air, and we felt it without knowing too much about it. We were in touch with the mood." [22]

Because of its emphasis on choice, the gesture painters found the Existentialist conception of freedom more to their liking than Surrealist automatism, which seemed too permissive to them. Nor would they accept the notion that the unconscious was a fixed realm containing pre-existing (if illusive) images, and that it was the function of the artist to reveal and illustrate them. Existentialism was attractive because it denied the idea that man has a definable nature, and because it emphasized his central role in determining his own existence. Hence, the existential-minded artist in his art as in life avoided subjecting himself to fixed and habitual patterns, standards, or ideas. To partake authentically in the human adventure, he had to live in a mood of expectancy, to remain open to change.

Furthermore, Existentialism focused on "alienation and estrangement; a sense of the basic fragility and contingency of human life; the impotence of reason confronted with the depths of existence; the threat of Nothingness, and the solitary and unsheltered condition of the individual before this threat." [23] But it must also be remembered that a man, no matter how vulnerable and anxious, who *makes himself* is something of a hero, even if a pathetic one. It was this duel awareness that shaped the sensibility of the gesture painters.

The abstract forms developed by the gesture painters were unprecedented in their extremeness, although they did acknowledge antecedents in Expressionism. Kandinsky's early improvisations were of special interest—an interest stimulated by a retrospective of more than 200 works at the Museum of Non-Objective Painting in 1945, and by the publication of his book *Concerning the Spiritual in Art* in the mid-1940's.[24] Kandinsky's mysticism did not strike a sympathetic chord, but his demand that art be based on "inner necessity" did: "The artist is not only justified in using, but is under a moral obligation to use, only those forms which fulfill *his own need*," even if such forms are abstract.[25] In a sense, Kandinsky can be considered the first Abstract Expressionist, but he stopped painting his impulsive improvisations around 1920, leaving it to the American gesture painters to develop this tendency further.

The Abstract Expressionists respected Kandinsky as a theoretician more than as a painter. They were not favorably disposed to the deep, illusionistic space in his improvisations or to what they felt to be his lack of painterly sensibility. Indeed, such artists as De Kooning and Jack Tworkov responded with far greater fervor to the Expressionism of Chaim Soutine. In the late 1940's, there was an upsurge of interest in the latter's painting, which manifested itself in a large exhibit of his works at the Mueum of Modern Art in 1950. In an article written at the time of the show, Tworkov examined Soutine's contribution from the vantage point of gesture painting and re-evaluated his relevance to current American painting (*Fig. 7-1*). His

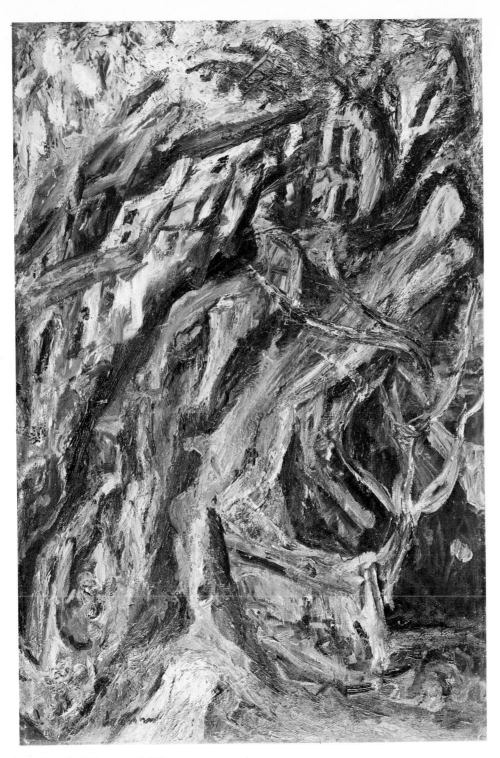

7–1 Chaim Soutine. *Gnarled Trees.* c. 1921.
Collection Mr. and Mrs. Ralph F. Colin, New York.

passion is not for the picture as a thing, but for the creative process itself. It negates professionalism. Soutine's painting contains the fiercest denial that the picture is an end in itself. . . . [It] is meant to have impact on the soul . . . The composition is not a plan, a previous arrangement. . . . It is rather the unpremeditated form the picture takes as a result of the struggle to express his motive. . . . This struggle on the part of the artist to capture the sequence of ephemeral experience is not only the heart of Soutine's method, but also expresses his tragic anxiety, his constant brooding over being and not-being, over bloom and decay, over life and death. . . . It requires the unity of instantaneous perceiving and doing. . . . It excludes touching up. . . . It is not a technique but a process. It is most unlike carpentry.[26]

99

Tworkov related Soutine's painting to contemporary gesture painting because of its

> impenetrability to logical analysis . . . that quality of surface which appears as if it had happened rather than as [being] "made" . . . [The attributes of Soutine's work] can be summarized as: the way his picture moves toward the edges in centrifugal waves filling it to the brim; his completely impulsive use of pigment as a material, generally thick, slow flowing, viscous, with a sensual attitude toward it, as if it were the primordial material, with deep and vibratory color; the absence of any effacing of the tracks bearing the imprint of the energy passing over the surface. The combined effect is of a full, packed, dense picture of enormous seriousness and grandeur, lacking all embellishment or any concession to decoration.[27]

Tworkov's assessment of Soutine's style could also be applied to most gesture painters. Indeed, it is the best summary of their aims.

7 Notes

1. Clement Greenberg, "Art," *The Nation*, CLXVI, No. 17 (April 24, 1948), 448.
2. George McNeil, "Spontaneity," *It Is*, No. 3 (Winter-Spring, 1959), 15.
3. Willem de Kooning, *The New York Times*, January 21, 1951, sec. 6, p. 17. De Kooning, "What Abstract Art Means to Me," *Museum of Modern Art Bulletin*, XVIII, No. 3 (Spring, 1951), 5–6. De Kooning was contemptuous of purist aesthetics for its rejection of subject matter. He asserted that throughout its history "Art meant everything that was in it—not what you could take out of it. There was only one thing you could take out of it sometime when you were in the right mood—that abstract and indefinable sensation, the esthetic part—and still leave it where it was. For the painter to come to the 'abstract' or the 'nothing,' he needed many things. Those things were always in life . . . But all of a sudden, in that famous turn of the century, a few people thought they could . . . invent an esthetic beforehand. . . . The question as they saw it, was not so much what you *could* paint but rather what you could *not* paint. . . . It was then that subject matter came into existence as something you ought *not* to have. . . . The 'nothing' part in a painting . . . they generalized, with their book-keeping minds, into circles and squares. They had the innocent idea that the 'something' existed 'in spite of' and not 'because of' and that this something was the only thing that truly mattered. They had hold of it, they thought, once and for all. . . . That 'something' which was not measurable, they lost trying to make it measurable."
4. Robert Motherwell, "Personal Statement," in cata-

logue of an exhibition, "A Painting Prophecy—1950," David Porter Gallery, Washington, D.C., February, 1945, n.p.

5. Robert Motherwell, "Painter's Objects," *Partisan Review*, XI, No. 1 (Winter, 1944), 97.

6. Hans Hofmann, in address to the American Abstract Artists, February 16, 1941, at a symposium on abstract art held at the Riverside Museum in conjunction with the annual exhibition of the AAA.

7. Frank O'Hara, "Franz Kline Talking," *Evergreen Review*, II, No. 6 (Autumn, 1958), 63.

8. Jackson Pollock, "My Painting," *Possibilities 1*, No. 1 (Winter, 1947–48), 79. Whether Pollock worked in an extremely spontaneous manner is unknowable, despite his statement and corroborating eyewitness reports, for the process of creation cannot be imagined by another person and used to elucidate or evaluate pictures. However, it is clear that Pollock's "drip" pictures *look* as if they were executed in the way he said they were. This look can be attributed to a conception of a kind of picture that Pollock desired, which would symbolize a kind of experience.

9. Robert Motherwell, in Introduction to the catalogue of his show at the Kootz Gallery, New York, April 28–May 17, 1947, n.p.

10. William Baziotes, "I Cannot Evolve Any Concrete Theory," *Possibilities 1*, No. 1 (Winter, 1947–48), 2.

11. Robert Motherwell and Harold Rosenberg, "Editorial Statement," *Possibilities 1*, No. 1 (Winter, 1947–48), 1.

12. Robert Motherwell, catalogue of an exhibition, "The School of New York," Perls Gallery, Beverly Hills, Calif., 1951, n.p.

13. Harold Rosenberg, "The American Action Painters," *Art News*, LI, No. 7, (December, 1952), in *The Tradition of the New* (New York: Horizon Press, 1959), pp. 33–34.

14. Edgar Wind, *Art and Anarchy*, (London: Faber & Faber, 1963), p. 98.

15. *Ibid.*

16. "An Interview With Jackson Pollock," taped by William Wright (Summer, 1950), in Frances V. O'Connor, *Jackson Pollock* (New York: Museum of Modern Art, 1967), p. 80.

17. George McNeil, "Spontaneity," *It Is*, No. 3 (Winter-Spring, 1959), 14.

18. Harold Rosenberg, in Introduction to Marcel Raymond, *From Baudelaire to Surrealism* (New York: Wittenborn, Schultz, 1949), n.p.

19. Harold Rosenberg, Introduction to the catalogue of a show of paintings by Baziotes, Romare Bearden, Byron Browne, Gottlieb, Holty, and Motherwell, entitled "Introduction to Six American Artists," at the Gallery Maeght in 1947, reprinted in *Possibilities 1*, No. 1 (Winter 1947–48), 75,

20. Meyer Schapiro, "The Liberating Quality of Avant-Garde Art," *Art News*, LVI, No. 4 (Summer, 1957), 38–40.

21. *Ibid.*

22. Willem de Kooning, conversation with the author, June 16, 1959. Clement Greenberg pointed to the interest of artists in Existentialism as early as 1946. In "Art," *Nation*, CLXIII, No. 2 (July 13, 1946), 54, he wrote: "What we have to do with here is an historical mood that has simply seized upon Existentialism to formulate and justify itself, but which has been gathering strength long before most of the people concerned had ever read Heidegger or Kierkegaard . . . Whatever the affectations and philosophical sketchiness of Existentialism, it is esthetically appropriate to our age . . . What we have to do with here, I repeat, is not so much a philosophy as a mood."

23. William Barrett, *Irrational Man*, (New York: Anchor Books; Doubleday, 1958), p. 31.

24. Wassily Kandinsky, *On the Spiritual in Art*, New York, 1946, was edited by Hilla Rebay and issued by the Solomon R. Guggenheim Foundation. Another edition, entitled *Concerning the Spiritual in Art* (New York: Wittenborn, Schultz, 1947), was edited by Robert Motherwell as one of the *Documents of Modern Art*.

25. Wassily Kandinsky, *Concerning the Spiritual in Art*, p. 74.

26. Jack Tworkov, "The Wandering Soutine," *Art News*, XLIX, No. 7, part 1 (November, 1950), 33, 62.

27. Tworkov, "The Wandering Soutine," p. 32. Tworkov admired Duchamp because he had painted pictures full to the brim, like Soutine. Duchamp's Dada attitude was also attractive, because of the leeway it gave artists and not because of its nihilism. There was not much sympathy for his anti-art stance.

8 Jackson Pollock
(1912–56)

AFTER 1947, Pollock placed canvases on the floor of his studio and moved around (and at times through) them, flinging, spotting, dribbling, and puddling pigment. He employed this gestural technique to paint as directly as he could, to bring more of himself, of his entire body rather than just his wrist and elbow, into contact with the canvas, to "literally be in the painting," as he said. Pollock's images appear to have been produced by the gyrations of his entire body—the instantaneous issue of the process. In a sense, they register his creative experience, both his "living" on canvas and his response to the evolving "life" of the picture. As he wrote:

> When I am *in* my painting, I'm not aware of what I'm doing. It is only after a sort of "get acquainted" period that I see what I have been about. I have no fears about making changes, destroying the image, etc., because the painting has a life of its own. I try to let it come through. It is only when I lose contact with the painting that the result is a mess. Otherwise there is pure harmony, an easy give and take, and the painting comes out well.[1]

Pollock's "drip" pictures are far different in conception from Gorky's Abstract Surrealist improvisations. Harold Rosenberg observed that for Gorky "gesture is never a sufficient starting point. His automatism is geared to creatures and scenes rather than to thrust, counter-movement and explosions of paint. . . . He observes the image that rises before him: he does not 'get into it'. . . . Psychologically, Gorky's . . . aim is the conversion of data through esthetic comprehension, rather than an organization of the artist's energy." [2]

Pollock's paintings are all-over patterns of linear details, more or less similar in kind and size. They are infused with surging energy, producing an immediate impact on the viewer, causing him to respond as an active participant rather than as a passive observer. This is particularly true of Pollock's wall-size pictures, which engage the viewer as all-encompassing environments.

The "drip" pictures shocked most people who saw them when they were first shown in 1948. Pollock's departure from traditional techniques did violence to conventional notions of what art was supposed to be; typical was one critic's characterization of Pollock as Jack the Dripper. However, a small number of artists and critics were stunned by the originality and dynamism of his painting. He was for them, as De Kooning said, the "ice-breaker," for he opened the way to a kind of painting that was more direct, improvisational, abstract, and larger in size than that of the Abstract Surrealists of the time or of such earlier pioneers of improvisation as Kandinsky. Pollock revitalized American abstraction, giving other artists the confidence to risk basing their own painting on the spontaneous gesture, knowing that it could yield a unified picture full of energy, drama, and passion.

Some writers on art, struck by the extreme, immediate and epic quality of the "drip" paintings and, perhaps in reaction against public hostility, conceived of Pollock as a heroic figure. They wrote of the work as a key to his biography and, with the artist's cooperation, wove stories about his life. Pollock was turned into a mythic American type—a kind of solitary, super-primitive, free of culture. Then they re-interpreted his painting according to the legends they wove about his life style. This has led to gross distortions, for Pollock was, in fact, an artist of sophistication and erudition, alive to most every tradition in Western art.

From the age of seventeen, Pollock was a familiar figure on the New York art scene. He studied initially (1930–32) with Thomas Hart Benton at the Art

Students League, then a center of aesthetic ferment. In 1935, he was employed by the WPA and came to know many artists on the Project. Toward the end of the 1930's, he befriended John Graham, who was the first to recognize his genius. In the early years of the following decade, Pollock was accepted into the Surrealist circle that formed around Peggy Guggenheim's Art of This Century Gallery, where he exhibited. He also became friendly with Putzel, Greenberg, and Hofmann. Even after moving to East Hampton in 1945, Pollock visited New York frequently, exhibiting yearly at the Art of This Century and Betty Parsons galleries (to 1951) and participating in the activities initiated by their members. He also maintained close contact with artist friends in New York, among them Tony Smith, Barnett Newman, James Brooks, Bradley Walker Tomlin, and Franz Kline.

At the start of his career, Benton introduced Pollock to Renaissance art. Disposed to painterly styles, he copied Rubens, the late Michelangelo, Rembrandt, and particularly El Greco.[3] These masters attracted Pollock because he saw his own temper reflected in their canvases: they often employed agitated, sweeping arabesques and strong value contrasts to shape tempestuous or mystical images. Indeed, gyrating rhythms had an obsessive appeal for Pollock; they were found in the pictures of most of the artists he was later influenced by: Ryder, Orozco, Siqueiros, Picasso, Miró, Masson, and Kandinsky. But, in response to an impetuous streak in his make-up, he used what he borrowed more violently and impulsively.

Of his student days, Pollock wrote: "My work with Benton was important as something against which to react very strongly, later on; in this, it was better to have worked with him than with a less resistant personality who would have provided a much less strong opposition."[4] But the Regionalist's influence was not entirely negligible; until 1938 (and probably later), Pollock painted Bentonesque pictures.[5] He was affected by his teacher's coarse, undulating contours and by his interest in myths, although he was largely indifferent to their transposition into folksy locales (Fig. 8-1). Cracker-barrel story-telling was too parochial to appeal to Pollock, whose bent was for the universal. At the same time, an inclination to the subjective disposed him to the art of Albert Pinkham Ryder, whom Pollock admired most in the early years of his career. Unlike Benton's contrived Americana anecdotes, Ryder's images issued from a brooding inner vision. Painted and repainted, his labored shapes took on more of an abstract and Expressionist character than those of any other nineteenth-century American romantic.[6]

During the 1930's, the motifs taken by Pollock from Benton, Ryder, and El Greco were submerged in convulsive and congested slashes of heavy pigment, resulting in works such as Seascape (Fig. 8-2). In these pictures, he employed dramatic chiaroscuro effects to create a dense, oppressive atmosphere. Even in this early period, Pollock's artistic personality began to emerge, as the directness and vehemence of execution anticipate his later "drip" pictures. His subjects at this time, such as abstract figures appearing to be engaged in some sacrificial rite, are often archetypal—the predecessors of his mythological themes of the 1940's.

Around 1938, Pollock turned from Benton to Orozco, Rivera, and Siqueiros, whose pictures he had known and admired earlier. He had watched Orozco and Rivera paint murals and had worked in 1936 in Siqueiros' New York workshop. Pollock's attraction to the Mexicans was a natural one, for their wall-paintings were far more epic and powerful than Benton's tame imitation of Renaissance conventions. He was also interested in some of their subjects—Indian

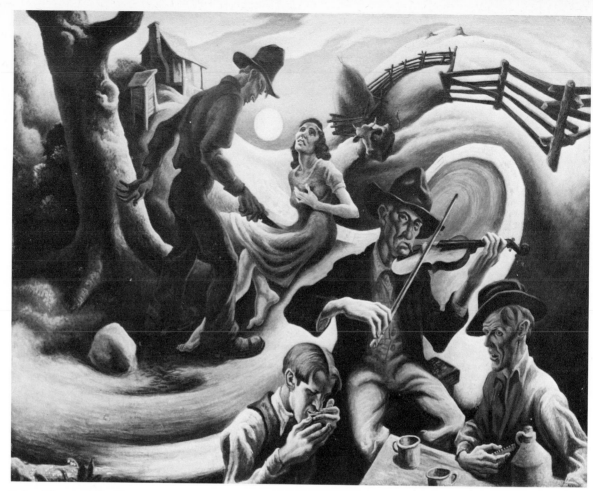

8–1 Thomas Hart Benton. *Ballad of the Jealous Lover of Lone Green Valley.* 1934.
University of Kansas Museum of Art, Lawrence, Kansas.

8–2 Jackson Pollock. *Seascape.*
 1934.
Collection Mrs. Lee Krasner Pollock,
New York.

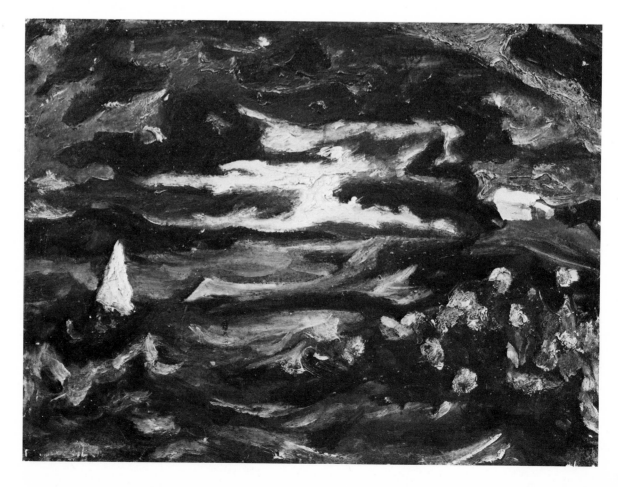

totemic and pictographic motifs—which were a source of his early scenes of ritual violence (*Fig. 8-3*). Pollock's amalgams of animal and human bones and anatomical parts were influenced by Orozco's murals at the New School for Social Research and Dartmouth College (*Fig. 1-4*), but whereas Orozco's intention was public—to familiarize the masses with their heritage and incite them to social revolution—Pollock's was private—to present mythic images culled from his inner world.

Pollock's interest in mythic content was probably stimulated by John Graham's article on "Primitive Art and Picasso," which appeared in the *Magazine of Art* in April, 1937.[7] Graham wrote of two basic traditions in art:

> The Greco-African culture is based on geometric design; it is centripetal and synthetic in principle . . . the Perso-Indo-Chinese culture . . . is based upon florid design; it is analytic and centrifugal in principle . . . In modern times we can trace the two different approaches in the work of various painters. The Perso-Indo-Chinese tradition has influenced the Impressionists; its florid design and its yellow and green color schemes are found in the paintings of van Gogh, Renoir, Kandinsky, Soutine, Chagal [sic]; the Greco-African is exemplified by Ingres, Picasso, Mondrian.[8]

There is some likelihood that Graham's essay influenced Pollock's choice of color and design, but this connection must not be overemphasized. Pollock's evolution as an artist was far too complex for any such simplistic speculation. Still, his outlook was surely affected by the following passage in Graham's article:

> Primitive races and primitive genius have readier access to their unconscious mind than so-called civilized people. It should be understood that the unconscious mind is the creative factor and the source and the storehouse of power and of all knowledge, past and future. . . . Most

8–3 Jackson Pollock. *Painting.* c. 1938.
Collection Mrs. Lee Krasner Pollock, New York.

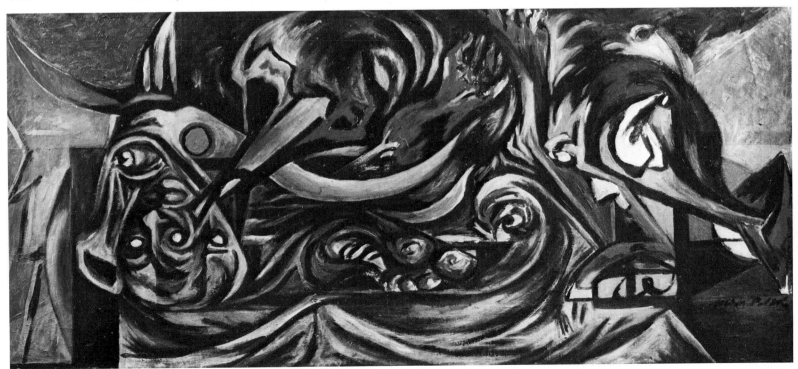

people lose access to their unconscious at about the age of seven. . . . This closure is sometimes temporarily relaxed by such expedients as danger or nervous strain, alcohol, insanity, and inspiration. Among primitive people, children, and geniuses this free access to the power of the unconscious still exists in a greater or lesser degree. . . . The Pre-Archaic Greeks with their painted warriors and maidens with duck-like heads, the Maori's green jade Tiki in the form of the human foetus, the Eskimo and North American Indian masks with features shifted around or multiplied, and the Tlingit, Kwakiutl, and Haida carvings in ivory and wood of human beings and animals, these all satisfied their particular totemism and exteriorized their prohibitions (taboos) in order to understand them better and consequently to deal with them successfully. Therefore the art of primitive races has a highly evocative quality which allows it to bring to our consciousness the clarities of the unconscious mind, stored with all the individual and collective wisdom of past generations and forms. In other words, an evocative art is the means and the result of getting in touch with the powers of our unconscious. It stimulates us to move and act along the intuitional line in our life procedure. Two formative factors apply to primitive art: first, the degree of freedom of access to one's unconscious mind in regard to observed phenomenon, and second, an understanding of the possibilities of the plain operating space. The first allows an imaginary journey into the primordial past for the purpose of bringing out some relevant information, the second permits a persistent and *spontaneous* exercise of design and composition as opposed to the *deliberate* which is valueless. These capacities allow the artist, in the first place, to operate . . . [with] the most elemental components of form. In this process . . . superfluous components . . . are dispensed with.[9]

In pictures executed from 1942 to 1947, Pollock repeatedly referred to the kind of primitive and mythic images described in Graham's article. He also relied increasingly on what Graham called "*automatic* 'ecriture'" ("free association based on memories of the racial past.")[10] In an interview of 1944, Pollock spoke of the significance to him of the Surrealists-in-exile: "I accept the fact that the important painting of the last hundred years was done in France. . . . the fact that good European moderns are now here is very important, for they bring with them an understanding of the problems of modern painting. I am particularly impressed with their concept of the source of art being the unconscious."[11] Some critics have taken this now-famous statement, one of the few by Pollock to have been recorded, to mean that the emigrés were responsible for introducing him to that idea. The Surrealists did affirm it, but Pollock's own thinking about the unconscious predated their arrival in America and diverged from theirs in its orientation to Jung rather than Freud (it was not by accident that Pollock chose a Jungian analyst when he entered psychotherapy in 1939). For Pollock, as for Graham, art was a means of scourging private demons—an attitude understood by his doctors, who used his drawings for therapeutic purposes.

During the late 1930's, Pollock was increasingly influenced by the School of Paris modernists, particularly Picasso. Graham's admiration of the Cubist master was probably one cause of Pollock's change in orientation. In his article of 1937, Graham wrote that "Picasso's painting has the same ease of access to the unconscious as have primitive artists plus a conscious intelligence."[12] Indeed, Picasso's subject matter engaged Pollock as much if not more than his Cubist design. The works of Picasso that interested Pollock most were the drawings for *Guernica* and those derived from Grünewald,

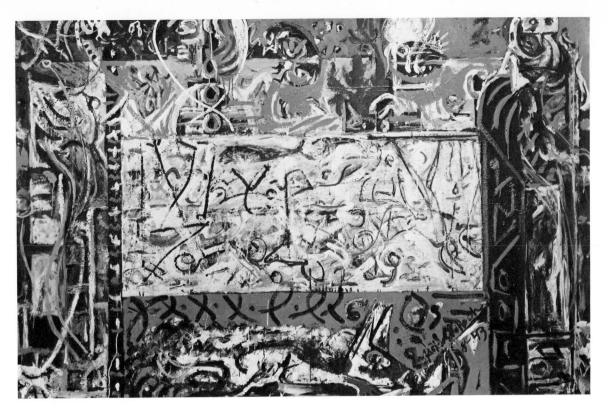

8-4 Jackson Pollock. *Guardians of the Secret.* 1943.
San Francisco Museum of Art, San Francisco, California;
Albert M. Bender Bequest.

which were published in *Minotaure,* a French Surrealist magazine. Pollock made hundreds of sketches that were free variations of Picasso's drawings but that had an even more turbulent and nightmarish quality, reminiscent in a way of American Indian masks and totems. Pollock's works were also more over-all and abstract than Picasso's, for he pulverized the latter's closed forms and scattered them over the surface in curvilinear rhythms.

Picasso was not the only Parisian painter to influence Pollock. He was familiar with Kandinsky's paintings at the Museum of Non-Objective Painting (where he worked as a custodian in 1943), and with Miró's ferocious females and Masson's fantasies of warring insects. Yet, unlike the Surrealists, who devised methods to sneak politely around the barriers of reason and inherited culture, Pollock stormed those barriers: not only did he search for a barbaric subject matter, but he employed the brush savagely, almost like a battering ram, reminding some critics of Expressionist handling. Pollock also sought to develop a fresh pictorial language, which was symbolized by the writing he introduced into some canvases in 1942. In *Stenographic Figure* and *Male and Female* (Fig. 4-3), both of that year, he mangled letters and numbers, interspersing them with shreds of anatomy to form new cryptic symbols. His aim at the time is suggested by the title of a canvas, *Search for a Symbol* (1943; *Fig. 2-6*). Pollock's graffiti have a source in Klee's and Miró's automatist symbols and signs, and in primitive hieroglyphics, but his are far more convulsive.

The violence of his painting led Pollock to an ambivalent attitude toward Cubism. On the one hand, he seemed intent on shattering its quasi-geometric design. Yet, during the early 1940's, he often employed it as a means of exerting control, as in *Guardians of the Secret* (1943; *Fig. 8-4*), which consists of two vertical rectangles framing a horizontal one. The underlying design in *Moon Woman Cuts the Circle* (1943; *Fig. 8-5*) is not geometric, but its planarity suggests a source in Cubism. Pollock's ambivalence toward Cubism probably motivated him to look to Masson, a pioneer automatist who also

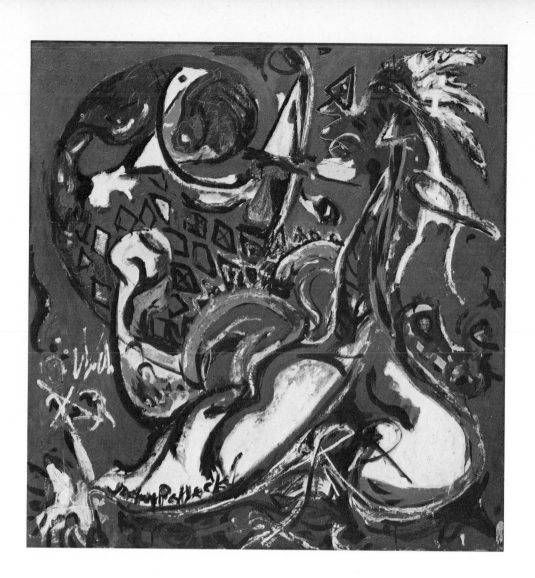

8–5 Jackson Pollock. *Moon Woman Cuts*
 the Circle. 1943.
Marlborough Gallery Inc., New York.

tried to retain certain elements of Cubist structure (*Fig. 2-3*). Pollock
was especially influenced by Masson's combination of Picasso-esque motifs
(particularly from the period of *Girl Before a Mirror*) with a palette suggestive
of American Indian art: his *Pasiphae* of 1943 (*IV*, p. 87) resembles Masson's
picture of the same name, completed shortly before. But the Masson is slow-
moving and refined, while the Pollock, orgiastic and crude, is devoid of the
precious artifices and urbane restraints associated with French *belle peinture*.[13]
 Pollock employed myths, some of them recounted in Jung's writings, to
enter into deeper preconscious realms. His titles provide general keys to his
content: several allude to Greco-Roman myths concerning animal sexuality,
among them, *She Wolf* and *Pasiphae* (first named *Moby Dick*).[14] Pollock
may have conceived of the physical activity of Pasiphae's bull and Ahab's
whale as symbolic of his manner of painting. Other canvases suggest mythic
rites, as *Moon Woman Cuts the Circle*. Of this picture, art critic Lawrence
Alloway wrote:

> The head of the figure on the right is a fragmented profile [of a red
> Indian] wearing a feathered bonnet . . . Sir Herbert Read suggested,
> in a letter to me . . . that it can be compared with a tattoo pattern
> of the Woman on the Moon made by the North American Indian
> tribe the Haida and reproduced in C. J. Jung's *Psychology of the Un-*
> *conscious*. . . . Read points out that "there is a reference on the same
> page to a Hottentot legend about 'cutting off a sizeable piece' of the
> moon." [15]

However, between 1942 and 1946, Pollock increasingly suppressed specific
references to myths, focusing instead on the mythic properties of his bio-

108

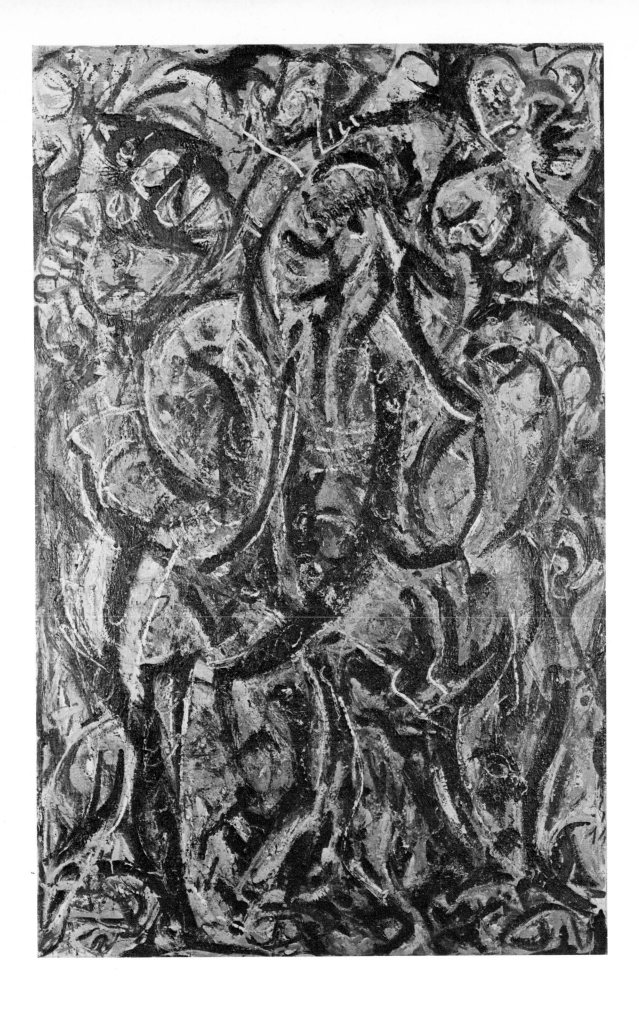

8–6 Jackson Pollock. *Gothic*. 1944
Collection Mrs. Lee Krasner Pollock, New York.

morphic forms in themselves. Motivated by what Barnett Newman called a "ritualistic will," Pollock now concentrated on the process of painting as a ritualistic act. This trend had begun in the more literal mythic pictures, in which he arrived at the imagery in the act of painting, depending on that act more than on iconography—unlike the Surrealists, who "finished" their automatist subjects, that is, who at one point treated painting as a process separate from image-making.[16]

During 1947, Pollock eliminated all recognizable symbols and signs from his work and began to rely exclusively on gestures—free-wheeling lines interlaced to create a frontal field. He no longer illustrated, interpreted, or symbolized myths, yet his content remained mythic in spirit. Pollock's gesturing reflected his inner compulsions and was in this sense autographic.[17] But his "living" on canvas appeared so delirious as to transcend the diaristic, to transform the autographic into the ideographic.[18] The painting became a kind of private ritual made visible. It was as if Pollock found the primitive common denominator of art and ritual. As the classical scholar Jane Harrison observed:

8–7 Jackson Pollock. *Sounds in the Grass: Shimmering Substance*. 1946.
Collection The Museum of Modern Art, New York;
Gift of Peggy Guggenheim.

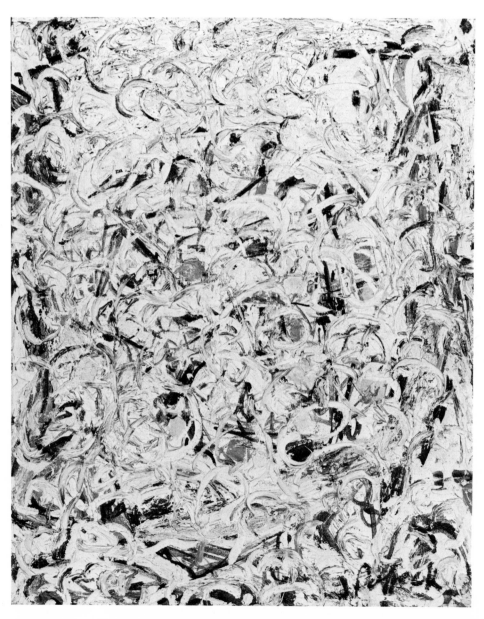

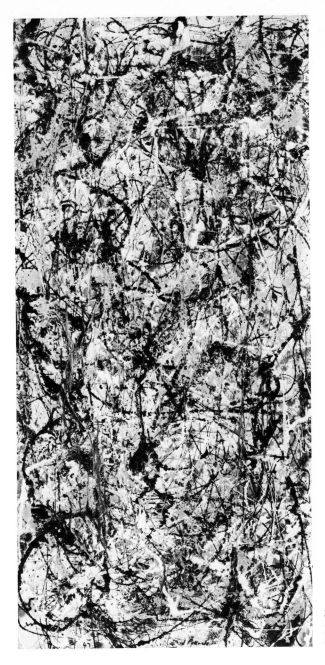

8–8 Jackson Pollock. *Cathedral*. 1947.
Dallas Museum of Fine Arts, Dallas, Texas;
Gift of Mr. and Mrs. Bernard J. Reis, New York.

"At the bottom of art, as its motive power and mainspring, lies not the wish to copy Nature or even to improve on her . . . but rather an impulse shared by art with ritual, the desire, that is, to utter, to give out a strongly felt emotion. . . . This common *emotional* factor it is that makes art and ritual in their beginnings well-nigh indistinguishable."[19] Pollock's all-over paintings convey the impression that his act of painting was absolute, an act in which the artist is totally immersed. Moreover, he seemed to have wanted his paintings to provoke a similar response in the viewer—that he lose himself in their delirium.

The moods of Pollock's "drip" paintings partake of two contrary states of consciousness—ecstasy and anxiety, although more often than not they embody the former. Indeed, they appeared increasingly euphoric with time: the shattered images, jagged angles, and raw colors of such earlier mythic pictures are far more barbaric than the graceful, fragile arabesques of the later abstractions. The "drip" paintings were initially apprehended as violent because of their assault on the audience's preconceptions about art, and when these prejudices were overcome the pictures were seen for what they actually were.

The change in Pollock's painting from brushed sign to "dripped" gesture was

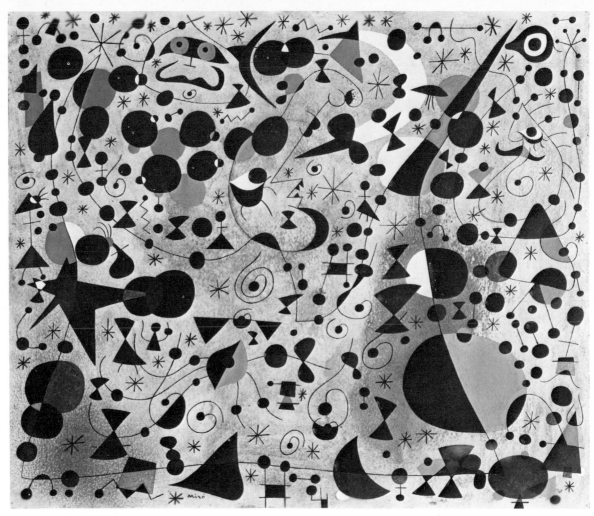

8–9 Joan Miró. *The Poetess,* from *Constellations* series. 1940.
Collection Mr. and Mrs. Ralph F. Colin, New York.

8–10 Jackson Pollock. *Convergence.* 1952.
Albright-Knox Art Gallery, Buffalo, New York;
Gift of Seymour H. Knox.

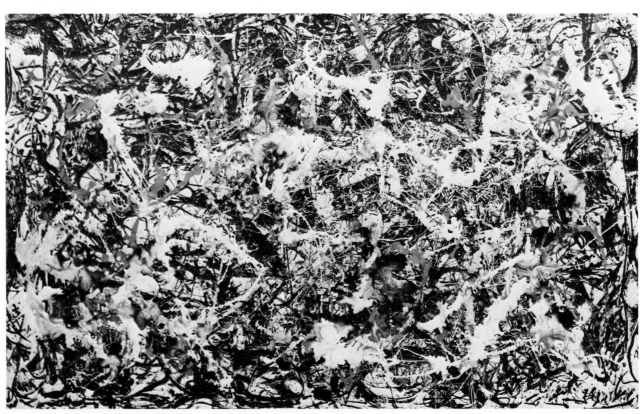

gradual. He had achieved an all-over image prior to the adoption of his new technique of drawing—in *Gothic* (1944; *Fig. 8-6*) and *Sounds in the Grass: Shimmering Substance* (1946; *Fig. 8-7*). In the latter, the mythic images are overlaid with a mesh of white brushstrokes, in whose interstices enigmatic bits of totems appear. The emphasis on drawn gesture is found in such pictures as *Guardians of the Secret* (1943), the central rectangle of which—containing the "secret"—is composed of a welter of abstract hieroglyphs. This automatist script becomes the subject of a number of all-over linear abstractions of 1946. The step from handmade scrawl to innovational "dripped" calligraphy is a short one, and, in 1947, Pollock took it in *Full Fathom Five* and *Cathedral* (*Fig. 8-8*), motivated by his conception of content as the issue of a total, free, and dramatic act. Pollock said in the summer of 1950, that "new needs need new techniques," and his technique of pouring paint yielded a more direct drawing—with swift, flowing, continuous lines—than that applied with brush or knife.[20]

It must be stressed that Pollock's "drip" painting evolved primarily from the slow internal development of his own style, and from suggestions by Graham and the Surrealist automatists, which fostered this development. There are many other accounts of the origins of the technique. Some acquaintances of Pollock believe that it occurred to him when he experimented in 1936 in Siqueiros' workshop with spray guns and airbrushes, using them to paint spontaneously. The paint-spattered floor was also supposed to have given him the idea. Others point to the Orientalizing ceramic bowls that Pollock made with Benton in 1934; to the Navajo Indians of New Mexico, who as a part of their ritual spilled colored earth to form elaborate designs; to "drip" works by Ernst and Hofmann; and, most unlikely, to Pollock's allegedly kicking over a can of paint or hurling one at a canvas. None of these stories, even if true, seem illuminating. In fact, the dripping of paint had long been an exercise in two-dimensional design in many art schools. What is significant is that Pollock was the first to employ the "drip" technique as a primary means of creating high art, and he could risk that only because it lent itself to a vision he needed to embody. Perhaps the Navajo Indians did influence Pollock, but not because they taught him the "drip" technique, but rather because they obliterated their pictures at the close of their ritualistic ceremony. To them, the act of painting was more important as magic than as picture-making. Their attitude may have given Pollock the confidence to take liberties with conventional approaches to painting.

Critics have also found sources outside of Pollock's own evolution for his adoption of all-over painting. Mark Tobey is often credited as one, although Clement Greenberg maintained that Pollock did not see Tobey's paintings when they were shown at the Willard Gallery in 1944.[21] It is likely that he knew them nevertheless, for in that year both artists had exhibited together in group shows.[22] In any case, Tobey's "white writing" was too miniscule in scale, reticent, and precious to interest Pollock. Although also small, Miró's series of twenty-two gouaches, entitled *Constellations* (1940; *Fig. 8-9*), was most likely more of an immediate influence. Greenberg recalled that, in 1944, Pollock had seen a few works by a primitive painter, Janet Sobel, and had "admired these pictures rather furtively: they showed schematic little drawings of faces almost lost in a dense tracery of thin black lines lying over and under a mottled field of predominantly warm and translucent color. . . . Later on, Pollock admitted that these pictures had made an impression on him." But far more significant was Greenberg's assertion that Pollock "had really anticipated his own 'all-overness' in a mural he did for Peggy Guggen-

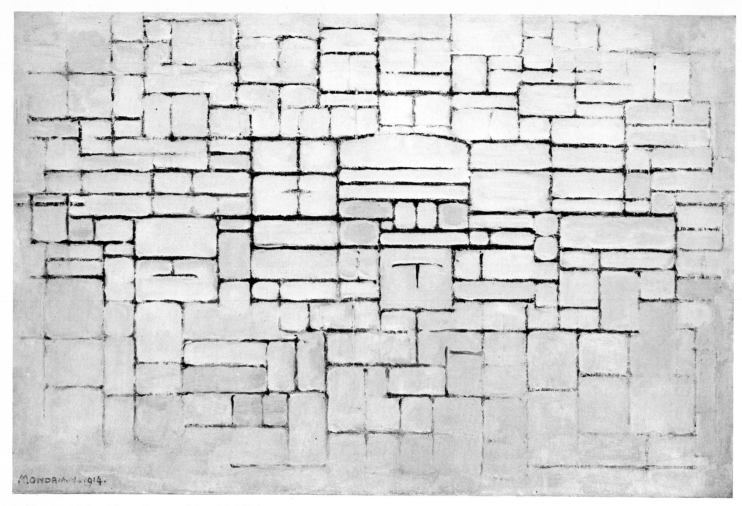

8–11 Piet Mondrian. *Composition* V. 1914.
Collection The Museum of Modern Art, New York;
Sidney and Harriet Janis Collection.

heim at the beginning of 1944" (*Fig. 11-4*).[23] (He might also have cited all-over pictures of the 1930's, such as *Flame*). Indeed, Pollock's earlier myth-inspired paintings so anticipate his later ones that what Manny Farber wrote in *The New Republic* in 1945 of works of that period applies almost as well to the subsequent "drip" canvases:

> . . . the artist seems to have started at one point with a color and continued it over the painting without stopping, until it had been composed with that color. In the process great sections of the previous design may be painted out, or the design changed completely. The painting is laced with relaxed, graceful, swirling lines or violent ones, until the surface is patterned in whirling movement. In the best compositions these movements collide and repeat to project a continuing effect of virile, hectic action. The paint is jabbed on, spattered . . . and painted in great sweeping continuous lines. The painting is generally heavily detailed . . . circular [in] movement. . . . An extraordinary quality of Pollock's composing is the way he can continue a feeling with little deviation or loss of purity from one edge to the other of the most detailed design.[24]

Pollock's fluid line was unconventional not only because of the direct manner in which it was applied, but because it did not define images or outline planes—two traditional functions of drawing. Instead, it trajected freely, as autonomous, painterly drawing. Lashed together into an interlace, his lines constitute an expansive web of forces, suspended in front of the passive canvas plane. These overlapping skeins produce a sense of space projecting out from

114

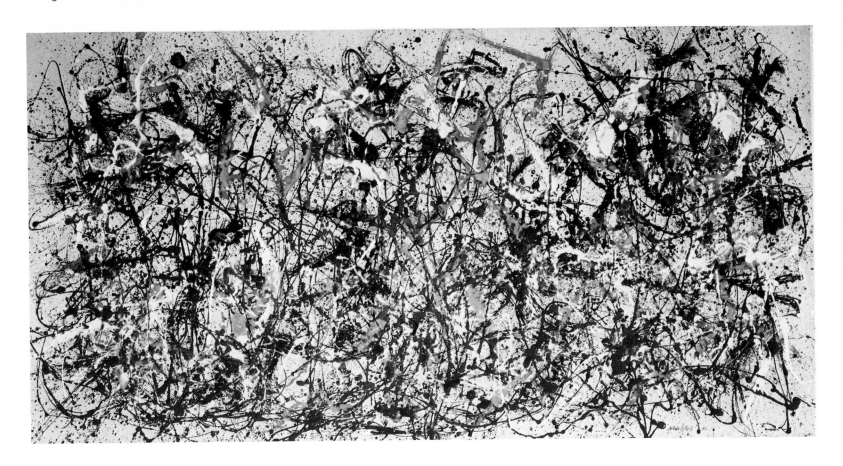

the picture surface. At the same time, the surface is not sectioned into planes but is apprehended as a field that occasionally seems invisible, dissolving into infinity, particularly when it is left bare, as in his best pictures. Pollock's color is more or less distributed over the surface and tends to accent the all-over scheme of lines—the field effect. This suggests the Pollock was primarily a draftsman, and the fact that he favored black and white (or aluminum, which functions as a variant of white) reinforces that impression.

The flow of energy through Pollock's configurations provides a unifying principle—a continuum of energy (*Fig. 8-10;* V, p. 90). This is not to say that the linear web is continuous, for it generally thins out at the edges, with the skeins curving back on themselves. Nor are the elements that make up the unitary image repetitive; they contain an astonishing variety of inventive patterns, rhythms, densities, and textures, of sudden twists and turns that are rarely predictable. Indeed, it is this very quality of surprise that distinguishes Pollock's greatest canvases. When the rhythms become too regular or repetitive, as in *Summertime (Number 9)* (1948), the configurations become obvious and banal, and lapse into a tasteful and unchallenging form of decoration. However, despite the diversity of Pollock's tracery, there are no sharp climaxes—no focal points on which the eye can settle. Forced to move constantly, it is compelled to apprehend the image as a whole. Because of the energy with which Pollock's field is charged, augmented by its large scale, it seems to expand, thereby suggesting extensions beyond the picture limits into infinity and evoking in the viewer a sensation of boundlessness—and this even though the webs rarely touch the edges.

Pollock's dynamic and expansive fields break sharply with the Cubist tradition that culminated in Mondrian's abstractions. The indeterminacy of his configurations stands diametrically opposed to the Platonic rationalism of Neoplastic architectonic composition. Whereas Mondrian focused on the structure of Cubism and deliberately pushed it to a purist extreme, Pollock used automatism to pulverize Cubist design into active arabesques. The former employed impersonal rectangles, clean contours and surfaces, while the latter favored the aggregation of "unfinished" gestures that call to mind his creative process. Mondrian found an absolute structure that for him symbolized the cosmic design underlying natural phenomena. Pollock, on the other hand, sought for a pattern that would embody a passionate private vision. Nevertheless, the energy that surges through his pictures suggests a universal dimension, issuing perhaps from a belief that energy is the common denominator of all phenomena.[25]

However, Pollock's "drip" pictures do have affinities with Mondrian's earlier Analytic Cubist ones (Fig. 8-11), as well as with Picasso's and Braque's.[26] In a formal sense, they can be viewed as a turning back from Synthetic Cubism to Analytic Cubism, the phase of Cubism that did not interest vanguard artists at that time. The way in which Pollock tended to organize his curvilinear patterns along horizontal and vertical axes in such pictures as *Autumn Rhythm* (1950; Fig. 8-12) may also have been inherited from Cubism. In disintegrating Synthetic Cubist architecture, Pollock seemed to be responding to countertendencies in modern art, notably Impressionism. The influence of Impressionism on Pollock is problematic. It is true that the "drip" pictures resemble Monet's *Nympheas*, yet Pollock did not see any of Monet's late canvases, except perhaps in reproduction, and Impressionism was not seriously or sympathetically considered by advanced artists during the 1940's. In the end, Pollock's pictures seem to break sharply with past and existing styles, for in following his inner needs and in rejecting all that was superficial and alien to them, he arrived at an unprecedented style. The manner in which Pollock transformed (destroyed) what he borrowed makes his painting appear far more radical than Gorky's, in which sources were combined but not obliterated.

Of all the departures in Pollock's painting, the one that most scandalized the public was his extreme reliance on accidental effects. It was widely believed that his pictures were mindless, utterly lacking in control and craft. Pollock himself denied the role of chance: "When I am painting I have a general notion as to what I am about. I *can* control the flow of paint: there is no accident." [27] Indeed, he valued clarity, but he was unafraid of what spontaneous imagination might contribute. He understood, as Eugène Ionesco wrote: "If lucidity is required . . . *a priori*, it is as though one shut the floodgates. We must first let the torrent rush in, and only then comes choice, control, grasp, comprehension." [28] Perceptive critics were quick to notice that Pollock employed accident to challenge habitual modes of drawing but that he never relinquished choice; as one wrote, "the seemingly uncomposable [is] composed." [29] According to eyewitness accounts, Pollock worked rapidly but without sacrificing decision-making, no matter how split-second. He also spent long periods of time studying his pictures, planning his next move or deciding whether to stop, continue, or destroy. Pollock was a consummate draftsman, the proof of which was the clarity with which he articulated his rhythms, so as to charge the entire surface with energy. Poet and art critic Frank O'Hara wrote that Pollock possessed the "amazing ability

to quicken a line by thinning it, to slow it by flooding, to elaborate that simplest of elements, the line—to change, to reinvigorate, to extend, to build up an embarrassment of riches in the mass by drawing alone."[30] His conscious artistry places him therefore in line with tradition, no matter how unconventional his drip technique may seem.

In part, Pollock had adopted the "drip" technique because it presented him with meaningful surprises. But after 1950, when he painted his "classic" pictures, it became too habitual. The need to invent new challenges appears to have prompted him to introduce the human figure as subject matter, or rather to find it in the process of painting (*Fig. 8-13*), moving toward the kind of anatomical abstraction that Willem de Kooning had begun to explore earlier. Some critics condemned Pollock's "return to the figure" as a retreat, but not Clement Greenberg: "Like some older masters of our time he develops according to a double rhythm in which each beat harks back to the one before the last. The anatomical motifs and compositional schemes sketched out in his first and less abstract phase are in this third one clarified and realized."[31] Indeed, Pollock appears to have looked back to the drawings of his mythic period and to have attempted to revive the subjects in them by dripping. His interest in these drawings may also account in part for his elimination of color; in 1951–52, he limited his palette to black (*Fig. 8-14*). But such a

8–13 Jackson Pollock. *Number 23 (Frogman).* 1951.
Courtesy of the Martha Jackson Gallery, Inc., New York.

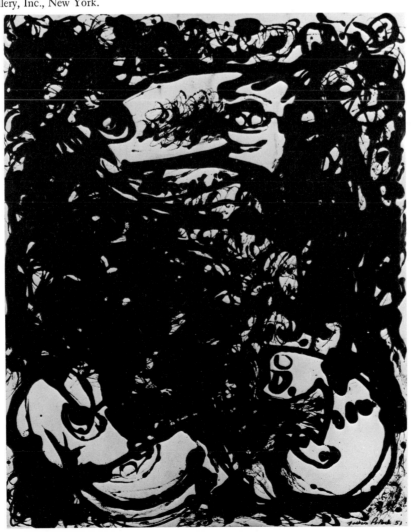

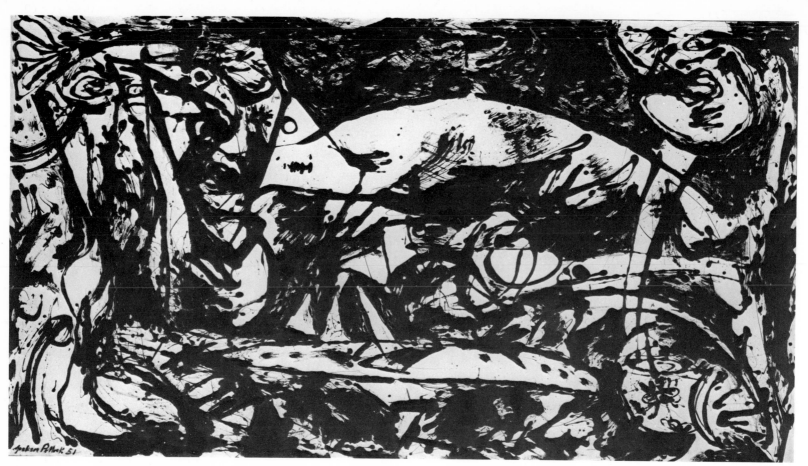

8–14 Jackson Pollock. *Number 14*. 1951.
Collection Mrs. Lee Krasner Pollock, New York.

move was a natural one, for Pollock was essentially a draftsman. However, he risked moving away from line in these abstractions; for the flung, thin line, he increasingly substituted the puddled area, generally coagulated and shiny in the centers and stained soft at the edges, where the thin paint soaked into the canvas. Although Pollock painted a few masterpieces in black on white, notably *Echo* (1951; *Fig. 8-15*), these painting on the whole are generally not his best, for he rarely succeeded in integrating areas into an all-over pattern.

By 1953, Pollock had exhausted the "drip" technique and abandoned it. At this time, his art went into crisis—and also his life. He had long been plagued by alcoholism, which he tried to overcome through psychoanalysis. Occasionally he succeeded; he stopped drinking from 1948 to the end of 1950, the period of his great "drip" pictures—*Autumn Rhythm* and *One* (*Number 31, 1950*). After he resumed drinking, his production of pictures dropped, particularly in the last three years of his life. In 1953 Pollock not only began to paint with the brush again but to re-introduce color into his works. *Portrait and a Dream* (*Fig. 8-16*) of that year was the transitional work; a "drip" painting, it is half black, half in color. Later canvases, such as *Easter and the Totem* (1953; *Fig. 8-17*), are brushed anatomical abstractions whose sources are in the black pictures and in the earlier mythic works of the 1940's.

Many of Pollock's last paintings are superior, but they lack the vitality and intensity that distinguished earlier works. Nevertheless, that does not lessen his inestimable contribution to American painting, for it was Pollock who unleashed the creative energies of the Abstract Expressionists.

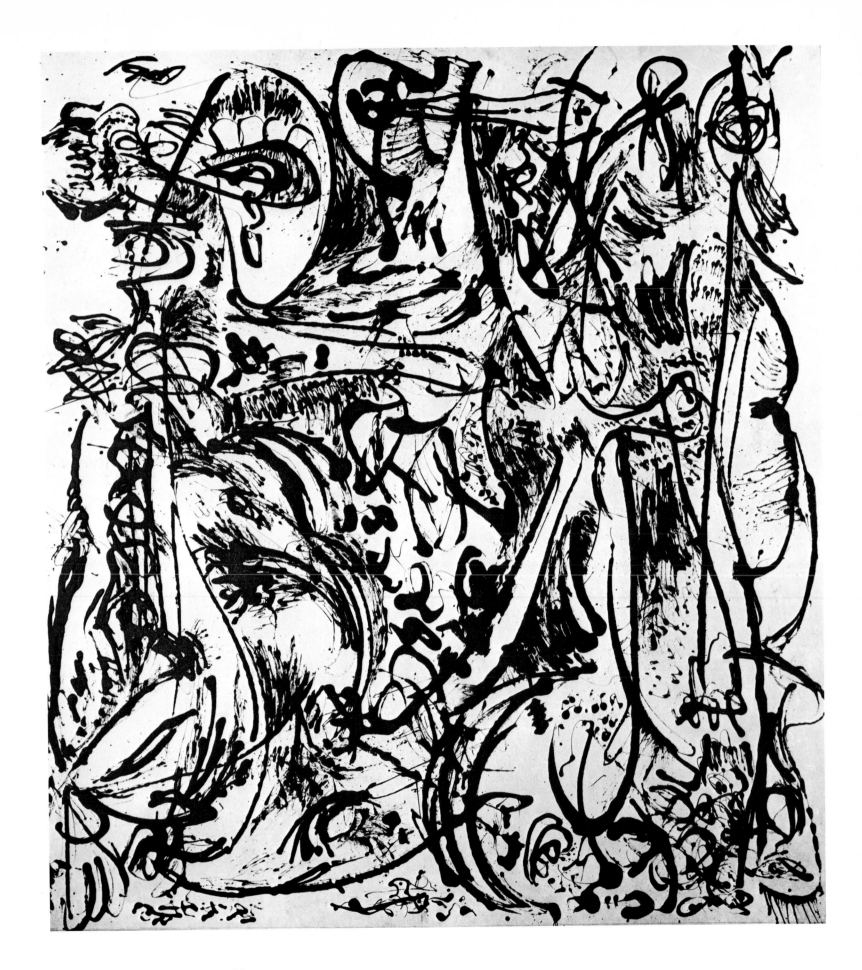

8–15 Jackson Pollock. *Echo*. 1951.
Collection The Museum of Modern Art, New York;
Acquired through the Lillie P. Bliss Bequest and the Mr. and Mrs. David Rockefeller Fund.

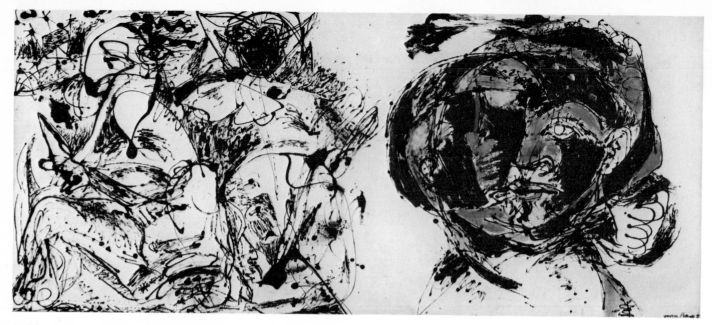

8–16 Jackson Pollock. *Portrait and a Dream.* 1953.
Dallas Museum of Fine Arts, Dallas, Texas;
Gift of Mr. and Mrs. Algur H. Meadows and the Meadows Foundation, Inc.

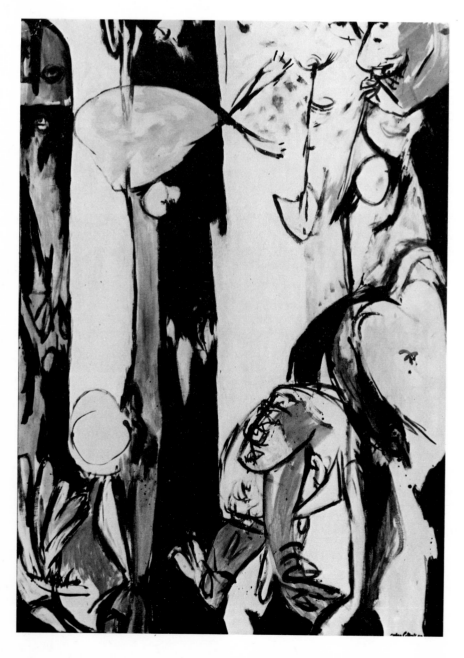

8–17 Jackson Pollock. *Easter and the Totem.* 1953.
Collection Mrs. Lee Krasner Pollock, New York.

1. Jackson Pollock, "My Painting," *Possibilities 1*, No. 1 (Winter, 1947–48), 79.

2. Harold Rosenberg, *Arshile Gorky: The Man, The Time, The Idea* (New York: Horizon Press, 1962), pp. 116–19.

3. James T. Valliere, "The El Greco Influence on Jackson Pollock's Early Works," *Art Journal*, XXIV, No. 1 (Fall, 1964), 6, wrote that "out of four surviving sketchbooks, the two largest contain drawings after compositions by El Greco, Rubens, Michelangelo and Rembrandt. . . . [They total 52 pages]. There are over sixty individual drawing compositions after El Greco. . . . approximately twenty . . . after Rubens, three after Michelangelo and one after Rembrandt's *Night Watch*. . . . [None] are dated. . . . [They are] obviously made after reproductions. . . . Pollock's library [150 books] . . . possessed three books on El Greco." Valliere believed the drawings were most likely executed between 1936 and 1938.

4. Jackson Pollock, "Jackson Pollock," *Arts and Architecture*, LXI, No. 2 (February, 1944), 14. (Answers to a questionnaire.)

5. Francis V. O'Connor, *Jackson Pollock* (New York: Museum of Modern Art, 1967), p. 24, quotes Sanford Pollock's letter of May, 1940, to Charles Pollock: "Jack is doing very good work. After years of trying to work along lines completely unsympathetic to his nature, he has finally dropped the Benton nonsense and is coming out with an honest creative art."

6. William C. Seitz, "Abstract Expressionist Painting in America" (Ph.D. dissertation, Princeton University, 1955), p. 414.

7. Most acquaintances of Pollock and Graham recall that the two men met prior to 1939, but it may have been as late as 1941, shortly before Graham included Pollock in a show he organized at the McMillan Gallery.

8. John D. Graham, "Primitive Art and Picasso," *Magazine of Art*, XXX, No. 4 (April, 1937), 236–37.

9. *Ibid.*, pp. 237–38.

10. John D. Graham, *System and Dialectics of Art* (New York: Delphic Studios, 1937), p. 31.

11. Pollock, "Jackson Pollock" (Answers to a questionnaire), p. 14.

12. Graham, "Primitive Art and Picasso," p. 239.

13. William Rubin, "Notes on Masson and Pollock," *Arts*, XXXIV, No. 2 (November, 1959), 42.

14. Tony Smith verified Pollock's obsession with animal sexuality in a conversation with the author, December 28, 1966.

15. Lawrence Alloway, catalogue of an exhibition, "Jackson Pollock," Marlborough Fine Art Ltd., London, June, 1961, Section 34, n.p.

16. *Ibid.*, Introduction, n.p.

17. Pollock in the narration for the Hans Namuth and Paul Falkenberg film *Jackson Pollock*, 1951, quoted in Bryan Robertson, *Jackson Pollock* (New York: Harry N. Abrams, 1960), p. 194. Pollock said: "I don't work from drawings or colour sketches. My painting is direct. . . . The method of painting is the natural growth out of a need. I want to express my feelings rather than illustrate them. Technique is just a means of arriving at a statement."

18. Lawrence Alloway, "Notes on Pollock," *Art International*, V, No. 4 (May 1, 1961), 38.

19. Jane Harrison, quoted in Herbert Read, *Icon and Idea* (Cambridge, Mass.: Harvard University Press, 1955) p. 57. There are other interpretations of Pollock's content. Many critics, European in the main, find his works to be metaphors of America, "the big country." Others see grasses, the city, and other natural phenomena. Still others view them as the embodiment of Existentialist ideas that were in the air; chance as a condition of life; the artist presented with fortuitous situations not of his own making must nonetheless find himself, make himself.

20. Pollock, quoted in O'Connor, *Jackson Pollock*, p. 79. Alloway in "Jackson Pollock," Section 54, wrote: "A brushstroke, if it is of any length, always reveals graduation, from its fullest load of paint to its depletion. The rapidity and linear continuity Pollock needed in his paintings (and which he can be seen reaching for in his pre-drip paintings), demanded the technical innovation. The result is . . . an ability to create long, racing marks."

21. Clement Greenberg, " 'American-Type' Painting," *Partisan Review*, XXII, No. 2 (Spring, 1955), 187.

22. In 1944, Pollock and Tobey exhibited in group shows at Putzel's 67 Gallery and at the Mortimer Brandt Gallery in a show organized by Sidney Janis.

23. Clement Greenberg, " 'American-Type' Painting," in *Art and Culture* (Boston: Beacon Press, 1961), p. 218.

24. Manny Farber, "Jackson Pollock," *New Republic*, CXII, No. 26 (June 25, 1945), 781.

25. Alfonso Ossorio, in Introduction to the Jackson Pollock show at the Betty Parsons Gallery, 1951, n.p.

26. Clement Greenberg, " 'American-Type Painting'," *Partisan Review*, Spring, 1955, 186–87.

27. Pollock, narration in Namuth film, cited in Robertson, *Jackson Pollock*, p. 194.

28. Eugène Ionesco, *Notes and Counter Notes*, Donald Watson, trans. (New York: Grove Press, 1964), p. 120.

29. Parker Tyler, "Jackson Pollock: The Infinite Labyrinth," *Magazine of Art*, XLIII, No. 3 (March, 1950), 93. Tyler remarked that the "drip" technique enabled Pollock to charge the distance between his painting tools and the canvas surface with as much chance as possible. "In other words, the fluidity of the poured and scattered paint places maximum pressure against conscious design. And yet the design *is* conscious." Robert Goldwater, in "Reflections on the New York School," *Quadrum*, No. 8 (1960), 27, also observed: "Pollock's long-arm strokes as he poured paint upon flat canvas were quick decisions ('inspirational' decisions) . . . but they were decisions made out of long experience as to just what visual rhythms would result from the muscular feel of his motion."

30. Frank O'Hara, *Jackson Pollock* (New York: Braziller, 1959), p. 26.

31. Clement Greenberg, "Jackson Pollock's New Style," *Harper's Bazaar*, No. 2883 (February, 1952), 174.

9 Willem de Kooning
(1904–)

DE KOONING had a considerable underground reputation among New York artists from the mid-1930's, yet he did not have his first one-man show until 1948, the year Pollock's "drip" paintings were exhibited. The black-and-white abstractions he showed then established him as a leading Abstract Expressionist. In these and all of his subsequent paintings, De Kooning tried to embody his anxious and restless life style. As he wrote in 1951:

> Art never seems to make me peaceful or pure. I always seem to be wrapped in the melodrama of vulgarity. . . . Some painters, including myself, do not care what chair they are sitting on. It does not even have to be a comfortable one. They are too nervous to find out where they ought to sit. They do not want to "sit in style." Rather, they have found that painting—any kind of painting, any style of painting—to be painting at all, in fact—is a way of living today, a style of living, so to speak.[1]

In order to translate his evolving life style into art, De Kooning relied on the unpremeditated act of painting, which enabled him to keep a picture open to new and unexpected possibilities and to purge it of habitual, atrophied mannerisms, much as Pollock had with the "drip" technique. The sense of openness to experience is evoked by the qualities of ambiguity and fluidity of De Kooning's works. As the eye moves in and out of interpenetrating areas, it picks up ever changing combinations and permutations—a multiplicity of meanings—that symbolize De Kooning's uneasy way of living and perhaps his attempt to express the entirety of his experience (an impossible ambition). His "nervousness" is also conveyed by the very manner of his painting, which is agitated and exhibits traces of innumerable revisions—changes of mind that bespeak a sense of self-doubt.

De Kooning's response to the pressures of his immediate experience caused him to diverge as radically from the past as Pollock had. Yet, simultaneously, he revealed his links to European art more explicitly than Pollock. What De Kooning said of Cubism applied to his own work: "It didn't want to get rid of what went before. Instead it added something." [2] De Kooning's ties to tradition are manifested in his technique of painting, his use of the human image, of spatial depth, and of a Cubist infrastructure. His gestures are brushed and scraped rather than "dripped" and so are less accidental, though not less unpremeditated, than Pollock's. Moreover, because his pictures are modified more than Pollock's, they appear more traditional and call attention to their painterly quality and precision of drawing, regardless of how impetuous and raw they look (De Kooning studied for eight years at the Rotterdam Academy, noted for the rigor of its academic approach, and that experience seems to have had a lasting effect on his drawing).

De Kooning's choice of the human figure as subject matter was another indication of his attachment to past art. He was one of a group of twentieth-century revolutionaries—including Matisse, Picasso, Léger, Klee, Soutine, and Miró—who strove for human images that would bear no reference to lifeless, outworn conventions. He was also attracted to figuration because of his love of "the vulgar and fleshy part" of Western art, indeed of flesh itself, "the stuff people were made of" and "the reason why oil painting was invented." [3] The human form is bulky and exists in space; De Kooning refused to deny it volume and depth, but he also insisted on asserting the picture surface. There are various means of reconciling the three-dimensionality of the figure with the flatness of the canvas plane: mass can be leveled by suppressing modeling; the body can be fragmented into planar anatomical

shapes and spread across the surface (the device favored by the Cubists); or the parts of the figure can be opened up and merged with the background to constitute a single image. At different times, De Kooning employed all these methods.

During the 1930's and early 1940's, De Kooning flattened his figures, as did Gorky and Graham (*Fig. 9-1*). Taking his cue from Picasso and Ingres, he tried to achieve an all-over intensity of drawing. His intention in part was to solve formal problems, but his pictures of solitary male subjects convey far more than that, evoking his own abject condition and that of millions of Americans in the Depression decade.[4] Nevertheless, the expressiveness of these figures depends largely on discrete components—a curved shoulder, creased pants—that tend to be perceived as detachable (*Fig. 9-2*). Such improvisations with segments of the anatomy were eventually to lead De Kooning to abstraction.[5] At the same time that he was fragmenting the figure, De Kooning was approaching abstraction from another direction—by simplifying still-life motifs, somewhat in the manner of Miró and Arp. During the late

9–1 Willem de Kooning. *Standing Man.* c. 1942.
Courtesy Wadsworth Atheneum, Hartford, Connecticut;
Ella Gallup Sumner and Mary Catlin Sumner Collection.

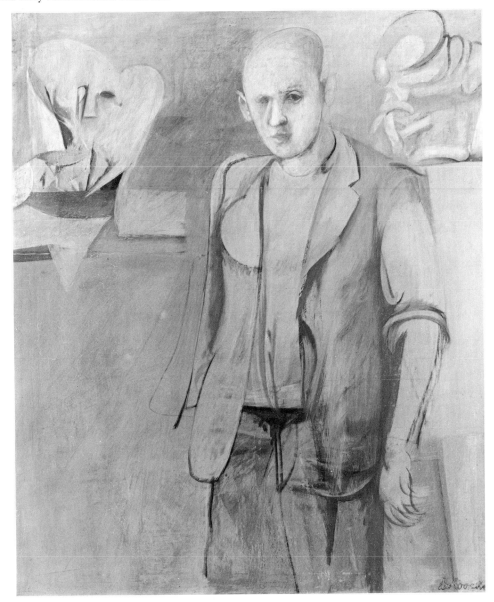

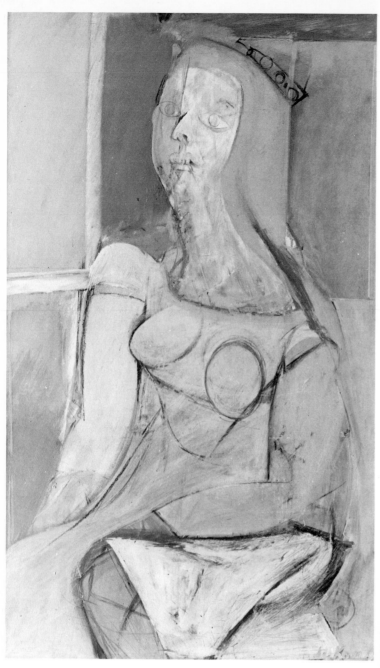

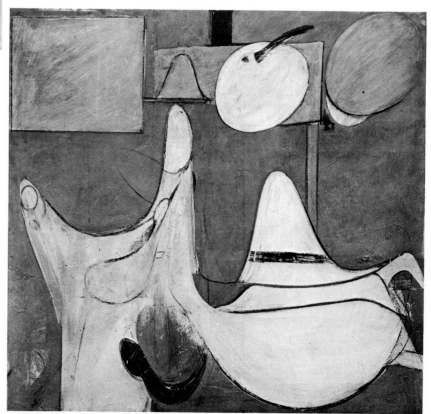

9–2　Willem de Kooning. *Queen of Hearts*. 1943–46.
Joseph H. Hirshhorn Foundation.

9–3　Willem de Kooning. *Untitled Painting*. c. 1942.
Private Collection, New York.

124

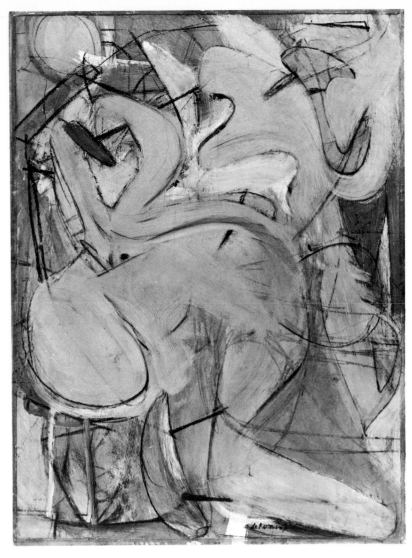

9-4 Willem de Kooning. *The Marshes*. c. 1945.
Collection University Art Museum, Berkeley, California;
Gift of Julian J. and Joachim Jean Aberbach, New York.

1930's and early 1940's, he painted a series of pictures composed of softly brushed planes that suggest the floating silhouettes of flasks, glasses, eggs, or drops of water (*Fig. 9-3*). These abstract still lifes, a mixture of refined purism and organic fantasy, generate a mood as poignant as that of his male figures.

After 1942, De Kooning increasingly employed automatism to fuse quasi-geometric and biomorphic forms and to loosen and open them (*Figs. 9-4, 9-5*). Like Gorky, he painted thinly; his surfaces were fragile and airy, his calligraphy graceful. The fantastic organisms he depicted are akin to Gorky's but differ in that they derive more from the human anatomy, as in *Pink Angel* (*VI*, p. 91). Gorky had occasionally improvised with anatomical parts, as in the arm of *Portrait of Master Bill* (*Fig. 9-6*)—which he painted of De Kooning *ca.* 1937—but such imagery was not central to his works as it was to De Kooning, who was to develop the possibilities of anatomical abstraction to the fullest.

In a series of abstractions begun around 1947 and shown the following year (*Fig. 9-7*) De Kooning freed anatomical parts from their familiar figural contexts and also integrated new motifs—scrawled letters and numbers—into his abstract montage of bodily fragments. At the time, De Kooning limited his palette to black and white. A number of reasons account for this: he used enamel housepaint because he could not afford expensive oils. He knew that house paint colors would fade and his sense of craftsmanship led him to avoid them. His love of tradition, in which monochromatic grisaille figured largely, was also partly accountable. Paradoxically, he also liked the unartful look of enamel. More importantly, however, his switch to black and white resulted from a need to simplify pictorial problems, much as the early

9–5 Willem de Kooning. Backdrop for *Labyrinth*. 1946.
Collection Allan Stone Gallery, New York.

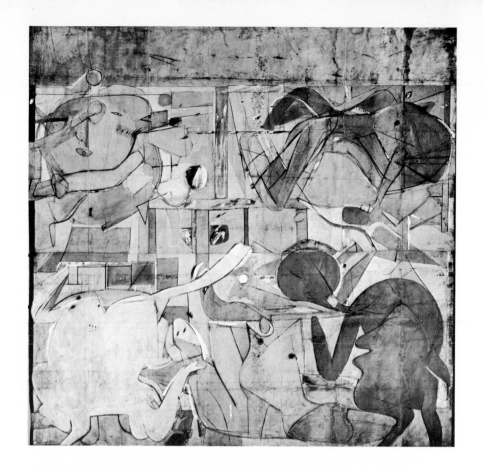

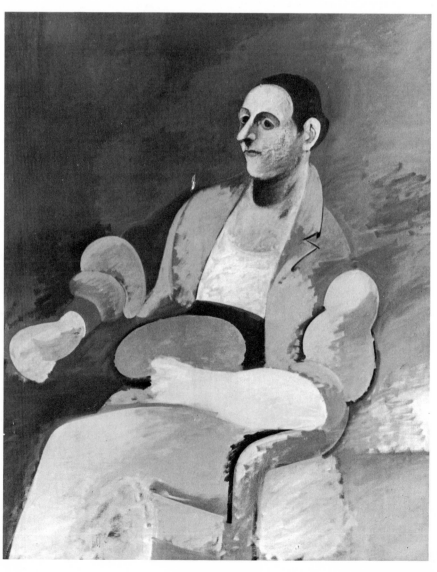

9–6 Arshile Gorky. *Portrait of Master Bill*. c. 1937.
M. Knoedler & Co., Inc., New York.

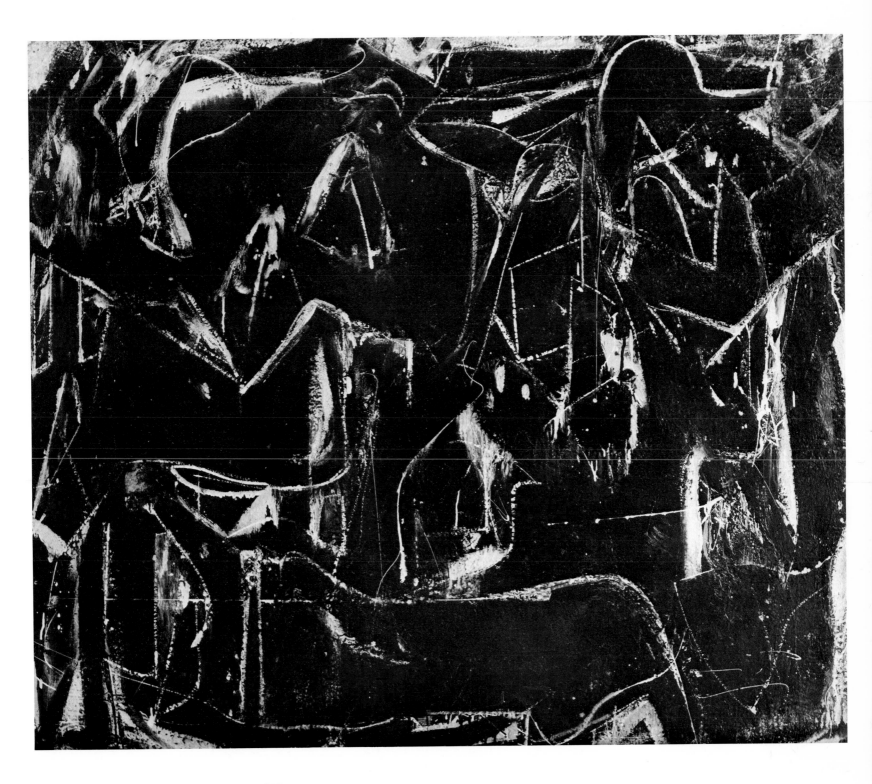

9–7 Willem de Kooning. *Dark Pond*. 1948.
Collection Mr. and Mrs. Richard L. Weisman, New York.

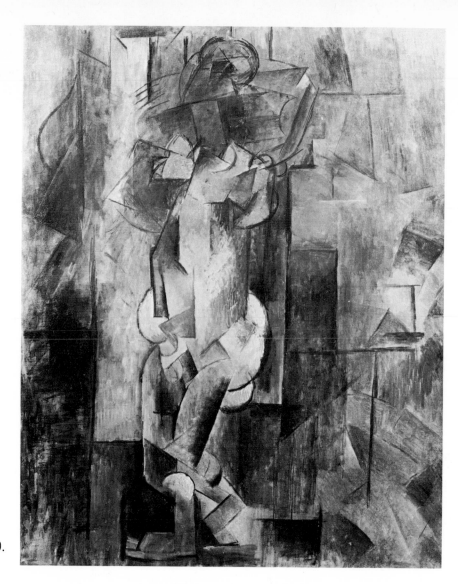

9–8 Pablo Picasso. *Nude Figure*. c. 1910.
Albright-Knox Art Gallery, Buffalo, New York.

Cubists had done. Color, however, soon re-entered his work. Critics generally stress that De Kooning's painting is primarily based on drawing; yet, he draws color with the brush, making line both coloristic and painterly in a way that the Cubists generally did not.

A major problem for De Kooning throughout his career was his relation to Cubism. He had been reared in it and could not deny its insistence on flatness and firm pictorial structure. At the same time, he desired a form that was more ambiguous, dynamic, and evocative of his own impulsive creative action.[6] In the black-and-white abstractions, areas interpenetrate to form a continuous surface; their planarity calls to mind Synthetic Cubism, but they are more equivocal, closer in a way to Analytic Cubism (*Fig. 9-8*) or to Duchamp's Futurist variant (*Fig. 9-9*). Much as the planes in Picasso's and Braque's canvases of 1909 to 1912 are shuffled, they are composed along horizontal and vertical axes into measured scaffolds. De Kooning's organic areas are, by contrast, ceaselessly shifting; images and backgrounds interchange, so that "parts do not exist. . . . It is impossible to tell what is 'on top of' what. There is no ground against which a shape appears. . . . No pauses or rests, no in-betweens." [7]

Even though the areas in De Kooning's abstractions are unbounded, they are also impacted, causing his canvases to look filled to the brim with voluminous matter. At the same time, these dense areas discharge energy as they collide and open up—implosively—unlike the expansiveness of Pollock's configurations. De Kooning's paintings, beginning with *Ashville* (1949; *Fig. 9-10*), *Attic* (1949; *Fig. 9-11*), and *Excavation* (1950; VII, p. 94)—three of his greatest

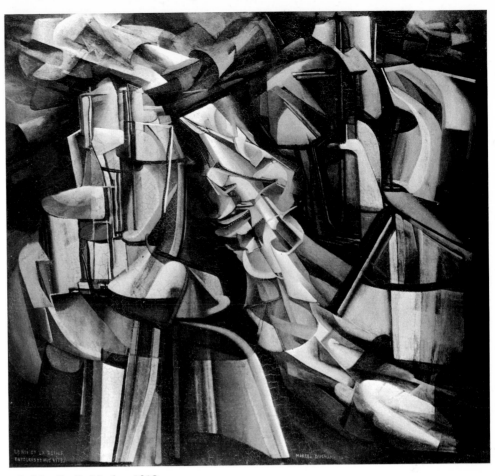

9–9 Marcel Duchamp. *The King and Queen Surrounded by Swift Nudes.* 1912.
Philadelphia Museum of Art, Philadelphia, Pennsylvania;
Louise and Walter Arensberg Collection.

9–10 Willem de Kooning. *Ashville.* 1949.
The Phillips Collection, Washington, D.C.

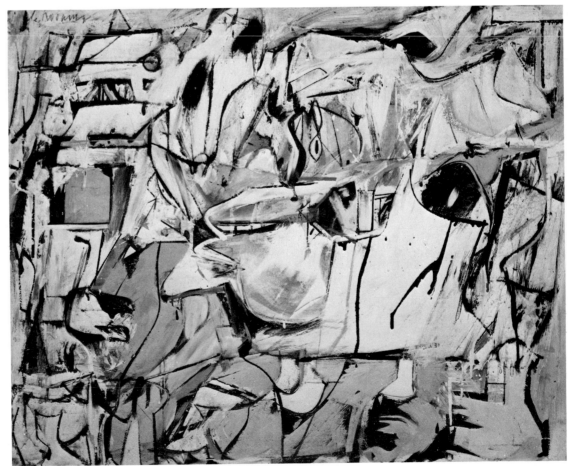

pictures—are more dynamic than any created by the other Abstract Expressionists. During the 1950's he emphasized painterly gesture increasingly, his primary expressive means becoming muscular, stridently pigmented slashes of the brush, reminiscent in look and feeling of Soutine's Expressionism, which De Kooning admired. Nevertheless, the ever shifting areas of his tempestuous brushwork remain stabilized by a Cubist infrastructure. In part, De Kooning's style is based on an original synthesis of Expressionist facture and classicizing Cubism.

De Kooning's growing reliance on the painterly gesture depended, however, on other motives. It can be regarded as a shift from improvising with the anatomical segment and with written script to improvising with the quasi-abstract mark—which continues to allude to the human form and is as personal as handwriting. This change reflected De Kooning's attempt to suggest the uncertainty and violence in his style of living—qualities that were found in the earlier works, in which he dismembered and dislocated bodily parts. Another reason for his adoption of gesture painting seems to have been his desire to submit all of his preconceptions—concerning the figure, Cubism, space—to the direct process of painting, in order to find his images in that process. Impelled by the passions generated while painting, he allowed the brushstrokes in themselves to carry the burden of content. In one sense, gesture painting is reductive, but De Kooning achieved complexity by making each mark the bearer of a variety of meanings. One arc of the brush, for example, might suggest the contour of a shoulder, its volume and the space behind it, or the letter C as if scrawled on the sidewalk—and, when related to other brushmarks, its possible meanings become endless.

9–11 Willem de Kooning. *Attic.* 1949.
Collection Mrs. Albert H. Newman, Chicago, Illinois.

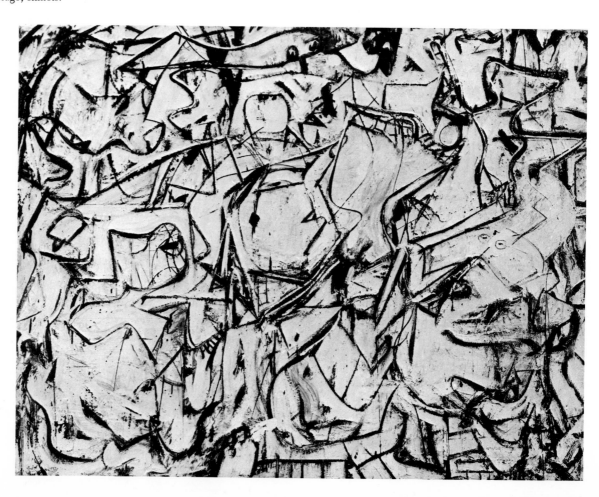

Gesture painting, which was seemingly devoid of artifice, conveyed more nakedly than ever before in art a sense of the painter's life experiences and of his creative struggles. Painting that manifested the signs of his creative struggle—and they are everywhere in De Kooning's pictures—was of far greater value to him than painting that exhibited qualities identified with the French regard for *métier*. De Kooning once said: "I never was interested in how to make a good painting. . . . I didn't work on it with the idea of perfection, but to see how far one could go—but not with the idea of really doing it. With anxiousness and dedication to fright maybe, or ecstasy." [8] Despite this, De Kooning is surely the greatest virtuoso painter of his time, in the painterly tradition of Rubens and Rembrandt (whose drawings he appears to quote at times). He does paint a "well-painted" picture and obviously intends to, yet somehow it never conveys the feeling of self-possession, generated by a confidence in man's destiny, found in past masterworks. The visible traces of countless revisions on the canvas indicate the long struggle to complete or perfect a picture, which nonetheless always looks unfinished, as if subject to further modification. Indeed, De Kooning's pictures more than anything else are metaphors for his own and modern man's existential condition, capturing the anxious, rootless, and violent reality of a swiftly paced urban life. De Kooning characterized the modern American metropolis as a "no-environment," remarking that its flux is totally alien to the stable milieu of the Renaissance, in which everything had a fixed place.

For De Kooning, man in this "no-environment" becomes a "no-figure."

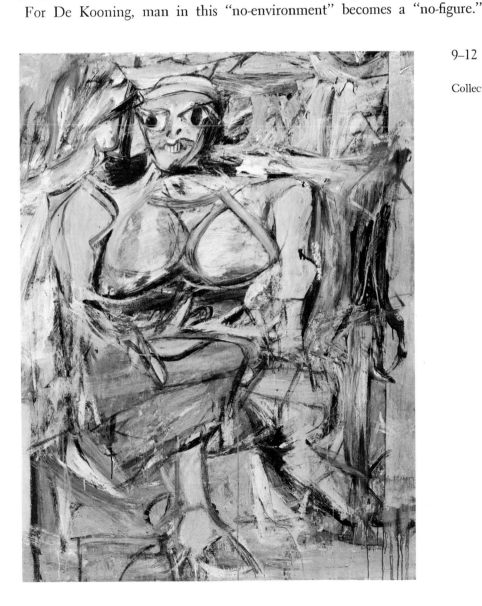

9–12 Willem de Kooning. *Woman I.*
1950–52.
Collection The Museum of Modern Art, New York.

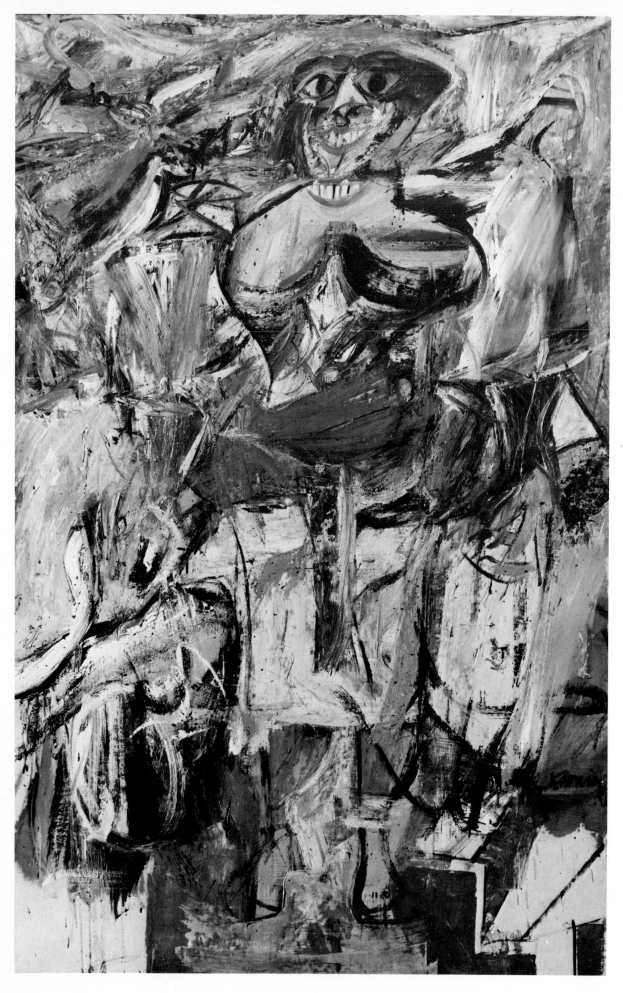

9–13 Willem de Kooning. *Woman and Bicycle*. 1952–53.
Collection Whitney Museum of American Art, New York.

The partially obliterated scrawled letters and numbers ("no-things") in many of his pictures—derived from the anonymous, brutally direct graffiti on tenement walls, peeling billboards, and sidewalks—also evoke the urban environment. The violence of De Kooning's gesture reflects that of the city, yet it also suggests that he has pitted himself angrily against his environment, resisting its overpowering threat to nullify the individual.

From 1949 to 1951, the main thrust in De Kooning's work was the fragmentation of anatomy into motile, energy-packed gestures. The shape of his increasingly vehement thick brushstrokes continued to suggest fleshy body parts in layered space, creating a "wall of living musculature." [9] Around 1951, De Kooning began to reconstitute the gestures into recognizable figures (*Figs. 9-12, 9-13*). These emerged eventually in a series of full-bodied, wide-eyed, toothy women who loom large in the picture space. Devoid of sentimental notions of beauty associated with the academic tradition, De Kooning's *Women* are unequaled in the history of art in fierceness, garishness, and hysteria. These qualities are conveyed with staggering immediacy by the tempestuous painting as well as by the close-up frontal image.

When first shown in 1953, these monumental females were attacked by critics as vulgar, monstrous, perverse, infantile, and horridly and shamelessly revealing. But in the Abstract Expressionist milieu itself, many artists questioned De Kooning's return to figural painting, considering this as a step backward, forgetting that he had never really rejected the figure. Some of his admirers, who were moved by the raw vitality of the *Women* yet who belittled representational art in general, minimized the role of the image, treating it as a "problem" in an otherwise abstract art or as a kind of disguised abstraction. De Kooning himself strongly disagreed with such interpretations, insisting that the female as subject aroused in him powerful passions. It was an image he felt compelled to grasp: "The *Women* had to do with the female painted through all the ages, all those idols, and maybe I was stuck to a certain extent; I couldn't go on. It did one thing for me: it eliminated composition, arrangement, relationships, light—all this silly talk about line, color and form—because that [the *Women*] was the thing I wanted to get hold of." [10]

De Kooning's *Woman* continues in the tradition of the females of Picasso, Léger, and Soutine, but she is far more immediate and frenzied, incorporating a multiplicity of intimate and unnerving feelings about woman as both human and majestic cult image, about man's relation to her, and about sex. However, De Kooning's vision may also stem from an aspect of the American experience so essential that others could not help but express it. For example, years before De Kooning painted the *Woman*, Henry Miller in *Tropic of Capricorn* imagined a female that might have been the painter's model:

> Yes, there she is coming full on, the sails spread, the eyes glowing. . . . The engine is going full steam . . . Tall, stately, full-bodied, self-possessed, she cuts the smoke and jazz and red-light glow like the queen mother of all the slippery Babylonian whores. On the corner of Broadway just opposite the comfort station, this is happening. Broadway—it's her realm. This in Broadway, this is New York, this is America. . . . Whatever made America made her, bone, blood, muscle, eyeball, gait, rhythm, poise, confidence, brass and hollow gut. She's almost on top of me . . . She's coming head on, through the plate glass window. If she would only stop a second, if she would only let me be just for one moment. But no, not a single moment does she grant me. Swift, ruth-

less, imperious, like Fate itself she is on me . . . The woman whom you never hoped to meet now sits before you, and she talks and looks exactly like the person you dreamed about. But strangest of all is that you never realized before that you had dreamed about her. . . . We are seated in a little booth in the Chinese restaurant . . . Every few minutes she lights a fresh cigarette which burns away as she talks. There is no beginning nor end . . . No knowing how or where she began. Suddenly she is in the midst of a long narrative, a fresh one, but it is always the same. Her talk is as formless as dream: there are no grooves, no walls, no exits, no stops. I have the feeling of being drowned in a deep mesh of words, of crawling painfully back to the top of the net, of looking into her eyes and trying to find there some reflection of the significance of her words—but I can find nothing, nothing except my own image wavering in a bottomless well.[11]

All of the associations evoked by De Kooning's images issue from the painting's fusion of voluptuousness and violence. William Seitz called it "a disquieting mixture of ugliness and seduction. One might think that the painter hated the opulent richness of his heavily-pigmented modulations . . . for with a harsh brush, or even with charcoal jabs which pulverize into wet impasto, blacks become intentionally 'dirt,' anti-color, like cuts of an unclean knife into the 'nice, juicy, greasy surface' which he says he likes." [12]

In 1955, De Kooning abandoned the female image and turned again to abstraction, but he retained the turbulent brushwork of the *Women* series. The transition began to occur in such pictures as *Woman VI* (1953; *Fig. 9-14*). His earlier abstractions were complex and dense, continuing to suggest the city (*Gotham News*, 1955–56; *Fig. 9-15*), but around 1957, he began to simplify his drawing by broadening the gestures and reducing their number. His pictures increasingly resembled "landscapes and highways and sensations of that, outside the city—with the feeling of going to the city or coming from it" (*VIII*, p. 95).[13] In keeping with the change of subject, the quality of energy in his painting changed as well. The anatomical segments in his canvases of the late 1940's and early 1950's are impacted in accordance with the constitution of the human body; the force in them is centripetal. In the later pictures, De Kooning unlocked these areas, and, in a sudden release of energy, they became expansive (*Fig. 9-16*).

As drawing was simplified, color became increasingly dominant. De Kooning continued to favor pinks, yellows, and blues, but they were more lyrical than in earlier works of the 1950's, in keeping with the landscape feeling. The color areas did not overlap as much as in former works, and so were flatter; yet, at the same time, they appear to thrust forward into the viewer's space and then to fall back into infinity. In this respect, De Kooning seemed to be challenging more than he had in the past the modernist convention proscribing illusionism. The lyrical quality of his abstract "landscapes" was accented by the organization of broad swaths along roughly vertical and horizontal axes, producing a stable kind of design. This design also seemed prompted by a classicizing urge. The painting thus became a kind of gestural geometry, as if Soutine had repainted a work of Mondrian.

Around 1960, female figures reappeared in De Kooning's canvases. The new nudes are somewhat related to the *Women* of the early and middle 1950's but are different in that they are landscape turned into figure. The first works in the series called to mind earth and fertility goddesses; later in the 1960's, they became frank instruments of sex—lustfully enticing, yielding yet demanding, and cruelly anxiety provoking (*Fig. 9-17*). Although they allude

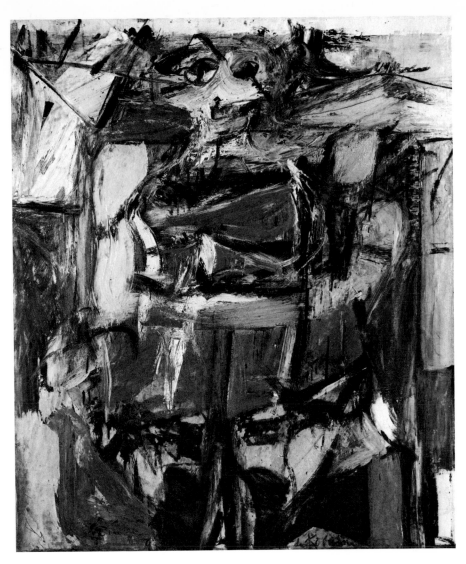

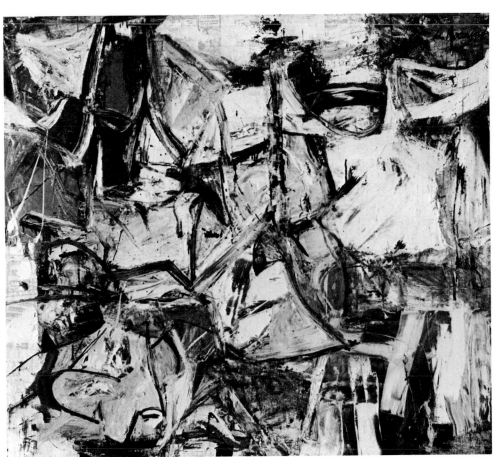

9–15 Willem de Kooning. *Gotham News.*
1955–56.
Albright-Knox Art Gallery, Buffalo, New York;
Gift of Seymour H. Knox.

135

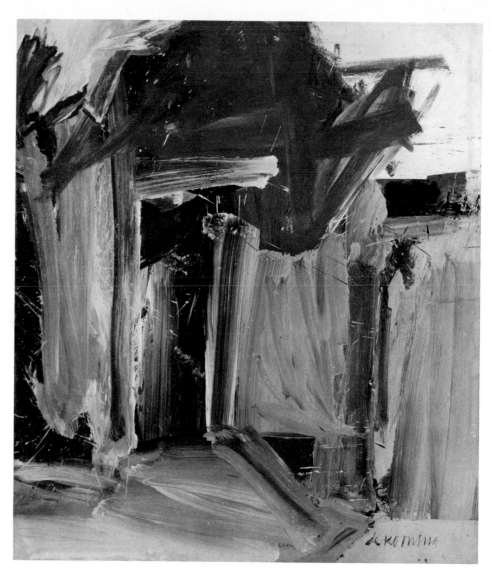

9–16 Willem de Kooning. *Door to the River*. 1960.
Collection Whitney Museum of American Art, New York;
Gift of the Friends of the Whitney Museum of American Art (and purchase).

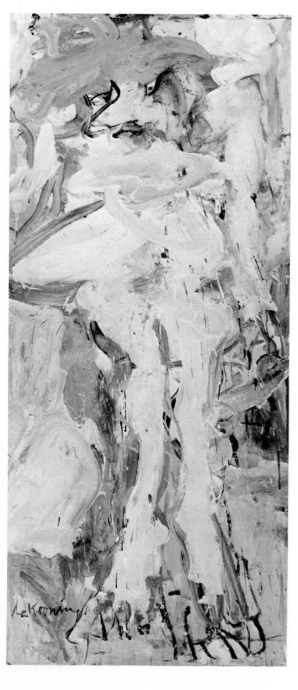

9–17 Willem de Kooning. *Woman Acabonic*. 1966.
Collection Whitney Museum of American Art, New York;
Gift of Mrs. Bernard Gimbel.

to Baroque and Rococo nudes, they are distorted by obsessions with the body and its functions, by desperate passions, psychological quandaries, and ferocious appetites that the old masters usually preferred not to depict.

De Kooning's works of the late 1940's and 1950's gave rise to hundreds of imitations. Indeed, of the older Abstract Expressionists, he was the most influential on the generation that matured in the 1950's. Accountable for his leading role was the freshness of his paintings and their masterliness, his availability to younger artists, his charismatic personality, and his verbal brilliance. He pointed the way to one kind of gesture painting, yet his radicalism was tempered by traditional values—a combination that proved attractive to large numbers of his contemporaries. Perhaps most important is the fact that the direct manner in which he exposed his complex experience struck a responsive chord in kindred artists.

9 Notes

1. Willem de Kooning, "What Abstract Art Means to Me," *Museum of Modern Art Bulletin*, XVIII, No. 3 (Spring, 1951), 7.
2. *Ibid.*
3. Willem de Kooning, quoted in William C. Seitz, "Abstract Expressionist Painting in America" (Ph.D. dissertation, Princeton University, 1955), pp. 319–20.
4. De Kooning, Gorky, and Graham posed a number of figural problems that they undertook to solve almost as a collective enterprise. In an interview with the author, De Kooning remarked that Graham once borrowed one of his canvases to copy his treatment of the shoulder. It is interesting to note that neither artist, nor Gorky, "solved" the hands, which were generally left "unfinished." At one point, these areas seem to have become the solution.
5. There are precedents for this practice, in Cubist dislocation of images and in Ingres' fetishistic treatment of necks and ankles.
6. De Kooning admired Cubism for its poetic ambiguity as well as for its emphasis on firm structure.

In "What Abstract Art Means to Me," p. 7, he wrote: "Of all movements, I like Cubism most. It had that wonderful unsure atmosphere of reflection —a poetic frame where something could be possible, where an artist could practice his intuition."

Clement Greenberg claimed that De Kooning, throughout his career, was a "late Cubist," but that conception is open to serious criticism. Greenberg emphasized only one aspect of De Kooning's design, ignoring his extreme departures from the earlier style.
7. Thomas B. Hess, *Willem de Kooning* (New York: Braziller, 1959), p. 24.
8. Willem de Kooning, "Content is a Glimpse," *Location*, I, No. 1 (Spring, 1963), 47.
9. Seitz, "Abstract Expressionist Painting in America," p. 320.
10. De Kooning, "Content is a Glimpse," p. 46.
11. Henry Miller, *Tropic of Capricorn* (New York: Grove Press, 1961), pp. 341–43.
12. Seitz, "Abstract Expressionist Painting in America," p. 209.
13. De Kooning, "Content is a Glimpse," p. 47.

10 Hans Hofmann (1880–1966)

HOFMANN, like De Kooning, was nurtured by modern European art. He spent the years from 1904 to 1914 in Paris, where he befriended many of the leading avant-garde artists of the Fauvist and Cubist movements. From 1915 to 1936, he devoted most of his time to the teaching of art; only in 1937 did he resume painting in earnest. Following the example of Robert Delaunay, his close friend in Paris prior to World War I, Hofmann attempted to merge compacted Cubist structure with explosive Fauvist and Expressionist color and facture, later introducing ideas suggested by Kandinsky's early improvisations, Surrealist automatism, and Mondrian's abstractions. His desire to amalgamate older styles reflected his traditional bent. In this, he was related to De Kooning, but with the difference that his firsthand familiarity with French painting and its aesthetics helped make him more secure in his traditionalism.

Nonetheless, Hofmann was also an innovator, influential in the development of Abstract Expressionism. Much as he relied on Cubist design throughout his career, he was one of the first to loosen it by opening its closed planes and by using color in itself to determine structure. As early as 1943, Hofmann began pitting areas of high-keyed color against each other, deriving the form of his picture from their interaction. This involved pulling receding areas up to the surface and pushing back areas that protruded, in order to flatten the picture plane. The sense of the push and pull turns a picture into a

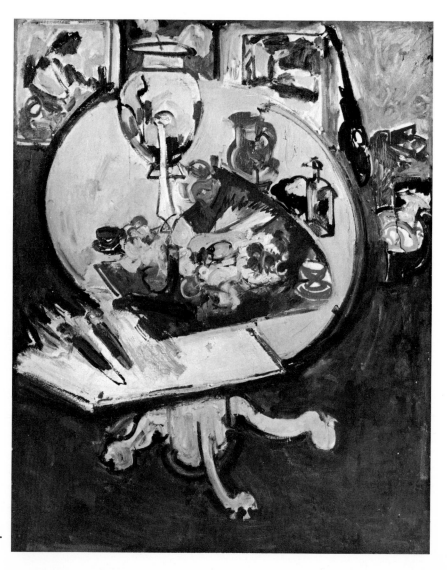

10–1 Hans Hofmann. *Still Life, Yellow Table in Green.* 1936.
Estate of Hans Hofmann.

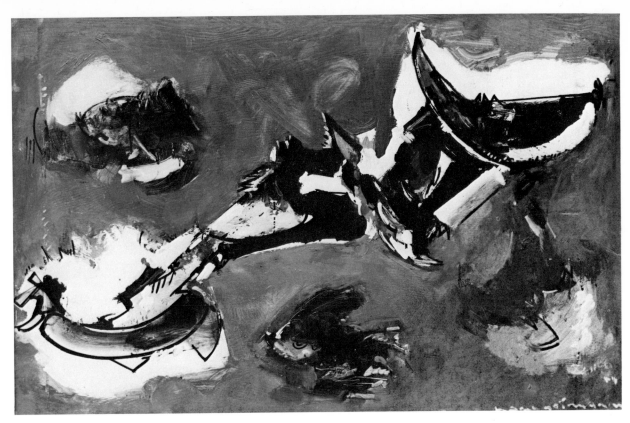

10–2 Hans Hofmann. *Black Demon.* c. 1944.
Addison Gallery of American Art, Phillips Academy, Andover, Massachusetts.

dynamic field of forces. At the same time that Hofmann maintained surface tension, he invested each area with a suggestion of the third dimension that made it feel ample. Contributing to this sense of plasticity was the richness of his pigmentation. Clement Greenberg remarked that Hofmann addressed "the picture surface consciously as a responsive rather than inert object, and painting itself as an affair of prodding and pushing, scoring and marking, rather than of simply inscribing or covering. . . . And it is thanks in part to Hofmann that the 'new' American painting in general is distinguished by a new liveliness of surface." [1]

Hofmann found the fullness of color and surface in the direct process of painting. However, he was also engaged in the calculated solution of formal problems, in "picture-making." He was by nature a theorist; his forty-three-year career as a teacher was proof of his strong need to analyze, systematize, and explain. His intellectual bent also disposed him to Cubist organization, whose logic dominated his teaching and painting into the 1940's. However, Hofmann was anything but a dry rationalist and believed that painting ought to be freely executed with a minimum of premeditation. He probably derived this idea from Kandinsky (whose improvisations he knew as early as World War I, when he stored many in his Munich studio), although he did not put it into practice wholeheartedly until after 1942. Hofmann's delight in spontaneous improvisation and paradoxically his penchant for posing difficult formal problems led him to invent an incredible variety of images and to venture in multiple directions simultaneously. He also introduced a number of radical ideas at an early date: for example, he was pouring paint on his canvases three years before Pollock used the technique.

From 1936 to 1941, Hofmann abstracted from nature, sectioning recognizable images into flat planes—in the Synthetic Cubist manner—and painting them with high-keyed colors whose sources were in Fauvism, as in *Still Life, Yellow Table in Green* (1936; *Fig. 10-1*). Even the most ambitious of these pictures were derivative and tamely bound to visual appearances.

139

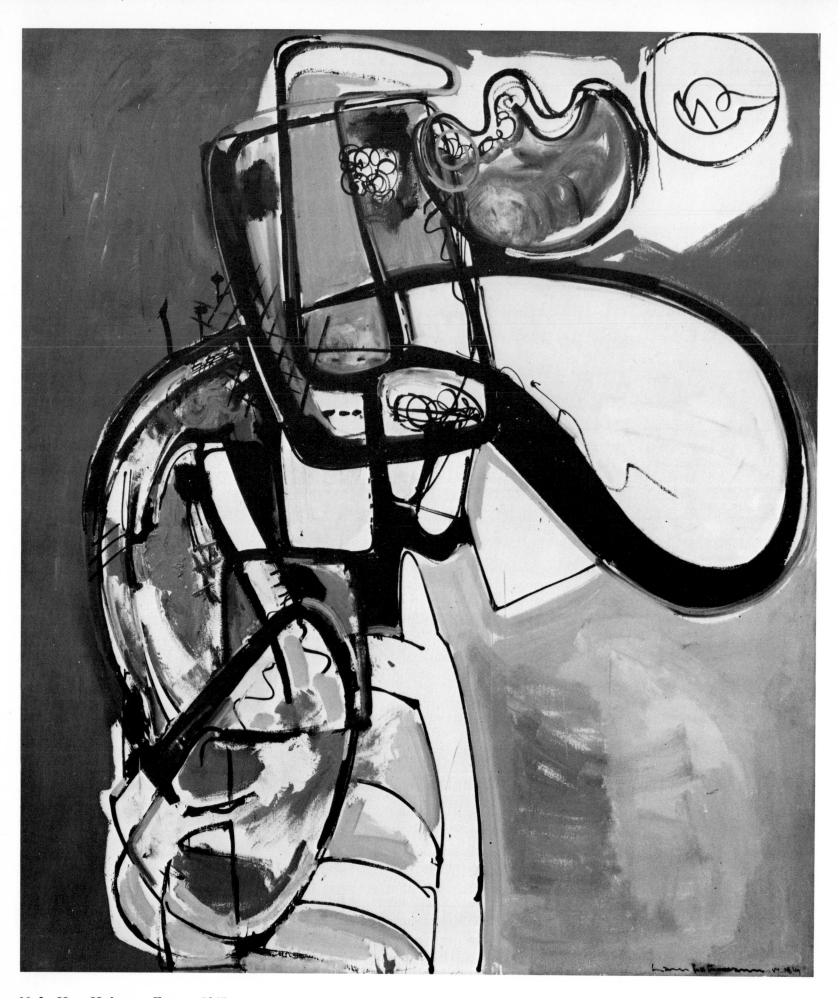

10–3 Hans Hofmann. *Ecstasy*. 1947.
Collection University Art Museum, Berkeley, California;
Gift of the artist.

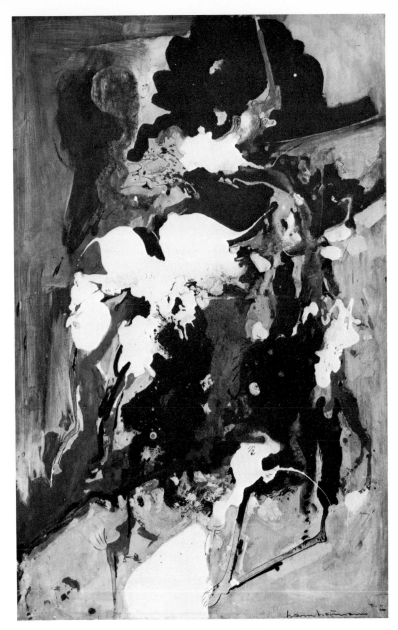

10–4 Hans Hofmann. *Effervescence*. 1944.
Collection University Art Museum, Berkeley, California;
Gift of the artist.

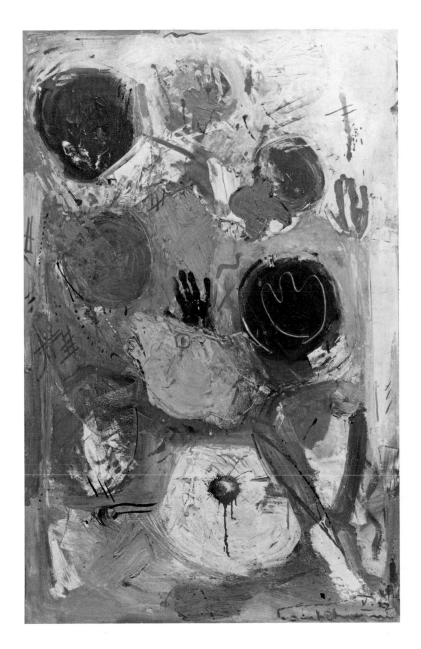

10–5 Hans Hofmann. *The Third Hand*. 1947.
Collection University Art Museum, Berkeley, California;
Gift of the artist.

However, the early works anticipate the originality of subsequent canvases, in that they are composed of complex and richly textured small shapes of contrasting vivid colors, painted so energetically that they tend to decompose the subjects and suggest the abstract shapes that he would later favor.

In 1942, Hofmann's painting grew increasingly impulsive. Prior to that year, he had disparaged Surrealism, but when its premises began to be re-evaluated by the New York vanguard, he was quick to grasp the possibilities of automatism, yet without sacrificing Cubist design.[2] By giving his work a freer, more organic and abstract look, Hofmann moved in the direction that Gorky, Pollock, Motherwell, Baziotes, Gottlieb, and Rothko were taking. Hofmann's imagery, like theirs, often had mythic connotations, as in *Idolatress I* (1944; *Fig. 4-6*), which depicts a ferocious harpy, and *Black Demon* (*ca.* 1944; *Fig.*

10-2). He continued to invent fantastic creatures and birds (a favorite motif) —frequently mechano-biomorphic—until around 1947 (*Fig. 10-3*).[3] Composed of flat, outlined organic shapes contained within the picture limits, such canvases as *Transfiguration* (1947; *IX*, p. 161) are reminiscent of works by Miró, Picasso, and Arp.

However, Hofmann had earlier begun to pursue a painterly direction, which for the first time he carried into near-abstraction during 1944. From then on, he often obliterated specific images, although he claimed throughout his life that he based his pictures on nature.[4] In 1944, Hofmann carried spontaneity to an extreme in a number of abstractions (*Effervescence*, 1944; *Fig. 10-4*) consisting of splashes and dribbles of pigment, which in their randomness and biomorphism were wholly opposed to Cubism in spirit. He was to paint in this manner intermittently until his death.

Hofmann's best-known and most consistently successful pictures are the abstractions he began in 1946; they are composed of vigorously brushed, high-keyed, open areas (*Figs. 10-5, 10-6, 10-7*). However, in most of his paintings in this tactile vein, even his most untamed, Hofmann did not entirely relinquish the articulated planes of Synthetic Cubism, although they tend to be disintegrated by the exuberant facture. Hofmann's works became sparer in 1951, consisting of paint loaded lines inscribed on white grounds, like expan-

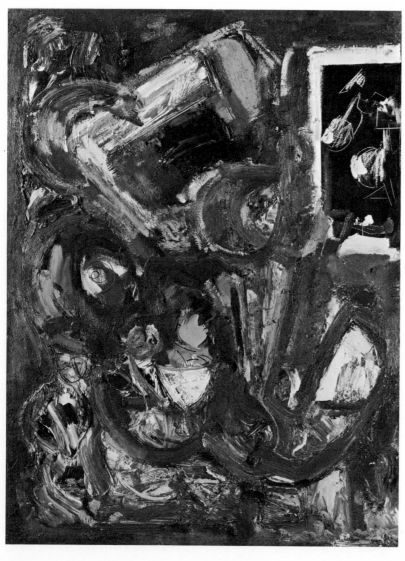

10–6 Hans Hofmann. *Blue Rhythm*. 1950.
Courtesy of The Art Institute of Chicago, Chicago, Illinois; Gift of the Society for Contemporary American Art.

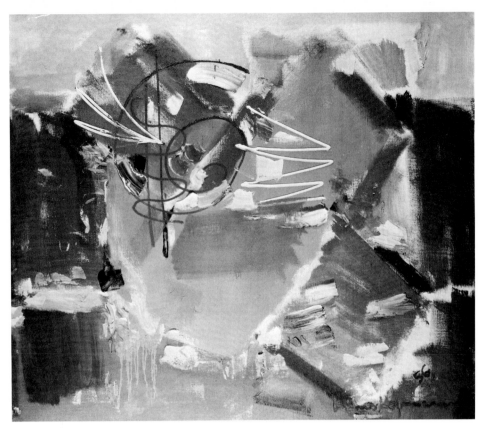

10–7 Hans Hofmann. *Capriccioso*. 1956.
Norman Mackenzie Art Gallery, University of Saskatchewan, Regina Campus.

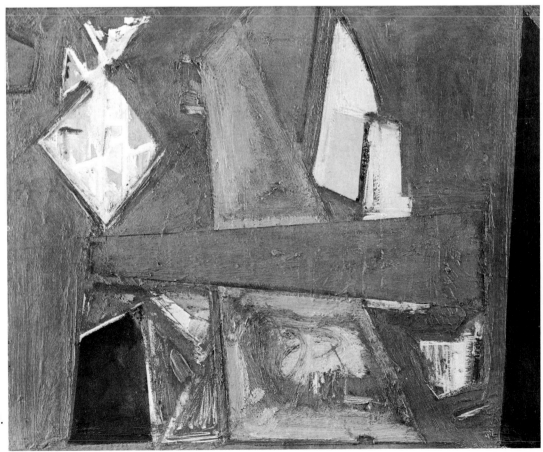

10–8 Hans Hofmann. *Blue Balance*. 1949.
New York University Art Collection, New York;
Gift of Harry Pinkerson.

143

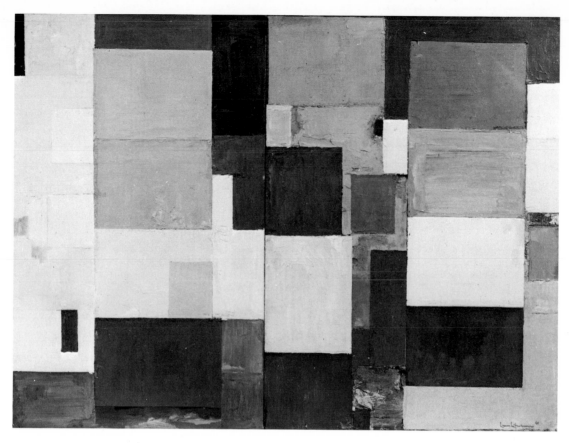

10–9 Hans Hofmann. *Combinable Wall I and II.* 1961.
Collection University Art Museum, Berkeley, California;
Gift of the artist.

sive fields. The following year, he resumed packing the entire surface with roughly rectangular areas of impasto.

In many of Hofmann's canvases executed after 1952, the areas are hardened into oblong planes placed among complexes of free calligraphy and ambiguous, loosely brushed areas—thus creating a mixture of elements associated with geometric abstraction, Fauvism, and Expressionism (X, p. 164). This trend is anticipated in *Blue Balance* (1949; *Fig. 10-8*).[5] Hofmann succeeded in reconciling these conflicting components by imparting a sense of volume to both, the open areas rendered as plastically as the delineated forms. In a series of pictures painted after 1958, the rectangles of flat color are multiplied until they cover the entire canvas, as in *Combinable Wall I and II* (1961; *Fig. 10-9*). These pictures are geometric abstractions in the manner of Mondrian, but they are not purist, for Hofmann's planes are paint loaded, and the vivid, dissonant colors (reminiscent of Matisse) strain to burst the stable rectangular containers.[6] In this series, Hofmann achieved a life-long ambition: a grand synthesis of Cubist architecture and Fauvist color, in an original, nonobjective style.

As if in reaction against the rigor of these compositions, Hofmann began a new series of splash paintings in the late 1950's. In other works, he denied the density of his customary pigmentation by drawing simple, broad, semi-transparent washes of pale, glowing color on the white surface (*Fig. 10-10*). Hofmann's masterwork in this vein, *Agrigento (Fig. 10-11)*, is composed of roughly rectangular swaths that call to mind his geometric abstractions of the late 1950's and his "white" paintings of 1951, but the openness and airiness of the color-soaked expanses are new in his work.

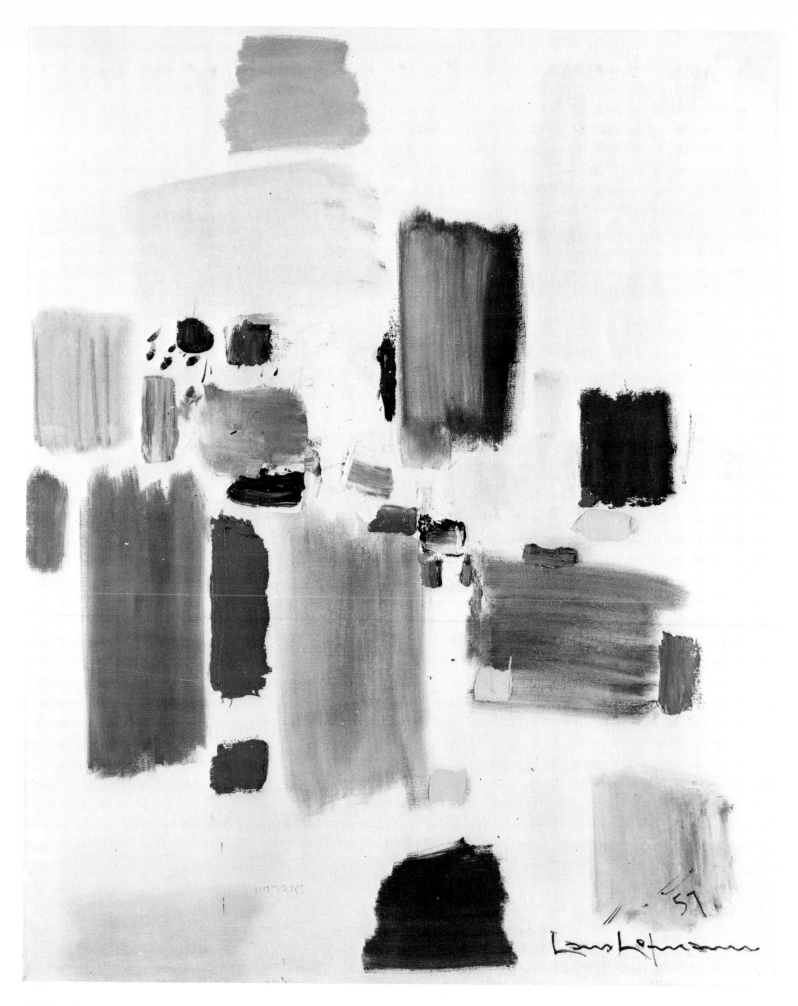

10–10 Hans Hofmann. *Sparks.* 1957.
Collection Mr. and Mrs. Theodore N. Law, Houston, Texas.

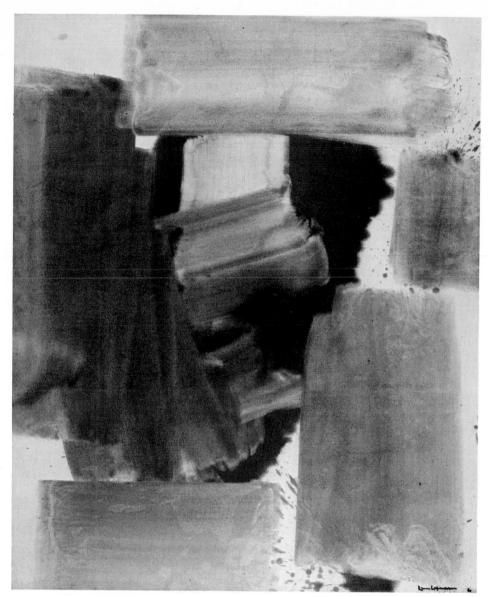

10–11 Hans Hofmann. *Agrigento*. 1961.
Collection University Art Museum, Berkeley, California;
Gift of the artist.

The push-and-pull tension of Hofmann's painting was symbolic in his eyes
of the underlying force-counterforce dynamic of nature. At the same time,
the interaction of planar elements creates a sense of volume, which, because
it is untangible and immaterial, paradoxically constitutes a synthesis of a
spiritual order. Hofmann also thought that the act of painting yielded psycho-
logical meanings; in his case, the opulent color and surfacing are the signs
of a hedonistic personality, high spirited and robust. During the mid-1940's,
critics considered his pictures related to German Expressionism; however,
Hofmann was temperamentally closer to the French Fauves, and on the
whole, his works convey an unabashedly joyous vision of life rarely shadowed
by a tragic cast. It is this quality that distinguishes them generally from the
more pessimistic pictures of his fellow Abstract Expressionists.

146

1. Clement Greenberg, *Hans Hofmann* (Paris: Editions Georges Fall, 1961), pp. 24–25.

2. The Surrealist bent in Hofmann's thinking is clear in his statement for the catalogue announcement for his show at the Art of This Century Gallery, 1944: "to me creation is a metamorphosis. The highest in art is the irrational. . . . incited by reality, imagination, bursts into passion the potential inner life of a chosen medium, the final image resulting from it expresses the **all** of oneself."

3. Hofmann was accepted by the myth-makers as one of them; his *Fury II* was included in the "Ideographic Picture" show organized by Barnett Newman at the Betty Parsons Gallery in 1947.

4. Frederick Wight, *Hans Hofmann* (Berkeley and Los Angeles: University of California Press, 1957), p. 23, quoted Hofmann: "The object should not take the importance. There are bigger things to be seen in nature than the object. To become [more] expressive, something must be suppressed. . . . But I have never given up the *object*."

5. Hofmann may have derived the idea of using rectangles in his painting from one of his teaching techniques: attaching pieces of construction paper to the canvases of his students. It may also be as Sam Hunter, *Hans Hofmann* (New York: Harry N. Abrams, 1964), p. 15, observed that the geometric diagrams in Hofmann's unpublished manual, *The Painter and His Problems*, were the source of the motifs in his geometric abstractions.

6. Greenberg, *Hans Hofmann*, p. 14.

11 The Color-Field Painters

GESTURE painting was one of the two mainstreams in Abstract Expressionism; color-field painting was the other. After 1947, its innovators—Still, Rothko, and Newman—focused increasingly on the expressive possibilities of color. In the process, they posed a formal problem new in art: If, in order to maximize the visual impact or immediacy of colors, they found that they had to apply them in large expanses that saturate the eye, had to eliminate figuration and symbolism, had to simplify drawing and gesture, and had to suppress the contrast of light and dark values that dull colors—how were they to avoid formlessness and compose cohesive pictures? Their solution was to adjust color areas to create a unified field, each zone of which would be of equal chromatic intensity. During the 1950's, a controversy arose over which of the three artists had actually initiated color-field abstraction. Still was the first to exhibit pictures in this manner—in 1947—and can be considered the pathfinder.[1] However, the three were close friends until around 1952, and any influences were probably reciprocal.

In treating a surface as a field, the color-field painters were akin to many gesture painters (Pollock for example), although their pictorial means in most other respects were dissimilar. Gesture painting was mainly linear, although as Greenberg pointed out, it could be coloristic in that the artist "draws with a full brush, with color and in masses, instead of tinting or filling in a prepared outline."[2] Conversely, too, drawing was crucial to color-field painting, for, being so simplified, any lapse in its vitality was readily visible and would destroy a picture. In a sense, the color-field painters tackled formal problems that were more difficult than those that confronted the gesture painters, for they diverged more radically from the familiar structural basis of Western art: the modulation of light and dark values to produce an illusion of mass in space.[3]

But the color-field painters, like the gesture painters, did not talk much about formal or art historical matters, at least not in their public statements. They stressed instead the primacy of content, and it was the shifts in their attitudes toward content that in large measure determined changes in their styles. During the early and middle 1940's, Rothko, Still, and Newman painted myth-inspired semi-abstractions. In the latter part of the decade, they conceived of making their symbols more universal and immediate, and so changed their pictorial means. Because the change in intention anticipated the change in form, an analysis of their ideas illuminates their stylistic developments.

At the beginning of 1947, Newman—who had earlier organized exhibitions of primitive art—arranged a show of contemporary paintings entitled "The Ideographic Picture" at the Betty Parsons Gallery. It included works by himself, Hofmann, Reinhardt, Rothko, Stamos, and Still, all of them members of the gallery. Newman's aim, like Putzel's earlier, was to define and label a direction in American art. In the catalogue to the exhibition, he wrote: "Spontaneous, and emerging from several points, there has arisen during the war years a new force in American painting that is the modern counterpart of the primitive art impulse."[4] The new painting was based on the "ideograph," which, according to the Century Dictionary as quoted by Newman, is a "character, symbol or figure which suggests the idea of an object without expressing its name."[5]

Newman regarded the ideographic painters as abstract symbolists—like the Northwest Coast Indian artists. But he also minimized the symbolic references, the allusions to observable phenomena in their paintings, and he con-

sidered the shapes they used as abstract, "directed by a ritualistic will towards metaphysical understanding." [6] That is, he implied that a nonsymbolic approach was possible, one that emphasized the expressive potential of the abstract shape in itself as "a living thing, a vehicle for an abstract thought-complex, a carrier of the awesome feelings he [the Kwakiutl Indian] felt before the terror of the unknowable. The abstract shape was, therefore, real rather than a formal 'abstraction' of a visual fact, with its overtone of an already known nature. Nor was it a purist illusion with its overload of pseudo-scientific truths." [7]

To supplant an art of "purist illusion," Newman proposed an art of "pure idea" that makes contact with the mystery of man's being and of his tragic condition. By 1948, he had come to equate the "pure idea" with the sublime and, like the eighteenth-century philosopher Edmund Burke, to think that it was incompatible with beauty. [8] Newman believed that "notions of the beautiful," of perfection and quality—what he called the Greek ideal—were built into European art, including modern art, the culmination of perfect form being Mondrian's geometry. Notions of the beautiful would have to be renounced if the sublime were to be suggested—that choice, Newman maintained, was understood only by a few of his contemporaries in America who had freed themselves of European culture and its preoccupation with beauty.

> The question that now arises is how, if we are living in a time without a legend or mythos that can be called sublime, if we refuse to admit any exaltation in pure relations, if we refuse to live in the abstract, how can we be creating a sublime art? We are reasserting man's natural desire for the exalted, for a concern with our relationships to the absolute emotions. We do not need the obsolete props of an outmoded and antiquated legend. . . . We are freeing ourselves of the impediments of memory, association, nostaglia, legend, myth, or what have you, that have been the devices of Western European painting. Instead of making *cathedrals* out of Christ, man, or "life," we are are making them out of ourselves, out of our own feelings. The image we produce is the self-evident one of revelation, real and concrete, that can be understood by anyone who will look at it without the nostalgic glasses of history. [9]

Although Newman repudiated European art as a whole because it aimed to achieve perfect form, he found within it an alternative approach, that of the Gothic or Baroque, which "consists of a desire to destroy form; where form can be formless." [10] He implied that this approach would be the most fruitful in creating a sublime art.

Rothko was also interested in the possibility of nonsymbolic mythic or metaphysical art. In the winter of 1947–48, he wrote that if art was to reveal "transcendental experiences," it would have to be rid of the familiar, of received images, ideas and forms. Archaic societies had incorporated with credibility elements from the everyday world into their rituals, but this had become impossible in modern times. Consequently: "With us the disguise must be complete. The familiar identity of things has to be pulverized in order to destroy the finite associations with which our society increasingly enshrouds every aspect of our environment." [11] In his painting, Rothko would strive for a form directly suggestive of his idea of transcendental drama. As he wrote in 1949: "The progression of a painter's work, as it travels in time from point to point, will be . . . toward the elimination of all obstacles between the painter and the idea, and between the idea and the observer. As examples of such obstacles, I give (among others) memory, history or geometry, which

are swamps of generalization from which one might pull out parodies of ideas . . . but never an idea in itself." [12]

Clyfford Still did not publish his views in the 1940's, but they were similar to those of his two friends. He believed that unless painting contained a new revelation, it was worthless.

> I held it imperative to evolve an instrument of thought which would aid in cutting through all cultural opiates, past and present, so that a direct, immediate, and truly free vision could be achieved, and an idea be revealed with clarity. . . . No shouting about individualism, no capering before an expanse of canvas, no manipulation of academic conceits or technical fetishes can truly liberate. . . . Thus it was necessary to reject the superficial value of materiel—its qualities, its tensions, and its concomitant ethic. Especially it became necessary not to remain trapped in the banal concepts of space and time, nor yield to the morbidity of "the objective position"; nor to permit one's courage to be perverted by authoritarian devices for social control. [13]

In sum, the intentions of the color-field painters were visionary; they aimed to create an abstract art suggestive of the sublime, of transcendence, of revelation. In the past, revelation has been the function of organized religion—including, of course, religious art. In the modern era, religious dogmas, rituals, symbols, and images have all lost their power to grip the imagination of artists. However, the yearning for a transcendental realm of being has not lessened, and some artists continue to seek means of expressing private visions of their infinite yearnings, in the hope of replacing the time-worn visions of organized religions, and this in a universe the existentially minded believed lacking in ultimate meaning. To achieve a new art of the sublime, the color-field painters tried to suppress in their art all references to familiar images in nature or in past and present art, since such references would elicit predictable responses. They were particularly antagonistic to Mondrian and repudiated his Neoplastic conception of the absolute, codified into a set of rules thought of as embedded in nature—that is, externally given—and as symbolic of its underlying fundamental relations. They refused to accept any system imposed from-without, for they wanted, in Newman's words, to make "*cathedrals* . . . out of ourselves." The divergence in their styles is proof of the privacy of their points of view.

Newman's vision was grand, but it was also tragic, for the individual is fallible and mortal. The disquiet generated by this awareness is felt in color-field abstractions as it is not in Mondrian's pictures, which aim to be calm, stable, and comforting. The color-field painters also rejected Neoplasticism because—like all Cubist-oriented abstraction—it had become too familiar to evoke the sublime. Not only was Neoplasticism the major force in American Nonobjective art of the 1930's, but it was an extension into abstraction of the entire tradition of Western classical art. In reaction, the color-field painters avoided cleanly contoured rectangles that formed tightly knit, asymmetrical compositions in perfect equilibrium or harmony, and spurned predetermined colors that functioned as adjuncts to the structure, adding to its stability. In addition, they abandoned the calligraphic, quasi-figurative symbols of their own earlier mythic pictures, which had come to appear too finite to evoke the infinite. They repudiated the automatist technique of the Surrealists because it yielded images that had become commonplace to the extent that they allowed the mind to digress into familiar patterns

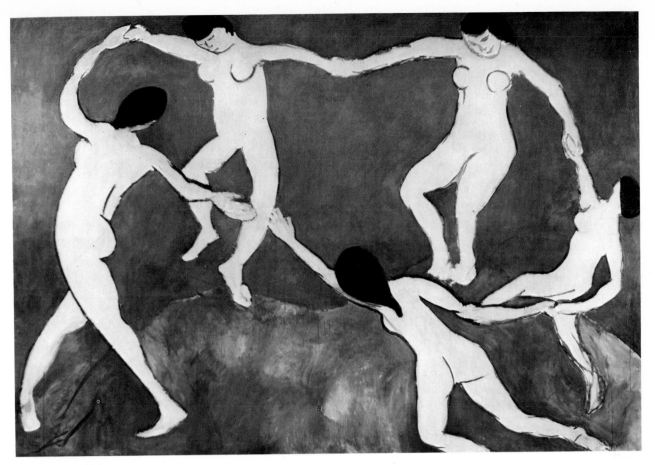

11–1 Henri Matisse. *Dance*. 1909.
Collection The Museum of Modern Art, New York;
Gift of Governor Nelson A. Rockefeller in Honor of Alfred H. Barr, Jr.

of perception. Moreover, automatist images seemed too autographic to suggest the universal.

Much as the color-field painters tried to deny all received ideas, their ambition was impossible to achieve, for, in fact, revolutionary art is always evolutionary. The color-field painters did indeed have forerunners who gave them permission to reach adventurously beyond figuration into abstraction. Among their precursors were Matisse (*Fig. 11-1*), Milton Avery (*Fig. 11-2*), and, to a lesser extent, Miró (*Fig. 11-3*), two of whose paintings in the Gallatin Collection were essentially color-fields.[14] The affective power of color in itself had earlier been noted by Matisse, who remarked that it can act "upon the inner sensibility like the sudden stroke of a gong." [15] Still, Rothko, and Newman used color to evoke the sublime directly. Moreover, they applied it in expanses that inundate the eye with an immediacy that stuns the viewer, numbing him into a state of detachement from his everyday attachments.

The areas that the color-field artists painted were open and appeared to expand beyond the picture edges, instead of being confined within the picture frame, as in Neoplastic paintings. Simple, indefinite, and seemingly vast expanses produce an "effect of infinity," which was listed by Burke as one of the attributes of the sublime, and it was this effect that the color-field painters wished to achieve.[16] To intensify further the sense of boundlessness, they favored closely valued colors whose transitions from area to area were not abrupt, painted their surfaces more or less evenly, and avoided sharp delineations in drawing. It was as if they were heeding Burke's warning that the imagination should not "at every change find a check . . . [making it] impossible to continue that uninterrupted progression which alone stamps on bounded objects the character of infinity." [17]

151

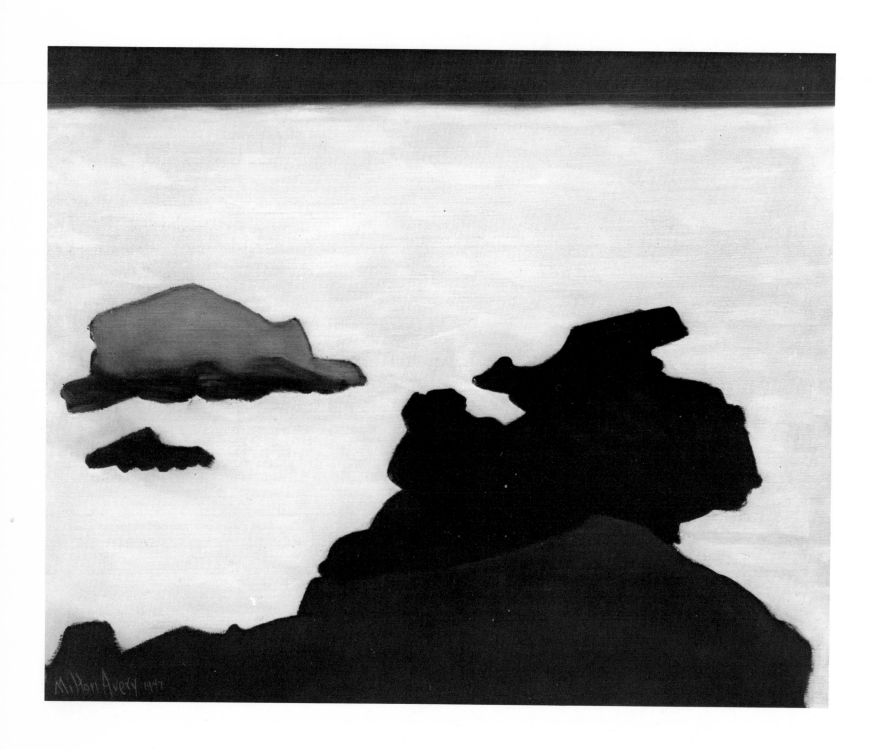

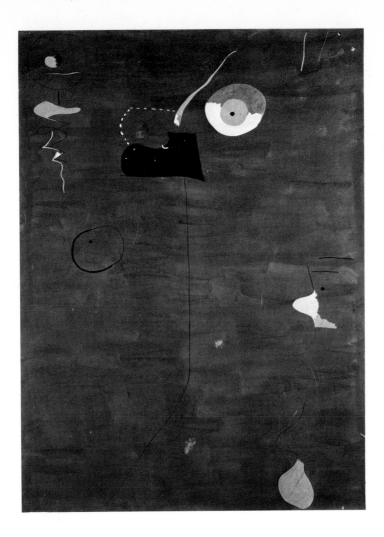

11–3 Joan Miró. *Painting (Fratellini)*. 1927.
Philadelphia Museum of Art, Philadelphia, Pennsylvania;
A. E. Gallatin Collection.

The simplification of pictorial means practiced by the color-field painters served a purpose other than that of creating an effect of infinity. It produced an elemental impact akin to that evoked by primitive art, which they greatly admired. Robert Goldwater wrote that there is

> a *common assumption* that pervades . . . [primitivistic] works and their apologetics. This is the assumption that externals, whether those of a social or cultural group, of individual psychology, or of the physical world, are intricate and complicated and *as such not desirable*. It is the assumption that any reaching under the surface, if only it is carried far enough and proceeds according to the proper method, will reveal something "simple" and basic which . . . will be more emotionally compelling than the superficial variations of the surface. . . . In other words, it is the assumption that the further one goes back—historically, psychologically, or aesthetically—the simpler things become; and that because they are simpler they are more profound, more important, and more valuable.[18]

Goldwater also remarked that "a simplification of technique and an omission of all detail, a deliberate suppression of nuance and overtone . . . [could lead to] a single, undifferentiated, overwhelming emotional effect."[19] The color-field painters carried this tendency to an extreme unprecedented in the history of art.

To augment the immediate sensation of all-pervading color, Still, Rothko, and Newman began to work on a monumental scale around 1950—recognizing, as Burke wrote, that "greatness of dimension, is a powerful cause of the sublime."[20] Paradoxically, however, they were interested in creating an effect opposite to awesomeness. As Rothko said in 1951:

I realize that historically the function of painting large pictures is painting something very grandiose and pompous. The reason I paint them, however—I think it applies to other painters I know—is precisely because I want to be very intimate and human. To paint a small picture is to place yourself outside your experience, to look upon an experience as a stereopticon view or with a reducing glass. However you paint the larger picture, you are in it. It isn't something you command.[21]

The huge size of color-field abstractions fulfilled yet another function: pictures that fill the viewer's field of vision become a kind of environment, special places that engage him with immediacy while screening him from his everyday surroundings and releasing him from them. The color-field painters intended their out-sized abstractions to be seen in small rooms rather than in public spaces, where they would function like murals within architectural settings. In a statement for his 1951 exhibition, Newman wrote: "There is a tendency to look at large pictures from a distance. The large pictures in this exhibition are intended to be seen from a short distance." [22] The large-scale canvas when viewed at close range generated a variety of responses simultaneously: It was disquieting, for a viewer who would naturally want to back away from a huge picture to take it all in could not do so in a small room; it was astonishing, this occurring, as Burke remarked, when "the mind is so entirely filled with its object, that it cannot entertain any other." [23] And it was intimate in the sense that Rothko used the word, and immediate, forcing the viewer to participate in it more totally than would be possible with a small-scale work.

Their interest in paintings as environments led the color-field artists to concern themselves with the manner in which their works were shown. This consideration was also prompted by their belief that a painting should be an unqualified act—a revelation. Consequently, they tried to control the conditions under which their paintings were revealed to the public, paying much attention to installation of their canvases or refusing to exhibit in group shows, since other pictures would impinge upon and qualify theirs. At times, they refrained from exhibiting at all, asserting that the atmosphere of "corrupt" galleries destroyed the meaning of their works.

Despite the differences in their pictorial means, the color-field and gesture painters have been linked together under the title of Abstract Expressionists. There is some justification for this, since they all shared a common romantic attitude. The gesture painters considered the artist an existential hero who tried to reveal as directly as he could his creative actions. By contrast, the color-field painters suppressed all record of their autographic processes; they conceived of the artist as an oracle and of his creative act as an attempt to reach a suprapersonal absolute.

During the 1940's, it was difficult to view gesture painting and color-field painting as separate directions, for they began to diverge markedly only after 1948. Prior to that date, all the Abstract Expressionists worked in more or less linear and quasi-figurative manners. Other factors that bound them together were their common assumption that painting had to express meaning beyond the mere arrangement of forms and colors and their desire to create an abstract art that was passionate, dramatic, and original. However, the color-field painters and the gesture painters had different attitudes toward originality, as painter Raymond Parker pointed out. To the color-field painter (or intent painter, as Parker called him), "meaningfulness in painting is inseparable from originality. . . . The terms of intent painting are exclusive; no forma-

tions or subjects used by other painters can be re-presented without yielding something in intention. . . . Clarity in painting depends on knowing other (past) art well enough that it can't reappear even in the cleverest disguise to allow confusion." But having once achieved an original form that fulfills his intention, "he regards as trivial the attempts to say something in a new way." [24] Thus, Parker accounted for the color-field painter's tendency to repeat the same format. The gesture painter, on the other hand (characterized by Parker as the direct painter), "is suspicious of anything appearing in the painting that he recognizes; he questions the already known. This is antistylistic in bias and bars quotes or allusions. . . . He must learn—and relearn for each painting—the creative leap to accept that which is seen for the first time: the painting is completed in the moment of his realization." [25] This difference in approach caused both groups to be somewhat suspicious of each other. Some gesture painters disparaged color-field abstraction because of its seeming repetitiveness as an "idea art," as too "intellectual," while some color-field painters felt that gesture painting was too much a matter of "method," which could not yield paintings that were unqualified acts.

Because both prized originality, the gesture and color-field painters dared to explore unfamiliar possibilities, whose ends could not be known. Therefore, the Abstract Expressionists welcomed extreme positions. But an extremist art is also dramatic, and the Abstract Expressionists shared a love of drama. This in part led them to paint the "big" picture. In retrospect, it seems that Abstract Expressionist paintings prior to 1950 were not very large in comparison to the huge pictures executed later. However, size is relative. At the time they were shown, the works seemed huge, which is what the artists intended. Many would have liked to have worked on an even larger scale but could not afford it. For example, in 1947, Pollock applied for a Guggenheim fellowship in order to paint "movable pictures which will function between the easel and mural. . . . I believe the easel

11–4 Jackson Pollock. *Mural.* 1943.
The University of Iowa Museum of Art, Iowa City, Iowa;
Gift of Peggy Guggenheim.

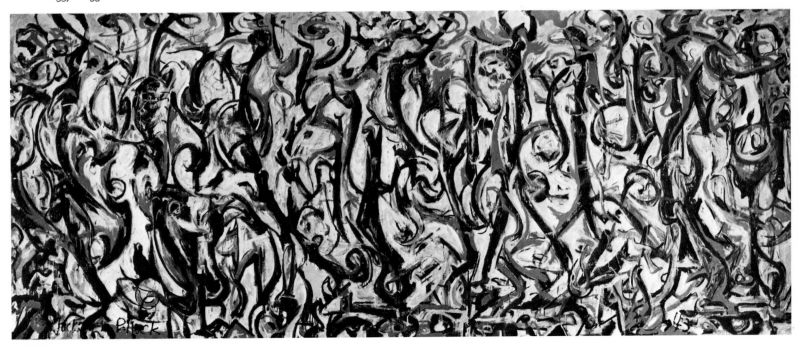

155

picture to be a dying form, and the tendency of modern feeling is towards the wall picture or mural " (*Fig. 11-4*). [26]

There were other motivations for the Abstract Expressionists' urge to create monumental pictures. As Motherwell said:

> The large format, at one blow, destroyed the century-long tendency of the French to domesticize modern painting, to make it intimate. We replaced the nude girl and the French door with a modern Stonehenge, with the sense of the sublime and the tragic. . . . One of the great images [of Abstract Expressionism] . . . should be the house-painter's brush, in the employ of a grand vision dominated by an ethical sensibility that makes the usual painter's brush indeed picayune.[27]

The radicality of the Abstract Expressionists' renewal of art is indicated by the public's shocked and angry response to their pictures. The artists expected that their assaults on perceptual habits would not be kindly received at first, but they were hurt by the intensity of public hostility and its duration. However, their disappointment was offset by a "sense of excitement," as Goldwater remarked: "The consciousness of being on the frontier, of being ahead rather than behind, of having absolutely no models however immediate or illustrious, of being entirely and completely on one's own—this was a new heady atmosphere." [28]

1. Clement Greenberg, " 'American-Type' Painting," *Partisan Review*, XXII, No. 2 (Spring, 1955), 190–93, considered Still to be "one of the most important and original painters of our time—perhaps the most original of all painters under fifty-five, if not the best. . . . His paintings were the first abstract pictures I ever saw that contained almost no allusion to Cubism. . . . An indirect sign of this importance is the fact that he is almost the only abstract expressionist to 'make' a school; by this I mean that a few of the many artists he has stimulated or influenced have not been condemned by that to imitate him, but have been able to establish strong and independent styles of their own. Barnett Newman . . . is one of these artists. . . . [Rothko] too, was stimulated by Still's example."

2. Clement Greenberg, "The Venetian Line," *Partisan Review*, XVII, No. 4 (April, 1950), 364.

3. Clement Greenberg, " 'American-Type' Painting," p. 189, remarked: "the most radical of all developments in the painting of the last two decades . . . involves a more consistent and radical suppression of value contrasts than seen so far in abstract art. We can realize now, from this point of view, how conservative Cubism was." William C. Seitz, "Abstract Expressionist Painting in America" (Ph.D. dissertation, Princeton University, 1955), p. 204, agreed with Greenberg: "Of all uses of color, the combination of tones *equivalent in everything but hue*—that is, of the same color value, of the same intensity, and of the same degree of tint or shade—is the most unprecedented, and in one sense, the most 'coloristic' of the contemporary solutions. A painting in complete conformity with this principle, if recorded on an ideally corrected black-and-white photograph, would appear as an unbroken tone of gray."

4. Barnett Newman, catalogue of an exhibition, "The Ideographic Picture," Betty Parsons Gallery, New York, January 20–February 8, 1947, n.p.

5. *Ibid.*

6. *Ibid.*

7. *Ibid.*

8. Newman's conception of the incompatibility between the sublime and the beautiful was influenced by that of Edmund Burke, *A Philosophical Enquiry into the Origin of Our Ideas of the Sublime and the Beautiful* (1757; New York, Columbia University Press, 1958). In "The Sublime Is Now," *The Tiger's Eye*, No. 6 (December, 1948), 51, Newman wrote: "Only Edmund Burke insisted on a separation [between the beautiful and the sublime]. Even though it is an unsophisticated and primitive one, it is a clear one."

9. Newman, "The Sublime is Now," pp. 51–53.

10. *Ibid.*

11. Mark Rothko, "The Romantics Were Prompted," *Possibilities 1*, No. 1 (Winter, 1947–48), 84.

12. Mark Rothko, in *The Tiger's Eye*, No. 9 (October, 1949), 114. (A statement on his attitude in painting.)

13. Clyfford Still, letter to Gordon M. Smith, catalogue of an exhibition, "Paintings by Clyfford Still," Albright-Knox Art Gallery, Buffalo, N.Y., November 5–December 13, 1959, n.p.

14. A number of Avery's canvases were close to color-field painting, for example, *Man and the Sea*, reproduced in *The Tiger's Eye*, No. 2 (December, 1947), 78. The picture was owned by Newman.

15. Henri Matisse, quoted in Monroe Wheeler, catalogue of an exhibition, "The Last Works of Henri Matisse," Museum of Modern Art, New York, 1961, p. 10.

16. Burke, *A Philosophical Enquiry into the Origin of Our Ideas of the Sublime and the Beautiful*, p. 72. Several critics have written at length about how Burke's ideas were embodied in Abstract Expressionist paintings. Of special value are Robert Rosenblum, "The Abstract Sublime," *Art News*, LIX, No. 10 (February, 1961), and Lawrence Alloway, "The American Sublime," *Living Arts* 2 (1963).

17. Burke, p. 74.

18. Robert Goldwater, *Primitivism in Modern Art* (New York: Vintage Books; Random House, 1967), p. 251. This was also the assumption underlying Jung's theories.

19. *Ibid.*, p. 114.

20. Burke, *A Philosophical Enquiry into the Origin of Our Ideas of the Sublime and the Beautiful*, p. 72.

21. Mark Rothko, statement delivered from the floor at a symposium on "How to Combine Architecture, Painting and Sculpture," at the Museum of Modern Art, 1951, printed in *Interiors*, CX, No. 10, 104.

22. Barnett Newman, statement (typescript) made for exhibition at Betty Parsons Gallery, New York, 1951, n.p.

23. Burke, *A Philosophical Enquiry into the Origin of Our Ideas of the Sublime and the Beautiful*, p. 57.

24. Raymond Parker, "Intent Painting," *It Is*, No. 2 (Autumn, 1958), 8–9.

25. Raymond Parker, "Direct Painting," *It Is*, No. 1 (Spring, 1958), 20.

26. Jackson Pollock, quoted in Francis V. O'Connor, *Jackson Pollock* (New York: Museum of Modern Art, 1967), pp. 39–40.

27. Robert Motherwell, an interview by Max Kozloff, *Artforum*, IV, No. 1 (September, 1965), 37.

28. Robert Goldwater, "Reflections on the New York School," *Quadrum*, No. 8 (1960), 26.

12 Clyfford Still
(1904–)

STILL began to paint the kind of color-field abstractions for which he is best known around 1947. They are generally composed of vertical paint-incrusted areas of flat color whose contours are jagged. The areas are not separable forms against a background but function as zones of a holistic field. The accent is on openness. No horizontals knit the verticals into a relational structure that might break the continuous plane. The areas that spread to the canvas edges are cut off, appearing to expand beyond the picture limits. The frayed drawing also acts to open up the areas, intensifying the effect of outward expansion.

Indeed, Still's paintings convey a sense of boundlessness more strongly than Rothko's or Newman's. The manner in which the images appear to soar, like tongues of flame, has struck some critics as "spiritual," symbolic of upward aspiration. Yet, paradoxically, there is a physicality in the muscular application of thick pigment that is not found in the thinly painted abstractions of Rothko and Newman.

When they were shown in 1947, Still's pictures made a powerful impression, partly because they provoked sensations of exaltation and liberation, and partly because they showed the way to a radically new abstract art. Still repudiated all established notions of what art ought to be in order to be "free from the fetishes of fear, estheticism, nostalgia, or mechanism." [1] He thought that the acceptance of received ideas could only lead to ingratiating decoration, and this he detested.[2] Indeed, his pictures suggest that he deliberately renounced painterly graces, sensuousness, and sophistication: the forms are ragged, looking as if they were arbitrarily drawn; the colors are dry and repeated in unrefreshing sequences; and the surfaces, consisting of paint troweled on with palette knives, are scabrous. In sum, these canvases, while elating, are nevertheless rude and dour.

Of all the Abstract Expressionists, Still was the most antitraditional. To him, the past represented "a body of history matured into dogma, authority, tradition. . . . The homage paid to it is a celebration of death. We all bear the burden of this tradition on our backs but I cannot hold it a privilege to be a pallbearer of my spirit in its name." [3] In another statement, Still elaborated:

> In the few directions we were able to look during the 1920's, whether to past cultures or the scientific, aesthetic, and social myths of our own, it was amply evident that in them lay few answers valid for insight or imagination. The fog has been thickened, not lifted by those who . . . looked back to the Old World for means to extend their authority in this newer land. . . . But that ultimate in irony,—the Armory Show of 1913—had dumped on us the combined and sterile conclusions of Western European decadence. . . . I, for one, refused to accept its ultimatums. To add to the body of reference or "sensibility" . . . I must equate with intellectual suicide.[4]

Cubism, in both its figurative and abstract manifestations, was Still's main target: he rejected the parlor paraphernalia that was the subject matter of its innovators and the geometry of later nonobjectivists; its relational design contained within the canvas rectangle; its implied horizon line, shallow depth, and small scale; and its well-made qualities. Of Cubist variants, Still most hated Bauhaus geometry, which for him expressed a mechanistic ideology that could lead to an authoritarian collective society, in which free men would be subjugated. Above all, he prized the solitary individual who assumed the responsibility for developing in his own vocation an original and

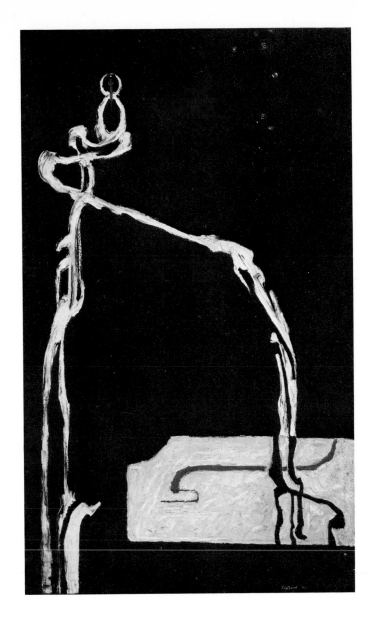

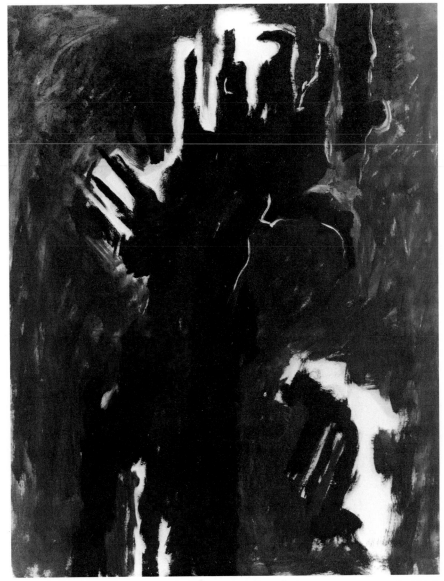

12–1 Clyfford Still. *Self-Portrait*. 1945.
San Francisco Museum of Art, San Francisco, California;
Gift of Peggy Guggenheim.

12–2 Clyfford Still. *Fear*. 1945.
Collection Betty Parsons, New York.

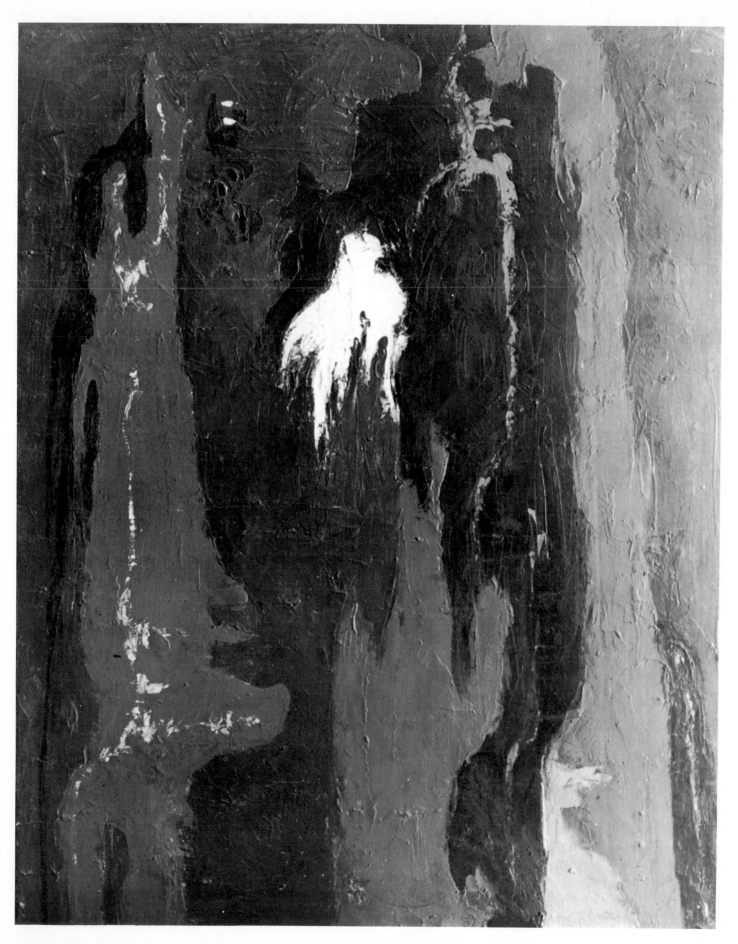

12–3 Clyfford Still. *Number 6.* 1945–46.
Collection Whitney Museum of American Art, New York;
Promised gift of B. H. Friedman.

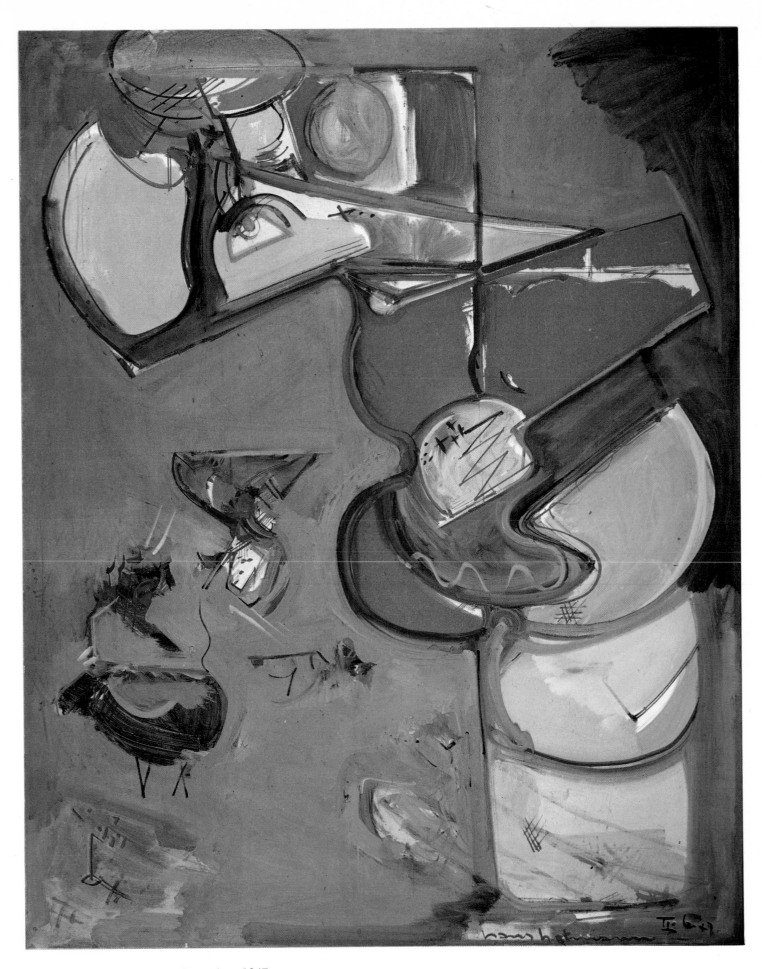

IX Hans Hofmann. *Transfiguration*. 1947.
André Emmerich Gallery, New York.

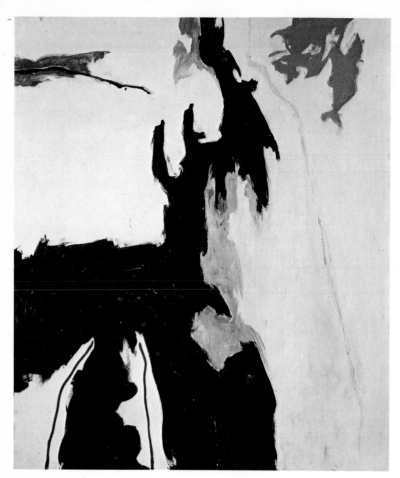

12–4 Clyfford Still. *1946-E.* 1946.
Marlborough Gallery Inc., New York.

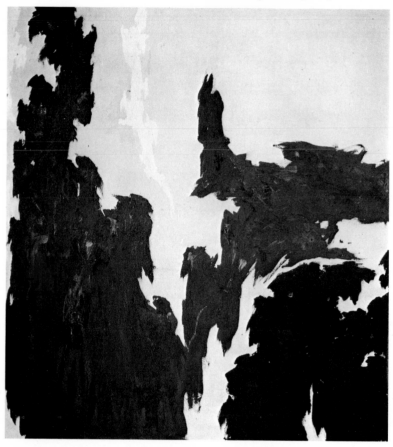

12–5 Clyfford Still. *1948.* 1948.
Marlborough Gallery Inc., New York.

absolute vision.[5] While spurning the Cubists, Still drew on other artists, much as he tried to avoid them all. Turner's atmospheric fields, and Gauguin's and Matisse's simple planes of color provided his points of departure. Of these three, he most admired Gauguin, who had tried to express a primal level of experience. (He was suspicious of Turner's pleasing, airy effects and Matisse's cultivated hedonism.) In general, however, his references to earlier styles were not explicit (as were De Kooning's and Hofmann's), for his abstractions convey more strongly their break with tradition than their continuity with it.

Still's abstractions evolved from two symbolic images. One was an upright man—the free individual—standing in a wide-open prairie landscape, reminiscent of the environment of his youth;[6] the other, the dualities of sun and dark earth, male and female—metaphors perhaps for good and evil.[7] Still's artistic development can be viewed as a synthesis of these two kinds of imagery into a more transcendent abstract statement. Indeed, he seemed to develop his visionary style by focusing on details from earlier pictures and amplifying them in later canvases to render them clearer and more immediate.

During the 1930's, Still painted a number of landscapes of the American West. He also painted distorted figures—the men bony and angular, the women bloated, pregnant. These pictures contained the elements of which

his later abstractions were composed. The same was true of *Totem Fantasy*, which was exhibited in 1940. The image, a semi-abstract figure that calls to mind an American Indian totem, consists of massive, organic shapes set off dramatically against a halo of light on an otherwise dark ground. This work and others of the time are also reminiscent of Picasso and Orozco, and are akin to the images that Gottlieb and Rothko were soon to paint, although they independently arrived at their mythic themes.

Still did not paint a great deal from the fall of 1941 to the summer of 1943 When he resumed work, his style became increasingly nonfigurative, stressing the expressive possibilities of abstract elements in themselves: upward-thrusting areas with torn or meandering contours, tenebrous browns and blacks, and stark contrasts of lights and foreboding darks (*Figs. 12-1, 12-2*). The emphasis now is less on image than on exploring the potential of shredded line and open field (*Fig. 12-3*). Although there are references to the figure in most of Still's works prior to 1946, they are generally so remote that the pictures must be considered abstract; by 1947, he had eliminated all the literal associations retained in his preceding canvases (*Figs. 12-4, 12-5*).

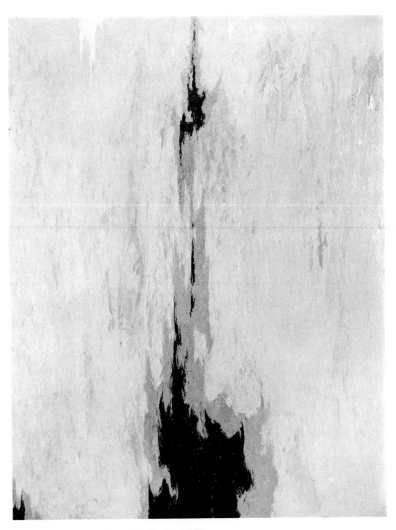

12–6 Clyfford Still. *1949-G.* 1949.
Marlborough Gallery Inc., New York.

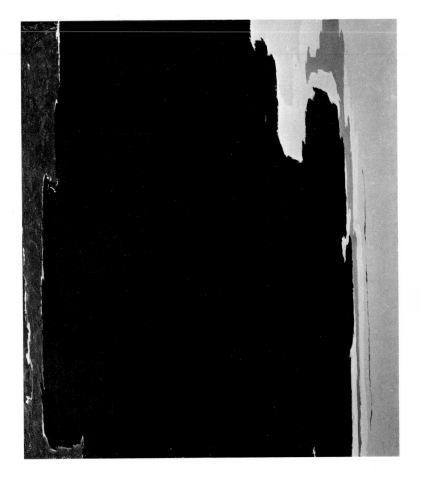

12–7 Clyfford Still. *Painting.* 1951.
Collection The Museum of Modern Art, New York;
Blanchette Rockefeller Fund.

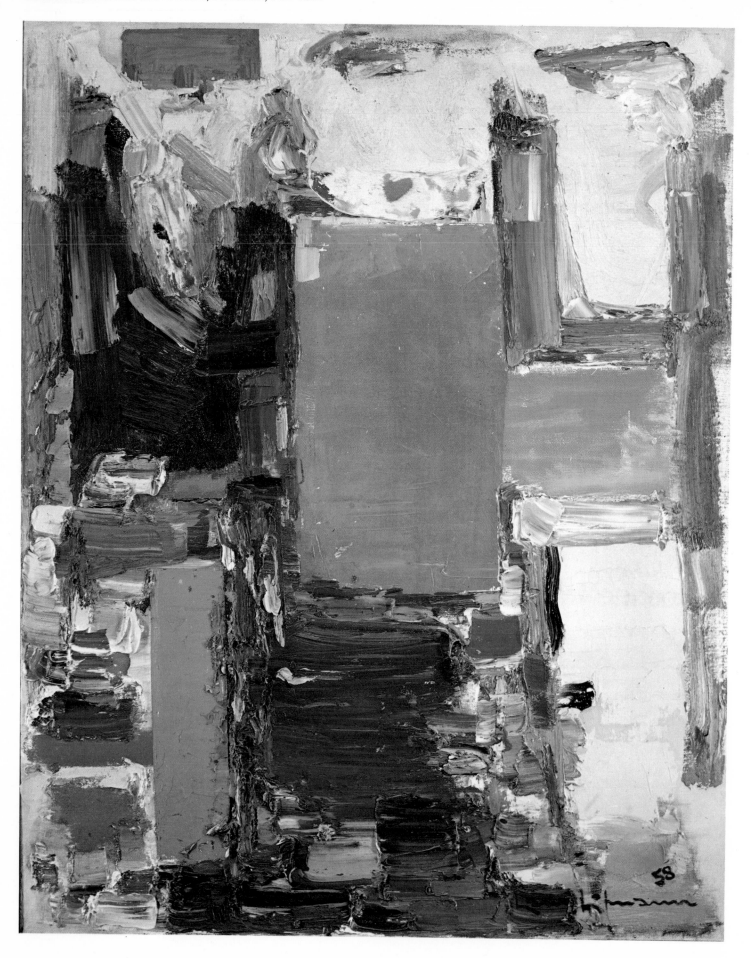

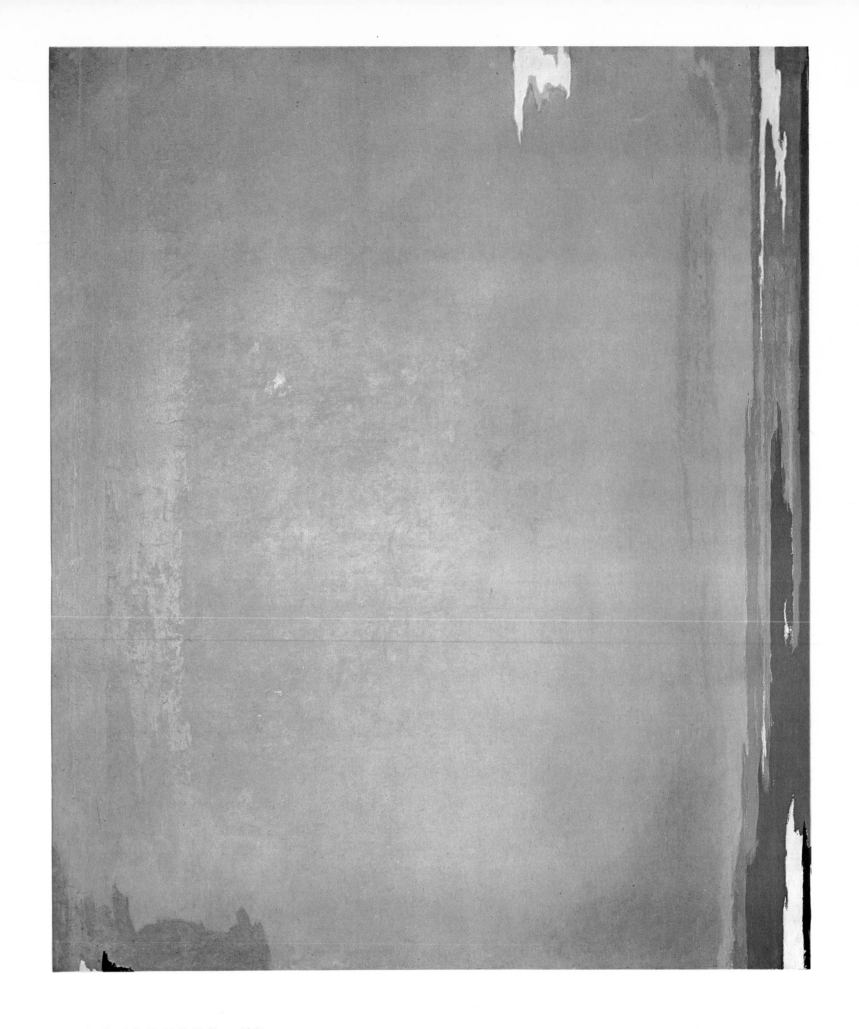

XI Clyfford Still. *1951 Yellow*. 1951.
Collection Mr. and Mrs. Frederick R. Weisman, Beverly Hills, California.

165

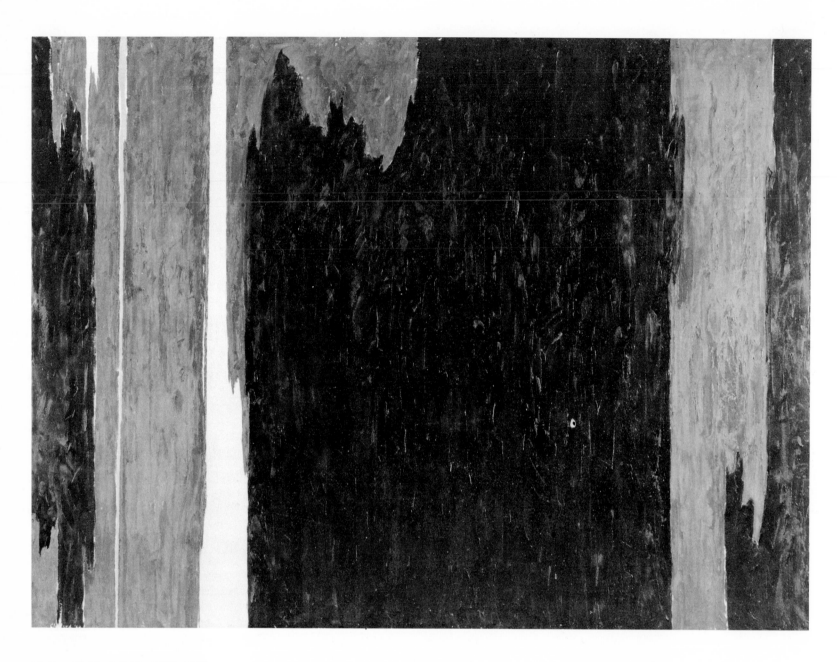

12–8 Clyfford Still. *1954*. 1954.
Albright-Knox Art Gallery, Buffalo, New York;
Gift of Seymour H. Knox.

As Still's work progressed, the effect of color-field grew more pronounced (*Fig. 12-6*). In 1948 and 1949, he painted several canvases almost entirely in black—the precursors of later, near monochromatic, high-keyed color-fields. During this period, however, he avoided vivid hues, preferring earth tones and other dark colors (*Fig. 12-7*). Still has been quoted as saying that he "consciously endeavored in his painting to disembarrass color from all conventional, familiar associations and responses; that is, from the pleasant, luminous, and symbolic. Especially in the painting of the 'forties he avoided the appealing, sensuous colors of, for example, the Fauves. . . . Since he wished to use color to depict directly a new, unique subject . . . he has to use it in a new and, for many, displeasing way." [8] From 1950 on, Still keyed up his colors, lightened his textures—leaving bare expanses of canvas in some works—and more clearly defined his areas, all of which produced a quality of open lyricism rarely found in his earlier work (*XI*, p. 165; *XII*, p. 168). He also began to paint canvases of enormous dimension to avoid the preciosity of small easel pictures tailored to the needs of middle-class parlors, and to elicit as strong and immediate a sense as he could of monumentality and boundlessness (*Figs. 12-8, 12-9*).

Still had his first one-man show in New York at the Art of This Century Gallery in the winter of 1946. Rothko's introductory remarks in the catalogue stated that Still had created a new "generic Myth.[6] As he himself [Still] has expressed it his paintings are 'of the Earth, the Damned, and the Recreated.'" Rothko also asserted that Still had transformed every shape into an "organic entity, inviting a multiplicity of associations." [9] Still's pictures of 1946 were given mythic titles—*Nemesis of Esther III, Buried Sun, Theopathic Entities*—but he soon repudiated such titles and their connotations as

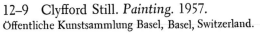

12–9 Clyfford Still. *Painting*. 1957.
Öffentliche Kunstsammlung Basel, Basel, Switzerland.

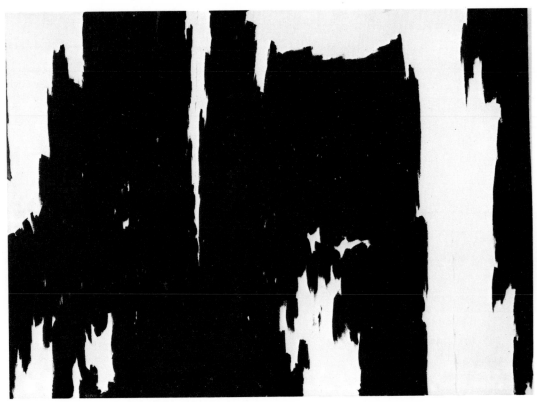

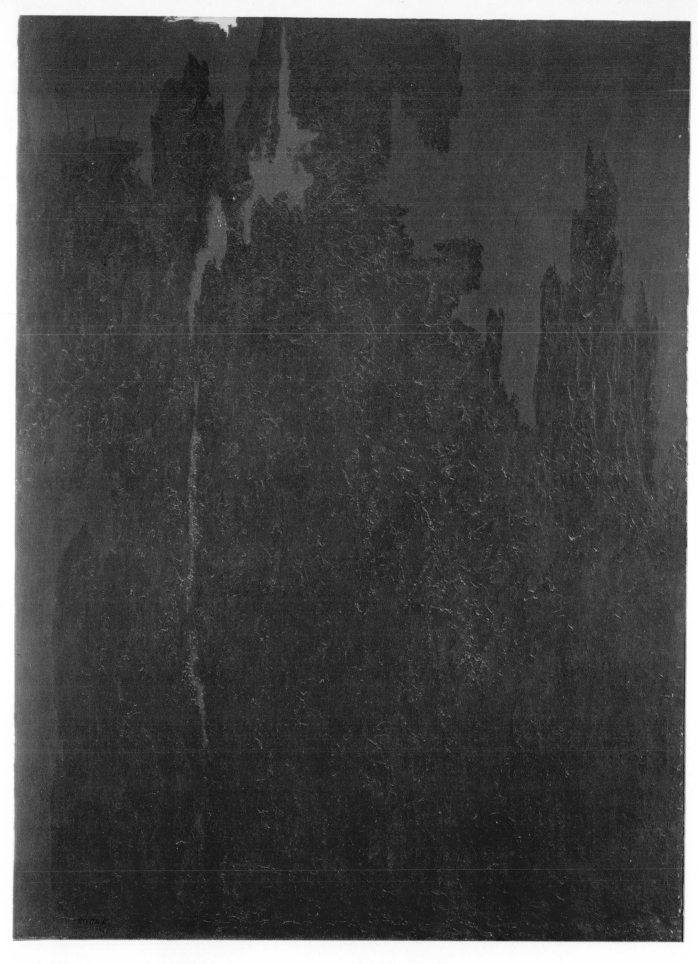

XII Clyfford Still. *1951-N*. 1951.
Marlborough Gallery Inc., New York.

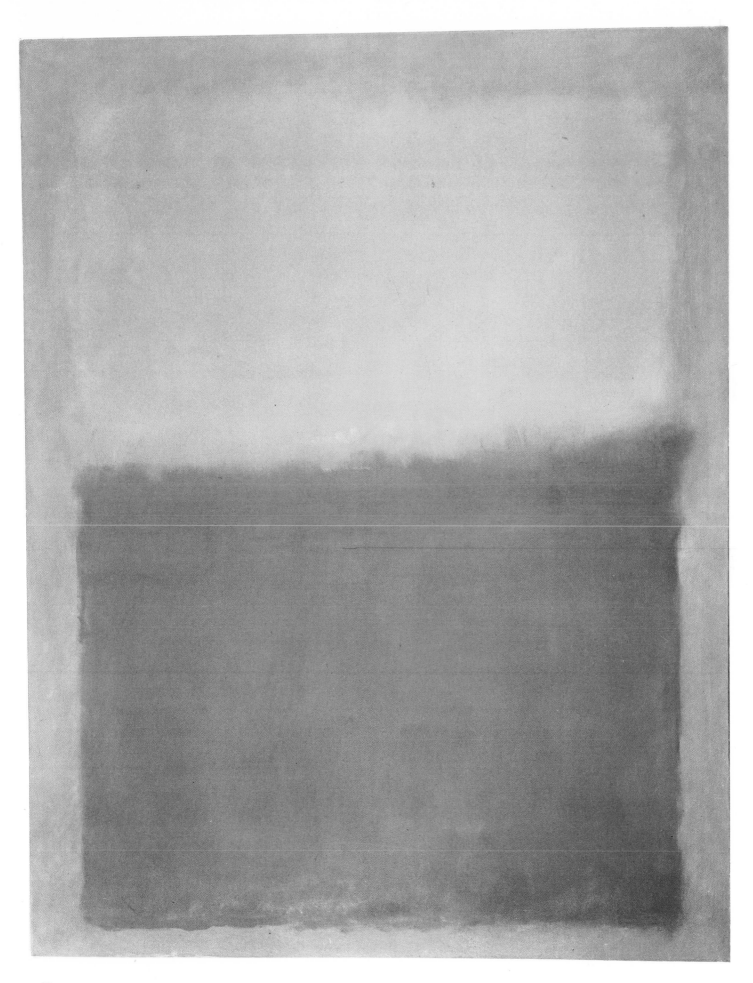

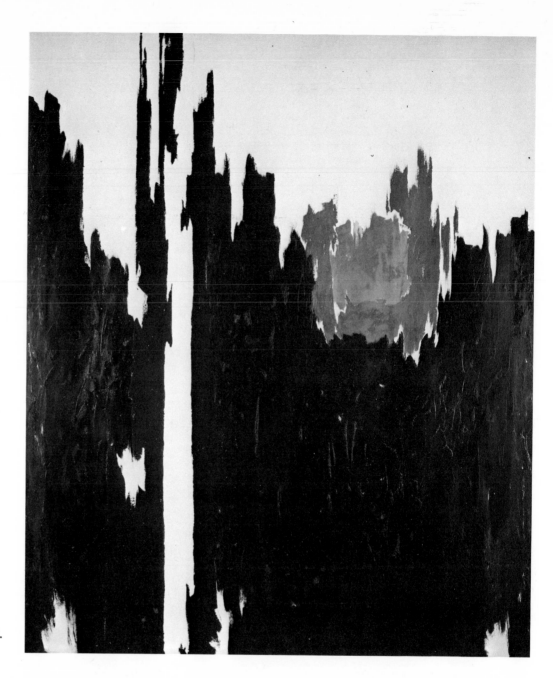

12–10 Clyfford Still. *1960.* 1960.
Marlborough Gallery Inc., New York.

misleading, for his intention had become more universal—to create visual metaphors of the sublime.

Yet critics have generally failed to consider the metaphysical connotations in Still's color-fields. They have preferred instead to treat his works as abstractions of panoramic Western plateaus—and, in this sense, as "American"— yet the associations with awesome crags, fissures, and other natural phenomena in the American landscape are superficial. There is, however, a feeling of America in Still's painting, a sense that he depicted the private odyssey of a pioneer who discovered a new frontier in art—art replacing the American West as the open frontier (*Figs. 12-10, 12-11, 12-12*). The conception of the artist as pioneer exploring a mythic terrain is suggested in Still's writings as well as in his paintings: "It was a journey that one must make, walking straight and alone. . . . Until one had crossed the darkened and wasted valleys and come at last into clear air and could stand on a high and limitless plain. Imagination, no longer fettered by the laws of fear, became as one with Vision. And the Act, intrinsic and absolute, was its meaning, and the bearer of its passion." [10]

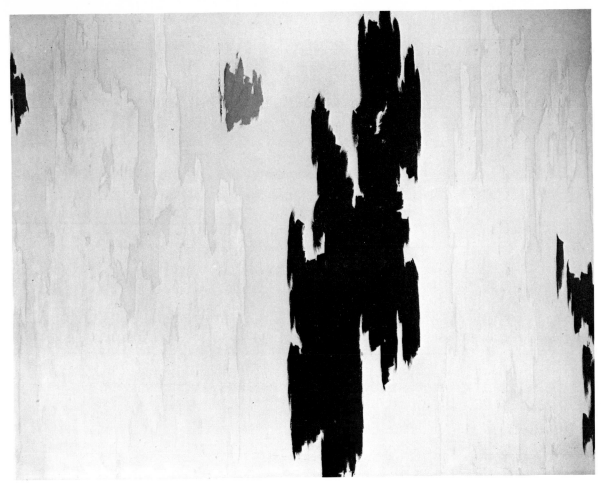

12–11 Clyfford Still. *1962-D.*
1962.
Marlborough Gallery Inc., New York.

12–12 Clyfford Still. *1964.* 1964.
Marlborough Gallery Inc., New York.

XIV Mark Rothko. *Black and Tan on Red.* 1957.
Collection Mr. and Mrs. I. Donald Grossman, New York.

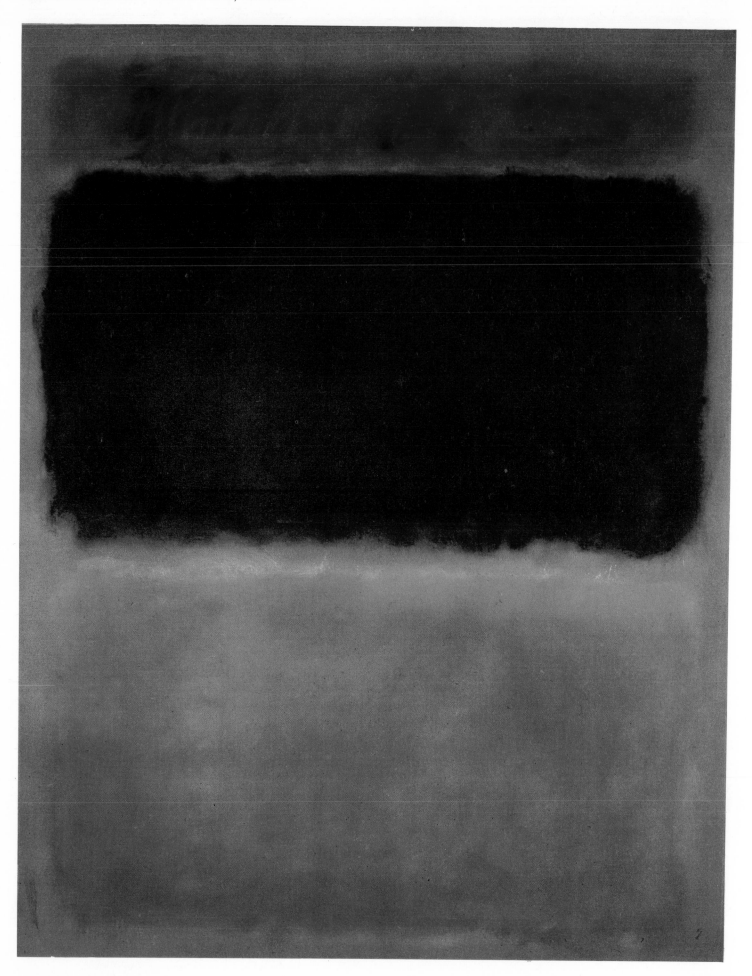

XV Barnett Newman. *Vir Heroicus Sublimis.* 1950–51.
Fractional gift to The Museum of Modern Art, New York, of Mr. and Mrs. Ben Heller, New York.

12 Notes

1. Stuart Preston, quoting Still, "Diversely Abstract," *The New York Times*, February 4, 1951, sec. 2, p. 14. (Still made this statement in 1950.)

2. Still also attacked those who are seduced by decoration—particularly curators, critics, art dealers, and collectors. He believed that the New York art world was venal, and from the end of 1952 to 1958, he refused to exhibit his work anywhere; he left New York in 1961. Ironically, Still's intransigeant broadsides against corruption and commercialism contributed to his renown and success as an artist. His Messianism is reflected in the sternness of his work, the denial of polite taste and easy virtuosity.

3. Clyfford Still, "Statement," catalogue of an exhibition, "Fifteen Americans," Museum of Modern Art, New York, 1952, p. 21.

4. Clyfford Still, letter to Gordon M. Smith, January 1, 1959, in catalogue of an exhibition, "Paintings by Clyfford Still," Albright-Knox Art Gallery, Buffalo, N.Y., November 5–December 13, 1959, n.p.

5. His heroes were Rembrandt, Blake, Longinus, Kierkegaard, Nietzsche, and Beethoven. Still admired Blake as a poet, not as a painter. His students reported that he often discussed Frye's work on the English mystic when he taught. When Still came to New York, he visited first The Metropolitan Museum, to see Rembrandt's paintings.

6. Clyfford Still, quoted in *Art News*, XLVI, No. 3 (May, 1947), 50, referred to the figure in landscape as a source of his imagery. In "Clyfford Still," *Magazine of Art*, XLI, No. 3 (March, 1948), 96, there appears: "Still feels that his fluid, often flame-like vertical shapes have been influenced by the flatness of the Dakota plains; they are living forms springing from the ground.".

7. Hubert Crehan, in "Clyfford Still: Black Angel in Buffalo," *Art News*, LVIII, No. 8 (December, 1959), 32, 33, 58–60, claimed that Still embodied a Manichean vision of good and evil. Perhaps Still's thinking was influenced by Blake's "The Marriage of Heaven and Hell," which, as William Barrett points out, *Irrational Man* (New York: Doubleday, 1958), p. 110, anticipates both Nietzsche and Jung. "If man marries his hell to his heaven, his evil to his good, Blake holds, he will become a creature such as the earth has not yet seen. Nietzsche put the same insight paradoxically: 'Mankind must become better and more evil.'"

8. Benjamin J. Townsend, "An Interview With Clyfford Still," *Gallery Notes*, XXIV, No. 2 (Buffalo, N.Y.: Albright-Knox Art Gallery, Summer, 1961), 13.

9. Mark Rothko, in Introduction to the Clyfford Still show at the Art of This Century Gallery, February 12–March 2, 1946, n.p.

10. Clyfford Still, letter to Gordon M. Smith, January 1, 1959, in "Paintings by Clyfford Still."

IN 1950, Rothko began to paint abstractions, each composed of a few softly painted and edged horizontal rectangles of luminous color placed symmetrically one above the other on a somewhat more opaque vertical ground. These pictures seem to be related to geometric abstraction but are, in fact, far different, since it is the field of resonant, atmospheric colors rather than the design that arouses the primary visual and emotional response.

Rothko's color-fields, though extreme, were the outcome of a long evolution. During the 1930's, he had painted isolated figures in urban settings. Of his artistic intention at that time, he later wrote: "For me the great achievements of the centuries in which the artist accepted the probable and familiar as his subjects were the pictures of a single human figure—alone in a moment of utter immobility." But he grew dissatisfied with this "solitary figure [who] could not raise its limbs in a single gesture that might indicate its concern with the fact of mortality and an insatiable appetite for ubiquitous experience in face of this fact." Increasingly, he felt "the need for a group of actors who are able to move dramatically without embarrassment and execute gestures without shame." [1] For a time, Rothko wondered whether he could achieve the quality or the variety of drama that he wanted by distorting or mutilating the human image, but he rejected this possibility as sadistic. Instead, around 1942, he adopted the Surrealist technique of automatism to combine human, animal, fish, and plant parts into biomorphic inventions (*Figs. 13-1, 13-2*)—the kin of Gorky's hybrids, Gottlieb's pictographs, and, especially, of Miró's shorthand symbols.

Rothko's choice of subject matter was influenced by Nietzsche's *The Birth of Tragedy*. By 1940, before he painted his automatist pictures, he was studying Greco-Roman myths, some of which he later selected as his themes. To Rothko, the myths of antiquity possessed the potential for fresh human content, that is, they contained timeless symbols inherent in man's psychic make-up, which were tragic because they expressed man's fears and predatory passions. [2] *The Omen of the Eagle* (1942), for example, was derived from the Agamemnon trilogy of Aeschylus, although the picture did not illustrate specific events of the story. Instead, Rothko, in an unpremeditated process of painting, conjured up biomorphic mutations, which he thought of as performers in a mythic drama: "Neither the action nor the actors can be anticipated, or described in advance. They began as an unknown adventure in an unknown space. . . . Ideas and plans that existed in the mind at the start were simply the doorway through which one left the world in which they occur." [3] Rothko himself summarized the content of *The Omen of the Eagle* as dealing with "the Spirit of Myth, which is generic to all myths of all times. It involves a pantheism in which man, bird, beast and tree—the known as well as the unknowable—merge into a single tragic idea." [4]

The pantheistic content to which Rothko aspired is suggested not only by his images but by the luminosity that permeates his 1940's pictures. The calligraphic figures and their grounds are thinly painted and freely brushed, generating a field of light-filled atmosphere. The softness of the aura is augmented by the pale colors that he favored. In fact, Rothko was so disposed to luminosity that in the mid–1940's he preferred watercolor and gouache to oil, for water-based mediums lend themselves to the production of light effects, and when applied in overlapping, nuanced scrims yield a sense of atmosphere. Reinforcing the field effect in many paintings after 1945 are horizontal bands running to the picture edges, in front of which Rothko

XVI Barnett Newman. *Onement No. 6.* 1953.
Collection Mr. and Mrs. Frederick R. Weisman, Beverly Hills, California.

13–1 Mark Rothko. *Geologic Reverie*. c. 1946.
Los Angeles County Museum of Art, Los Angeles, California;
Gift of Mrs. Marion H. Pike.

13–2 Mark Rothko. *Vessels of Magic*. 1947.
Courtesy of The Brooklyn Museum, Brooklyn, New York.

177

13–3 Mark Rothko. *Number 26*. 1947.
Collection Betty Parsons, New York.

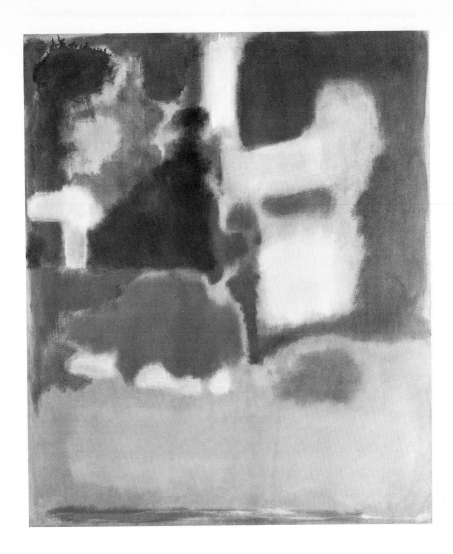

13-4 Mark Rothko. *Number 18.* 1949.
Collection The Museum of Modern Art, New York;
Gift of Mrs. John D. Rockefeller III.

floated his calligraphy. The atmosphere and background planes anticipate elements in his later abstractions.

Although the hybrids in Rothko's myth-inspired pictures are abstract, they do allude to observable phenomena—underwater organisms or the paraphernalia used in primitive rituals.[5] Around 1947, Rothko came to believe that any references to nature and existing art, because they were known, finite, and limiting, conflicted with the idea of a universal, supernatural "Spirit of Myth."[6] Consequently, Rothko purged his painting of ideographic symbols and automatist calligraphy and began to paint washes of color that seemed to drift across the canvas (*Fig. 13-3*). He soon reacted against the diffuseness of these pictures, however, and in order to solidify them, made the areas roughly rectangular (*Figs. 13-4, 13-5, 13-6*). In 1950, he reduced the number of elements in each picture to two or three, coalesced them into large rectangles of approximately similar width, and simplified the design by placing the shapes one above the other in symmetrical arrangements (*Fig. 13-7*). He also started to paint on a more monumental scale. In these abstractions, Rothko achieved the clarity, immediacy, and drama that he desired, to the extent that he repeated this general format in all of his subsequent pictures (*Figs. 13-8, 13-9; XIII,* p. 169, *XIV,* p. 172).[7]

Rothko's rectangular planes are distinct, but they also constitute a field. Rothko meant for his paintings to be perceived at once as a whole, and he achieved a holistic quality by spreading his color areas over the surface, terminating them near the canvas limits. He "drew" the contours of the rectangles close to the picture edges in order to render his design unobtrusive and to stress the outer borders of the entire work and hence the work as an

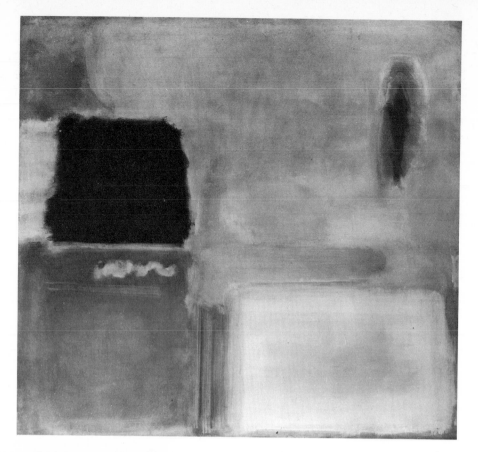

13–5 Mark Rothko. *Mauve Intersection (Number 12).* 1948.
The Phillips Collection, Washington, D.C.

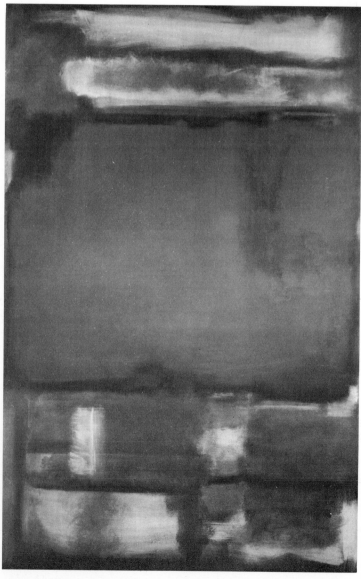

13–6 Mark Rothko. *Number 24.* 1949.
Collection Joseph H. Hirshhorn.

entity. The field effect is augmented by the rectangular shapes in themselves, which are composed symmetrically and do not set up agitated movements within the work; the blurring of the contours also prevents abrupt divisions. The sense of a holistic picture is further reinforced by bleeding the shapes into the ground, fusing both into a single plane.

Because Rothko's shapes are rectangular, critics have related them to Mondrian's. There is, however, little affinity between Rothko's symmetrical fields of volatile, atmospheric, and variegated color and Mondrian's assymmetrical, hard-edged, relational structures, in which flat, predetermined primary colors are adjuncts of the stable design. Rothko is, in fact, far less akin to the Neoplasticists than he is to Matisse (whom he esteemed as the greatest revolutionary in modern art) and to his close friend Milton Avery, much as he tried to suppress all allusions to the paintings of others.[8] He was influenced by the simple, frontal color shapes of both Matisse and Avery and by the latter's loose brushwork and sober palette. Rothko's field painting is also related to Still's and Newman's, but its sense of atmosphere is unlike Still's tactile impasto or Newman's wall-like matte surface.

Muted drawing and elementary design serve to accent the role of color,

13–7 Mark Rothko. *Number 10.* 1950.
Collection The Museum of Modern Art, New York;
Gift of Philip Johnson.

13–8 Mark Rothko. *Untitled.* 1951.
Collection Mr. and Mrs. Gifford Phillips, Santa Monica, California.

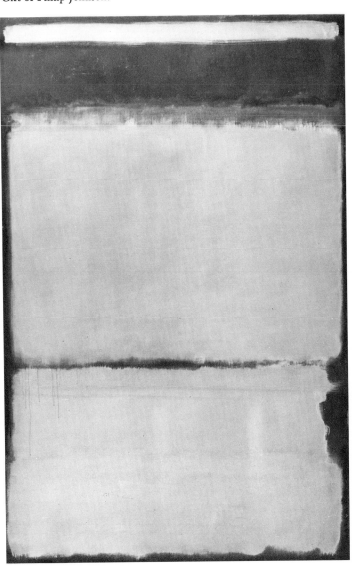

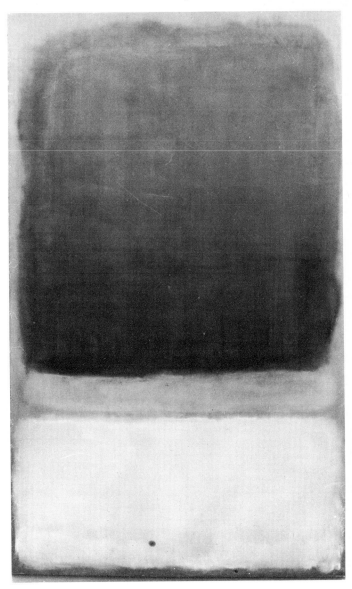

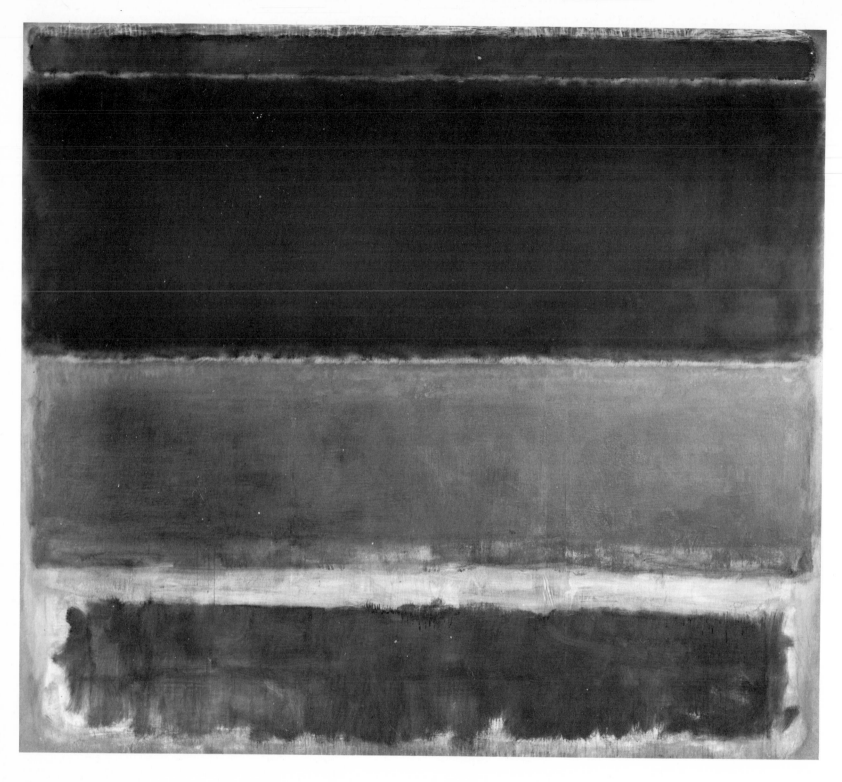

13–9 Mark Rothko. *Four Darks in Red.* 1958.
Collection Whitney Museum of American Art, New York;
Gift of the Friends of the Whitney Museum of American Art,
the Charles Simon Fund, Samuel A. Seaver, and Mr. and Mrs. Eugene Schwartz.

and color is Rothko's major expressive means. Yet he himself insisted that he was no colorist, wishing to disassociate himself from hedonistic painters who exploited the sensuous and decorative attributes of color, and wishing also to direct attention to meanings other than pleasure. To specify these meanings is a difficult matter, for Rothko did not employ explicit symbols, and all of his abstract pictorial elements require multiple and often equivocal readings. As Robert Goldwater wrote, in their "unrelenting frontality . . . their constant symmetry, and simplicity," the pictures are "enormously willful." But he added that they are "unrelated to a formulating will," since they lack "all traces of the process of their making." There is no "hint of how they came to be, nothing that suggests the action of the artist . . . either through gesture or direction or impasto, nothing that defines the imposition of the will, either through an exact edge or a precise measurement." [9]

The passivity and impersonality of Rothko's brush and reductive design are, on the one hand, ironic, as is all self-effacement. On the other hand, they suggest a desire on his part that the viewer vacate the active self. This can lead to cosmic identification, but that has a tragic dimension, for it evokes the ultimate loss of self—death. The sense of self-transcendence is prompted by the immediate and inundating quality of Rothko's color. The myriad pulsations generated by minute surface changes give rise to an overwhelming chromatic sensation. The all-pervading impression is intensified by the field effect, the environmental size of the pictures, and the illusion of atmosphere generated by the thinly coated color. The subtly stained and blotted modulations of color that dematerialize both surfaces and contours transform the rectangular planes into blocks of colored ether. The blurring of the edges prevents the shapes from hardening and dislodges them, causing them to hover outward, enveloping the viewer in the luminous aura they radiate. Conversely, the rectangles also seem to recede, turning into layers of veils that shroud some mysterious presence that one is made to feel is there and to which one must penetrate. As one does in suspenseful reverie, one feels drawn into vast apparitional spaces that threaten to dissolve both the viewer and his world. At the same time, the frontal parallel patterns accentuate the picture plane and counteract the sense of depth, preventing the surface from vaporizing too much. Although each eroded rectangle is disembodied, it reads as a more or less finite container, the ominous presence is therefore materialized. Rothko's brooding colors in uneasy juxtapositions add to the foreboding feeling, as do the disembodied surfaces. The suppression of textures, of the earthbound physicality of paint matter, stimulates the imagination to soar into hallucinatory recesses of quavering, dark-tinted light.

Perhaps out of respect for the spectator's need to experience his own condition, Rothko allows the viewer a certain freedom of response by his self-effacement and reticence. Hence, his canvases are protean to the degree that they invite the viewer to complete their tragic message; his monologue turns into a dialogue. His abstractions become a kind of stage set for a drama, before which the viewer is transformed into an actor who plays his solitary self. The evolution of Rothko's painting points to this: in many of the earlier mythic pictures, the forms themselves are the actors in front of a backdrop of horizontal bands; in the abstractions after 1950, the backdrops become the sole image, whose quiescent simplicity calls into existence a complexity of introspective thoughts and feelings in the sensitive viewer.

13 Notes

1. Mark Rothko, "The Romantics Were Prompted," *Possibilities 1*, No. 1 (Winter, 1947–48), 84.

2. Rothko's interest in a tragic content was to dispose him early to Existentialism. His article in *Possibilities 1* combines ideas held by Nietzsche and Kierkegaard, both precursors of contemporary Existentialism.

3. Rothko, "The Romantics Were Prompted," p. 84.

4. Mark Rothko, quoted in Sidney Janis, *Abstract and Surrealist Art in America* (New York: Reynal & Hitchcock, 1944), p. 118.

5. William C. Seitz, in "Abstract Expressionist Painting in America" (Ph.D. dissertation, Princeton University, 1955), p. 82, wrote that Rothko's images "lie just at the periphery of recognition; imitating plant, animal, or human form; shields, arrows, and other objects associated with primitive rites; or fantastic costumes of fur and feathers." As such, they are reminiscent of African and Oceanic art, in which diverse motifs and materials are mixed. Thomas B. Hess, in *Abstract Painting* (New York: Viking Press, 1951), p. 146, and Lawrence Alloway, "The Biomorphic Forties," *Artforum*, IV, No. 1 (September, 1965), 22, felt that Rothko's subjects are of marine origin; in Alloway's words, the artist painted "an imagined ocean floor in which linear organisms wiggle as his wrist moves, creating animate forms transparent to their misty backgrounds."

6. Rothko was reluctant to make a move into complete abstraction. As late as 1945, in "A Personal Statement: A Painting Prophecy—1950," catalogue of an exhibition, David Porter Gallery, Washington, D.C., February, 1945, n.p., he wrote that he was troubled by his abandonment of figuration. "If I have faltered in the use of familiar objects, it is . . . for the sake of [a mythic] action which they are too old to serve, and for which, perhaps, they had never been intended." He acclaimed the Surrealists for uncovering the "glossary of the myth" and for establishing "a congruity between the phantasmagoria of the unconscious and the objects of everyday life. . . . which for me is the only source book for art." But, at the same time, he questioned their approach. "I love the object and the dream far too much to have them effervesced into the insubstantiality of memory and hallucination." In the same statement, he was sympathetic to the abstract artist who "has given material existence to many unseen worlds and tempi. But I repudiate his denial of anecdote just as I repudiate the denial of the material existence of the whole of reality." Even more, Rothko feared the dehumanization in nonobjective art, whose aim, as he saw it, was only formalistic. In *The Portrait and the Modern Artist*, mimeographed script of a broadcast, with Adolph Gottlieb, on "Art in New York," H. Stix, director, WNYC, New York, October 13, 1943, p. 3, Rothko said: "Today, the artist is no longer constrained by the limitation that all of man's experience is expressed by his outward appearance. Freed from the need of describing a particular person, the possibilities are endless . . . in that sense it can be said that all of art is the portrait of an idea."

7. After 1950, Rothko changed his format only in his murals, the change—from horizontal to vertical forms—dictated by the horizontal shape of the murals.

8. In 1954, Rothko titled a picture *Homage to Matisse*, a significant gesture, for he had been numbering his works since 1949.

9. Robert Goldwater, "Reflections on the Rothko Exhibit," *Arts*, XXXV, No. 6 (March, 1961), 44.

NEWMAN carried the color-field idea to greater extremes than either Still or Rothko. In his first show at the Betty Parsons Gallery, early in 1950, he exhibited abstractions, each composed of a single, almost flat color interrupted by one or more narrow vertical bands of contrasting colors. Surprisingly, most Abstract Expressionists, disposed though they were to extremist art, were hostile to Newman's painting—a fact that prompted Clement Greenberg to wonder whether pictures so generally disparaged could have been that bad.[1]

The main reason for the rejection of Newman was the almost complete absence of signs of painterliness in his works—the kind of touch found in Rothko's nuanced surfaces or Still's textures. Moreover, Newman was better known in the art world as a polemicist than as a painter. He had begun to write introductions to catalogues and other essays early in 1944; he did not exhibit until the start of 1947, when two of his works were seen in the "Ideographic Picture" show that he organized at the Parsons Gallery. That Newman wrote extensively about art is significant, for the concepts developed in his essays influenced the evolution of his style. Newman denied that he was a painter of ideas, and with justification, for the effect of his color-fields is not intellectual but one of an engulfing chromatic sensation whose immediacy inhibits cerebration. Yet, as he said in 1950: "The artist's intention is what gives a specific thing form."[2]

Newman's writings emphasized content, but they also contained suggestions of the formal elements that were incorporated in his paintings. A collaborator with Gottlieb and Rothko on the letter to *The New York Times* in 1943, Newman called for an art that embodied "the essence of the myth" and had "the impact of elemental truth."[3] It would consist of simple, large, flat shapes, because they were unequivocal and anti-illusionistic. Early in 1944, Newman wrote in the catalogue of Gottlieb's show that the figure in Western art "has always stayed an object, a grand heroic one, to be sure, or one of 'beauty,' yet no matter how glorified, an object nevertheless."[4] Gottlieb had repudiated this conception, and Newman praised him for that. Later that year, Newman arranged a show of Pre-Columbian sculpture at the Wakefield Gallery. In his introduction to the exhibition, he wrote: "The sense of dignity, the high seriousness of purpose evident in this sculpture, makes clearer to us why our modern sculptors were compelled to discard the mock heroic, the voluptuous, the superficial realism that inhibited the medium for so many European centuries."[5]

Newman was particularly antipathetic to the super-realism of the academic Surrealists. In 1946, he compared it to the primitive Oceanic art then on view at the Museum of Modern Art. He maintained that the Surrealists'

> intent to make the real more so by means of the use of illusion resulted in theatricalism that is the ultimate reason for its failure. Eventually we un-masked the illusion and realized that to the artists it was also an illusion, that it was they who did not feel the magic. Because realism, including that of the imagination, is, in the last analysis, deceitful. Here resides the true difference with respect to the Oceanic artist. . . . And we perceive it, because we see that it came from within to without. Deceptive journalistic tricks do not exist. The primitive artist gives us a vision, complete and naive.[6]

Newman set out to achieve such a total vision—with dignity and high seriousness. He strove to discover a form that was neither figurative, illusionistic, object-like, mock heroic, narcissistic, voluptuous, nor beautiful.

Although Newman rejected academic Surrealism, he did for a time adopt

14–1 Barnett Newman. *The Death of Euclid*. 1947.
Collection Betty Parsons, New York.

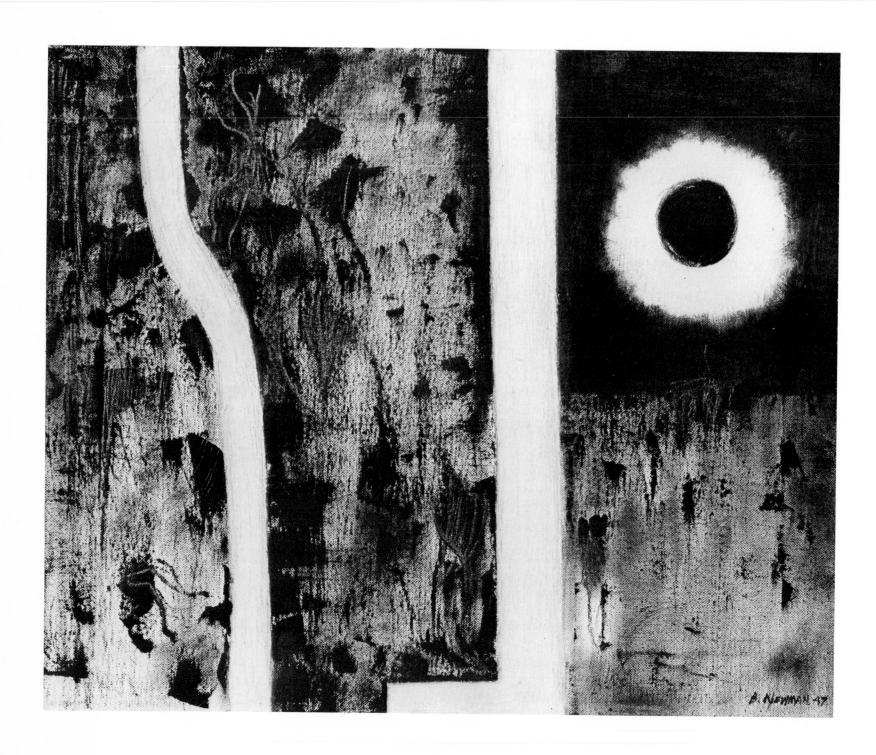

the technique of automatism to paint biomorphic abstractions containing sun-moon images with mythic connotations (*The Death of Euclid*, 1947; *Fig. 14-1*). During this period, he and other New York myth-makers found inspiration in primitive art, particularly that of the Northwest Coast Indians, in which, as he wrote, the abstract shape "was directed by a ritualistic will towards metaphysical understanding" and was "a carrier of the awesome feelings he [the Indian painter] felt before the terror of the unknowable."[7] Carrying this line of thinking further, Newman asserted that "the basis of an esthetic act is the pure idea . . . that makes contact with mystery—of life, of men, of nature, of the hard, black chaos that is death, or the grayer, softer chaos that is tragedy. For it is only the pure idea that has meaning." Newman remarked that his painting would be neither the "space cutting nor space building [of Cubism], not construction nor fauvist destruction; not the pure line, straight and narrow [of Mondrian and other geometricists], nor the tortured line, distorted and humiliating [of Expressionism]; not the accurate eye, all fingers [of Realism], nor the wild eye of dream, winking [of academic Surrealism]."[8] Thus, Newman was prepared to turn away from his myth-inspired image-making and to search for a non-objective and a non-relational or nonconstructed design.

In 1948, Newman began to consider his "pure idea" sublime and to oppose it to the ideal of beauty that he identified with European art—the desire "to exist inside the reality of sensation (the objective world, whether distorted or pure) and to build an art within the framework of pure plasticity (the Greek

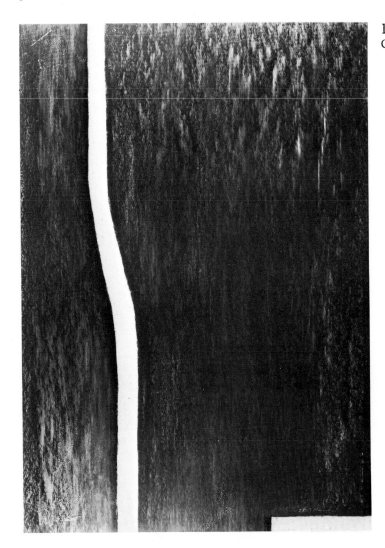

14–2 Barnett Newman. *The Euclidian Abyss.* 1946–47.
Collection Mr. and Mrs. Burton Tremaine, Meriden, Connecticut.

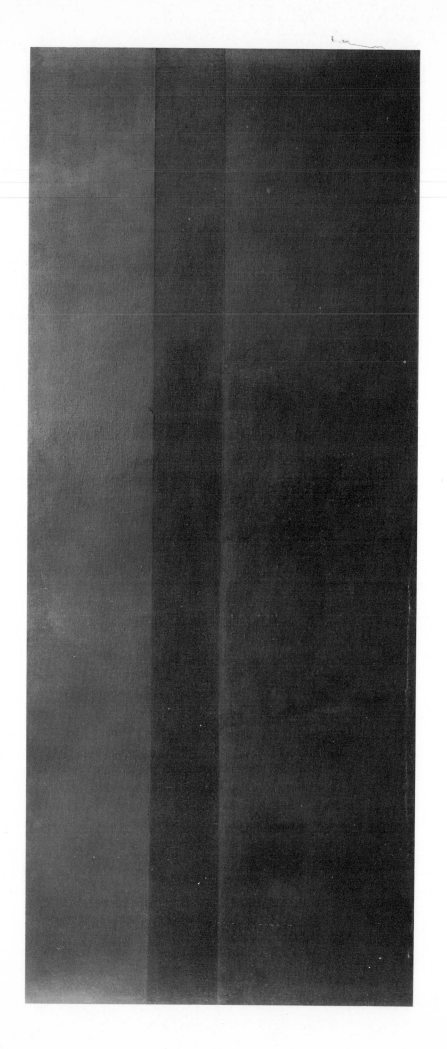

14–3 Barnett Newman. *Abraham.* 1949.
Collection The Museum of Modern Art, New York;
Philip Johnson Fund.

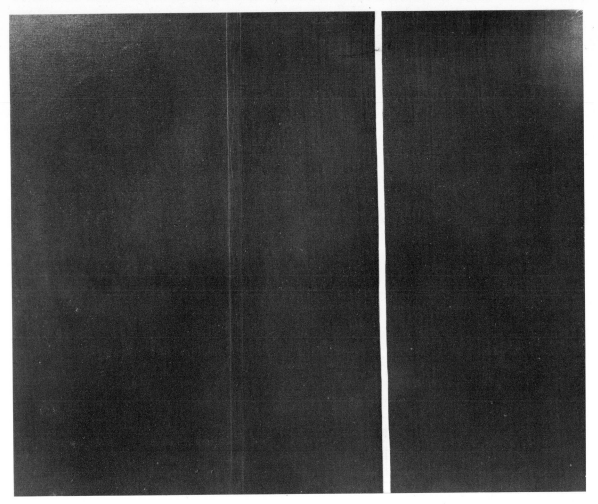

14-4 Barnett Newman. *Covenant*. 1949.
Joseph H. Hirshhorn Collection.

ideal of beauty whether that plasticity be a romantic active surface, or a classic stable one)."[9] Instead of perfect form—whether figurative or abstract, geometric or painterly—Newman broached the possibility of a new art in which "form can be formless," whose antecedents were in the Gothic and Baroque (to which he later added Impressionism)—an art that would suggest the mysterious sublime rather than the beautiful.[10] Thus, Newman established the premises of the field abstractions he was about to begin painting.

Just as Newman's field painting was anticipated by his writing, so was the kind of line that he came to employ. In 1946–47, repudiating "the pure line, straight and narrow" and "the tortured line, distorted and humiliating," he developed the kind of drawing in *The Euclidian Abyss* (*Fig. 14-2*) of that year. At the same time, he began to suggest what line meant to him. In an article entitled "The First Man Was an Artist," he wrote: "Man's first expression . . . was a poetic outcry . . . of awe and anger at his tragic state, at his own self-awareness and at his own helplessness before the void. . . . The purpose of man's first speech was an address to the unknowable." Original man's behavior was aesthetic before it was utilitarian. His "hand traced the stick through the mud to make a line before he learned to throw the stick as a javelin. . . . The God image, not pottery, was the first manual act. . . . Adam, by eating from the Tree of Knowledge, sought the creative life to be, like God, 'a creator of worlds.' . . . In our inability to live the life of a creator can be found the meaning of the fall of man."[11] In this statement, Newman implied that his line would be gestural, like that of primitive man—a poetic outcry in the void that, at the same time, would be a world of his creation.[12]

Newman also wanted his line to be epic; he abstracted line from figuration

189

and mass in order to use it as a free, personal gesture in free space. But his stripes can also be perceived as figures, ravaged by space; their tremorous, eroded edges suggest vulnerable human touches, while their verticality evokes man's aspirations to the sublime, as in Still's pictures.

Newman himself emphasized the role that drawing plays in his pictures, stating that "drawing is central to my whole concept. . . . I am always referred to in relation to my color. Yet I know that if I have made a contribution, it is primarily in my drawing. . . . Instead of using outlines, instead of making shapes or setting off spaces, my drawing declares the space. Instead of working with the remnants of space, I work with the whole space." [13] This Newman did more single-mindedly than any of his contemporaries (*Figs. 14-3, 14-4, 14-7*). Each of his abstractions is a field graspable immediately and in its entirety. The vertical bands within it, though they suggest images, are not perceived as things, separated from the ground, advancing or receding. Rather, they are accents that energize the continuous area and give it scale, at once making it appear a vast expanse while preventing it from becoming amorphous and inert. The stripes are varied in color, width, and placement so as to clarify scale, but they do not constitute a structure. In Newman's painting, there are no horizontals crisscrossing the verticals to produce separate, finite forms, which are then composed into relational images, as in a Mondrian canvas (*Fig. 14-5*). Indeed, he seemed to challenge the latter's "part-to-part-to-whole"

14–5 Piet Mondrian. *Composition with Blue Square II.* 1936–42.
Collection The Museum of Modern Art, New York; Sidney and Harriet Janis Collection.

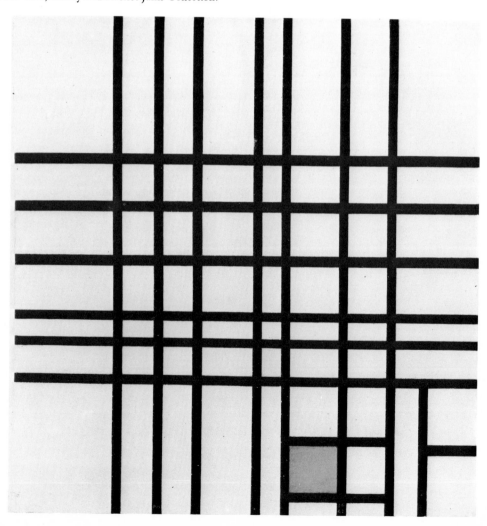

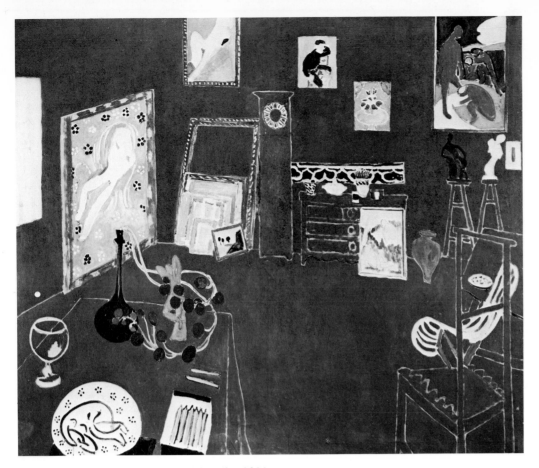

14-6 Henri Matisse. *The Red Studio*. 1911.
Collection The Museum of Modern Art, New York;
Mrs. Simon Guggenheim Fund.

14-7 Barnett Newman. *Tertia*. 1964.
Nationalmuseum, Stockholm, Sweden.

conception by verging on geometric abstraction to underline his departures from rational space-building.[14] The fact that Newman's bands echo the picture's vertical edges and cross its horizontal borders contributes to this kind of holistic perception.

Yet, despite the importance of drawing, the primary element in Newman's abstractions is color—the field of a single color (including black and white). Indeed, in his reliance on color, Newman is closer to Matisse (*Fig. 14-6*) than to any Cubist-inspired artist. Literally to inundate the viewer in color, he began, around 1949, to work on a huge scale; his greatest works, such as *Vir Heroicus Sublimis* (1950–51; XV, p.173), *Onement No. 6* (1953; XVI, p. 176), and *Day One* (1951–52; XVII, p. 242), are wall-size. Another reason he enlarged his formats was to provoke an immediate, total response, to turn perception into an act of communion, of *"participation with"* rather than *"reaction to"* a work.[15] Newman's color suggests his private vision of the sublime—private because its cast is determined by the artist's temperament. Notwithstanding its eye-filling plentitude, his color is rarely sensuous; rather, it conveys a sense of sternness, a quality augmented by the rigorous simplification of design. To intensify the optical impact of the monochrome, Newman suppressed atmospheric and tactile details. But this lack of surface inflection serves other purposes as well. It underscores his antipathy to voluptuousness, virtuosity, and Expressionist narcissism. In a sense, his stark surfaces are primitivistic, but the suppression of the physicality of paint matter also points to metaphysical or spiritual meanings—which is Newman's principal intention.

14 Notes

1. Clement Greenberg, "Feeling Is All," *Partisan Review*, XIX, No. 1 (January–February, 1952), 101.

2. "Artists' Sessions at Studio 35 (1950)," in *Modern Artists in America*, Robert Motherwell and Ad Reinhardt, eds. (New York: Wittenborn, Schultz, 1952), p. 18.

3. Adolph Gottlieb and Mark Rothko (in collaboration with Barnett Newman), "Letter to the Editor," *The New York Times*, June 13, 1943, sec. 2, p. 9.

4. Barnett Newman, in Introduction to catalogue of Adolph Gottlieb exhibition, Wakefield Gallery, New York, February 7–19, 1944, n.p.

5. Barnett Newman, in Introduction to "Pre-Columbian Stone Sculpture," catalogue of an exhibition, Wakefield Gallery, New York, May 16–June 5, 1944, n.p.

6. Barnett Newman, "Las Formas Artisticas del Pacifico," *Ambos Mundos*, June, 1946, pp. 51–55. Quoted from a translation by Barbara Reise, "Primitivism in The Writings of Barnett Newman: A Study in the Ideological Background of Abstract Expressionism" (M.A. Thesis, Columbia University, 1965), pp. 18–19.

7. Barnett Newman, in Introduction to catalogue of an exhibition, "The Ideographic Picture," Betty Parsons Gallery, New York, January 20–February 8, 1947, n.p.

8. *Ibid.*

9. Barnett Newman, "The Sublime Is Now," *The Tiger's Eye*, I, No. 6 (December 15, 1948), 52–53.

10. *Ibid.*, 51.

11. Barnett Newman, "The First Man Was an Artist," *The Tiger's Eye*, I, No. 1 (October, 1947), 59–60.

12. In "Unanswerable Question," *Newsweek*, LXVII, No. 19, May 9, 1966, p. 100, Newman restated this intention (almost two decades later), when he wrote, of a series of fourteen pictures entitled *The Stations of the Cross*, that Christ's last words "Why hast thou forsaken me?" were the entire Passion of Christ, and it was that, not the anecdote, that gripped him: "I'm trying to illuminate that cry. It's the universal cry—What's going on? I wanted to hold the emotion, not waste it in picturesque ecstasies. The cry, the unanswerable cry, is world without end. But a painting has to hold it, world without end, in its limits."

13. Dorothy Gees Seckler, "Frontiers of Space," *Art in America*, No. 2 (Summer, 1962), 86–87.

14. Allan Kaprow, "Impurity," *Art News*, LXI, No. 9 (January, 1963), 54.

15. Barnett Newman, in Introduction to catalogue of Theodoros Stamos exhibition, Betty Parsons Gallery, New York, February 10–March 1, 1947, n.p.

IN 1957, Gottlieb began a series of pictures that have come to be called "Bursts," each composed of a large disk within a halo suspended above a jagged area. The upper orb is luminous, modulated, contained; the lower expanse flat but loosely painted, erupting. The two planes set up a dialogue of pictorial elements, but they also suggest meanings beyond their formal attributes, the two contrasting yet interacting abstract elements symbolizing duality in all of its varied manifestations: earth and sun (or moon); the kinetic and the static; the gesturally free and the controlled; shape and field.

Gottlieb had begun to juxtapose disparate symbols some fifteen years earlier, in 1942, when he started a series of "Pictographs" that was to occupy him for the following decade (*Fig. 15-1*). These pictures were sectioned into all-over, roughly rectilinear grids that flattened the space and eliminated pronounced focal points. Within the compartments were painted flat images, detached from their familiar contexts; they ranged from recognizable, schematized fish, reptiles, birds, and animals to anatomical parts and abstract signs.

The "Pictographs" reflected a change in Gottlieb's aesthetic attitude. During the 1930's, he had painted American scenes (*Fig. 1-17*) in the manner of Milton Avery. After the despair of Pearl Harbor, Gottlieb looked to mythology and to primitive art for subject matter. As he wrote:

> Rothko and I temporarily came to an agreement on the question of subject matter; if we were to do something which could develop in some direction other than the accepted directions of that time, it would be necessary to use different subjects to begin with and, around 1942, we embarked on a series of paintings that attempted to use mythological subject matter, preferably from Greek mythology. . . . it seemed that if one wanted to get away from such things as the American scene or social realism and perhaps cubism, this offered a possibility of a way out, and the hope was that given a subject matter that was different, perhaps some new approach to painting . . . might also develop. And as it turned out, such a new approach did develop. At least, it was a different approach than either of us could have arrived at if we hadn't taken a radical departure with respect to subject matter. Well, eventually, of course, we did not remain loyal to the idea of using mythology and ancient fables as subjects.[1]

Gottlieb did in part derive his "Pictographs" from a group of Magic Realist pictures he had painted in 1939—landscapes containing boxes in which such marine objects as shells and coral were placed (*Fig. 15-2*). But his design was influenced even more by American Indian petroglyphs and totems, and by ancient hieroglyphs. The colors he favored—earth, clay, and bark—also called to mind Indian painting.

Because of his new conception of content, Gottlieb was attracted to the ideas of the Surrealists, being influenced by their juxtaposition of incongruous images and by their automatist technique (*Fig. 15-3*). He differed from most Surrealists, however, in his attempt to recollect man's prehistoric past, and in his rejection of academic illusionism, illustration, and of Surrealism's anti-aesthetic bias.[2] Yet, at the same time, he repudiated prevailing aesthetics, including those of Americans who imitated the School of Paris masters, although his own grid composition owed much to Klee, Mondrian, and Joaquín Torres-García (*Fig. 15-4*), and his imagery to Miró and Picasso. Gottlieb remarked that he adopted the name "Pictograph" to indicate his disdain for received notions of what "good" painting should be, for that

15 Adolph Gottlieb
(1903—)

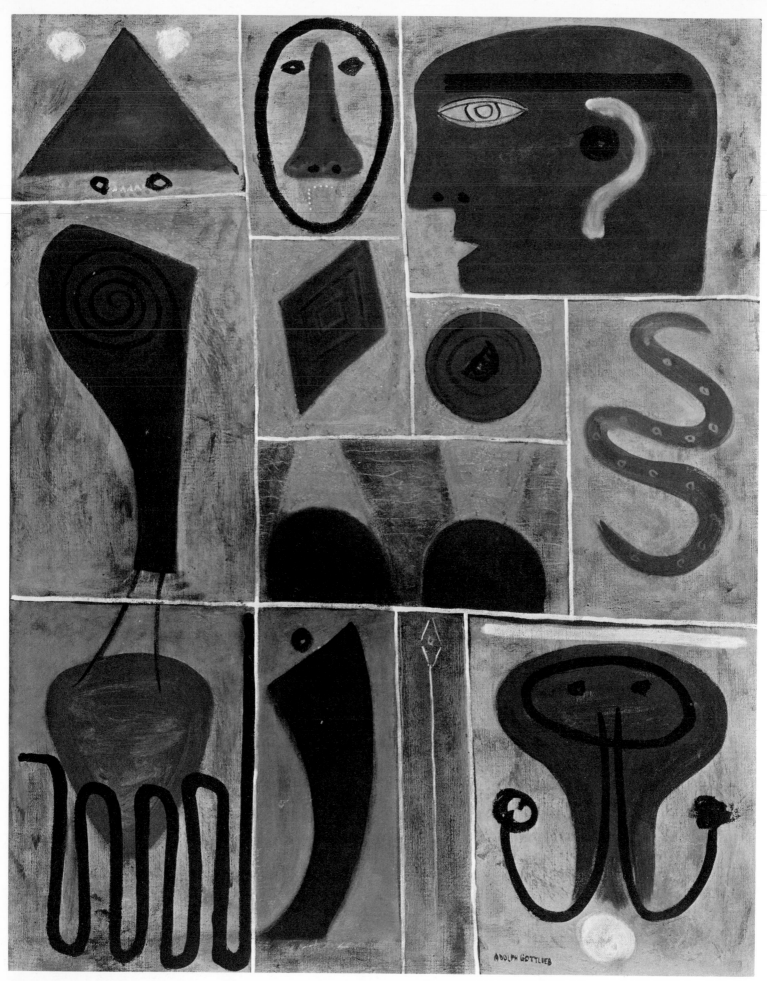

15–1 Adolph Gottlieb. *Voyager's Return*. 1946.
Collection The Museum of Modern Art, New York;
Gift of Mr. and Mrs. Roy Neuberger.

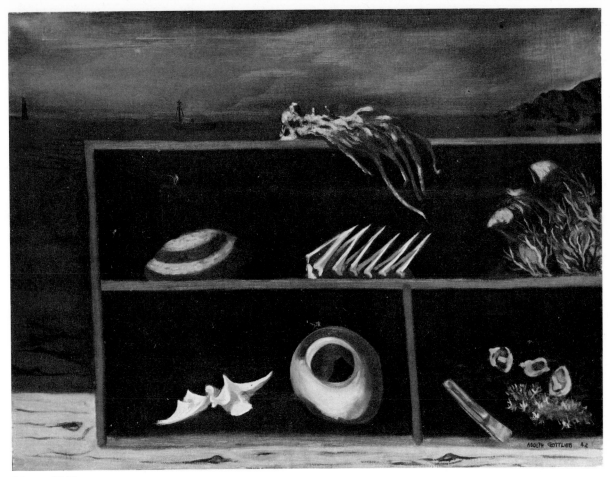

15–2 Adolph Gottlieb. *The Sea Chest.* 1942.
The Solomon R. Guggenheim Museum, New York City.

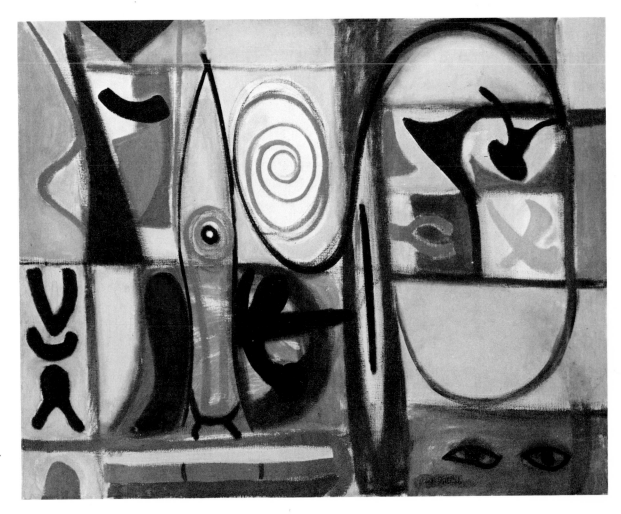

15–3 Adolph Gottlieb. *Quest.*
1948.
New York University Art Collection;
Gift of Mr. and Mrs. Samuel Kootz.

195

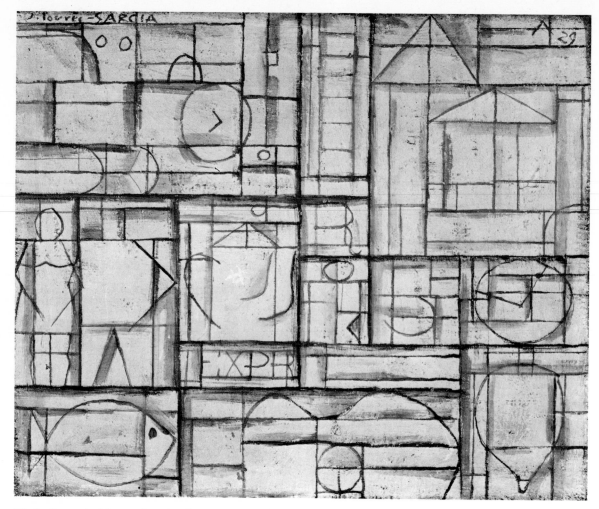

15–4 Joaquín Torres-García. *Composition.* 1929.
Philadelphia Museum of Art, Philadelphia, Pennsylvania;
A. E. Gallatin Collection.

meant the acceptance of an academic strait-jacket. It was therefore necessary for me to utterly repudiate so-called "good painting" in order to be free to express what was visually true for me. . . . Paint quality is meaningless if it does not express quality of feeling. . . . Subjective images do not have to have rational association, but the act of painting must be rational, objective and consciously disciplined. I consider myself a traditionalist, but I believe in the spirit of tradition, not in the restatement of restatements.[3]

The images in Gottlieb's "Pictographs," though often recognizable, are not interrelated in any rational manner. He wrote: "I take the things I know —hand, nose, arm—and use them in my paintings after separating them from their associations as anatomy. I use them as a totality of what they mean to me. It's a primitive method, and a primitive necessity of expressing, without learning how to do so by conventional ways. . . . It puts us at the beginning of seeing." [4] There is no narrative sequence in the "Pictographs"; the images can be related in any direction, and this was Gottlieb's intention. He arrived at his cryptic motifs and their juxtapositions through free association, and meant the viewer to be similarly free in interpreting and linking them.

Although the "Pictograph" provided a schema capable of rich variation, Gottlieb had exhausted its possibilities by 1952.[5] Three years earlier, he had started to venture in new directions: In *Ancestral Image* (1949), he simultaneously compressed the "Pictograph" into a central mass and magnified the motif of one compartment. The single form suggests an ominous totemic semaphor. The thin, linear planes resembling limbs, tentacles, and claws that

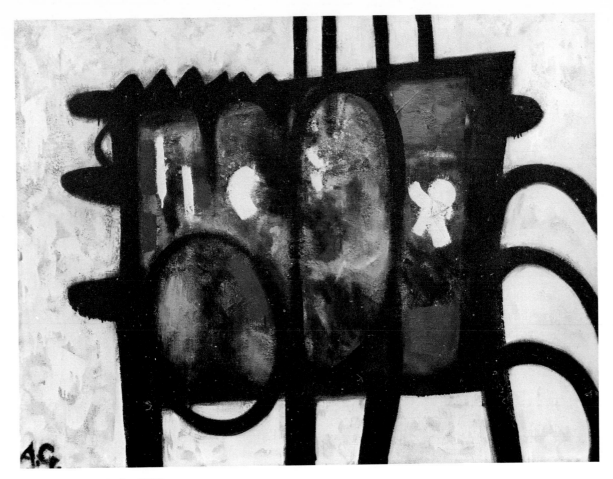

15–5 Adolph Gottlieb. *Unstill Life.* 1952.
Collection Whitney Museum of American Art, New York;
Gift of Mr. and Mrs. Alfred Jaretzki.

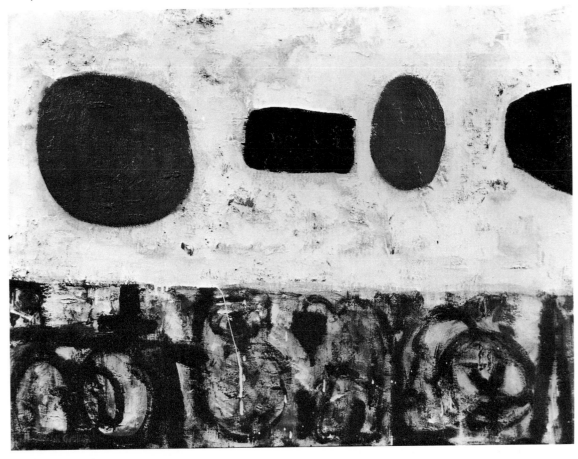

15–6 Adolph Gottlieb. *Frozen Sounds II.* 1952.
Albright-Knox Art Gallery, Buffalo, New York;
Gift of Seymour H. Knox.

197

15–7 Adolph Gottlieb. *Blue at Night.* 1957.
Virginia Museum of Fine Arts, Richmond, Virginia.

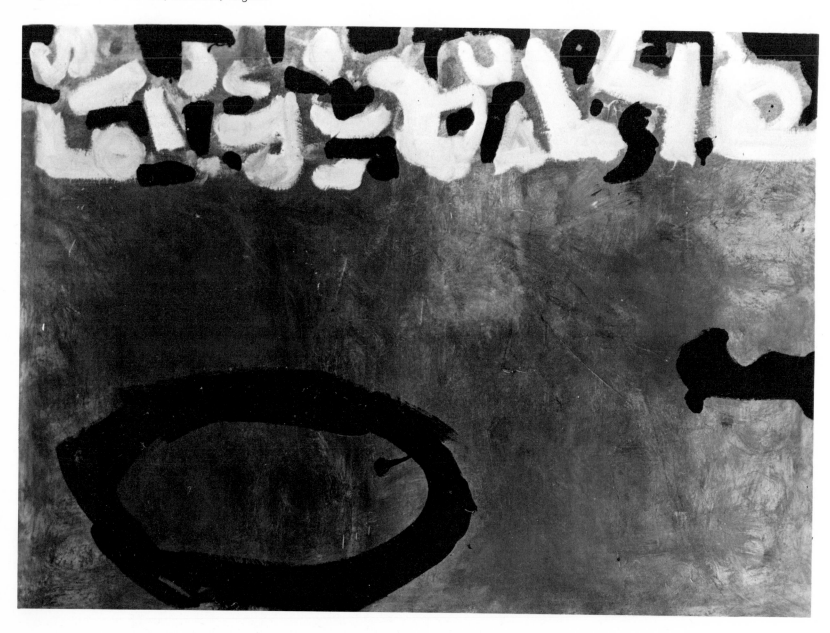

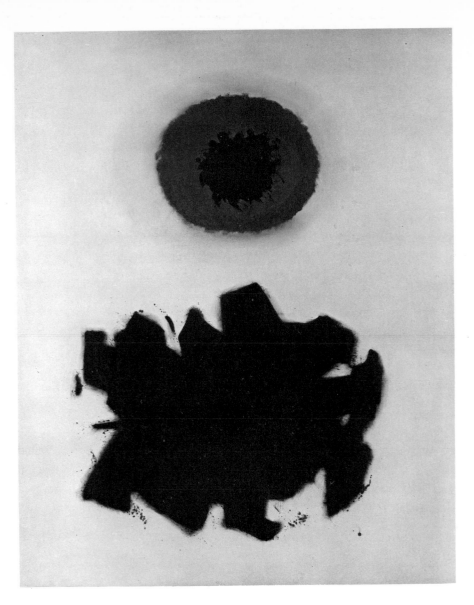

15–8 Adolph Gottlieb. *Circular.* 1959.
Marlborough Gallery Inc., New York.

15–9 Adolph Gottlieb. *Rolling II.* 1961.
Los Angeles County Museum of Art, Los Angeles, California;
Estate of David E. Bright.

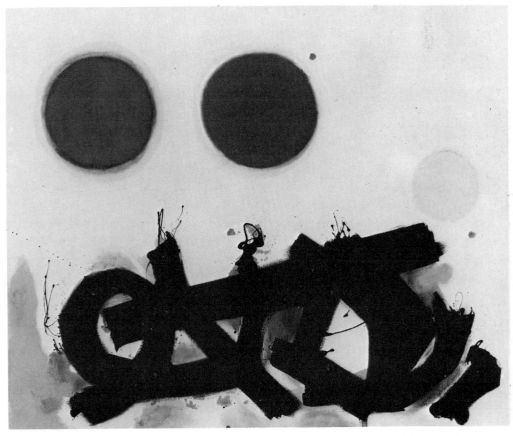

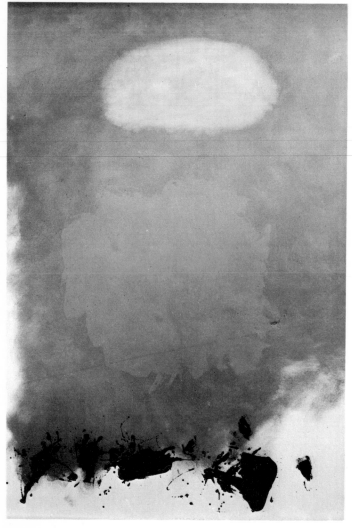

15–10 Adolph Gottlieb. *Rising*. 1962.
Brandeis University Art Collection, Waltham, Massachusetts;
Gevirtz-Mnuchin Purchase Fund.

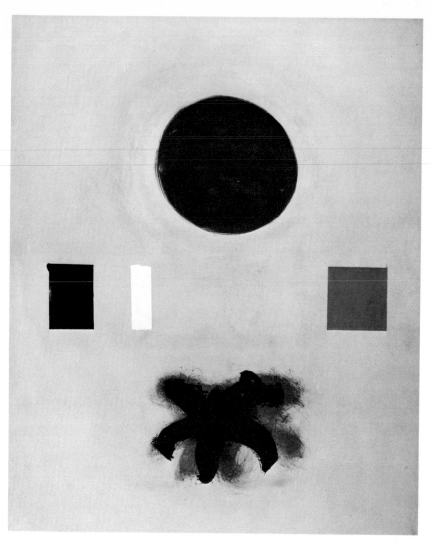

15–11 Adolph Gottlieb. *Scale*. 1964.
Marlborough Gallery Inc., New York.

stretch from it to the picture edges are all that remain of the rectangular grids. In *Unstill Life* (1952; *Fig. 15-5*), Gottlieb incorporated "Pictographic" sections—now rounded—within the bulky shape, and in *Frozen Sounds II* (1952; *Fig. 15-6*) he turned the central image into the earth plane of an abstract landscape. In *Tournament* (1951), Gottlieb abridged the symbols into abstract signs—wiggles, crosses, ovals, arrows, zigzags—shorn of all literal associations, while in *Armature* (1954), he eliminated all symbols and signs, integrating an active curvilinear grid with a rectilinear one, like strained-glass leading.

From 1952 to 1956, Gottlieb tended to concentrate on a series of "Imaginary Landscapes"—horizontal pictures composed of roughly circular and horizontal astral planes suspended above dense earth and containing energetically painted gestural swaths, often reminiscent of the earlier symbols (*Figs. 15-6, 15-7*). In 1957, he coalesced the sky and earth forms of these abstract landscapes into the vertical "Bursts" (*Fig. 15-8*). His motive seems to have been to abstract and so to generalize his symbols, to "universalize" them. Gottlieb achieved in his own work the kind of content he had written about seven years earlier in a statement on Gorky: "What he felt, I suppose, was a sense of polarity, not of dichotomy; that opposites could exist simultaneously within a body, within a painting or within an entire art. . . . These

are the opposite poles in his work. Logic and irrationality; violence and gentleness; happiness and sadness, surrealism and abstraction." [6] At this time, Gottlieb also condensed his forms, while enlarging them to make them more immediate and monumental.[7] In his reduction and simplification of pictorial elements and in his magnification of scale, he approached the color-field painters.

During the 1960's, Gottlieb retained the basic format of the "Bursts" but put them through a great variety of permutations (*Figs. 15-10, 15-11*). In *Rolling II* (1961; *Fig. 15-9*), for example, two solar disks hover over a large calligraph. In *Brink* (1959; *XVIII*, p. 243) the earth is shattered into multi-colored fragments. In the "Bursts," there was greater stress on the picture plane as a field of white or of a single color than in the "Pictographs" or the "Imaginary Landscapes." Nevertheless, Gottlieb's field is not as holistic and immediate as that of Newman, Still, or Rothko, since he centered his shapes, removing them from the picture edges, thereby isolating them as shapes and focusing attention on their symbolic connotations. Indeed, more than any of his contemporaries, Gottlieb translated the ideas of both gesture painters and color-field painters into an abstract symbolism.

1. Adolph Gottlieb, "An Interview with David Sylvester," *Living Arts*, No. 2 (London: 1963), 4, 10.
2. Adolph Gottlieb, Statement in the "Ides of Art: The Attitudes of 10 Artists on Their Art and Contemporaneousness," *The Tiger's Eye*, I, No. 2 (December, 1947), 43.
3. Adolph Gottlieb, statement in *The New Decade* (New York: Whitney Museum of American Art, 1955), pp. 35–36.
4. Adolph Gottlieb, *Untitled Edition—MKR's Art Outlook*, No. 6, (New York: December, 1945), 4, 6.
5. Diane Waldman, in "Gottlieb, Signs and Suns," *Art News*, LXVI, No. 10 (February, 1968), 66, wrote that Gottlieb's "forms could either be neatly compartmentalized within any or all of the rectangles shaped by the intersecting verticals and horizontals, they could spill out over the structure . . . or they could imply a tacit awareness of the grid without its actual use . . . or he could subvert the grid by other means: with wedges of color underlying or placed over it, by blurring the contour between two forms, by the use of a dense impasto blanketing the surface of the canvas, by filling only certain compartments with images. The size and placement of the forms set up a rhythmic progression whose directional force is in opposition to the static nature of the grid."
6. Adolph Gottlieb, in Introduction to catalogue of Gorky exhibition, Kootz Gallery, New York, March 28 –April 24, 1950, n.p.
7. Gottlieb, actually began to enlarge the size of his canvases somewhat earlier—in 1954.

16 Robert Motherwell
(1915–)

IN 1951, Motherwell wrote: "Every intelligent painter carries the whole culture of modern painting in his head. It is his real subject, of which everything he paints is both an homage and a *critique*, and everything he says a gloss." [1] This remark stresses one of the attitudes shared by all of the Abstract Expressionists who, much as they strove for the new, steeped themselves in past art. Motherwell was history-minded to a greater degree than his contemporaries. Not only did he deliberately synthesize diverse ideas culled from twentieth-century art in his own painting, but so strong was his intellectual bent that throughout his career he wrote extensively on art—in *VVV*, *Dyn*, *Partisan Review*, *Possibilities*, and *Modern Artists in America* (he helped edit the last two periodicals)—and also directed the *Documents of Modern Art*, a series of illustrated books by modern masters about modern movements. In effect, Motherwell shaped history-in-the-making, for the texts that he edited broadened the knowledge of his fellow artists and their public in the 1940's and 1950's.

In his own development, Motherwell first grounded himself in the tradition that began with Baudelaire and Delacroix (the subject of a thesis he wrote at Harvard) and extended through Rimbaud, Mallarmé, and Lautréamont into

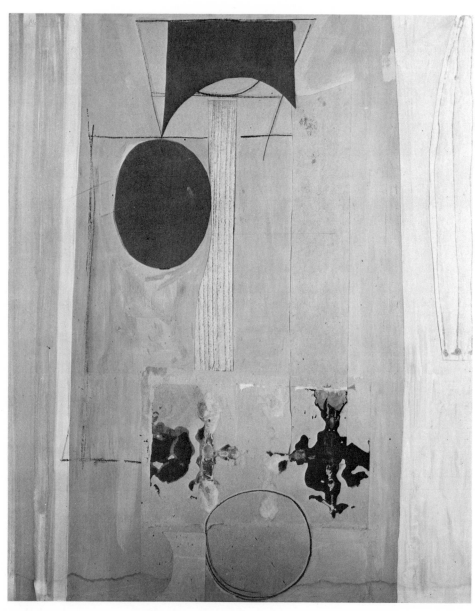

16–1 Robert Motherwell. *Mallarmé's Swan*. 1944.
Contemporary Collection of The Cleveland Museum of Art, Cleveland, Ohio.

Surrealism. His assimilation of French culture was highly rational, although he recognized that the Romantics, Symbolists, and Surrealists were intent on venturing beyond the limits of rationality. Moreover, he was attracted by the urge for innovation in the French modern tradition. In 1949, he named a germinal painting, *The Voyage* (1949; *Fig. 16-5*), after a poem by Baudelaire, the last line of which reads: "To the depths of the unknown to find the new." But the new was rooted in history, and Motherwell, as he said of Joseph Cornell, tried to "incorporate [a] sense of the past into something that could only have been conceived of at present." [2]

In 1940, he began to meet the Surrealists-in-exile and to participate in their activities. At first, he was strongly influenced by Matta's conception of automatism and employed it in a number of linear improvisations. But, unlike the Surrealists in general, Motherwell was drawn to the "well-painted" flat pictures of Picasso, Matisse, Miró, and Mondrian. To him, Miró was the greatest of the Surrealists, for that master used automatism to create poetic images without lapsing into literary references and illusionism, and without sacrificing artistic finesse. Consequently, Motherwell soon reacted against the unpainterly quality, deep space, and amorphous design that he favored in his earlier works, and started to improvise loose planar structures whose sources were in Synthetic Cubism. Torn bits of paper lent themselves to this process, and Motherwell incorporated these fragments into his pictures, such as *Mallarmé's Swan* (1944; *Fig. 16-1*). Most of his shapes were organic, frequently quoting those of Miró and Picasso, but he also painted near-geometric bands that suggest the influence of Neoplasticism, as in *The Little Spanish Prison* (1941–44; *Fig. 16-2*). During this period, he introduced the design of ovals wedged between vertical rectangles and a palette of white, black, ocher, and cerulean (*Fig. 16-3*)—pictorial elements he has favored throughout his career. Linear automatism continued to play a role in the formulation of Motherwell's imagery, but increasingly most of what he allowed to remain of his drawings was the contours of his shapes. As linear calligraphy ceased to be stressed, areas of color began to play a growing role, prompting Motherwell in the direction of color-field painting. At the same time, he tended toward gesture painting, substituting the brushstroke for the drawn line and composing his planes from painterly marks, as in *Emperor of China* (1947; *Fig. 16-4*).

Motherwell's desire for masterliness led him to focus on the aesthetic qualities of painting. But, as he wrote in 1946, "in this stage of the creative process, the strictly aesthetic . . . ceases to be the chief end in view." The need was to use the process of painting as the "*means* for getting at the infinite background of feeling in order to condense it into an object of perception." Motherwell turned away from the Surrealists who aimed to divulge unconscious imagery automatically and who disregarded deliberate painterly processes, since he believed that the artist's "task is to find a complex of qualities whose feeling is just right—veering toward the unknown and chaos, yet ordered and related in order to be apprehended." [3]

Taking his cue from the Symbolists, Motherwell conceived of such painting as symbolic, corresponding to feelings and ideas. Indeed, he believed that "correspondences" were unavoidable: "The 'pure' red of which certain abstractionists speak does not exist, no matter how one shifts its physical contexts. Any red is rooted in blood, glass, wine, hunter's caps, and a thousand other concrete phenomena. Otherwise we should have no feeling toward red or its relations, and it would be useless as an artistic element." [4] In 1944, Motherwell wrote that "all my works, consist of a dialectic between the con-

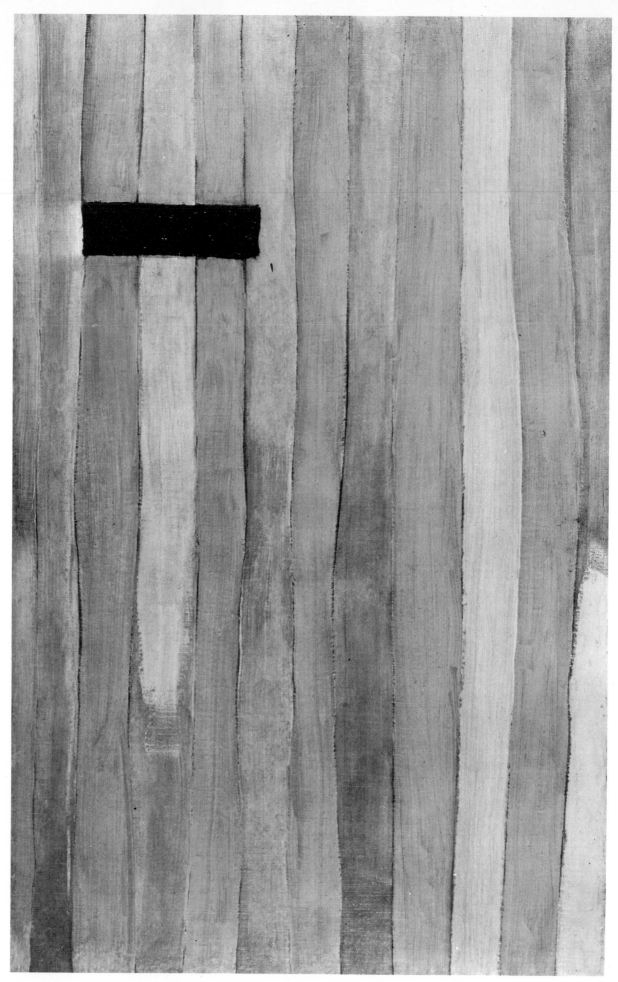

16–2 Robert Motherwell. *The Little Spanish Prison.* 1941–44.
Collection of the artist;
Promised gift to The Museum of Modern Art, New York.

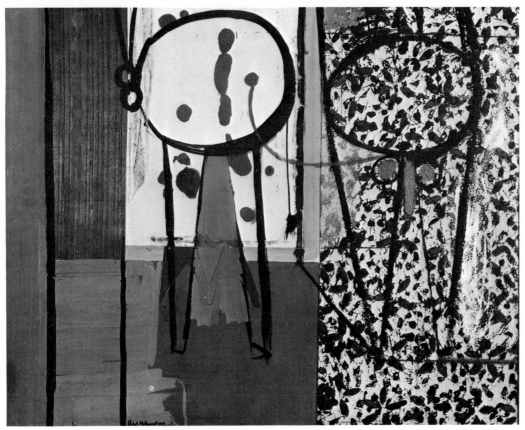

16–3 Robert Motherwell. *Pancho Villa, Dead and Alive.* 1943.
Collection The Museum of Modern Art, New York.

16–4 Robert Motherwell. *Emperor of China.*
1947.
Chrysler Art Museum, Provincetown, Massachusetts.

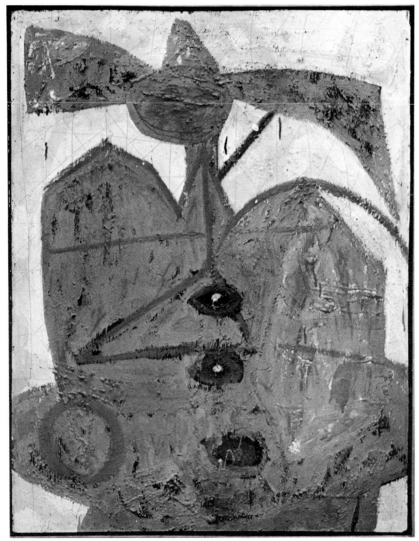

scious (straight lines, designed shapes, weighted colors, abstract language) and the unconscious (soft lines, obscured shapes, *automatism*) resolved into a synthesis which differs as a whole from either." [5] Prior to 1949, his quasi-figurative and abstract symbols tended to be too contrived to possess the suggestiveness that the Symbolists deemed essential to poetry. Moreover, his painting, although distinctive and often masterly, was too derivative to open up radical ways of seeing and experiencing.

However, in a series of pictures entitled *Elegies to the Spanish Republic* (*Figs. 16-6, 16-7*), begun in 1949, Motherwell achieved a fresh dramatic poetry. These canvases were to be central to his body of work; by the end of 1965, he had painted more than a hundred. The *Elegies* were composed mainly of frieze-like sequences of vertical black planes, rectangular and oval in shape, that loom large on white grounds. In their planarity and biomorphism, they are related to the artist's earlier pictures and to those of Miró, Matisse, and Picasso. Yet, by simplifying his images, by making them more abstract and enlarging them, Motherwell transcended these sources. Indeed, he alluded more strongly to the works of his contemporaries. His elemental canvases have affinities to color-field abstraction, but his shapes are distinct and more gestural—thus fusing the two main tendencies in Abstract Expressionism. The desire to merge diverse artistic directions remained a powerful motive in the *Elegies*, as it had been in his earlier works. The starkness of the design is "American" in look, yet the surfaces are "well-painted" in the sensuous manner identified with the School of Paris. In sum, the *Elegies* are an original synthesis in an immediate and monumental form of all the qualities Motherwell valued in modern art: symbolism, flatness, sensuousness, automatism, biomorphism, and abstraction.

Referring to the Spanish Civil War, which was the inspiration for the *Elegies*, Motherwell wrote: "I was twenty-one in 1936 and that was the most moving political event of the time." [6] But he started to paint Spanish themes

16–5 Robert Motherwell. *The Voyage.* 1949.
Collection The Museum of Modern Art, New York;
Gift of Mrs. John D. Rockefeller III.

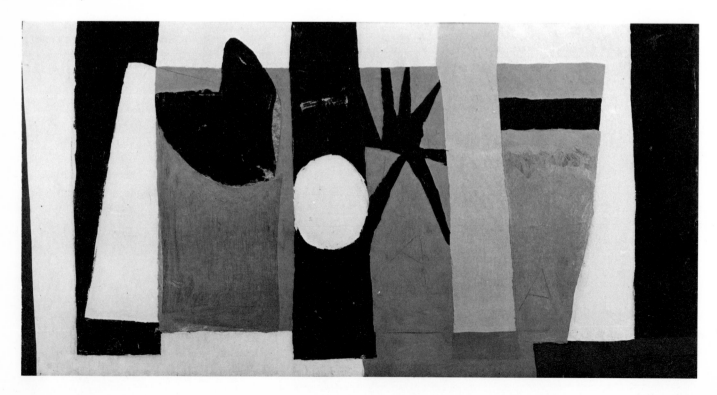

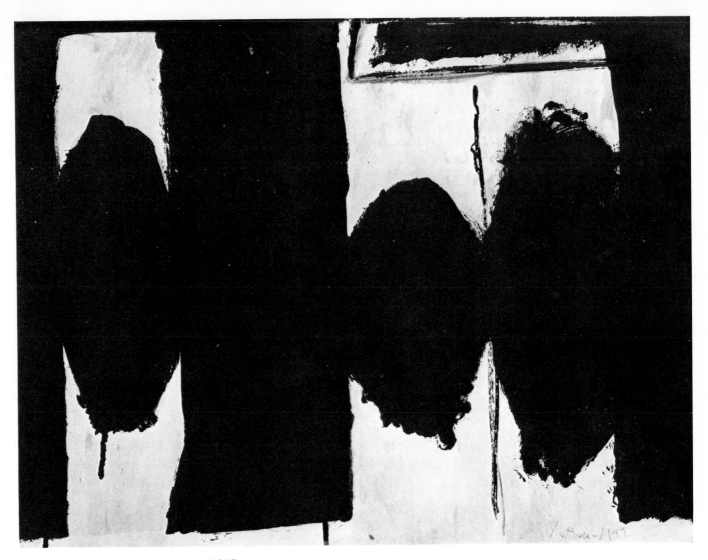

16–6 Robert Motherwell. *At Five in the Afternoon*. 1949.
Collection of the artist.

some half-dozen years after Franco's conquest—during World War II—and he did not begin the *Elegies* until a dozen years after the Civil War ended. The Spanish pictures, though socially conscious, are far more expressive of a nostalgia for a lost cause, and it was Motherwell's intention to be subjective, to internalize his sentiments in order to make them more genuine in feeling. In a sense, the war in Spain was to Motherwell what the North African lion hunt was to Delacroix—an occasion for romantic yearnings.

Motherwell himself said: "The *Spanish Elegies* are not 'political' but my private insistence that a terrible death happened that should not be forgot. . . . The pictures are also general metaphors of the contrast between life and death, and their interrelation." [7] The "life" in Motherwell's *Elegies* is charged with sex. His images refer to seemingly pregnant female bodies, and perhaps to "the phallus and 'cojones' of the sacrificial bull hung on the whitewashed wall." [8] The erotic quality is accented by the fleshiness of the brushwork, but this in turn is countered by the austerity of the design and the dominant black and white. Like many Romantics before him—witness Delacroix in the *Death of Sardanapalus*—Motherwell suggests sex and death simultaneously. His black, for example, is at once funereal and yet more alive than the whites. Black and white are also the "colors" of much of Spanish art, for example, of Goya's late "black" pictures and Picasso's *Guernica*, but they also call to mind Matisse's sensual "black" paintings, which were exhibited in New York in 1948 and made a strong impression on local artists.

Motherwell's palette also evokes the Spanish landscape, which resembles

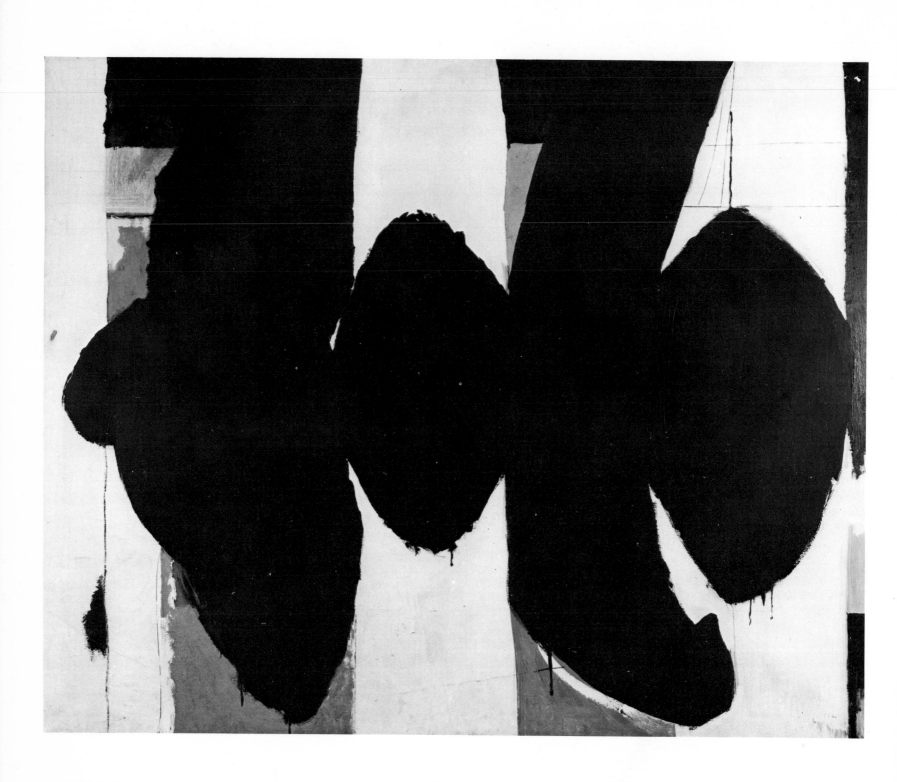

16–7 Robert Motherwell. *Elegy to the Spanish Republic XXXIV*. 1953–54.
Albright-Knox Art Gallery, Buffalo, New York;
Gift of Seymour H. Knox.

16–8 Robert Motherwell. *Iberia No. 18.* 1958.
Collection of the artist.

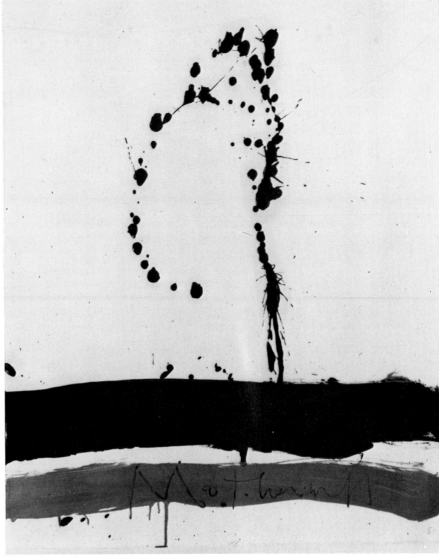

16–9 Robert Motherwell. *Beside the Sea No. 5.* 1962.
Collection of the artist.

that of the region in California where he grew up; yet, since he did not visit Spain until 1958, it can be surmised that his choice of color and form was affected by childhood memories. In 1949, the year he began the *Elegies*, Motherwell wrote of a miner's graveyard in the American West:

> Beyond, the town's ruins, burnt sienna, pink, yellow ochre—arid and clear in the distance . . . Here silent monuments of the past rest, in white October sun. . . . Crystal light! Vertical personages gaping, a broken grave. . . . the desert air is white, Mallarmé's swan.[9]

After 1949, he painted many huge canvases. On the whole, Motherwell's move toward the big picture seems to have been motivated by a desire to monumentalize symbols of his private sentiments, to make them more immediate and dramatic. But he continued to execute intimate pictures throughout his career, such as the gestural *Je t'aime* series (*XIX*, p. 246) of the mid-1950's —introverted homages to woman and to France—and numerous collages of which he wrote: "The papers . . . are usually things that are familiar to me, part of my life . . . a way to work with autobiographical material." [10] The sense of intimacy Motherwell achieved in his small pictures (*Figs. 16-8, 16-9*) is imparted even by his largest canvases (*Fig. 16-10*), a factor that distinguishes them from the more suprapersonal, visionary statements of Pollock, Still, Newman, and Rothko.

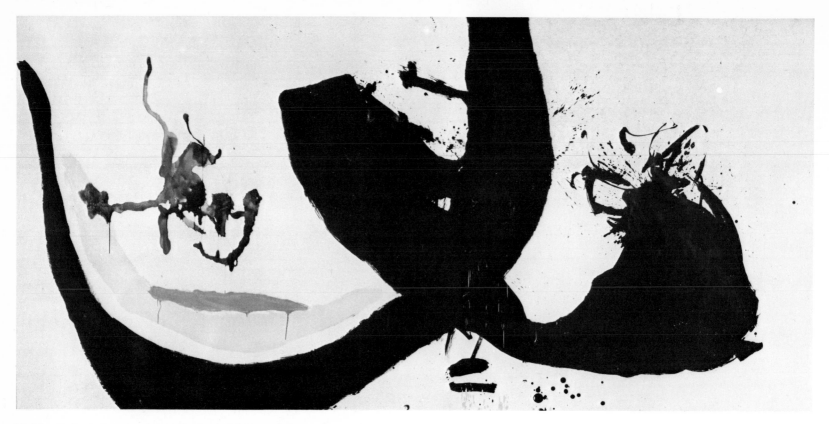

16–10 Robert Motherwell. *Black on White*. 1961.
The Museum of Fine Arts, Houston, Texas.

16 **Notes**

1. Robert Motherwell, catalogue of an exhibition, "The School of New York," Perls Gallery, Beverly Hills, January, 1951, n.p.
2. Robert Motherwell, "Joseph Cornell," unpublished Preface (June 26, 1953), for a catalogue of the Cornell exhibition at the Walker Art Center, Minneapolis, Minn., July-August, 1953, n.p.
3. Robert Motherwell, "Beyond the Aesthetic," *Design*, XLVII, No. 8 (April, 1946), 14–15.
4. Robert Motherwell, "Beyond the Aesthetic," p. 15.
5. Robert Motherwell, Statement in Sidney Janis, *Abstract and Surrealist Art in America* (New York: Reynal & Hitchcock, 1944), p. 65.

6. Robert Motherwell, a conversation at lunch, Smith College, Northampton, Mass., November, 1962. Notes (3 pages) transcribed by Margaret Paul, January, 1963.
7. *Ibid.*
8. Eugene Goossen, "Robert Motherwell and the Seriousness of Subject," *Art International*, III, No. 1–2 (1959), 34.
9. Robert Motherwell, in Introduction to Marcel Raymond, "From Baudelaire to Surrealism," in *Documents on Modern Art*, X (New York: Wittenborn, Schultz, 1949), n.p.
10. Robert Motherwell, a conversation at lunch, Smith College.

BY the end of World War II, organized Surrealist activities virtually ceased in America. On the whole, the emigrés had not been at ease here, and their work suffered as a consequence (this was probably due equally to the growing staleness of their pictorial ideas). As Max Ernst recalled in 1946:

> During my first months in New York there were many Paris painters here. At first the surrealist groups seemed to have real strength; but little by little they began to break up. It was hard to see one another in New York. The café life was lacking. . . . As a result in New York we had artists, but not art. Art . . . is to a great degree a product of [artists'] exchange of ideas. . . . There is more loneliness—more isolation among artists [here] than in France.[1]

When peace came, many of the emigrés returned to Europe. *View*, the last of the magazines oriented toward Surrealism, suspended publication in 1947, and, in that year, Peggy Guggenheim closed her Art of This Century Gallery.

As the 1940's progressed, Surrealist art generated less and less excitement among vanguard New York artists. In 1947, Nicolas Calas, a Surrealist spokesman, organized a show at the Hugo Gallery entitled "Bloodflames," which featured the Abstract Surrealists Hare, Gorky, Kamrowski, Lam, Matta, and Isamu Noguchi, whose works were installed in an environment designed by Frederick Kiesler. Because it featured abstract art, the show stimulated some interest in vanguard circles, but that was not to happen again. At that very time, the Abstract Expressionists were beginning to evolve radical, abstract styles that could not at all be thought of as Surrealist. This was not immediately apparent, and in retrospect, the years 1946 and 1947 appear as a kind of incubation period. During that time, the Abstract Expressionists were generally ignored by art magazines, the mass media, and museums, and although they often met privately, they did not organize to bid for public recognition. Their main public activities were the shows they held in the Betty Parsons, Samuel Kootz, and Charles Egan galleries, which became the centers of vanguard art. Only after they had had the opportunity of seeing their own works on gallery walls over a period of time did the artists themselves grasp its cumulative value and power and react strongly against its comparative neglect. From 1946 to 1951, the three galleries (and the Art of This Century, until it closed) exhibited the Abstract Expressionists in show after show. During the six seasons, for example, Pollock had seven one-man exhibitions; Rothko and Hofmann six; Gottlieb, Baziotes, Reinhardt, and Motherwell, five; Still, four; De Kooning, three; and Newman and Franz Kline, two. Taken together, these shows made a strong impression on fellow artists and on the art conscious public, although the latter was in the main hostile.

After 1947, several new magazines—the most important of which were *The Tiger's Eye*, *Possibilities 1*, and *Modern Artists in America*—began to feature statements and illustrations of works by the Abstract Expressionists.[2] *The Tiger's Eye* was a general cultural magazine, published in nine numbers from 1947 to 1949. It was edited by Ruth Stephan; the art editor was her husband, the painter John Stephan, who exhibited at the Parsons Gallery. Newman, who wrote an article for the initial issue, became an assistant editor for the second number and remained in that position until the fourth issue was published in June, 1948. With these two painters as policy makers, the magazine was highly responsive to artists' opinions, particularly those in the Parsons group. *Possibilities 1* also reflected the thinking of the Abstract Expressionists. Its art editor was Robert Motherwell; the members of its editorial

staff—Harold Rosenberg (writing) and John Cage (music) among them—
were close to vanguard artists. Although it appeared in only one number, in
the winter of 1947–48, *Possibilities 1* printed important statements and repro-
ductions of pictures by Motherwell (who, with Rosenberg, outlined the
magazine's policy), Baziotes, Pollock, and Rothko. *Modern Artists in Amer-
ica* was published once in 1952. Edited by Motherwell and Ad Reinhardt,
it aimed to dispel misunderstandings concerning abstract art and to docu-
ment events as they happened. The magazine printed dozens of illustra-
tions of current abstract paintings and sculptures, and part of the transcript
of a three-day conference in 1950, in which Baziotes, Brooks, De Kooning,
Gottlieb, Newman, Hofmann, Motherwell, Reinhardt, Stamos, and Tomlin
participated.

During the early and mid-1940's, the most important single spokesman on
behalf of Abstract Expressionism was Clement Greenberg, whose art criticism
appeared in *The Nation* and *Partisan Review*. Other critics sympathetic
toward the tendency were Weldon Kees, who wrote for *The Nation*; James
Johnson Sweeney, and Robert Goldwater, both of whom published in *Parti-
san Review*. The established art magazines were far slower in giving coverage
to Abstract Expressionism. First to do so was the *Magazine of Art*, after it
came under Goldwater's editorship late in 1947. From 1948 to 1951, it ran
features on De Kooning, Still, Motherwell, Rothko, Pollock, and Gorky. *Art
News* ignored the Abstract Expressionists until Thomas B. Hess became its
managing editor in January, 1948. Slowly they received more mention, but
they were not featured in separate articles until 1950; during the 1950's, *Art
News* was more sympathetic toward Abstract Expressionism than any other
art publication. In 1948, a monograph on Hans Hofmann was published, the
first on an Abstract Expressionist. It accompanied a retrospective of his paint-
ing held at the Addison Gallery of American Art in Andover, Massachusetts
(the first major one-man show given by a museum to an Abstract Expression-
ist). Entitled *Search For the Real and Other Essays*, the monograph included
writings by Hofmann and a summary of his career by Bartlett H. Hayes, Jr.
Other books that dealt seriously with the Abstract Expressionists were James
Thrall Soby's *Contemporary Painters* (1948); John I. H. Baur's *Revolution
and Tradition in Modern American Art*, and Andrew C. Ritchie's *Abstract
Painting and Sculpture in America*, both published in 1951. In that year also
there appeared the first general book to feature the Abstract Expressionists,
Hess's *Abstract Painting*.[3]

In the late 1940's and early 1950's, museums began increasingly to include
Abstract Expressionists in important exhibitions. The first of these shows was
"Fourteen Americans," organized in 1946 by Dorothy C. Miller at the Mu-
seum of Modern Art; it included canvases by Gorky and Motherwell. The
painters themselves also began to win awards and honors. In 1947, for
example, Baziotes received a major prize at the Thirty-Eighth Annual Ex-
hibition held at the Art Institute of Chicago, the first given an Abstract
Expressionist.

These books, magazine articles, museum shows, and prizes were all indica-
tive of the growing recognition granted to Abstract Expressionism by the art
world. The public could no longer ignore it but remained generally hostile,
a sign of which was the bitter condemnation in the mass media of the prize
awarded Baziotes. The antagonism of the popular magazines was beginning
to soften, however. On October 11, 1948, *Life* ran a special feature entitled
"A *Life* Round Table on Modern Art," a section of which was devoted to

"Young American Extremists." The fifteen writers on art who participated were in the main critical of the new art, but dealt with it seriously.[4]

By 1948, the Abstract Expressionists had become convinced that the art they were creating was more vital, radical, and original than any being produced elsewhere and organized for the purpose of counteracting hostility from art officialdom; what had begun as an underground movement finally came out into the open. The event that provoked vanguard artists was the decision of the Institute of Modern Art in Boston to change the word "modern" in its name to "contemporary." In a statement justifying the change, the Institute's director, James S. Plaut, condemned modern art as an obscure and negative academic style that had ceased to communicate to the public. Vanguard artists expected—and received—derogation from President Truman (who called modern painting "scrambled eggs"), know-nothing Congressmen, the mass media, and hidebound art critics, but they would not silently endure abuse from an important museum. In March, the Modern Artists Group of Boston met to denounce Plaut's statement. In New York, Bradley Walker Tomlin suggested that local artists also protest the statement and, at the same time, condemn "uninformed" art critics who supported Plaut's position. Painter Paul Burlin called together a group (in Stuart Davis's studio) that organized a protest meeting at the Museum of Modern Art in May, 1948.

A second protest occurred two years later—in May, 1950—when eighteen Abstract Expressionist painters (including Gottlieb, Motherwell, Baziotes, Hofmann, Newman, Still, Reinhardt, Pollock, Rothko, Tomlin, De Kooning, and Brooks), supported by ten sculptors, sent an open letter to Roland L. Redmond, president of the Metropolitan Museum of Art, upbraiding his decision to hold a juried national exhibition entitled "American Painting Today—1950." They attacked as "notoriously hostile to advanced art" the five regional juries, the national jury, and the jury of awards, asserting that they would not submit works to the competition. *The New York Times* ran the story on its front page, and reports also appeared in other New York newspapers. The *Herald Tribune* ran an editorial entitled "The Irascible Eighteen" (the name stuck in the public's mind), denouncing the artists for distortion of fact. The mass-circulation magazines soon considered the controversy important enough to cover: after the show opened at the Metropolitan, *Life* ran its now famous photograph of the protesting artists.[5] The wide publicity given the Irascibles attested to—as it contributed to—the public's growing interest in Abstract Expressionist painting.

In 1948, the Abstract Expressionists started to join together in a varied number of activities. In the fall of that year, Baziotes, David Hare, Motherwell, and Rothko founded a school at 35 East Eighth Street, which at Newman's suggestion, they named "The Subjects of the Artist." Still participated in the initial planning but did not teach there; Newman joined the faculty at the beginning of the second semester. With the exception of Newman, the entire faculty had had shows at the Art of This Century Gallery between 1944 and 1946; in 1948, all were exhibiting at the Parsons and the Kootz galleries. At first alone, and later with the help of Newman, Motherwell organized a series of Friday evening lectures by advanced artists. These sessions were open to the public, and the turnout was large. The artists who lectured during the 1948–49 season were: John Cage ("Indian Sand Painting or the Picture that is Valid for One Day"), Richard Huelsenbeck ("Dada Days"), Hans Arp (whose talk was translated by Kiesler), De Kooning ("A Desperate View"), Fritz Glarner ("On Relational Painting"), Julien Levy ("On Surrealism in

America"), Gottlieb ("The Abstract Image"), Reinhardt ("Abstraction"), and Harry Holtzman ("Everyman His Own Hero").

The School was a financial failure, and it closed in the spring of 1949. The following fall, three professors from New York University's School of Art Education took over the loft and used it to provide studio and exhibition space for their students. Naming the loft Studio 35, they continued the Friday evening lectures until the spring of 1950.[6] The final activity at Studio 35 was the three-day closed conference of leading vanguard artists.[7]

In the fall of 1949, the organization that came to be known simply as the Club or the Eighth Street Club was founded, and through the 1950's, it remained the focal point of Abstract Expressionist activities. Although its charter members attended and participated in the Friday evening lectures of The Subjects of the Artist School and Studio 35, it was formed independently of both.[8] Many of the artists who started the Club had met in the 1930's while working on the Federal Art Project; others had got acquainted at the meetings of the Artists Union and the American Abstract Artists, in Hans Hofmann's school, and in Greenwich Village restaurants, particularly the Waldorf Cafeteria on Sixth Avenue off Eighth Street, which during World War II became a popular hangout.

The Club was governed by a voting committee consisting of those charter members who remained active and others they elected. The dominant force in Club affairs was Phillip Pavia, who was treasurer and who arranged the programs. All Club rules were determined by the voting committee without recourse to the membership, but they were not enforced rigidly. To become a member of the Club, one had to be sponsored by a voting member and be approved by the committee. New members were selected because of their compatibility and not because of how they painted. Membership jumped quickly; by the summer of 1950, the original twenty had tripled. Most of the Abstract Expressionists joined within a few months, including the faculty of The Subjects of the Artist School, with the exception of Rothko (although he appeared sporadically at the beginning). Pollock and Still never became members.

Reacting against the hostile public at large, vanguard artists met at the Club to seek out their own kind and to create their own audience, mostly of fellow artists. The Club became the core of a subculture whose purpose was as much social as it was intellectual—like that of the Paris cafés. For artists venturing into untried areas in art, the need to exchange ideas was urgent. Most Club members agreed with De Kooning, who said: "There's no way of looking at a work of art by itself; it's not self-evident—it needs a history, it needs a lot of talking about; it's part of a whole man's life." [9] It must be stressed, however, that the premises of gesture and color-field painting had already been established; the discussions after 1948 may have instilled in artists greater confidence to follow radical ideas but did not give rise to any. Although the premises of Abstract Expressionism were not first broached at the Club, the incessant discussions forced each artist to renew his ideas constantly, to justify his painting to himself by justifying it to his colleagues.

A diverse group with irreconcilable aesthetic aims, the Club members could never promote a specific aesthetic program. But most of them were abstract artists, and many were inclined to gesture painting, particularly that of De Kooning, who was the best known and most charismatic. Most members abhorred all systems, ideologies, and categories—anything that might curb expressive possibilities. We agree only to disagree—this was their

unwritten motto. This led to flexibility and openness, for, as Tworkov wrote in his journal: "The enthusiastic clash of ideas that takes place at the Club has one unexpected and, in my belief, salutory effect—it destroys, or at least reduces, the aggressiveness of all attitudes. One discovers that rectitude is the door one shuts on an open mind." [10] Contributing to this sense of freedom was the democratic attitude of Club members. Each respected the others as equals.

Another impetus to openness was the verbal style of the Abstract Expressionists. On the whole, they refused to focus on formal analysis, pictorial fact, or the look of works, fearing perhaps that such an approach would have implied that Abstract Expressionism was a fixed and established style whose attributes could be identified. The artists found it more exciting to discuss how and why an individual involved himself in painting. Conversation was treated as the verbal counterpart of the painting activity, and artists tried to convey what they really felt in both as directly, personally, and passionately as they could. This often led to trenchant and provocative insights that more than compensated for the frequent lapses into confused and egotistic bombast. It also generated bitter personality conflicts, for, as Goldwater remarked: "Since the artist identified with his work, intention and result were fused, and he who questioned the work, in however humble a fashion, was taken to be doubting the man." [11]

This "semi-public auto-criticism," as Thomas B. Hess called Club talk, created frustrating difficulties for many participants.[12] Subjective responses could rarely be checked against specific works. Goldwater wrote:

> The proceedings always had a curious air of unreality. One had a terrible time following what was going on. The assumption was that everyone knew what everyone else meant, but it was never put to the test; no one ever pointed to an object and said, see, that's what I'm talking about (and like or don't like). Communication was always entirely verbal. For artists, whose first (if not final) concern is with the visible and the tangible, this custom assumed the proportions of an enormous hole at the center.[13]

The Club was meant to be private and informal. At first, meetings were generally prearranged by phone calls on the spur of the moment. However, the Club soon took on a more public and formal character, first by inviting speakers, and then, after 1951, by arranging panels of artists. These programs became the Club's major activity, and they attracted critics, historians, curators, dealers, collectors, and avant-garde allies in the other arts, some of whom were admitted into membership. But the Club continued to limit its audience primarily to artists. The panel format and the presence of influential tastemakers made the discussions at the Club somewhat self-conscious and inhibited. The spot for blunt conversation came to be the Cedar Street Tavern on University Place, off Eighth Street. Artists began to go there when the panels got dull or after them, and then late every night when the Club was not open. The Club lectures began in the late winter of 1949–50. In the beginning, the speakers were not artists but philosophers William Barrett, Hannah Arendt, and Heinrich Bluecher; composer Edgard Varèse; social critic Paul Goodman; Joseph Campbell, author of *Hero With 1000 Faces*; Father William Lynch of Fordham University; and art critic Thomas B. Hess. There were also parties held in honor of artists who were having one-man shows or who were visiting from abroad, and of figures in the other arts, such as

Dylan Thomas on the occasion of his first trip to America. The Club lectures and, later, the panel discussions that featured artists, made available to members and their friends the latest ideas in all creative fields. As Tworkov wrote: "I think that 39 East 8th is an unexcelled university for an artist. Here we learn not only about all the possible ideas in art, but learn what we need to know about philosophy, physics, mathematics, mythology, religion, sociology, magic." [14]

Of all the topics discussed publicly by the Abstract Expressionists and the writers close to them during the late 1940's and early 1950's, the one that recurred most often and that generated the greatest controversy was the problem of community, of defining mutual ideas and interests. The artists felt that their works taken together did not constitute a collective style, yet they recognized that they shared a kind of common culture, a certain sensibility, of which aesthetics was but a part. They tried to clarify this state of mind, much as their endeavors always ended without a consensus.

In the fall of 1949, Harold Rosenberg and Samuel Kootz tried to indicate a cohesive movement by organizing a group exhibition entitled "The Intrasubjectives." The artists included were Baziotes, De Kooning, Gorky, Gottlieb, Graves, Hofmann, Motherwell, Pollock, Reinhardt, Rothko, Tobey, and Tomlin. The name of the show was taken from José Ortega y Gasset's "On the Point of View of the Arts," and the catalogue quoted from it: "The guiding law of the great variations in painting is one of disturbing simplicity. First, things are painted; then sensations; finally, ideas. This means that in the beginning the artist's attention was fixed on external reality; then on the subjective; finally on the intrasubjective. These three stages are three points on a straight line." [15] Robert Goodnough, who interviewed the participating artists, defined intrasubjective as "the content of consciousness." [16] In the catalogue, Kootz separated the Intrasubjectives in his show from all artists who painted from nature, including those who arrived at abstraction through Cubism: "Theirs [the Cubists'] has, in the main, been as an objective art, as differentiated from the new painters' inwardness. The Intrasubjective artist invents from personal experience, creates from an internal world rather than an external one." [17]

Robert Goldwater, the editor of the *Magazine of Art*, was also interested in defining new tendencies in contemporary art. At the beginning of 1949, he invited sixteen critics to assess the state of American art. [18] Most were sympathetic to abstraction in its diverse manifestations, while insisting that it did not invalidate representational art. Yet most felt that there was generally little to get excited about in American art. The two exceptions were Clement Greenberg and Douglas MacAgy, who singled out the Abstract Expressionists for acclaim, pointing to their originality and vitality and to their equality—if not superiority—to the French artists of their generation. As Greenberg wrote:

> There is, in my opinion, a definitely American trend in contemporary art, one that promises to become an original contribution to the mainstream and not merely a local inflection of something developed abroad. . . . The trend is broad and deep enough to embrace artists as divergent in feeling and means as the late Arshile Gorky, Jackson Pollock, Willem de Kooning, David Smith, Theodore Roszak, Adolph Gottlieb, Robert Motherwell, Robert De Niro and Seymour Lipton . . . I would say that three or four of them are able to match anything being done by artists of the same generation elsewhere in the world. [19]

216

The question of whether a community existed among the Abstract Expressionists was broached again and again at a three-day conference at Studio 35 in 1950, but the participants found it difficult to specify what bound them together, even in general terms.[20] At one point, Alfred Barr asked bluntly for "the most acceptable name for your direction or movement? (it has been called abstract-expressionist, abstract-symbolist, intra-subjectivist, etc.)." De Kooning responded: "It is disastrous to name ourselves."[21] However, the participating artists did elaborate on this issue under another guise: the difference between American and French art and the relative merits of each. Motherwell opened the discussion by remarking that

> "young French painters who are supposed to be close to this group . . . in 'finishing' a picture . . . assume traditional criteria to a much greater degree than we do. They have a real 'finish' in that the picture is a real object, a beautifully made object. We are involved in 'process' and what is a 'finished' object is not so certain."

> Hofmann: "Yes, it seems to me all the time there is the question of a heritage. It would seem that the difference between the young French painters and the young American painters is this: French pictures have cultural heritage. The American painter of today approaches things without basis. The French approach things on the basis of cultural heritage—that one feels in all their work. It is a working towards a refinement and quality rather than a working toward new experiences, and painting out these experiences that may finally become tradition. The French have it easier. They have it in the beginning."

> De Kooning: "I am glad you brought up this point. It seems to me that in Europe every time something new needed to be done it was because of traditional culture. Ours has been striving to come to the same point that they had—not to be iconoclasts."

> Gottlieb: "There is a general assumption that European—specifically French—painters have a heritage which enables them to have the benefits of tradition, and therefore they can produce a certain kind of painting. It seems to me that in the past fifty years the whole meaning of painting has been made international. I think Americans share that heritage just as much, and that if they deviate from tradition it is just as difficult for an American as for a Frenchman. It is a mistaken assumption in some quarters that any departure from tradition stems from ignorance. I think that what Motherwell describes is the problem of knowing what that tradition is, and being willing to reject it in part. This requires familiarity with his past. I think we have this familiarity, and if we depart from tradition, it is out of knowledge, not innnocence."

> De Kooning: "I agree that tradition is part of the whole world now. The point that was brought up was that the French artists have some 'touch' in making an object. They have a particular something that makes them look like a 'finished' painting. They have a touch which I am glad not to have."[22]

The issue of American versus French painting had provoked considerable interest earlier. Paris had been the capital of world art before World War II, and most New Yorkers expected that after France was liberated from the Nazis, it would resume its former position. In the summer of 1946, Greenberg wrote reverently: "The School of Paris remains still the creative fountainhead of modern art, and its every move is decisive for advanced artists everywhere else—who are advanced precisely because they show the capacity to absorb and extend the preoccupations of that nerve-center and farthest

nerve-end of the modern consciousness which is French art." [23] But the more postwar French art was exhibited in New York the less it was applauded. During the following winter, Greenberg reversed his opinion. In a review of the first large-scale show of the "School of Paris, 1939 to 1946," held at the Whitney Museum, he stated: "The show itself is shocking. Its general level is, if anything, below that of the past four or five Whitney annual exhibitions of Ame ican painting—about the lowness of which I have expressed myself rather strongly in the past, lamenting the sad state of American art in our day." [24] His rejection of the School of Paris soon became extreme: "when one sees . . . how much the level of American art has risen in the last five years . . . then the conclusion forces itself, much to our own surprise, that the main premises of Western art have at last migrated to the United States." [25]

In 1953, Greenberg summed up his feelings about the Paris–New York polarity:

> There is a crucial difference between the French and American versions of so-called abstract expressionism despite their seeming convergence of aims. In Paris they finish and unify the abstract picture in a way that makes it more agreeable to standard taste . . . (which . . . is usually at least a generation behind the best of the art contemporaneous with it). For all the adventurousness of their "images," the latest generation in Paris still go in for "paint quality" in the accepted sense. They "enrich" the surface with films of oil or varnish, or with buttery paint. Also, they tend to tailor the design so that it hits the eye with a certain patness; or else the unity of the picture is made to depend on a semblance of the old kind of illusion of depth obtained through glazing or tempered color. The result is softer, suaver, and more conventionally imposing . . . [The Abstract Expressionist] vision is tamed in Paris— not, as the French themselves may think, disciplined. The American version is characterized . . . by a fresher, opener, more immediate surface. [It is] harder to take. Standard taste is offended. . . . Do I mean that the new American abstract painting is superior on the whole to the French? I do. Every fresh and productive impulse in painting since Manet, and perhaps before, has repudiated received notions of finish and unity, and manhandled into art what until then seemed too intractable, too raw and accidental, to be brought within the scope of esthetic purpose. This extension of the possibilities of the medium is an integral factor of the exaltation to be gotten from art, in the past as now. I miss this factor in too much of the latest Parisian painting; the latter does not challenge my sensibility enough.[26]

In another article, Greenberg implied that the divergences between American and French art issued in large measure from the differences in the ways of living of artists here and abroad. The New Yorkers had a

> more intimate and habitual acquaintance with isolation . . . or rather the alienation that is its cause. . . . [It] is the condition under which the true reality of our age is experienced. And the experience of this true reality is indispensible to any ambitious art. . . . What is much more real at the moment [than the Paris scene which suppresses reality] is the shabby studio on the fifth floor of a cold-water, walk-up tenement on Hudson Street; the frantic scrambling for money; the two or three fellow-painters who admire your work; the neurosis of alienation that makes you such a difficult person to get along with. . . . The alienation of Bohemia was only an anticipation in nineteenth-century Paris; it is in New York that it has been completely fulfilled.[27]

Greenberg's assessment of French art and of the reasons for its decline was shared by most of the New York vanguard. But the denigration of the School of Paris was not unanimously accepted; Hofmann asserted: "The master[s] of Paris give undiminished proof of Strength/ Tenacity and/ Courage in a/ continued struggle for inward development/ Paris is not the soul of France alone/ it is the hearth of the world/ it is the spiritual center." [28] Other artists —the most extreme of whom was Clyfford Still—maintained conversely that the collapse of postwar Parisian art was the final proof of the decadence of European culture. A fresh start was being made in America.[29]

French critics and artists who visited here joined in the controversy, natu-rally questioning the claim that New York was artistically superior to Paris but generally with a defensiveness new to the French. Georges Mathieu was so unnerved by what he felt to be the animosity of many New York artists to the School of Paris that he wrote a letter to twenty-five of them in the spring of 1952, decrying American chauvinism:

> I have been very surprised to hear that in New York you had not im-mediately recognized Wols as one of the most worthy brothers, the Rimbaud of Painting. I do not want to believe that a narrow minded nationalism has had anything to do with the reserve you showed at the time of his exhibit. I am all the more surprised because no other place in the world could have been more fit and better prepared to appreci-ate him than New York.[30]

But what Mathieu experienced in 1952 was indifference more than hostility. Indeed, much of the Abstract Expressionists' loss of esteem for the School of Paris stemmed from their inevitable maturing as artists. Even those who had once venerated foreign masters had come to believe that their hero-worship had been exaggerated. Thus, the issue of nationalism was of far less im-portance than the process of maturing, for the American vanguard had always been internationalist in outlook. Now it simply concentrated on its own art and ideas, recognizing to be sure that they were the most vital in the world.

The New Yorkers' discussions were innumerable, as were the questions raised, but there were certain recurrent themes. One, the character of the Abstract Expressionists' sensibility, was considered at length in the winter of 1952 by a Club panel consisting of Guston, De Kooning, Kline, George Mc-Neil, and Tworkov. The discussion was typical of most at the time. De Koon-ing suggested that there were two attitudes in art. The first was romantic, sym-bolized by Van Gogh's potato, which one could watch change—grow, rot, dis-appear—if one did not eat it. The second was classical, symbolized by Arp's pebble, which changes very little. If it were big enough, one could keep down the dead with it. De Kooning concluded by saying that the classical ideal was not favored much today. McNeil declared that he liked De Kooning's concern with Van Gogh instead of with Cézanne, whose formalism had dominated abstract art. He asserted that all abstraction until the 1940's was based on the virtue of the organized picture. The future, however, would embrace disorganization, for it would deal with the essence of defeatism. The anti-formalistic process would depend on some kind of irrational rationality, something that would ultimately appear rational and valued. This quality was found in the paintings of Van Gogh and not Cézanne. Van Gogh risked failure; Cézanne had too much pride for that. His pictures always had to be successes. Today, artists needed the opposite of putting one plane before another plane and relating them, they needed to take modern art out of the clinic and put it back into human experience. If they saw structure in the

past, they must now be antistructural. As soon as something was established, it was the job of the artist to disestablish it, to negate the past—not to contribute another statement in hushed terms.[31]

The probability of failure was raised repeatedly at the Club. As McNeil remarked, the abstract expressionists shared Van Gogh's dilemma. He had desired success, but failure was inherent in his striving to transcend known efforts. Having embraced an open system, he was always aware of an elusive something beyond, and this knowledge made him desperate. De Kooning agreed and added that even failure was not possible anymore: there were no models and one could not revert to the "isms" of the past. One could not fail, because there was no possibility of success.[32] Yet the artist could strive, and this was valued by the gesture painters as sufficient motivation in itself—the reason they did not accept Dada's nihilistic orientation. They thought of the artist who strove as heroic, for—vulnerable though he was and doomed to miserable failure—he could affirm himself in his art. The ambivalence of their attitude was similar to that of T. E. Lawrence, who as Irving Howe remarked,

> found it hard to believe in the very deeds he drove himself to perform. His apparent fulfillment of the hero's traditional tasks was undercut at every point by a distrust and mockery of the idea of heroism. He could not yield himself to his own *charisma*; he was never certain of those secret gifts which for the hero ought to be an assured possession; he lived in the nerve's edge of consciousness, forever tyrannized by questions. . . . the hero as he appears in the tangle of modern life is a man struggling with a vision he can neither realize or abandon.[33]

A number of Abstract Expressionists, De Kooning in particular, believed that by affirming themselves in their art, they might force themselves on the world. Nevertheless, they recognized that the world did not want them— proof of which was the poverty in which they lived. De Kooning said in 1950 that "we have no position in the world—absolutely no position except that we just insist upon being around." [34] Later, at a Club session, De Kooning maintained that the artist could not seem to get into the world actively and in this respect was a failure. Referring to Van Gogh's career to make his point, he remarked that the Dutch artist was something of a coward because he could not find a way of fulfilling his desire to do something about the world as a preacher, and so became an artist out of inertia. De Kooning confessed that Van Gogh's turn to painting lowered him in his estimation, for art was no way to lead a heroic life.[35]

De Kooning's characterization of Van Gogh's weakness could be applied to those American artists dedicated to social ends in the 1930's, who in the following decade transferred their commitment to art. In general, the Abstract Expressionists granted the seriousness of the political situation of the time and its pressures, but they resisted the "temptation . . . to conclude that organized social thinking is 'more serious' than the act that sets free in contemporary experience forms which that experience has made possible." [36] They believed that such forms, although they might not have immediate political impact, possessed broader social influence. Private, passionate, and intransigent, their art offered an alternative to mass culture. Moreover, in their very lives as creative individuals, they assumed a rebellious stance against the "outside" world, in which the individual was increasingly in the power of vast bureaucracies and unable to act meaningfully.

In part, the Abstract Expressionists' regard for the individual led them to reject geometric abstraction, which they identified with the impersonal ra-

tionalization underlying modern society. Although this was occasionally alluded to, the discussion of Cubist-inspired nonobjective styles and their relation to Abstract Expressionism took other forms. The issue was forced by a small number of geometric artists within the Abstract Expressionist group who were drawn to it because of its liveliness. The most vociferous was Ad Reinhardt. He was freer in his criticism of Abstract Expressionism because he was by nature a polemicist with a flair for satire, and because he had painted "expressionist" pictures during the 1940's (although he began his career in art by working in a geometric abstract manner and returned to it in the 1950's). Reinhardt espoused an extreme Purist position—an outgrowth of 1930's rationales but no mere restatement of them. He asserted that the Purist artist was concerned solely with art-as-art, and that no extra-aesthetic references were permissible. Reinhardt had arrived at this point of view prior to the formation of the Club. In 1946, he ridiculed Surrealist content and the interest taken by many of his friends in primitive art, particularly that of the Northwest Indian. Reinhardt diverged briefly from an aestheticist position in 1947, when he exhibited *Dark Symbol* and *Cosmic Sign* in Barnett Newman's "Ideographic Picture" show. But in the following year, he attacked "transcendental nonsense, and the picturing of a 'reality behind reality.'" Instead, he professed a desire for "pure painting [which] is no degree of illustration, distortion, illusion, allusion or delusion." [37]

Reinhardt maintained that art for its own sake was a kind of content, and he objected to the Abstract Expressionists' conception of geometric abstraction as contentless and to their belief that they had inaugurated a rebirth of content. He also questioned the acceptance of Expressionism as a new standard of judgment. What was the value of psychology or violence? Why must the artist beat his chest or pound his fist? [38] Why could he not be detached and nonanguished? According to Reinhardt, the artist-as-artist tried to define what art ought to be, and he achieved his goal through a reasoned and conscious process of negation, of separating art-as-art from what it was not—art-as-life.

> The one object of fifty years of abstract art is to present art-as-art and as nothing else, to make it into the one thing it is only, separating it and defining it more and more, making it purer and emptier, more absolute and more exclusive—non-objective, non-representational, non-figurative, non-imagist, non-expressionist, non-subjective. The only and one way to say what abstract art or art-as-art is, is to say what it is not.[39]

Hence, the Purist distills the quintessence of art by purging elements in past art that prevent the rendering of it directly and exclusively. Deriving art from art is an art historical, academic, formalist approach. Nevertheless, Reinhardt built a vanguard principle into his traditionalism by insisting that art undergoes a continual revolution, ridding itself of excess baggage and progressing inexorably toward its own pure essence.

Reinhardt asserted that an artist's concern with purity in art results in purity in his public role. By this standard, impure art perverts the artist who creates it. Reinhardt wrote: "Any combining, mixing, adding, diluting, exploiting, vulgarizing or popularizing abstract art deprives art of its essence and depraves the artist's artistic conscienceness." [40] To him, the worst sinners in his own time, the most impure and therefore the most immoral, were the Abstract Expressionists, whom he ridiculed at every opportunity as "the café-and-club primitive and neo-Zen-bohemian, the Vogue-magazine-cold-water-flat-fauve and Harpers-Bazaar-bum, the Eighth-street-existentialist and Easthamption-aesthete, the

Modern-Museum-pauper and international-set-sufferer, the abstract-'Hesspressionist' and Kootzenjammer-Kid-Jungian, the Romantic-ham-'action'-actor." [41]

Reinhardt's derision was reciprocated by the Abstract Expressionists, but the issue of purism concerned them and they dealt with it seriously. They (the gesture painters in particular) were most troubled by the purist claim that they had re-introduced into abstract art retrogressive suggestions of nature, the kind that most geometric artists had rigorously purged from their canvases. The purists spurned not only explicit figurative and semifigurative motifs but illusionist space (even when identifiable subjects were missing), the kind of space generated by gesture painting. Their attack on "realism" in Abstract Expressionism was especially relevant in the early 1950's, for De Kooning, Pollock, and many of their younger followers were painting representational pictures. However, the gesture painters refused to consider the abstraction-versus-figuration issue an important one. They even questioned, as Elaine de Kooning wrote, the artist's need to " 'respect the integrity of the picture plane' (integrity here is a synonym for flatness and, for some odd reason, there is a great deal of respect for flatness in this doctrine). . . . In art, flatness is just as much an illusion as three-dimensional space. Anyone who says 'the painting is flat' is saying the least interesting and least true thing about it." [42]

This remark indicates the gesture painters' rejection of all limitations in art, of all narrowing of expressive possibilities. Moreover, many insisted that the values attributed to purist abstraction applied to their own pictures. During the three-day conference at Studio 35 in 1950, De Kooning asserted:

> "I consider all painting free. As far as I'm concerned, geometric shapes are not necessarily clear."
>
> Reinhart: "An emphasis on geometry is an emphasis on the 'known,' on order and knowledge."
>
> Ferber: "Why is geometry more clear than the use of swirling shapes?"
>
> Reinhardt: "Let's straighten out our terminology, if we can. Vagueness is a 'romantic' value, and clarity and 'geometricity' are 'classic' values."
>
> Motherwell: "Lippold resents the implication that a geometric form is not 'clear.' "
>
> Tomlin: "Would you say that automatic structure is in the process of becoming, and that 'geometry' has already been shown and terminated?"
> De Kooning: "Yes."
>
> Motherwell: "It seems to me that what de Kooning is saying is plain. He feels resentful that one mode of expression should be called more clear, precise, rational, finished, than another." [43]

Above all, the Abstract Expressionists questioned—and repudiated—purist psychological and philosophical premises. They objected to Reinhardt's exclusion of emotion, no matter how unseemly, and to his assertion that art ought to be separated from an artist's experiences and visions. Indeed, their primary intention was to join the two.

1. Max Ernst, "Eleven Europeans in America," *Museum of Modern Art Bulletin*, XIII, Nos. 4–5 (1946), 17.

2. Abstract Expressionism was discussed in three other little magazines. The *New Iconograph* was a quarterly published in five issues in 1946–47. It was the organ of a small group of New York artists who exhibited at the Galerie Neuf in New York and were friendly with Kenneth L. Beaudoin, its editor. The magazine was disposed to a mythic art; its views were somewhat akin to those Gottlieb, Rothko, and Newman had begun to develop some four years earlier. The *New Iconograph*'s primary claim to fame was an early article on Rothko by Oscar Collier, printed in the fall of 1947. *Instead* appeared in six numbers, 1947–48. It was edited by Lionel Abel with the aid of others, among them, Matta; it was primarily philosophical and political in its orientation but ran an occasional article on art, for example, a reprint of André Breton's "Arshile Gorky" and illustrations of drawings by European Surrealists, as well as those of Gorky and Baziotes. *Instead* had a strong Surrealist cast, but it also included critiques of Existentialism, among the earliest to be printed in America. An annual, *trans/formation*, "a world review of the arts, communication and environment," came out three times from 1950 to 1952; it was edited by Harry Holtzman with the aid of Nicolas Calas, Stuart Davis, and Marcel Duchamp. In its treatment of art, *trans/formation* favored geometric abstraction and Surrealism, but it also ran Willem de Kooning's "The Renaissance and Order" (a talk he gave at Studio 35 in the winter of 1949–50), cartoons satirizing the art world by Ad Reinhardt, and illustrations of the works of Rothko, Baziotes, and Pollock.

3. Among the artists Hess singled out were Tomlin, Motherwell, De Kooning, Gorky, Gottlieb, Rothko, Pollock, Jack Tworkov, Tobey, Baziotes, Hofmann, Kline, Esteban Vicente, and Reinhardt.

4. The fifteen writers who participated in the "*Life* Round Table on Modern Art" were Russell W. Davenport (moderator), Meyer Schapiro, Georges Duthuit, Aldous Huxley, Francis Henry Taylor, Sir Leigh Ashton, R. Kirk Askew, Raymond Mortimer, Alfred Frankfurter, Theodore Green, James Johnson Sweeney, Charles Sawyer, H. W. Janson, A. Hyatt Mayor, and James Thrall Soby. „

5. The caption in *Life* read: "The solemn people above, along with three others, made up the group of 'irascible' artists who raised the biggest fuss about the Metropolitan's competition. . . . Their revolt and subsequent boycott of the show was in keeping with an old tradition among avant-garde artists. . . . The effect of the revolt of the 'irascibles' remains to be seen, but it did appear to have needled the Metropolitan's juries into turning more than half the show into a free-for-all of modern art."

6. Studio 35 was not connected with The Subjects of the Artist School or with New York University. The three professors—Robert Iglehart, Tony Smith, and Hale Woodruff—paid the rent, but students, notably Robert Goodnough, helped organize activities and arrange the lectures.

7. The participants of the artists' sessions at Studio 35 were Baziotes, Janice Biala, Louise Bourgeois, James Brooks, De Kooning, Jimmy Ernst, Herbert Ferber, Gottlieb, Peter Grippe, David Hare, Hofmann, Weldon Kees, Ibram Lassaw, Norman Lewis, Richard Lippold, Seymour Lipton, Motherwell, Newman, Richard Pousette-Dart, Reinhardt, Ralph Rosenborg, Theodoros Stamos, Hedda Sterne, David Smith, and Bradley Walker Tomlin. Parts of the transcript were published in "Artists' Sessions at Studio 35 (1950)," *Modern Artists in America*, Robert Motherwell and Ad Reinhardt, eds. (New York: Wittenborn Schultz, 1952).

8. The charter members of the Club were Lewin Alcopley, George Cavallon, Charles Egan, Gus Falk, Peter Grippe, Franz Kline, De Kooning, Lassaw, Landes Lewitin, Conrad Marca-Relli, E. A. Navaretta, Phillip Pavia, Milton Resnick, Reinhardt, Jan Roelants, James Rosati, Ludwig Sander, Joop Sanders, and Jack Tworkov.

9. Willem de Kooning, in a film script, *Sketchbook Number 1: Three Americans* (New York: Time, Inc., 1960), n.p.

10. Jack Tworkov, "Four Excerpts from a Journal," *It Is*, No. 4 (Autumn, 1959), 12.

11. Robert Goldwater, "Reflections on the New York School," *Quadrum*, No. 8 (1960), 30.

12. Thomas B. Hess, *Willem de Kooning*, New York, 1959, p. 13.

13. Robert Goldwater, "Everyone Knew What Everyone Else Meant," *It Is*, No. 4 (Autumn, 1959), 35.

14. Tworkov, "Four Excerpts from a Journal," p. 12.

15. José Ortega y Gasset, catalogue of "The Intrasubjectives," quoted from "On the Point of View of the Arts," *Partisan Review*, XVI, No. 8 (August, 1949), 834.

16. Robert Goodnough, "Subject Matter of the Artist," an unpublished class paper at New York University, 1950.

17. Samuel Kootz, catalogue of an exhibition, "The Intrasubjectives," Kootz Gallery, September 14–October 3, 1949, n.p. Harold Rosenberg wrote the other introduction.

18. Robert Goldwater, editor, "A Symposium: The State of American Art," *Magazine of Art*, XLII, No. 3 (March, 1949), 82–102. The critics were Walter Abell, Alfred H. Barr, Jr., Jacques Barzun, John I. H. Baur, Holger Cahill, John Devoluy, Alfred Frankenstein, Lloyd Goodrich, Clement Greenberg, George Heard Hamilton, Patrick Herron, H. W. Janson, Douglas MacAgy, Daniel Catton Rich, James Thrall Soby, and Lionel Trilling.

19. Clement Greenberg, in Goldwater, *Ibid.*, p. 92.

20. The problem of community was also central in the panels on Abstract Expressionism at the Club in 1952; in a series of eight panels entitled "Has the Situation Changed?" at the Club in April and May, 1954; in another series at the Club with the same heading in January, 1958, and February, 1959; and in four panels entitled, "What is the New Academy?" at the Club in the spring of 1959, which were continued in seventeen statements by artists, entitled "Is There a New Academy?" printed in two parts in *Art News*, LVIII, Nos. 4, 6 (Summer and September, 1959).

21. "Artists' Sessions at Studio 35 (1950)," *Modern Artists in America*, pp. 17, 22.

22. *Ibid.*, pp. 12–13.

23. Clement Greenberg, "Art," *The Nation*, CLXII, No. 26 (June 29, 1946), 792.

24. Clement Greenberg, "Art," *The Nation*, CLXIV, No. 8 (February 22, 1947), 228.

25. Clement Greenberg, "Art Chronicle: The Decline of Cubism," *Partisan Review*, XV, No. 3 (March, 1948), 369. Goldwater agreed with Greenberg's estimate. In "Art Chronicle: A Season of Art," *Partisan Review*, XIV, No. 4 (July-August, 1947), 414, he wrote: "The Whitney Museum's guest showing of the younger French painters proved disappointing, and a surprise only in the unexpected frankness of its derivations. . . . All this but emphasized that however one may rate contemporary American art in the absolute sense, here, as elsewhere, this country has a more important international burden to carry."

26. Clement Greenberg in a symposium titled, "Is the French Avant-Garde Overrated?" *Art Digest*, XXVII, No. 20 (September 15, 1953), 12, 27.

27. Clement Greenberg, "Art Chronicle: The Situation at the Moment," *Partisan Review*, XV, No. 1 (January, 1948), 82–83.

28. Hans Hofmann, "Reply to Questionnaire and Comments on a Recent Exhibition," *Arts and Architecture*, LXVI, No. 11 (November, 1949), 23.

29. Exhibitions contrasting French and American art kept alive the controversy concerning the relative merits of each. The two most important shows were "Painted in 1949: European and American Painters," organized by the Parisian dealer Louis Carré and held at the Betty Parsons Gallery, and, in the following year, "Young Painters in U.S. and France," organized by Leo Castelli at the Sidney Janis Gallery. Castelli's show coupled fifteen Americans with fifteen Parisians: Brooks–Wols, Cavallon–Coulon, De Kooning–Dubuffet, Ferren–Goebel, Jimmy Ernst–Singier, Gatch–Pallut, Gorky–Matta, Graves–Manissier, Kline–Soulages, Pollock–Lanskoy, Reinhardt–Nejad, Rothko–De Stael, Sterne–Da Silva, Tobey–Bazaine, and Tomlin–Ubac.

30. Georges Mathieu, *Declaration to the Abstract Avant-Garde Painters* (A Letter to Twenty-Five American Artists), April, 1952, n.p.

31. William C. Seitz, notes of a conversation between Guston, Kline, De Kooning, McNeil, and Tworkov, moderated by Mercedes Matter, at the Club, February 22, 1952.

32. *Ibid.*

33. Irving Howe, *A World More Attractive* (New York: Horizon Press, 1963), pp. 19–20.

34. "Artists' Sessions at Studio 35 (1950)," *Modern Artists in America*, p. 16.

35. Seitz, notes of a conversation, February 22, 1952.

36. Robert Motherwell and Harold Rosenberg, editorial preface, *Possibilities 1* (Winter, 1947–48), 1.

37. Ad Reinhardt, Statement in the catalogue of his exhibition at the Betty Parsons Gallery, October 18–November 6, 1948, n.p.

38. Seitz, notes of a conversation, February 22, 1952.

39. Ad Reinhardt, "Art-as-Art," *Art International*, VI, No. 1 (December 20, 1962), 36–37.

40. *Ibid.*, p. 37.

41. Ad Reinhardt, "The Artist in Search of an Academy; Part Two: Who are the Artists?" *College Art Journal*, XIII, No. 4 (Summer, 1954), 315. Reinhardt assumed a polemical stance because he believed, as he wrote in "Art-as-Art," p. 37: "The one fight in art is not between art and non-art, but between true and false art, between pure art and action-assemblage-art, between abstract art and surrealist-expressionist-anti-art. . . . The one struggle in art is the struggle of artists against artists, of artist against artist, of the artist-as-artist within and against artist-as-man, -animal, or -vegetable."

42. Elaine de Kooning, "Subject: What, How or Who?" *Art News*, LIV, No. 2 (April, 1955), 29. This article contains many of the ideas presented by Elaine de Kooning in a paper read at the Club, January 25, 1952.

43. "Artists' Session at Studio 35 (1950)," *Modern Artists in America*, p. 19.

REINHARDT'S painting was shaped by 1930's Cubist abstraction and by 1940's Abstract Expressionism. It was, in fact, from a synthesis of these antithetical tendencies that his post-1950 style was derived. From 1937 to 1941 (and later, for he did not limit himself to a single style in the 1940's), Reinhardt painted geometric abstractions (*Fig. 18-1*) that were influenced by Miró, Léger, Mondrian, Gris, Stuart Davis, and Carl Holty (the latter had been his teacher and had brought him into the American Abstract Artists group). During the early 1940's however, Reinhardt reacted against Cubist picture-making, for it had become too mechanical, too confining. Having previously employed paste-ups as preparatory sketches for his geometric oils (a common practice in the 1930's), he now made collages by slicing up magazine and newspaper illustrations, each cut so that references to objects were

18 Ad Reinhardt
(1913–67)

18–1 Ad Reinhardt. *Untitled.* 1939.
Collection Mrs. Rita Reinhardt, New York.

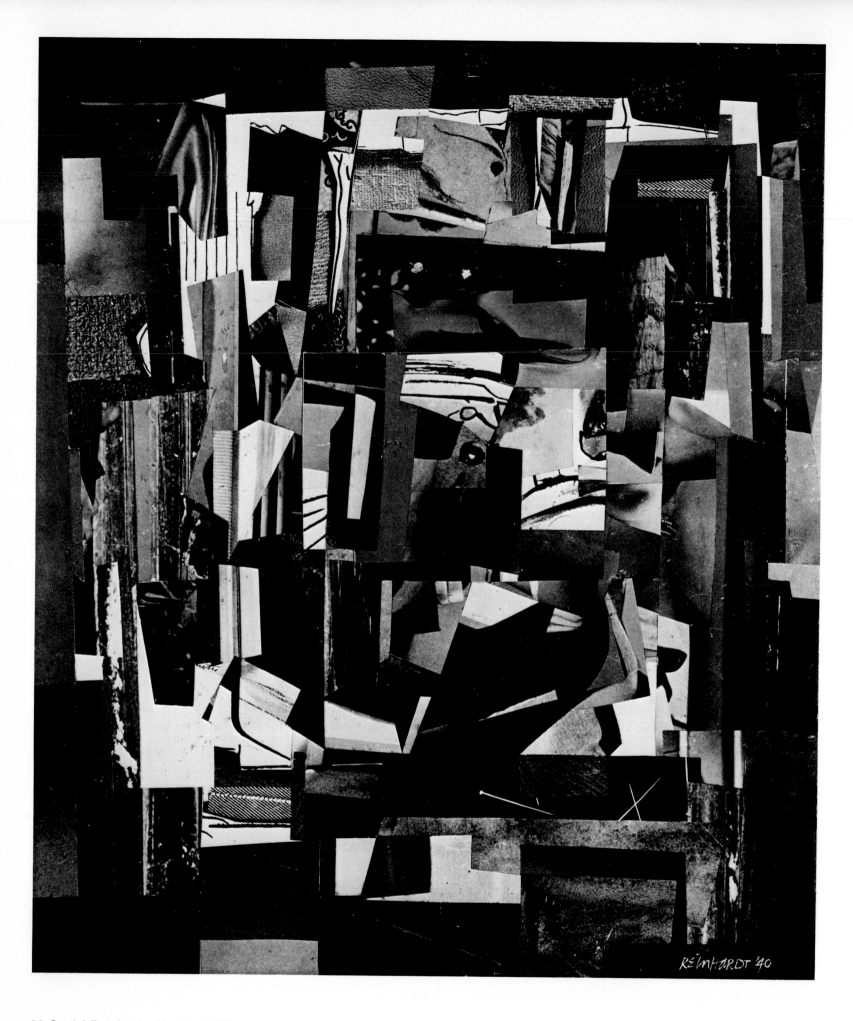

18–2 Ad Reinhardt. *Untitled*. 1940.
Collection Mrs. Rita Reinhardt, New York.

226

18–3 Ad Reinhardt. *Number 18.* 1949.
Collection Whitney Museum of American Art, New York.

18–4 Ad Reinhardt. *Number 111.* 1949.
Collection Mrs. Rita Reinhardt, New York;
Promised gift to The Museum of Modern Art, New York.

227

18–5 Ad Reinhardt. *Untitled*. 1950.
Collection Mrs. Rita Reinhardt, New York.

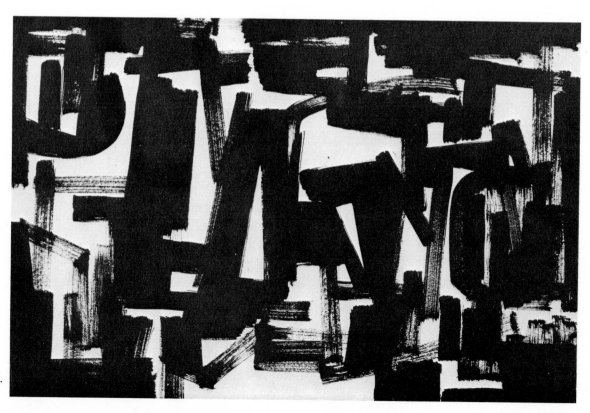

18–6 Ad Reinhardt. *Untitled*. 1950.
Marlborough Gallery Inc., New York.

18–7 Ad Reinhardt. *Blue-Green*. 1950.
Marlborough Gallery Inc., New York.

obliterated, leaving only disembodied textures, which he juxtaposed incongruously in a manner reminiscent of Surrealism (*Fig. 18-2*). In other works, Reinhardt loosened up tightly knit structure by working more directly, painting quickly over hard-edged forms, complicating, shredding, and melting them (*Fig. 18-3*). The free-flowing lines and amorphous patches that resulted call to mind Oriental calligraphy, Impressionist and Expressionist facture, and Surrealist automatism in particular. But even the freest of them are too orderly, too bound to a conceptual infra-Cubist design to have issued from unconscious impulses. Still, the all-over patterns of open and closed shapes of richly varied brushwork evoke mysterious grottoes and other phantasmagoria like the collages of the period. Although Reinhardt's intentions were formal, his improvisations are closer in appearance to those of Tobey, Hofmann, and Rothko than to paintings by the American Abstract Artists.

As Reinhardt turned away from geometry, he grew friendly with the future Abstract Expressionists. He was closest to Newman, Rothko, and Still; like them, he came to reject gestural intricacy and to reduce his pictorial means, tending toward color-field abstraction (*Fig. 18-4*). Around 1950, he simplified his linear calligraphy into broadly brushed swaths and confined his palette, often to a single color on a white ground (*Figs. 18-5, 18-6*). Soon after, he

limited the direction of the barlike gestures to the horizontal only (*Fig. 18-7*). In many pictures, his hues were high-keyed (a reversion to his Davis-inspired color of the 1930's) and dissonant. In 1952, Reinhardt hardened the bars into flat rectangles, at first arranged asymmetrically, then centered into cruciform patterns (*Figs. 18-8, 18-9*). In each of these canvases, he used one all-over color—red, blue, or black—but the tones of the rectangles were varied slightly. Thus, Reinhardt had returned to geometric abstraction but with a closer affinity to nonrelational color-field painting.

In some respects, Reinhardt's intentions resembled those of Newman, Still, and Rothko. Like them, he wanted to create an absolute, timeless, suprapersonal art, and his stance was as moralistic as theirs. Unlike them, however, he renounced extra-aesthetic associations in favor of a purist approach. Reinhardt deliberately emptied his painting of gesture, the signs of the artist's creative process, of his active presence and temperament; he also removed relational design; motile, organic shapes (which evoke life more than do geometric ones); and varied, vivid colors.[1] After 1954, he attempted to subtract all color and line by graying his colors, making them colorless and indistinguishable. As the tones grew closer in value, the lines that separated them dissolved, becoming almost imperceivable divisions. Drawing, like color, tended to invisibility, forcing the viewer to strain to make either out. What remains perceptible on first viewing is only a homogenous dark field.

Reinhardt created what he considered his ultimate picture in 1960—a five-foot-square canvas composed of nine almost identical gray squares—and he repeated it until his death (*XX*, p. 247). About this series, he wrote that he aimed "to paint and repaint the same one thing over and over again, to repeat and refine the one uniform form again and again. Intensity, consciousness, perfection in art come only after long routine, preparation and attention."[2] Reinhardt's programmatic method did not lead to mechanical rendering, for he seemed to have begun each picture afresh, striving for an absolute statement as if he had not achieved it before; the tonal variety of his late works bears witness to this fact.

Although Reinhardt was a classicizing artist who strove for clarity, he also accomplished its opposite, for his black paintings deny visual logic, as if illustrating De Kooning's remark that geometry is not clear. In order to expunge color and line, Reinhardt shrouded them in an obscure atmosphere, a romantic element he did not want but could not avoid. Much as his abstractions make clear his intention of removing color from color, the ghosts of colors remain and function as colors. And the harder the eye strains, the sharper the colors stand out from the monochrome field. Thus, Reinhardt is revealed as a colorist who cultivated a low-resgister palette, blackened instead of brightened, and the most nuanced of color interactions. This may have been his real intention, and if it was, it accounts for the tonal diversity of his last paintings. The minute shifts in color generate vibrations that prevent the pictures from becoming static, inert, and monotonous (qualities he ostensibly desired), for they keep the eye nervously alert. Furthermore, although the "black" paintings look anonymous and self-effacing, they are original and immediately recognizable as Reinhardt's invention, as personal as his signature.

Reinhardt also intended his late pictures to communicate nothing but themselves. In this too, however, the reverse holds true, for the cruciform squares can be regarded as symbols.[3] The image of the cross is filled with Christian associations—to the Crucifixion, to cathedral architecture. Reinhardt gener-

18–8 Ad Reinhardt. *Number 15*. 1952.
Albright-Knox Art Gallery, Buffalo, New York;
Gift of Seymour H. Knox.

18–9 Ad Reinhardt. *Abstract Painting: Red*. 1952.
Collection Mr. and Mrs. Gifford Phillips, Santa Monica, California.

alized the form so that symbolic allusions are minimized, yet his works do suggest icons—emptied of meaning, however. Furthermore, although he meant his "black" paintings to be aloof and inaccessible, their gray atmosphere induces the viewer to enter into them, to decipher the design and color; the darkness is ambiguous and haunting, inviting associations and suggesting mysteries.

Priscilla Colt wrote that Reinhardt's "pushing of the visible toward the brink of the invisible, of logic toward the brink of illogic, of the material to the verge of immateriality, inevitably, suggest a link with a transcendent level of existence. . . . the black square may be regarded as a 'ritual aid' in a quasi-religious search." [4] The peering itself that the pictures require can cause in the viewer a contemplative and, at times, a trancelike state that may also be considered religious. Reinhardt denied mystical interpretations of his work, but he did elevate art-as-art into an object of worship. However, his primary intention remained the creation of an extreme, classicizing abstract art whose predetermined, schematic, and repetitive form was impersonal and impassive. This anti-Romantic aim was opposed to that of the Abstract Expressionists, yet Reinhardt must ultimately be numbered among them, because he frequented their circle during the 1940's and evolved his later purist style in direct response and reaction to their ideas, and because—no matter how inadvertently—his style possesses Romantic qualities.

18 Notes

1. In "Art-as-Art," *Art International*, VI, No. 10 (December 20, 1962), 37, Reinhardt wrote: "No lines or imaginings, no shapes or composings or representings, no visions or sensations or impulses, no symbols or signs or impastos, no decoratings or colourings or picturings, no pleasures or pains, no accidents or readymades, no things, no ideas, no relations, no attributes, no qualities—nothing that is not of the essence."

2. Ad Reinhardt, "Art-as-Art," *Environment*, I, No. 1 (Autumn, 1962), 81.

3. Ad Reinhardt, in "Angkor and Art," *Art News*, LX, No. 8 (December, 1961), 66–67, wrote: "Everything is square, cruciform, unified, absolutely clear. . . . All is one vast symbolism. . . . All images share the 'state of identical form.'"

4. Priscilla Colt, "Notes on Ad Reinhardt," *Art International*, VIII, No. 8 (October 20, 1964), 34.

DURING the late 1940's, James Brooks (1906–), Bradley Walker Tomlin (1899–1953), Franz Kline (1910–62), and Philip Guston (1913–) began to venture in the direction of gesture painting. Pictures they had seen by Pollock, De Kooning, and others, and discussions with these artists about their aesthetic premises imbued them with a new confidence and boldness. Within a short period, all had achieved individual styles. With the exception of Kline, these artists were of a quieter temperament than Pollock or De Kooning, and their paintings tended to be lyrical, or nonaggressive.

Brooks had been on the Federal Art Project during the Depression decade and had earned a widespread reputation as a muralist. Indeed, his major wall paintings—*The Acquisition of Long Island* (1937–38), at the Woodside Library, and *Flight* (1938–42; *Fig. 19-1*) at LaGuardia Airport, both in New York City (and later destroyed)—were among the most accomplished murals painted in this country at the time. During this period, Brooks was associated with the Regionalists, but he did not share in their chauvinistic repudiation of avant-garde European painting. The geometric abstraction practiced by most of the American Abstract Artists did not interest him but the canvases of Matisse and Picasso did—particularly Picasso, who had concentrated on abstract pictorial structure while retaining figuration. During the four years that he worked on the La Guardia mural, Brooks ventured increasingly toward abstraction, but he had to postpone any radical departures because World War II intervened, requiring him to serve in the army from 1942 to 1945.

When he was discharged, Brooks returned to easel painting and executed abstractions in a Synthetic Cubist manner (*Fig. 19-2*). Based on figural and still-life motifs, they consisted of roughly rectangular flat forms organized along vertical and horizontal axes, but the shapes were varied with arabesque elements that were to be preponderant in his later gesture paintings. The dominant colors were cool—muted grays, blues, and pinks such as he had favored in his earlier murals. Over the years, this palette was to become a singularly personal one. The fastidious adjustment of pictorial elements soon proved inhibiting to Brooks, and after 1948, he began to paint more directly and freely, his canvases growing looser, more fragmented and abstract. They were still tentative but pointed to the stylistic direction he was about to take.

Pollock's "drip" paintings were the liberating influence. In 1949, Brooks began to pour pigment onto the back of absorbent canvas and to use the accidental suggestions of forms that soaked through as points of departure (*XXI*, p. 250). However, his painting was different in method and feeling from Pollock's. Pollock added skein upon skein of pigment—impulsively; his paintings are paroxysmal, raw, and fast in tempo. Brooks worked and reworked each of his ghosts of stained pigment into massive areas that approach, melt into, push, or slither away from but rarely pierce each other; his pictures are measured, nuanced, and rhythmically slow. This nonaggressive quality is accented by the close-valued, sober colors and thinly painted surfaces that he preferred to clashing hues and an assertive impasto.

Brooks' canvases from the period 1949 to 1953, in which whipped lines carve out overlapping serpentine areas, are, on the whole, more complex and active than his later ones. In 1953, he suddenly returned to the kind of Cubist structure found in his paintings of 1947, but this seemingly backward step contained the beginnings of a new stylistic development (*Fig. 19-3*). As opposed to the fluid curvilinearity of earlier pictures, his works became more angular and impacted; transparency gave way to density, the linear to the

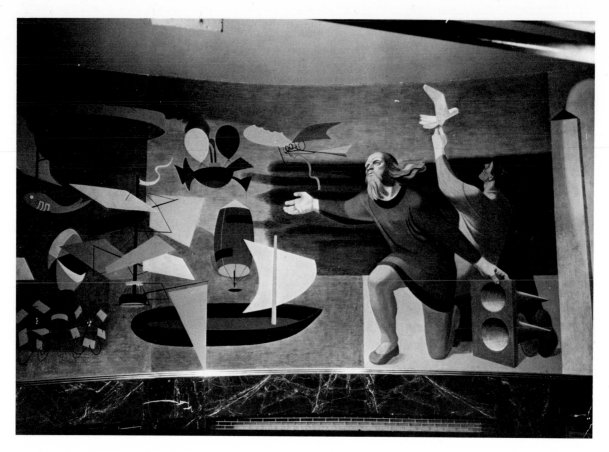

19–1 James Brooks. *Leonardo da Vinci*. Detail of *Flight*. 1938–42.

painterly. There appeared to be a new emphasis on conscious shaping, more akin to the process of De Kooning and Guston than to that of Pollock. During the 1960's, Brooks re-introduced calligraphic motifs (*Fig. 19-4*), but these free-wheeling lines were disassociating, psychically jarring elements that countered the slow momentum and calm of his painting.

In general, the areas in Brooks' pictures move slowly inward from the edges, jostle each other gently, expanding and contracting, as they probe for their own positions (*Figs. 19-5, 19-6*). The ambiguous areas have a way of "floating in and out of focus," as Thomas B. Hess observed, so that no element becomes static, and the eye is kept in perpetual motion.[1] But despite the state of flux, the areas are interlocked to hold the surface. This was Brooks' intention, for, as he once wrote, he was concerned more with relationships than with images. Hence, he "looks for form as a sentry does at night, by looking around it. Images become so fused and inter-dependent that they no longer exist as such, and instead of a drama of competing images the painting exists as a resolved whole."[2] To Brooks, the simultaneous containment and release found in his canvases had a more profound meaning: it became a metaphor for "the conflict between spontaneous and deliberate behavior."[3]

This dualism is the essential content of Brooks' work. As he wrote: "The painter convinces himself that he is working with formal relations alone, and that is his strength. He really knows that the relationships are meaningful only if they imbed his real reason for painting—a way of feeling that is forming and unnamed."[4] Intent on avoiding the habitual, the known, Brooks employed chance effects. Nevertheless, his painting was thoughtfully evaluated and refined. Indeed, one aspect of Brooks' attitude—his profession-

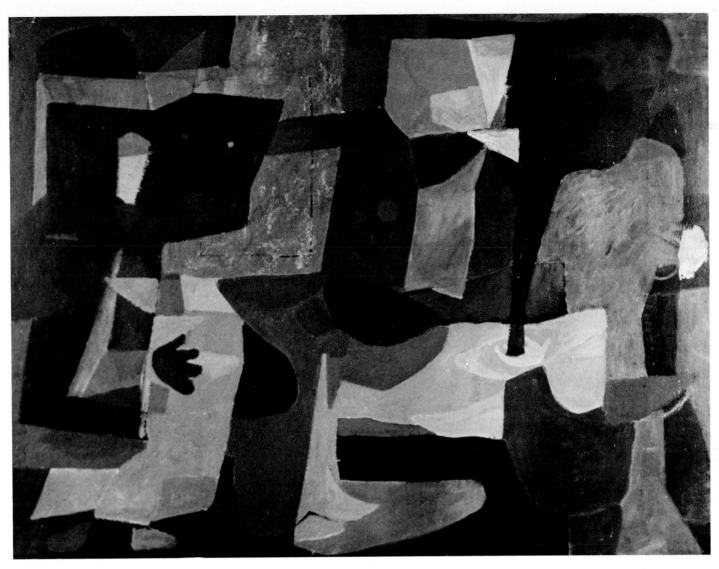

19–2 James Brooks. *Dialogue*. 1947.
Collection of the artist.

19–3 James Brooks. *K-1953*. 1953.
Collection of the artist.

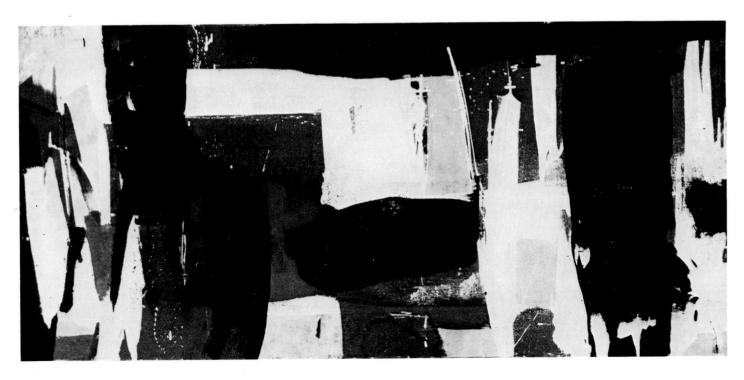

19–4 James Brooks. *Bozrah*. 1965.
Collection Mr. and Mrs. Julian Eisenstein, Washington, D.C.

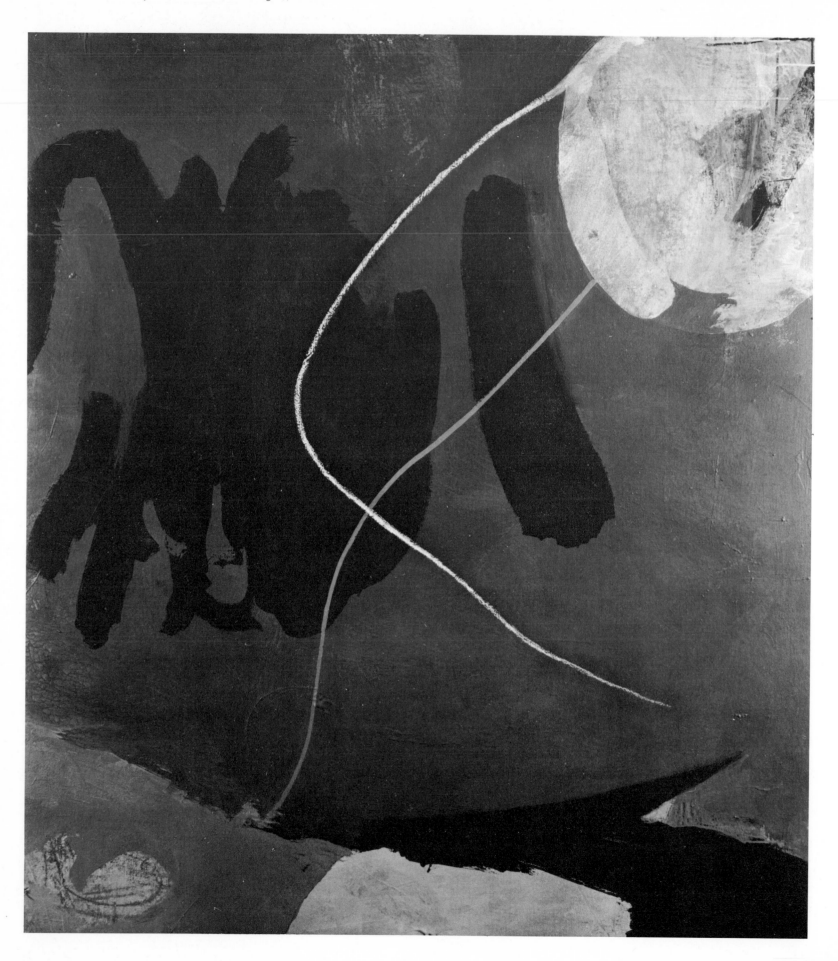

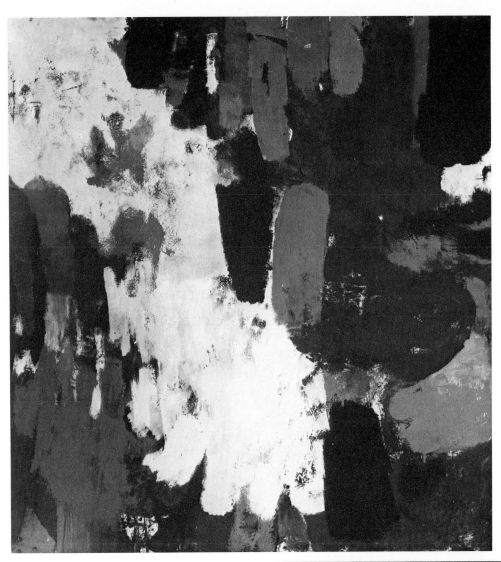

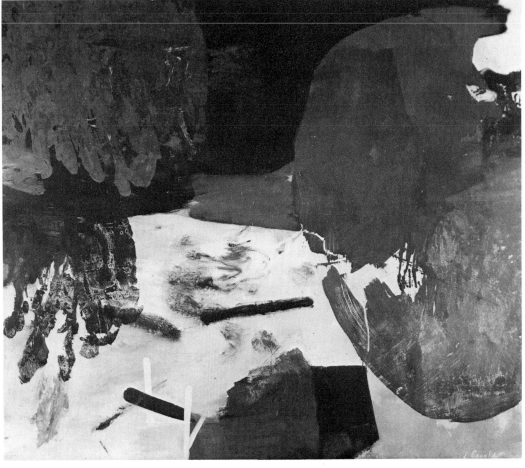

19–5 James Brooks. *Floxurn*. 1955.
Collection of the artist.

19–6 James Brooks. *Sull*. 1961.
Collection Winston H. Price, Baltimore, Maryland.

237

alism—is reminiscent of that of Constable, who, when Blake said of one of his drawings, "'This is not drawing . . . this is inspiration,'" retorted dryly, "'I had meant it to be drawing.'"[5]

Most writers on art have overlooked the deeper content in Brooks' painting and have stressed instead its seeming relationship to nature.[6] It is true that the tonal colors, organic shapes, airiness, and leisurely movement are all suggestive of the countryside, especially when compared to violent gesture paintings that evoke the city. But, more significant, these elements are born of a particular artistic temperament—one that is quiet, thoughtful, and lyrical.

A contemplative note is also struck in the works of Bradley Walker Tomlin. In 1948, he wrote of the painting of Frank London, a close friend who had died three years earlier, that it contained

> strange juxtapositions of matter, at once so gay and so sober. . . . one can scarcely attach labels to specific parts, which, in their ultimate relationships achieve meaning on so many levels. . . . There is beneath this odd collection of paradoxical elements, a view of life which is deeply reflective. . . . The wit which flashed about the man himself with such piercing spontaneity speaks out, brilliantly beribboned yet strangely tempered by a muted bird call. The elegant decay . . .[7]

What Tomlin wrote of London could be applied to his own semi-abstractions from roughly 1939 to 1947, and, more generally, to his subsequent abstractions. In the earlier pictures, such as *Burial* (1943; *Fig. 19-7*), figura-

19–7 Bradley Walker Tomlin. *Burial*. 1943.
The Metropolitan Museum of Art, New York;
George A. Hearn Fund, 1943.

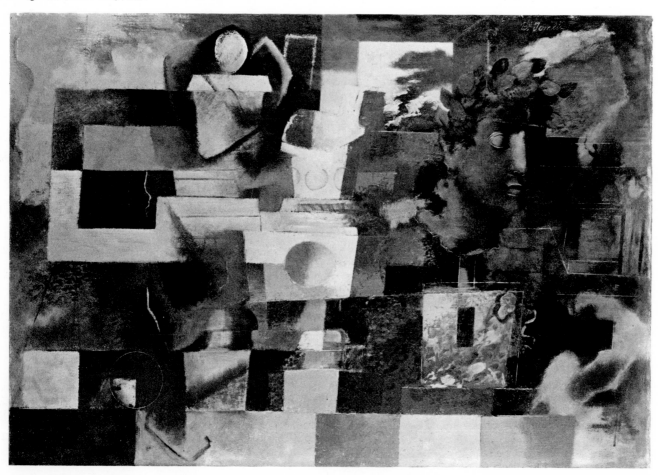

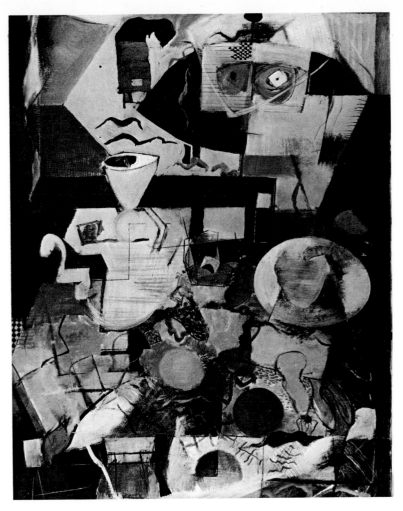

19–8 Bradley Walker Tomlin. *Arrangement*. c. 1944.
Collection Krannert Art Museum, University of Illinois, Champaign, Illinois.

tive details—plaster heads, vases, wings, cats—are juxtaposed incongruously and integrated into an underlying rectilinear design derived from Synthetic Cubism. But the planar geometry is softened by quiet colors and by painterly and atmospheric effects. The mood is dreamlike, akin to the Neo-Romantic and Surrealist works that Tomlin had seen in large numbers at the Museum of Modern Art's "Fantastic Art, Dada, Surrealism" show in 1936–37—works that had greatly impressed him.

In the mid-1940's Tomlin began to suppress illustrational motifs and to loosen rigid Cubist composition by painting more impulsively. The beginnings of this tendency are evident in *Arrangement* (*ca.*1944; *Fig. 19-8*). In 1946 the drawing became increasingly free-wheeling, released from the function of defining planes, and curvilinear rather than angular. Miró's influence is strongly felt in this picture, but it is more abstract and fluid. In 1948, Tomlin started to paint a series of pictures composed of white calligraphic ribbons on black grounds, such as *Tension by Moonlight* (1948; *Fig. 19-9*). The drawing is freer than that in earlier works, closer to and probably influenced by Gottlieb's signs, Tobey's "white writing," and Reinhardt's abstract impressionism. In his black-and-white abstractions, Tomlin achieved simplicity and directness and succeeded in making line painterly—an important step, for he was, and remained to the end, primarily a draftsman.

However, extreme spontaneity seemed not to have been congenial to him, as it was to Pollock. Tomlin apparently needed an articulated structure, and he soon tried to introduce that without sacrificing his new-found freedom. In 1949, he discovered a method for assimilating both elements—by im-

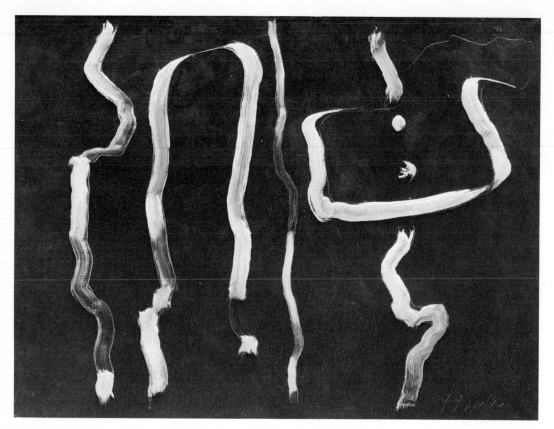

19–9 Bradley Walker Tomlin. *Tension by Moonlight*. 1948.
Betty Parsons Gallery, New York.

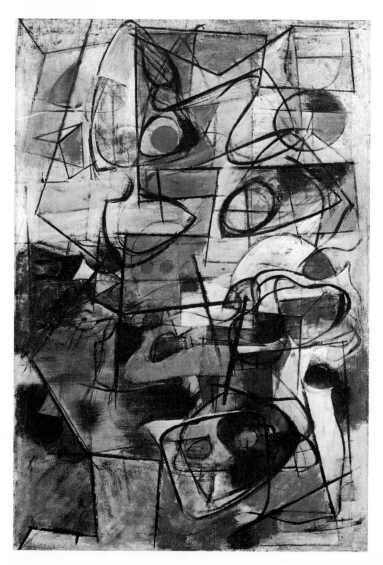

19–10 Bradley Walker Tomlin. *Number 10-A*. 1949.
Collection Dustin Rice, New York.

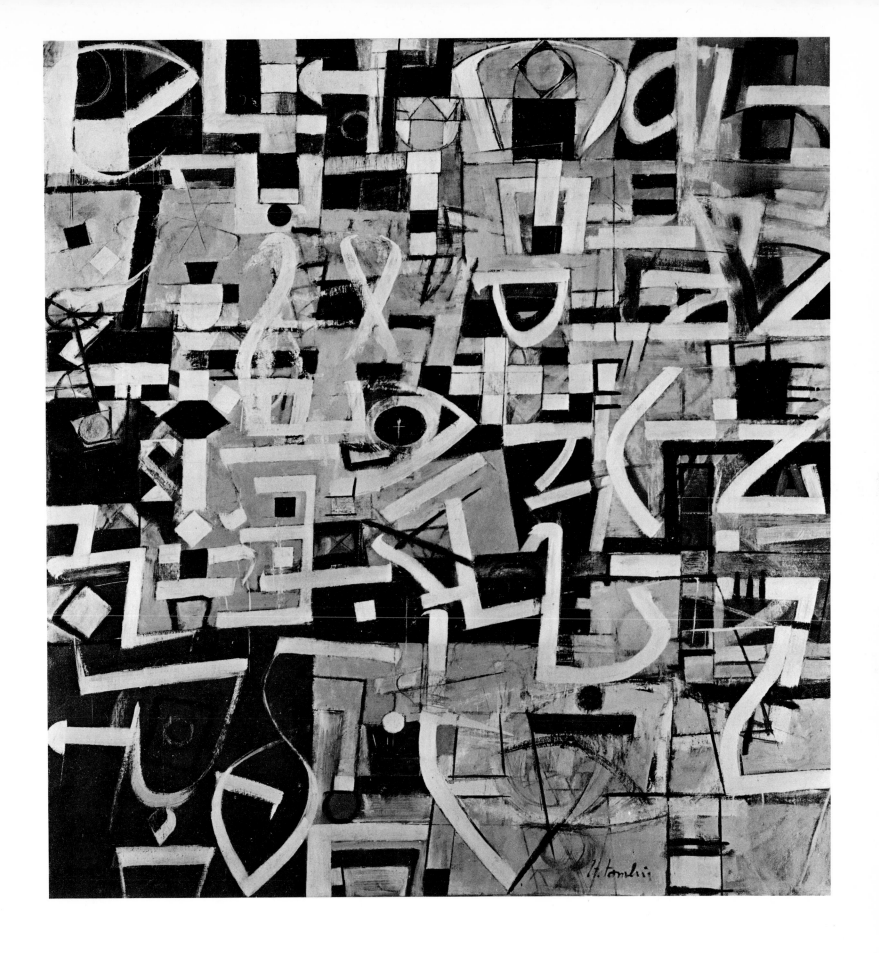

19–11 Bradley Walker Tomlin. *Number 20.* 1949.
Collection The Museum of Modern Art, New York;
Gift of Philip Johnson.

XVII Barnett Newman. *Day One.* 1951–52.
Collection Whitney Museum of American Art, New York;
Gift of the Friends of the Whitney Museum of American Art (and purchase).

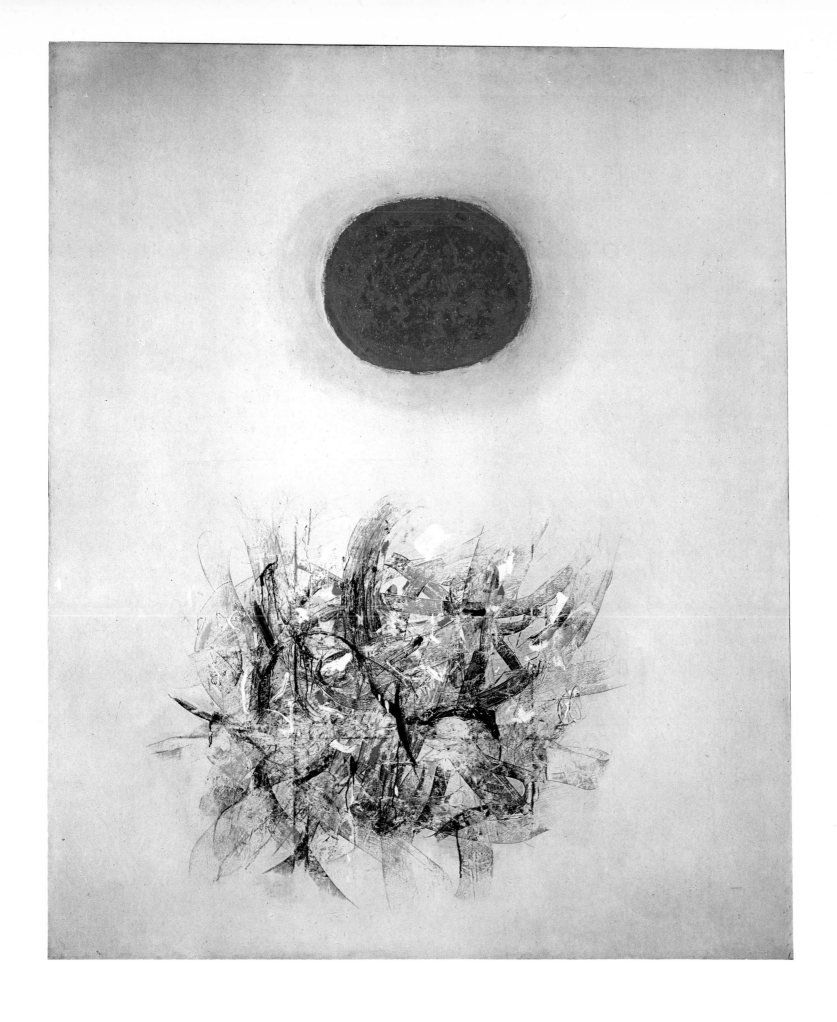

XVIII Adolph Gottlieb. *Brink*. 1959.
New York University Art Collection, New York.

243

provising architectonic grids from free brushstrokes (*Figs. 19-10, 19-11, 19-12, 19-13;* also *XXII,* p. 251). As he put it, "geometric shapes can be used to achieve a fluid and organic structure." [8] The overlapping gestures in shallow depth are roughly vertical and horizontal, and although seemingly all-over, are contained—restrained—within the picture limits. In this, they are closer to Cubism than the earlier calligraphies, but they diverge from Cubism in that they are more impetuous.

In the final years of his life, Tomlin abbreviated the ribbons of his earlier pictures into staccato dabs, scattered as if at random all over the surfaces (*Fig. 19-14*). Although the last works look more spontaneous than the earlier ones, the levitating dabs convey the impression of having been worked and reworked until their scale, placement, and contrapuntal rhythms were perfect. Indeed, of all the Abstract Expressionists, Tomlin was the most controlled and sober. He shied away from the extremes of exuberance and sensuousness in his rectilinear calligraphy as well as in his choice of colors (he favored tans, olives, and off-whites). His painting is also the most elegant and graceful of his contemporaries, yet it never lapses into decorativeness, for it possesses an elegaic cast that is its most affecting quality.

Franz Kline, like Brooks and Tomlin, was influenced by his fellow Abstract Expressionists, notably by his close friend De Kooning, but he followed his

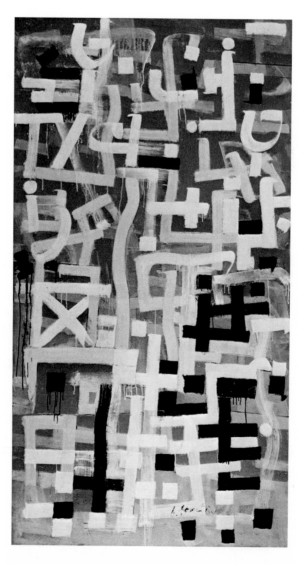

19–12 Bradley Walker Tomlin. *Number 5.* 1949.
Private Collection, New York.

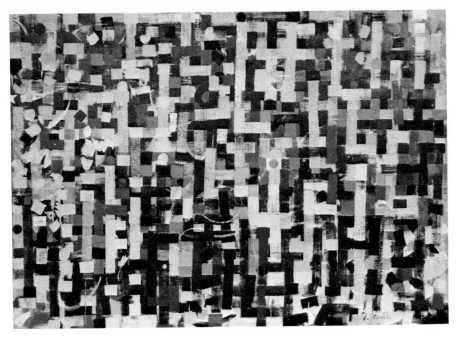

19-13 Bradley Walker Tomlin. *Number 10.* 1952–53.
Munson-Williams-Proctor Institute, Utica, New York.

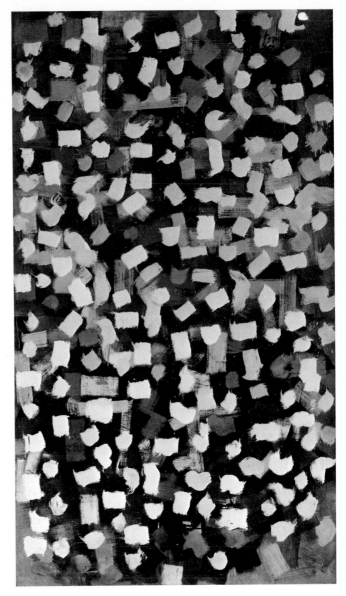

19-14 Bradley Walker Tomlin. *Number 5.* 1952.
Collection Betty Parsons, New York.

own bent and very rapidly evolved a unique style, a style that so strongly etched itself on the sensibility of the 1950's that it was difficult then to look at any black-and-white picture without thinking of Kline—and this despite the fact that De Kooning, Motherwell, Tomlin, and Pollock also painted black-and-white series. Like De Kooning, Kline seized the dynamism of contemporary urban life in his canvases, but compared to De Kooning's impacted and ambiguous images, Kline's simpler and clearer configurations convey a more confident, high-spirited attitude.

In 1950, Kline began to paint gesture paintings—abstract configurations of black-and-white swaths that collided with each other as they hurtled at different velocities off the canvas edges. Kline has commonly been thought to have been influenced by Oriental sumi-ink calligraphy, but, in fact, his raw energy-packed painting has little affinity with the Oriental calligrapher's soft, flowing brush on a passive white ground. As Kline himself remarked: "The Oriental idea of space is an infinite space; it is not painted space, and . . . [mine] is. . . . calligraphy is writing, and I'm not writing. People sometimes think I take a white canvas and paint a black sign on it, but this is not true. I paint the white as well as the black, and the white is just as important." [9]

Indeed, Kline was steeped in the Western tradition, heir to the old masters who composed in chiaroscuro and grisaille, and to such modern masters of

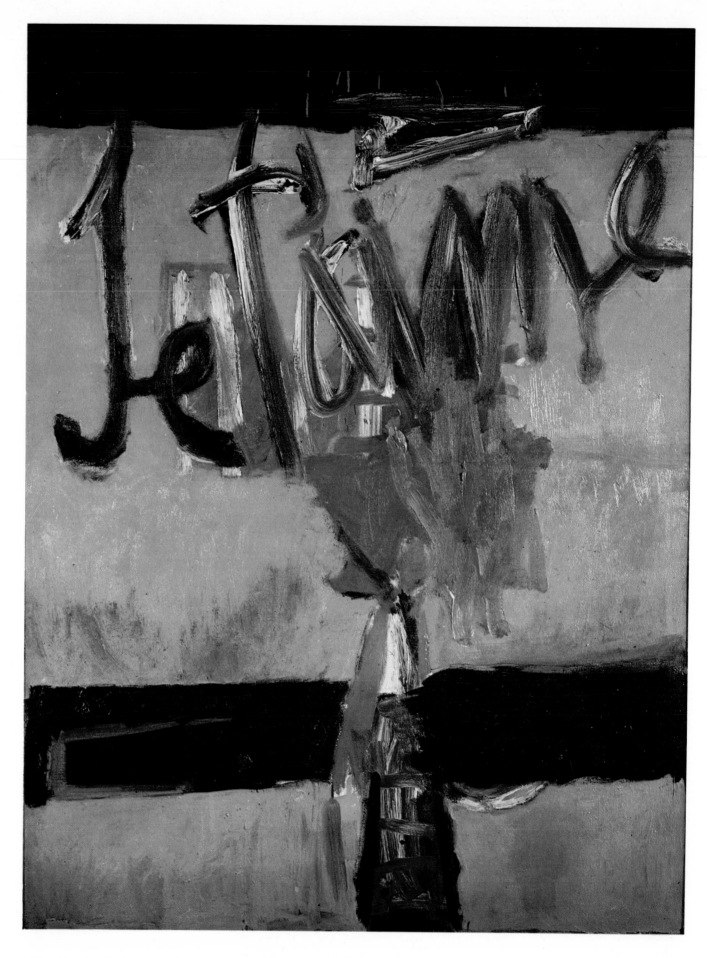

XIX Robert Motherwell. *Je t'aime, IIA.* 1955.
Collection Mr. and Mrs. I. Donald Grossman, New York.

XX Ad Reinhardt. *Black Painting*. 1960–66.
Collection Mrs. Rita Reinhardt, New York.

19–15 Franz Kline. *Seated Woman Doing Needlework*. 1945.
Estate of Franz Kline.

19–16 Franz Kline. *Man on Horse*. c. 1944.
Estate of Franz Kline.

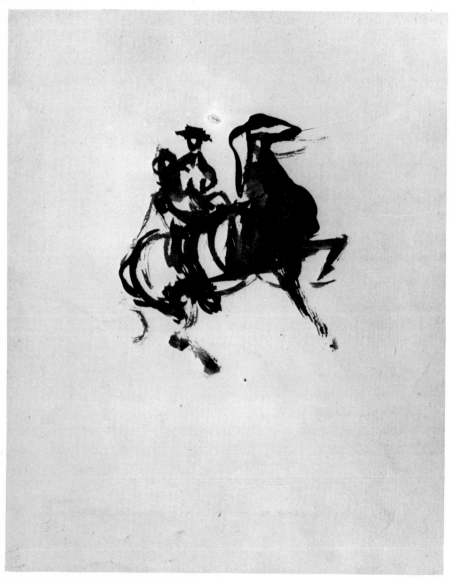

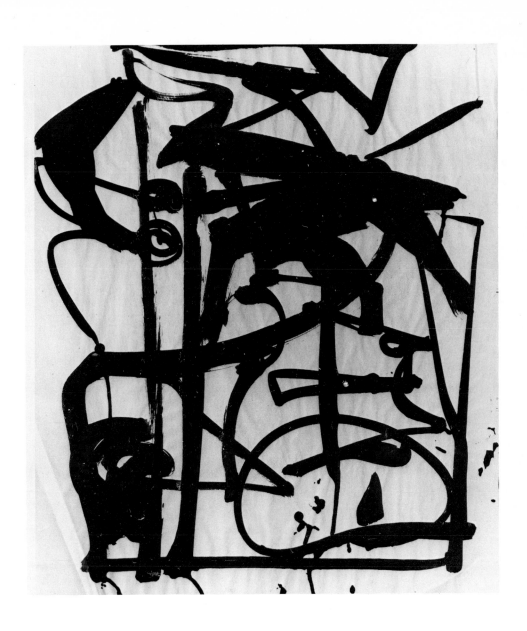

19–17 Franz Kline. *Untitled*. c. 1950.
Estate of Franz Kline.

drawing as Goya, Toulouse-Lautrec, Daumier, and Picasso.[10] Moreover, from
the beginning of his career (when he was the cartoonist for his high school
newspaper), Kline was primarily a draftsman, his earlier works tending to
be monochromatic or based on value contrasts, and drawn with the brush.

Although he was friendly with De Kooning and other Abstract Expression-
ists during the 1940's, Kline painted figurative pictures until 1949. In that
year, his "conversion" to abstract gesture painting occurred, as he enlarged
some of his quick sketches, mostly of figures (*Figs. 19-15, 19-16*), in a Bell-
Opticon. His friend Elaine de Kooning reported that Kline was astonished
by what he saw: "A four by five inch brush drawing of the rocking chair . . .
loomed in gigantic black strokes which eradicated any image, the strokes
expanding as entities in themselves, unrelated to any reality but that of their
own existence. . . . From that day, Franz Kline's style of painting changed
completely." [11] It is likely that Kline would have ventured into gesture paint-
ing had he never used the Bell-Opticon, for his subjects were becoming in-
creasingly shorthand, their contours transformed into abstract marks, in
what seemed to be a desire for greater directness, immediacy, and drama
(*Fig. 19-17*). His subsequent development bears this out, for, as Elaine de
Kooning wrote: "He began to work on sheets of newspaper with a three-inch

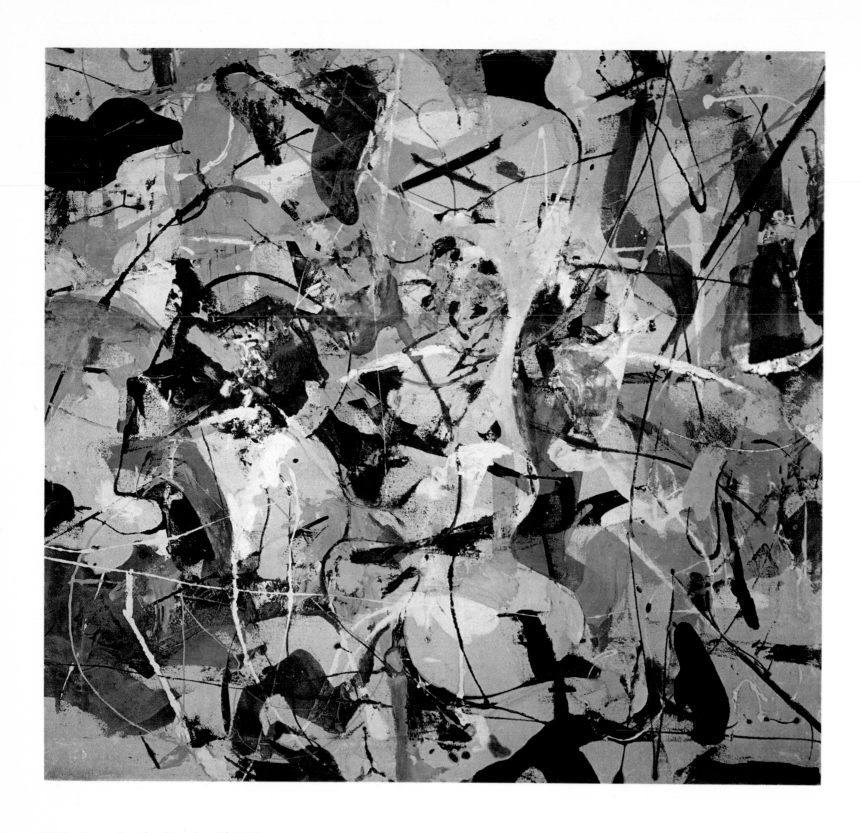

XXI James Brooks. *Number 36.* 1950.
Collection of the artist.

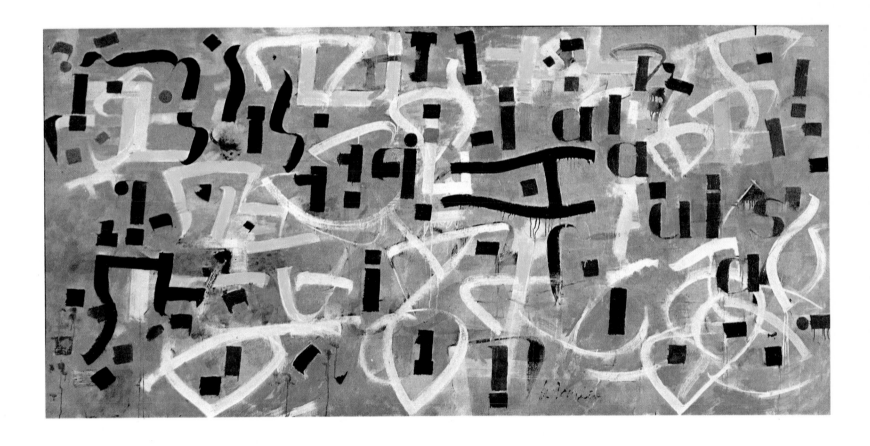

251

19–18 Franz Kline. *Untitled.*
c. 1950.
Estate of Franz Kline.

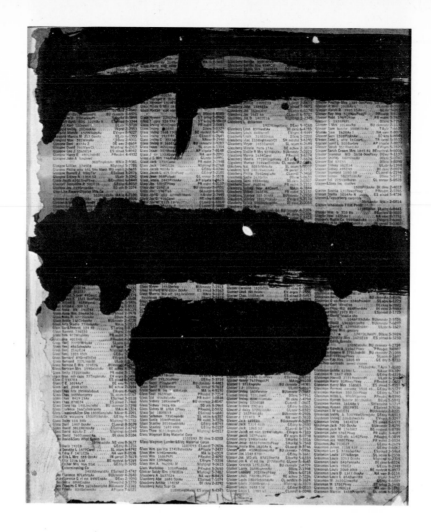

19–19 Franz Kline. *Chief.* 1950.
Collection The Museum of Modern Art, New York;
Gift of Mr. and Mrs. David M. Solinger.

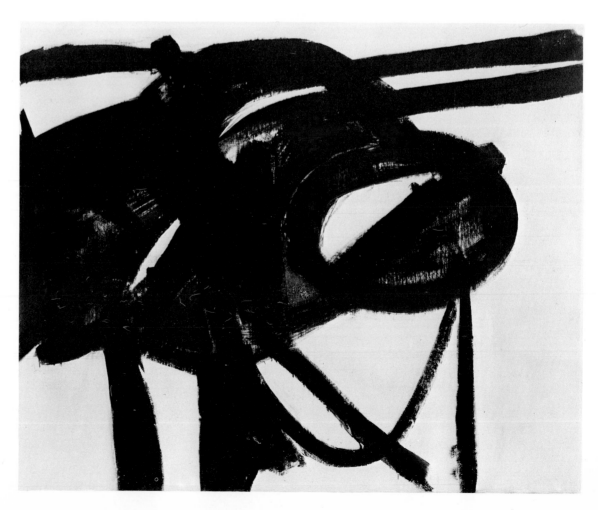

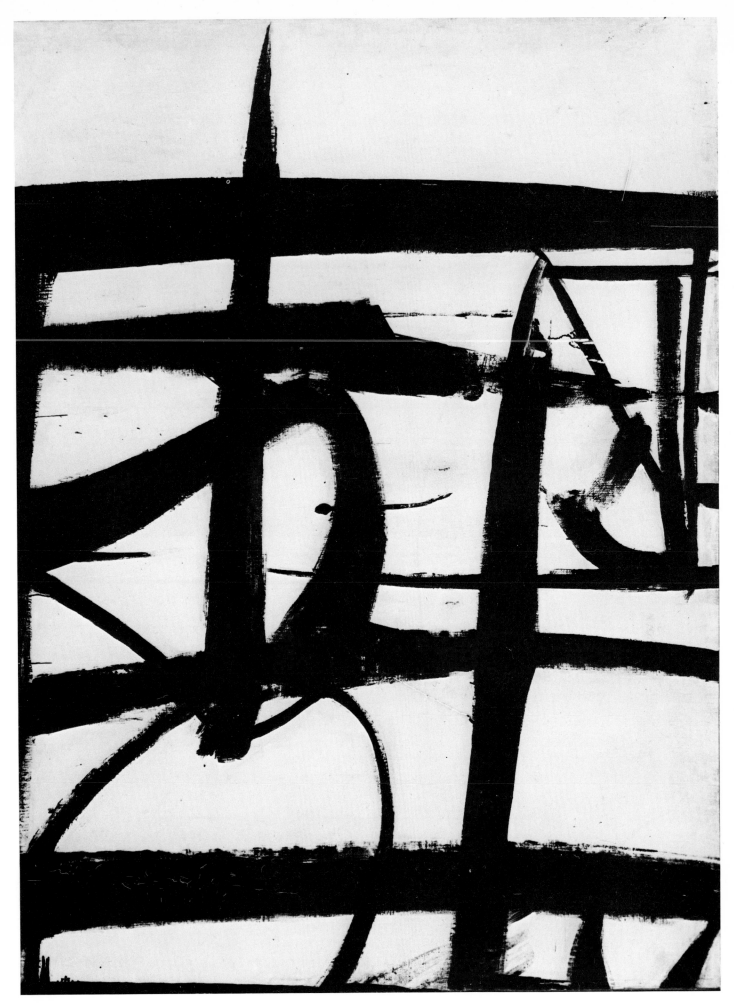

19–20 Franz Kline. *Cardinal*. 1950.
Collection George and Elinor Poindexter, New York.

253

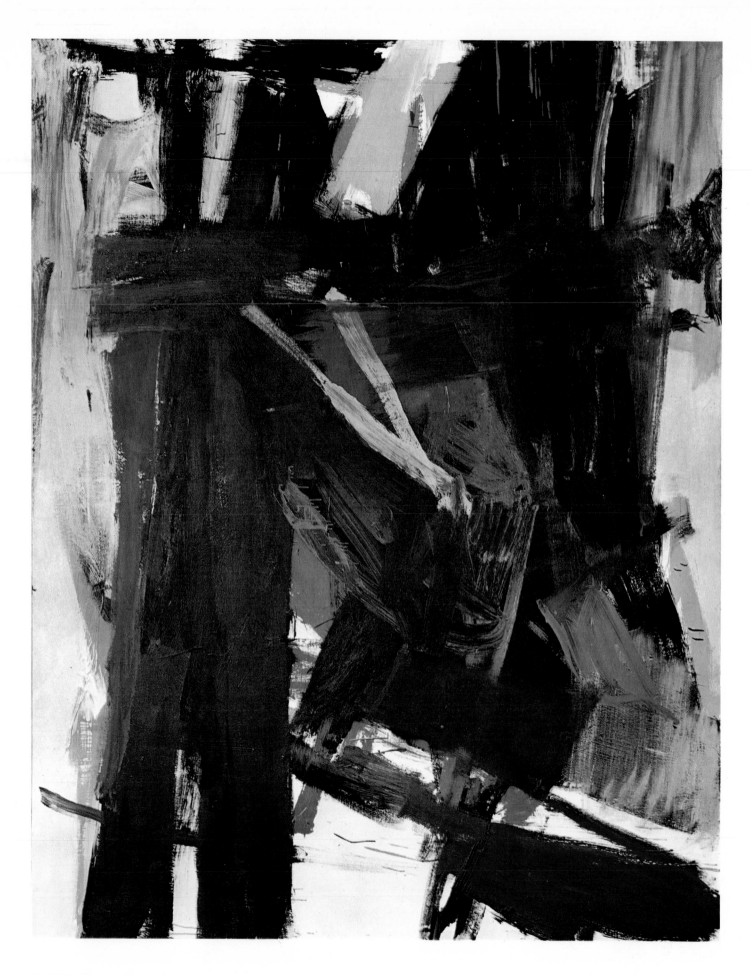

XXIII Franz Kline. *King Oliver*. 1958.
Collection Mr. and Mrs. I. Donald Grossman, New York.

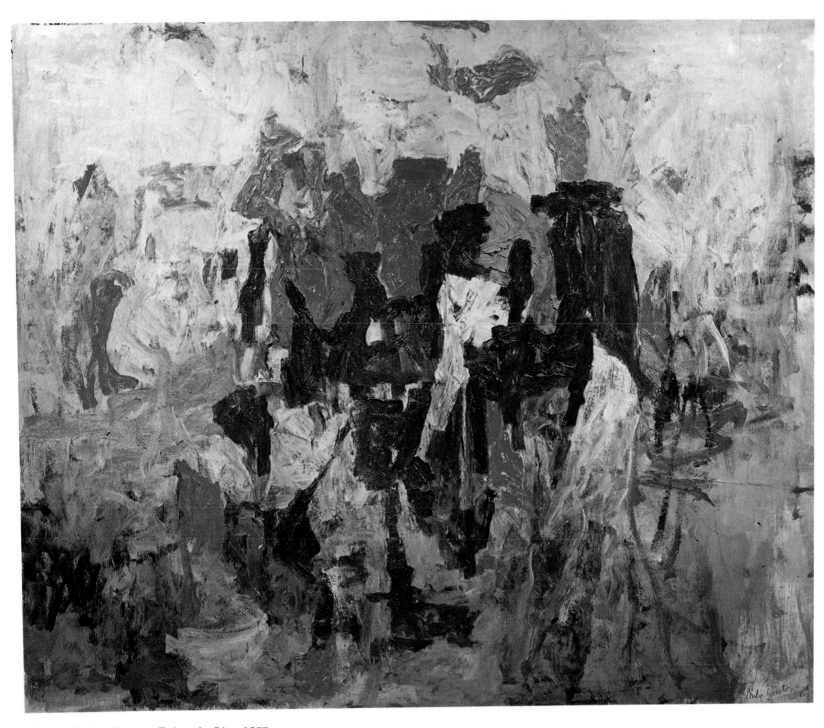

XXIV Philip Guston. *Painter's City*. 1957.
Collection Mr. and Mrs. I. Donald Grossman, New York.

housepainter's brush and black enamel (*Fig. 19-18*). The size of the newspaper, almost immediately, was unbearably confining. Then came the six- or eight-inch brushes, the six- or eight-foot canvases, the five-gallon cans of paint and the big, black images with the bulk and the force and the momentum of the old-fashioned engines that used to roar through the town where he was born" (*Figs. 19-19, 19-20*).[12]

Despite the immediacy and power of Kline's imagery, his painting is remarkably refined. His process on the whole was improvisational, although he often modeled his oils on sketches. Yet Kline's "organizing in front of you" (as he said of Bonnard) included deliberate modification, visible in the contrast of mat and gloss nuances, and in the bite of edges achieved by repeated overpainting of black and white.[13] Indeed, it is probable that Kline's canvases could not have attained the visual impact they have had he not painted them so thoughtfully.[14]

Kline's gesture paintings were, in his own words, "painting experiences. I don't decide in advance that I'm going to paint a definite experience, but in the act of painting, it becomes a genuine experience for me. . . . I'm not painting bridge constructions, sky scrapers or laundry tickets."[15] But his pictures do in fact allude to coal-country scenes—memories perhaps of things seen in central Pennsylvania, where he grew up (*Fig. 19-21*); to trestles or engines, after which many of his works are named (for example, *Chief, Caboose*); and to New York's ever changing face—the skeletons of partly demolished or constructed buildings or the old Third Avenue El—a favorite subject of his pre-abstract paintings (*Fig. 19-22*). The black-and-white abstractions also provoke thoughts about the human condition as a dramatic

19–21 Franz Kline. *Pennsylvania*. 1954.
Collection George and Elinor Poindexter, New York.

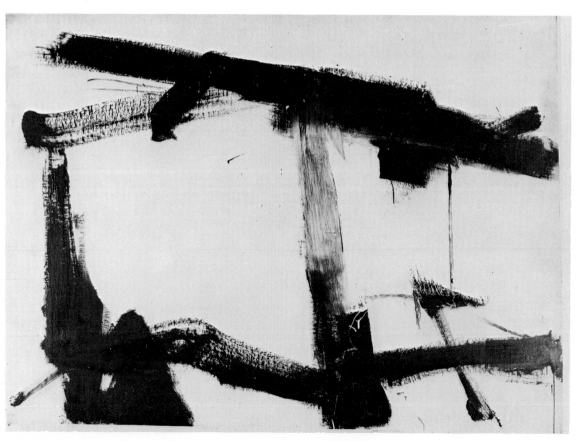

conflict of opposing forces that is resolved in a precarious equilibrium. The blacks are oppressive; they seem to want to imprison, to swallow up the whites that struggle to be free, to expand, breathe, and open up.

The blacks are linear in Kline's abstractions of the early 1950's. Subsequently, they grew more massive; he also tended in time to enlarge his formats, indicating a desire to render his images more forceful and monumental (*Figs. 19-23, 19-24*). In 1958, Kline began to use half-tones increasingly, shrouding his hulking scaffolds in a dark atmosphere and slowing their inner actions. What the best of these pictures—for example. *Siegfried* (1958; *Fig. 19-25*) —lose in power, they gain in mystery. Around this time, Kline also introduced colors into his painting, employing them at first as adjuncts of black, then, shortly before his death, as hues rather than values. With a few exceptions, such as *King Oliver* (1958; *XXIII*, p. 254), the color-paintings are not as strong as his earlier black-and-white abstractions. Nevertheless, as Frank O'Hara wrote, Kline "was not at all interested in pursuing a style toward the dead-end of expertise. When problems did not exist, he created them." [16]

Kline's pictures are marked by changes of mind, yet they look unequivocal because their boldness and immediacy divert the viewer's attention from all

19–22 Franz Kline. *The Bridge.* 1955.
Munson-Williams-Proctor Institute, Utica, New York.

19–23 Franz Kline. *Accent Grave.* 1955.
The Cleveland Museum of Art, Cleveland, Ohio;
Anonymous gift.

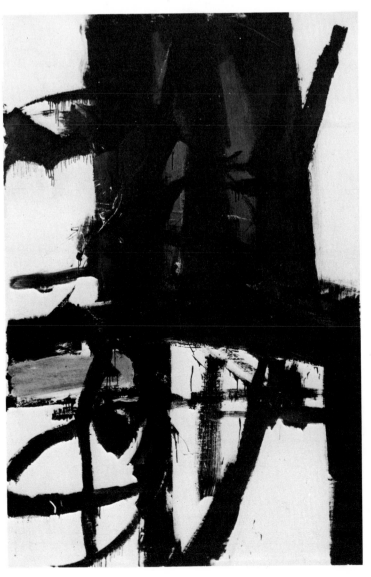

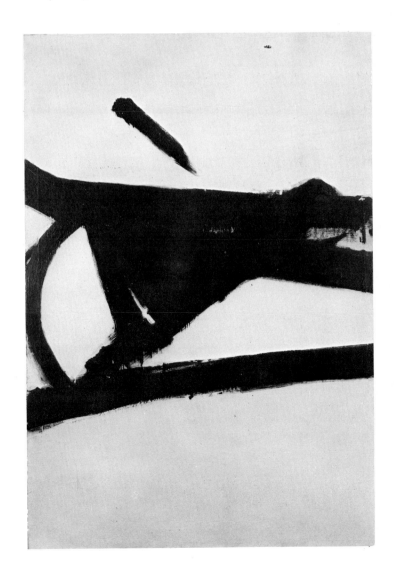

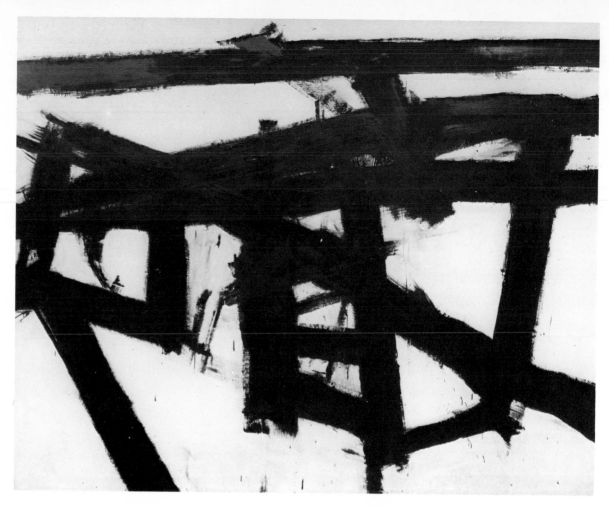

19–24　Franz Kline. *Mahoning.* 1956.
Collection Whitney Museum of American Art, New York;
Gift of the Friends of the Whitney Museum of American Art.

traces of self-doubt. Not so the gesture paintings that Philip Guston painted after 1951: Everything in them appears tentative in the extreme, each move offset by a countermove. The short strokes that comprise his abstractions are partly erased, the semi-effacements remaining as details of the images, as if Guston could not decide to let the marks stand unqualified. The touches of pigment and the open areas into which they are congealed are tremulous, seemingly about to shift. The colors are modified or grayed, suggesting that once the artist asserted a hue he nervously withdrew it. The color areas, scattered as if haphazardly, are clustered near (but not in) the centers of the pictures and thin out toward the borders. They rarely break the canvas edges, as if lacking the resolution to do so. Although the brushmarks are fleshy and articulate the surface, the painterly nuances and halftones produced by the modulated colors and erasures generate an amorphous atmosphere. The frayed edges of white canvas, while they assert the materiality of the picture plane, also serve to unhinge the images in indeterminate space. This spatial ambiguity adds to the seeming hesitancy of the painting. A number of critics have mistaken Guston's equivocation for timidity, failing to grasp that much of the expressive content of his pictures stems from their ability to convey the difficulty of choosing from among mutable alternatives experienced in the process of painting, which, in a broader sense, refers to a central existential problem of contemporary man.

Guston's aesthetic intention was to try in the act of painting to discover forms that embodied ephemeral states of feeling at the outer limits of aware-

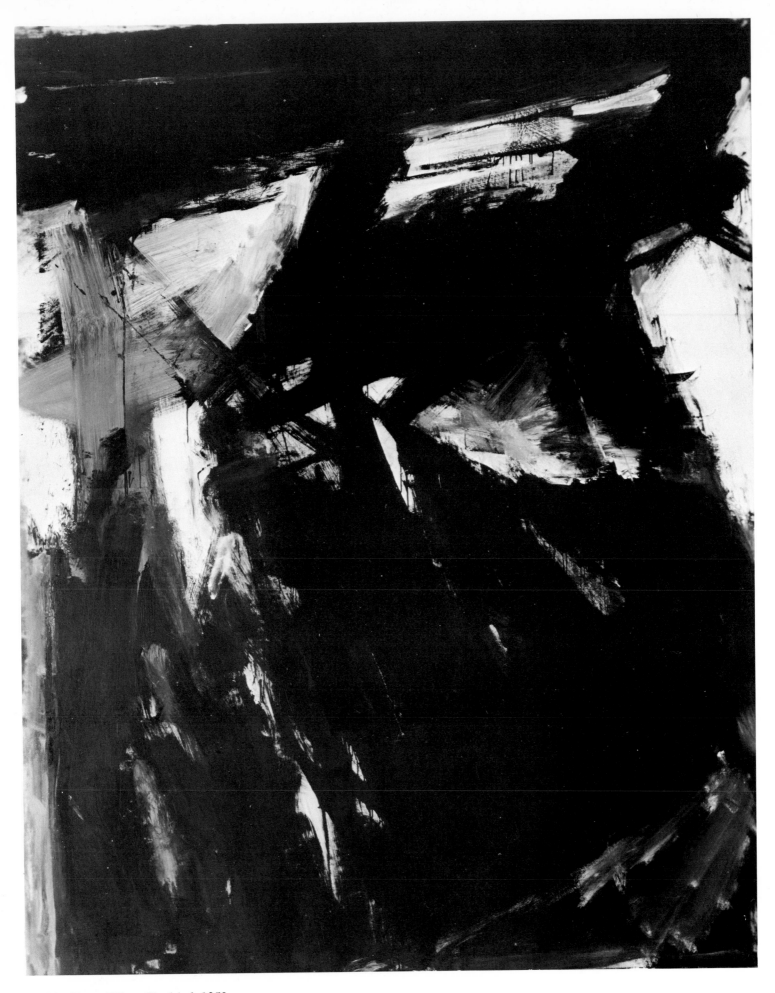

19–25 Franz Kline. *Siegfried*. 1958.
Museum of Art, Carnegie Institute, Pittsburgh, Pennsylvania;
Gift of Friends of the Department of Fine Arts.

19–26 Philip Guston. *Martial Memory*. 1941.
City Art Museum of St. Louis, St. Louis, Missouri.

19–27 Philip Guston. *If This Be Not I*. 1945.
Collection Washington University Gallery of Art, St. Louis, Missouri.

ness. He usually began a canvas with thoughts of former works, both his own and others, and with conceptions of an ideal picture. But he considered such ideas too familiar to be interesting for long, while at the same time refusing to admit momentary impulses. Thus, painting became a "tug-of-war between what you know and what you don't know," between the moment and the pull of memory.[17]

Memory played a crucial role in Guston's painting. Remembered experiences and works of art provided much of his content throughout his career. Around 1930, while still a high school student, he was deeply moved by Giorgio de Chirico's haunting city scenes and Picasso's classical figures of the 1920's. Curiosity about their antecedents prompted him to work with ideas taken first from Masaccio, Signorelli, and Mantegna—all of whom treated space as a void in which to project three-dimensional forms—and then from Piero della Francesca and Paolo Uccello, who flattened volumes as the Cubists were later to do. Guston's interest in Renaissance frescoes led him to mural painting, a move that was also motivated by his social consciousness.[18] His murals of the 1930's, executed while he was employed on the Federal Art Project, were generally considered among the most promising by a young American—especially his last one (1938–40) for the Queensbridge housing project.

In 1941, Guston resumed oil painting, developing sections of the Queensbridge mural. His first easel picture at this time was *Martial Memory* (*Fig. 19-26*), whose subject is a mock battle of small boys with wooden swords, trash-can-cover shields, and pot helmets. The figures, flattened into overlapping planes, and the patterns of swords call to mind Uccello's and Piero's battle scenes, as seen from the vantage point of Cubism; the stage-like setting and the ghostly urban architecture in the background are reminiscent of De Chirico. *Martial Memory* was painted during World War II and can be taken to refer to that conflict, but it contains other meanings, at once more generalized and private. The figures are frozen and solemn, as if their mock warfare had suddenly turned into ritual.[19] At the same time, the tableau-like picture expresses the strangeness of childhood experiences and Guston's nostalgia for them. In subsequent paintings, the most ambitious of which is *If This Be Not I* (1945; *Fig. 19-27*), the subjects are also children, now bizarrely masked but rendered in a more painterly Neo-Romantic manner. The forms are more fully modeled and the spaces in between are full of shadowy atmosphere—a reversion to his Renaissance-inspired pictures of the early 1930's.

In 1946, Guston again flattened his images—more extremely than in *Martial Memory*—and began increasingly to distort and disjoint them, motivated apparently by a growing inner need to make the forms themselves stand for feelings. This need was to prompt Guston to abstraction, and in 1947–48 he made the move—in *The Tormenters* (*Fig. 19-29*), which was based on the lower half of *Porch No. 2*, his last representational picture (*Fig. 19-28*). But it was difficult for Guston to come to terms with abstraction, and in the following three years, he completed only two more canvases, both of which made references to landscape forms. His malaise in this period of transition seems also to have been reflected in the heavy textures produced by labored overpainting, oppressive reds and blacks, and constrained, quasi-geometric design.

In the fall of 1948, Guston went to Italy for a year, and, while there, mostly sketched towns shimmering in a white Mediterranean light. When he re-

19–29 Philip Guston. *The Tormentors.* 1947–48.
Collection of the artist.

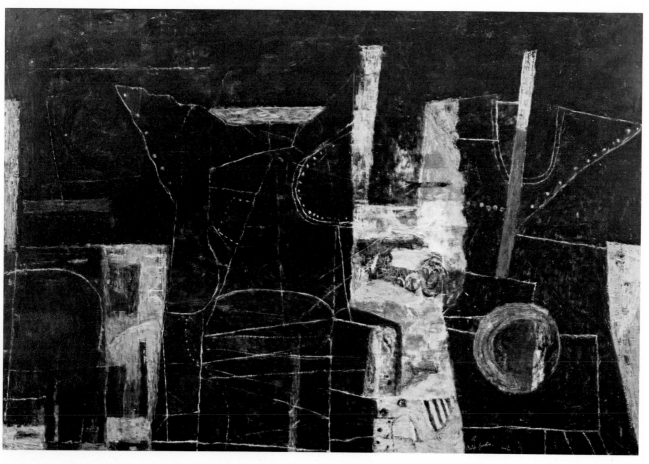

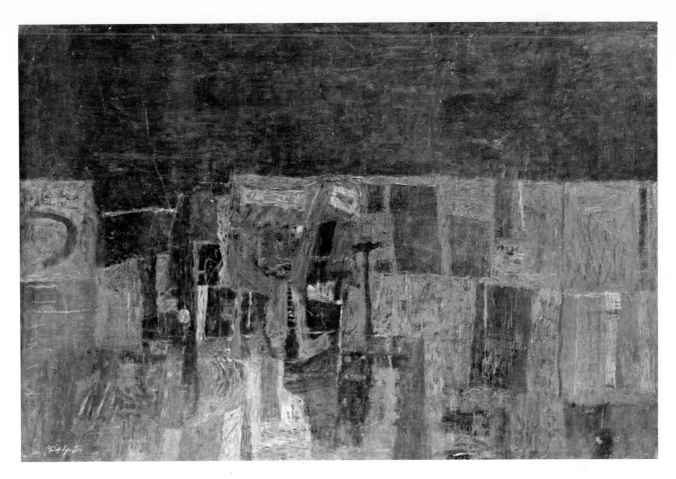

19–30 Philip Guston. *Review*. 1948–49.
Collection of the artist;
on loan to The Solomon R. Guggenheim Museum, New York City.

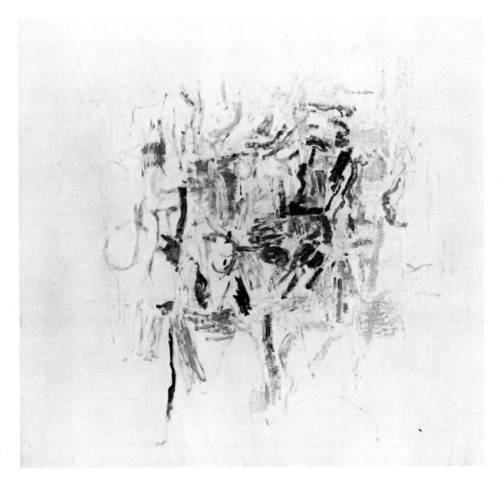

19–31 Philip Guston. *White Painting No. 1*. 1951.
Private Collection, Los Angeles, California.

263

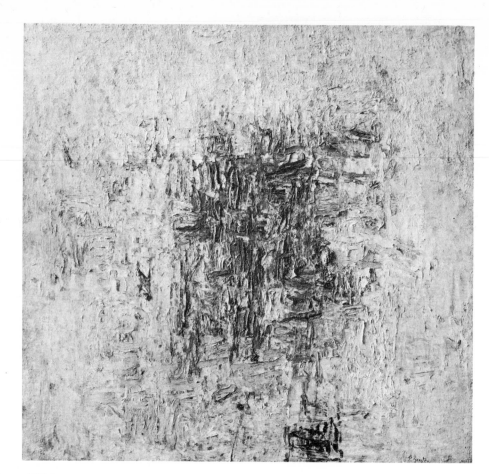

19–32 Philip Guston. *Zone*. 1954.
Collection Mr. and Mrs. Ben Heller, New York.

sumed painting in America, he dissolved the linear patterning found in *The Tormenters* in a field of dense pigmentation, as in *Review* (1948–49; *Fig. 19-30*). In 1951, Guston suddenly arrived at his mature style: in *White Painting No. 1* (*Fig. 19-31*) he isolated spare, ribbon-like paint marks on an airy field of white canvas—reminiscent of the lines and atmosphere of his Italian drawings. Of this picture, he wrote: "The desire for direct expression finally became so strong that even the interval necessary to reach back to the palette beside me became too long; so one day I put up a large canvas and placed the palette in front of me. Then I forced myself to paint the entire work without once stepping back to look at it. I remember that I painted this [picture] in an hour." [20]

In 1952, Guston reacted somewhat against the seeming randomness of his design and began to arrange his brushstrokes in vertical and horizontal directions (*Fig. 19-32*)—like Mondrian's plus-and-minus series. The painterly facture and luminosity of his style so strongly called to mind Impressionism that one critic called his work Abstract Impressionism to distinguish his lyrical tendency from the more aggressive Expressionist direction in gesture painting.[21] Indeed, Guston's quivering, pale rose light was more delicate than that of any of the other gesture painters of his generation.

However, the period of the rose-tinted abstractions lasted only from 1951 to 1954, and in retrospect stands apart from Guston's main body of work, which is marked by a gray melancholy. After 1954, his brushstrokes congealed into large, weightier areas, his color grayed, and black was increasingly

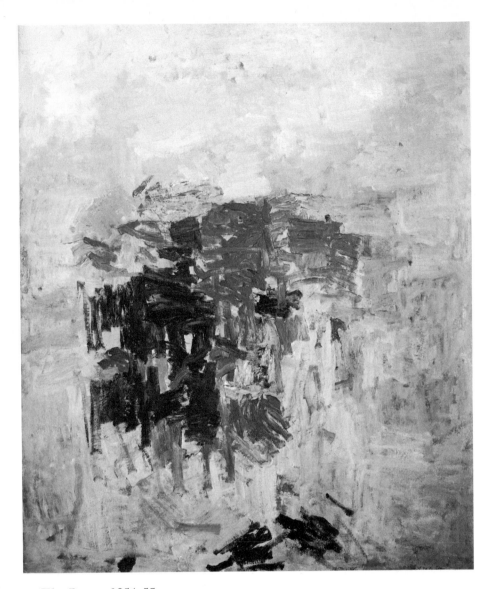

19–33 Philip Guston. *The Room*. 1954–55.
Los Angeles County Museum of Art, Los Angeles, California;
Contemporary Art Council Fund.

introduced into his palette, generating a dark atmosphere like the brooding mood of his 1940's pictures (*Figs. 19-33, 19-34*; also XXIV, p. 255).

The bulkier shapes and the *sfumato* in Guston's painting suggest objects and figures in obscure space. After 1958, he began to articulate motifs that vaguely resembled disembodied heads, balloons in cryptic comic strips, and vestiges of familiar things, such as city streets (*Fig. 19-35*). In a way, Guston reverted to his earlier figurative style, but with a difference: The images now appeared to be the phantoms of the children with their make-believe paraphernalia—memory traces of enigmatic protagonists in an ominous play. As if following the dictates of his remembered experiences, Guston sacrificed much of the sensuousness and refinement that marked his earlier abstractions. His gestures became blunter and rougher, his colors, grayed and smeared; after 1962, color virtually disappeared. In the works of the 1960's, Guston carries the Neo-Romantic bent that motivates most of his paintings to an extreme. Indeed, of all the Abstract Expressionists, he was the most preoccupied with fugitive, somber reveries that are full of nostalgia and fear.

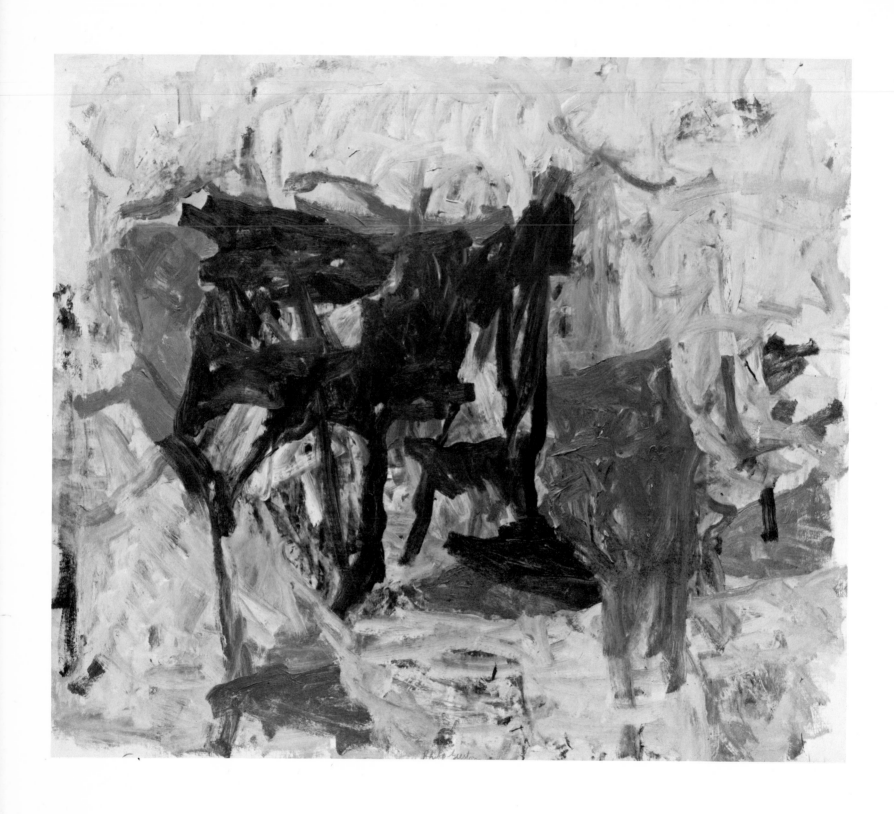

19–34 Philip Guston. *Untitled*. 1958.
Collection of the artist;
on loan to The Solomon R. Guggenheim Museum, New York City.

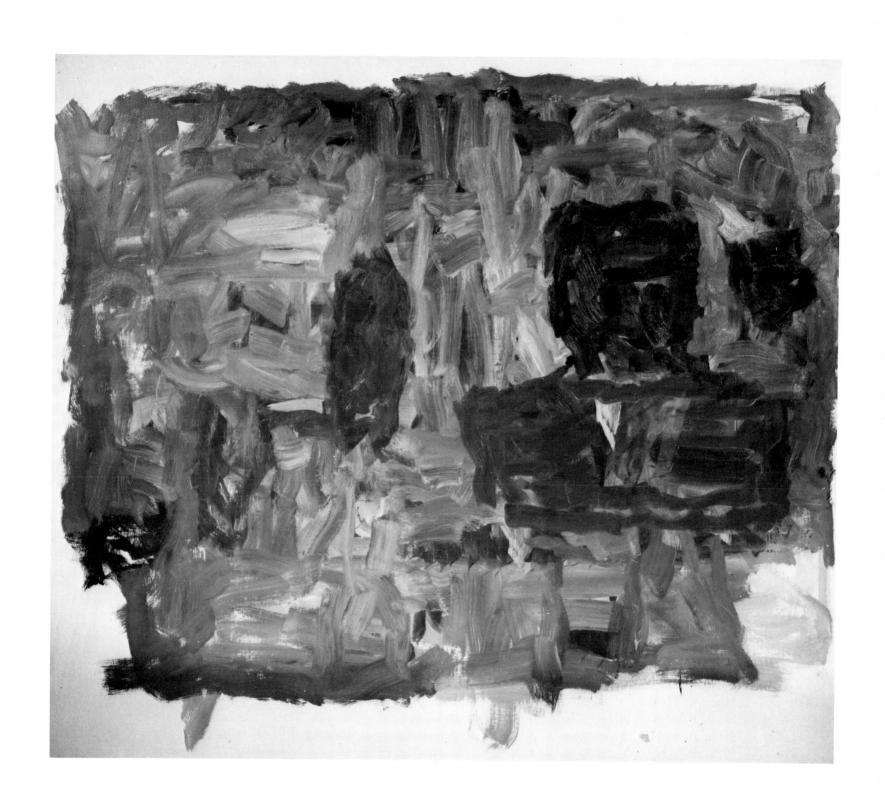

19–35 Philip Guston. *Looking.* 1964.
Collection of the artist.

19 Notes

1. Thomas B. Hess, *Abstract Painting* (New York: Viking Press, 1951), pp. 137, 140.

2. James Brooks, Statement in catalogue of an exhibition, "40 American Painters, 1940–50," University Art Gallery, University of Minnesota, Minneapolis, June 4–August 30, 1952, n.p.

3. James Brooks, transcript of a statement (April, 1953).

4. James Brooks, Statement in catalogue of an exhibition, University Art Gallery, University of Minnesota, n.p.

5. Aldous Huxley, *On Art and Artists*, Morris Philipson, ed. (New York: Meridian Books, 1960), p. 111.

6. Brooks refused to submit a work to the "Nature in Abstraction" show at the Whitney Museum in 1958.

7. Bradley Walker Tomlin, in Foreword to catalogue of an exhibition, "Frank London," Woodstock Art Association Gallery, Woodstock, New York, 1948, n.p.

8. Bradley Walker Tomlin, in *Modern Artists in America*, Robert Motherwell and Ad Reinhardt, eds. (New York: Wittenborn, Schultz, 1952), pp. 19–20.

9. Katherine Kuh, *The Artist's Voice: Talks with Seventeen Artists* (New York and Evanston: Harper & Row, 1960), p. 144.

10. Kline was also indebted to the English caricaturists. When he died, there remained in his estate books of illustrations by Rowlandson, Keen, and May. He also saved many of the political cartoons published by Low around 1940.

11. Elaine de Kooning, catalogue of a memorial exhibition, "Franz Kline," Washington Gallery of Modern Art, Washington, D.C., October 30–December 27, 1962, p. 14.

12. Elaine de Kooning, "Two Americans in Action: Franz Kline/Mark Rothko," *Art News Annual*, No. 27, Part II (Christmas edition; November, 1957), 179.

13. Frank O'Hara, "Franz Kline Talking," *Evergreen Review*, II, No. 6 (Autumn, 1958), 60.

14. Robert Goldwater, catalogue of an exhibition, "Franz Kline," Marlborough-Gerson Gallery, New York, March, 1967, pp. 6–7.

15. Katherine Kuh, *The Artist's Voice*, p. 144.

16. Frank O'Hara, in Introduction to catalogue of a traveling exhibition, "Franz Kline," Galleria Civica Moderna d'Arte, Turin, November 5–December 1, 1963, quoted from an English typescript.

17. Philip Guston, in "Three Painters: A Symposium," *Asterisk*, No. 9 (Spring, 1959), 29.

18. Guston painted a few social protest pictures: *Conspiracy* (1932), whose subject is the Ku Klux Klan, and *Bombardment* (1937), a Spanish Civil War theme. In 1934, he traveled to Mexico to study the wall paintings of the Social Revolutionary artists there at first hand. Upon his return to the United States, he joined the WPA mural project in Los Angeles and then, in 1936, in New York.

19. H. W. Janson, "*Martial Memory* by Philip Guston and American Painting Today," *Bulletin of the City Art Museum of St. Louis*, XXVII, Nos. 3–4 (December, 1942), 40–41.

20. H. Harvard Arnason, catalogue of an exhibition, "Philip Guston," Solomon R. Guggenheim Museum, New York, May 2–July 1, 1962, p. 21

21. Louis Finkelstein, "New Look: Abstract-Impressionism," *Art News*, LV, No. 1 (March, 1956), 36–37, 66.

AFTER 1950, the Abstract Expressionists came to believe with growing assurance that their work was of greater value than any other of that time, and that it would be of historical significance. The Ninth Street show of 1951 corroborated this opinion. Organized by a group of Club members, it consisted of sixty-one paintings and sculptures by an equal number of artists.[1] Most of the participating artists did not think that the show would attract much attention, but, in fact, it did, generating a feeling that something of consequence had been achieved in American art. The Abstract Expressionists' awareness of their new position was also reflected in the Introduction to *Modern Artists in America* (1952), written by its editors, Motherwell and Reinhardt. They stated "that by 1950, Modern Art in the United States has reached a point of sustained achievement worthy of a detached and democratic treatment." [2] The purpose of the magazine was not to promote vanguard art, for it had already attained recognition, but to dispel misunderstandings about it and to chronicle its development impartially and accurately.

Modern Artists in America was "democratic," in that it gave coverage to all tendencies in modernist art. On the whole, however, the first-generation Abstract Expressionists were not as catholic, for they had begun to exclude from their activities artists of lesser reputation and those who had realized their individual styles, no matter of what distinction, at a later date and so could be considered followers. For example, the three-day conference at Studio 35 in 1950 was not open to all vanguard artists but was limited to a selected group. The protest against the Metropolitan Museum that was proposed at the Studio 35 sessions was confined to eighteen painters, the so-called Irascibles, and ten sculptors. To be sure, the policy of restriction was largely unintentional at first. Artists chose each other because they were friends and were affiliated with certain galleries, notably Parsons and Kootz. But the attitude of exclusivity soon became conscious—certainly by the beginning of 1951, when Motherwell, the most historically oriented of the Abstract Expressionists, organized a show entitled "The School of New York," which included seventeen painters, most of whom had taken part in the Studio 35 conference and in the Irascibles' action.[3] Motherwell's aim, as the title of his exhibition signifies, was to counterpose an American style to that of the School of Paris in a bid for status. In retrospect, it appears that a desire for historical position, not only in relation to European artists of their own generation but to their American followers, led the first-generation Abstract Expressionists to establish a pantheon.

The interpersonal relations of those artists who continued to meet more or less regularly—at the Club or the Cedar Street Tavern—suffered from the introduction of the notion of "leaders" and "followers." The sense of camaraderie, which in the past had been based on an attitude of tacit equality, was soured by jealousy and the fear of being patronized. A certain degree of economic success, although it was meager for most artists well into the 1950's, hindered fraternization even more. To be sure, no one could begrudge a fellow artist sufficient money to function with greater concentration as an artist— or even to live comfortably. But the Abstract Expressionists, for whom sales had for so long seemed an incredible fantasy, had conditioned themselves to expect nothing from a philistine public, and when the "enemy" began to buy their works, they wondered whether they had "sold out," and whether their paintings continued to possess the anti-middle-class values they so prized —questions asked guiltily by better-off artists and resentfully by their im-

poverished colleagues. It was frequently suspected that social climbing, art-world conspiracies, and the like were responsible for success—a line of thinking that led to intense hatreds in which no interchange was possible. Another reason for the break-up of the first generation was that, as the artists grew older, they naturally felt less need to talk about art. To be sure, the Club remained an active force; 1952 was one of its liveliest years. However, the seeds of its dissolution were already present: In May of that year, a meeting was devoted to the topic of disbanding the Club because it had outlived its usefulness. The disintegration of the loose fraternity of Abstract Expressionists marked the end of a fertile phase of the New York art scene.

As the 1950's progressed, Abstract Expressionist painting was shown more and more widely, discussed in innumerable lectures and symposia in museums, colleges, and art centers—often by members of a growing and vocal second generation of artists—and featured in art magazines and the mass media. Moreover, the premises of Abstract Expressionism were systematized and broadcast to an ever growing audience by art critics close to the artists, the most influential of whom were Greenberg, Rosenberg, and Hess.

In his book *Abstract Painting* (1951), and in *Art News* magazine, of which he was executive editor, Hess championed the older Abstract Expressionists, notably De Kooning, and their followers. He traced the roots of contemporary styles in past modernist traditions, maintaining that New York had replaced Paris as the fountainhead of world art and that its vanguard had inherited the cosmopolitanism, confidence, ambition, and radicality no longer possessed by the School of Paris.[4]

Rosenberg was less historical and more existential in his approach than Hess, as is clear in his most widely discussed article, "The American Action Painters," which appeared in *Art News* late in 1952. Rosenberg asserted that the art he called "action painting" was new and revolutionary—an unprecedented departure from all past and existing styles and from all aesthetic criteria. As he wrote:

> At a certain moment the canvas began to appear to one American painter after another as an arena in which to act—rather than as a space in which to reproduce, re-design, analyze or "express" an object, actual or imagined. What was to go on the canvas was not a picture but an event.[5]

Rosenberg remarked that artists had been basing their paintings on conceptions of society and art:

> The big moment came when it was decided to paint. . . . Just to PAINT. The gesture on the canvas was a gesture of liberation, from Value—political, aesthetic, moral. . . . On the one hand, a desperate recognition of moral and intellectual exhaustion; on the other, the exhilaration of an adventure over depths in which he might find reflected the true image of his identity.[6]

Elaborating on the meaning of action painting, Rosenberg remarked that it

> is a "moment" in the adulterated mixture of his [the artist's] life. . . . The act-painting is of the same metaphysical substance as the artist's existence. . . . what gives the canvas its meaning is not psychological data [as in Surrealism] but *role*, the way the artist organizes his emotional and intellectual energy as if he were in a living situation.

Rosenberg declared that the action painters in their "gesturing with materials" had discarded traditional aesthetic references as irrelevant. "Form, color,

composition, drawing, are auxiliaries . . . [which] can be dispensed with. What matters always is the revelation contained in the act." [8] Convinced that the artist's existential experience was the exclusive mainspring of action painting, Rosenberg dismissed tradition out of hand, considering it a barrier that blocked the artist's path to his authentic being. He believed that the artist who valued the past assumed that the important thinking had been done before he started to paint his picture, and that consequently his aim became to make a picture in a definable style, even when that style was new.[9] Rosenberg's conception of action painting reflected the thinking and rhetoric of the gesture painters, for they, too, valued existential action and reviled aesthetic performance. Painting meant more to them than mere picture-making; its purpose was emotional discovery, which involved freeing themselves of received ideas or, as Rosenberg put it, a "revolution against the given, in the self and in the world." [10]

It is understandable that Rosenberg should have desired to underscore the primacy of the unqualified, direct, and unpremeditated act of painting, but in order to dramatize his conception of an action painter, he went to such an extreme that none of the artists who could be subsumed under his label would follow. They questioned his assertion that the action painters could discard every traditional reference, for none could help but begin with ideas culled from past art and from their own earlier works. The gesture painters chose to work in a loose, painterly manner, for example, because historically it had come to be accepted as more appropriate for certain kinds of Romantic meaning than geometry. Moreover, the painterly tendency seemed to be more viable than others—open to fresher extensions that could lead to a revitalization of painting. To be sure, they diverged radically from past painterly styles, but their departures, no matter how original and personal, could be made (and could be recognized by their audience) only with reference to existing art. This was unavoidable. In addition, there was a long tradition of innovation built into modern art, for, as Goldwater remarked: "They were the very conscious heirs of a century of artistic change." [11] Later, Rosenberg himself stressed that heritage, entitling one of his books *The Tradition of the New*.

Many gesture painters also objected to Rosenberg's conception of action painting on the grounds that it might be thought of as a program for making a type of picture—and it was often interpreted in this way. Taken as method, action painting did not correspond to the manner in which those identified with it actually painted. Nor did it approximate the way that spectators could respond to the works. Rosenberg maintained: "Criticism must begin by recognizing in the painting the assumption inherent in its mode of creation. Since the painter has become an actor, the spectator has to think in a vocabulary of action: its inception, duration, direction—psychic state, concentration and relaxation of will, passivity, alert waiting. He must become a connoisseur of the gradations between the automatic, the spontaneous, the evoked." [12] The viewer cannot possibly fulfill this demand, for, as William James remarked, the process of creation is unknowable and it cannot be imagined or relived. In the case of Pollock's "drip" paintings, for example, one cannot determine the degree of spontaneity as against the degree of deliberate control. Nor can one draw the fine line, if in fact such a line exists, that separates psychic urgencies from conscious artistry. For example, one can only say that Pollock's dripped lines look free, certainly when compared to the drawing of other artists up to his time, and thus can be taken for metaphors of freedom.

Believing that action painting had done away with aesthetic criteria, Rosen-

berg consistently refused to "indicate why any action painting is valid *as a painting* nor how to tell a good one from a bad one." [13] The artists themselves, however, continually made value judgments on aesthetic grounds, even though they did not arrive at any consensus concerning the tests of quality. Rosenberg did set up criteria for judgment, among them "authenticity" and "seriousness." Given his point of view, he could not have established any other standard. As Irving Howe remarked: "The triumph of literary [or artistic] modernism is signalled by a turn from truth to sincerity, from the search for objective law to a desire for personal response. The first involves an effort to apprehend the nature of the universe . . . the second involves an effort to discover our demons within, and makes no claim upon the world other than the right to publicize the aggressions of candor. Sincerity becomes the last-ditch defense for men without belief, and in its name absolutes can be toppled, morality dispersed and intellectual systems dissolved." [14]

However, such a quality as "seriousness," even when it could be sensed in a painting, could not be determined or dealt with objectively, that is, checked against a picture. And many artists and critics denied its usefulness in the analysis of art, opting for a more factual approach based on the identification of formal elements and the comparison of styles. Foremost among such critics was Clement Greenberg (although, in 1952, he had written: "We cannot be too often reminded how decisive honesty is in art.") [15] He maintained that modernist artists were increasingly occupied with what is unique in the nature of their mediums and that they were transforming their styles by eliminating impurities or expendable conventions that denied the medium (in painting, this meant figuration and illusionism). He also asserted that stylistic changes result from artists' reactions against outworn formal solutions in the art of the recent past. During the early and mid-1940's, Greenberg preferred Cubist abstraction to other styles, but, turning slowly against its derivitiveness, he began to favor "painterly" abstraction, which broke from Cubism and which "continues the centuries-old tradition of painterly—*malerisch*—'loosely' executed, 'brushy' painting." [16] Nevertheless, painterly abstraction continued to be informed by Cubism, as Greenberg later concluded: "The grafting of painterliness on a Cubist infra-structure was, and will remain, the great and original achievement of the first generation of Painterly Abstraction." [17]

Greenberg grew dissatisfied with painterly painting as a viable direction in the early 1950's, primarily because of its Cubist component; by 1955, he was championing the antithesis of Cubism—a purely chromatic field abstraction, which he believed was a revival of Impressionism. Greenberg's change of mind was slow and tortured, taking some seven years, from 1948 to 1955. In the 1940's, his attitude toward the "colorists" of modern art had been a negative one; they were minor artists working in outmoded styles. Typical was his criticism in 1943 of Milton Avery, whom he called "a '*light*' modern who in oil can produce offspring of Marie Laurencin and Matisse that are empty and sweet, with nice flat areas of color. . . . The painting is almost faultless within its limitations, but it has been seen before." [18] In 1945, Greenberg chided Hofmann in an otherwise enthusiastic review for letting "color dictate too much," [19] and Monet for succumbing to the fallacy of chromaticism: "Monet in his last period offered the mere texture of color as adequate form in painting. . . . [and] forgot that art is relations, not matter, and that it exists primarily by virtue of relations." [20] Greenberg granted that Monet "produced an occasional strong painting after 1890 . . . but on the whole his

design disintegrated progressively and his color thinned out and lost its juice." [21] In 1947, Greenberg gave Bonnard a left-handed compliment, allowing that he showed "that Impressionism still has something left to say," and that it could indicate a "way of approaching abstract painting that makes a detour around cubism." [22] This idea would later become central to his thinking, but, at the time, he maintained: "The abstractness of the cubists and Matisse's flatness are the symptoms of a new vision in art, whereas Bonnard's is an extension of the same vision by which Monet painted his lilypads." [23]

In the spring of 1948, Greenberg noted "a decline of cubism," indeed, a decline of the masters of the School of Paris: "Matisse, the late Bonnard, and even the late Vuillard seem to have been spared by the general debility. . . . [Yet] Cubism is still the only vital style of our time, the one best able to convey contemporary feeling, and the only one capable of supporting a tradition which will survive into the future and form new artists." [24] Why, then, had it collapsed? "[An] age may repudiate its real insights. . . . In a time of disasters the less radical artists . . . will perform better . . . they need less nerve." [25] But Greenberg seemed ill at ease with this explanation:

> The problem for criticism is to explain why the Cubist generation and its immediate successors have . . . fallen off in middle and old age, and why belated Impressionists like Bonnard and Vuillard could maintain a higher consistency of performance during the last fifteen years. . . . And why, finally, Matisse, with his magnificent but transitional style, which does not compare with Cubism for historical importance, is able to rest so securely . . . as the greatest master of the twentieth century.[26]

At the same time that Greenberg became troubled about the decline of Cubism, he began to re-evaluate Matisse's ideas as they were being used by a number of New York artists, who "in distinction to the French . . . [are attempting] to create a larger-scale easel art by expanding Matisse's hot color, raised several degrees in intensity, into the bigger, more simplified compositional schemes which he himself usually reserved for blacks, grays and blues." [27] Greenberg also began to reconsider the Impressionist tradition, which he came to believe was the most viable in contemporary art. In 1955, he wrote a major article entitled " 'American-Type' Painting," in which he asserted:

> Value contrast, the opposition and modulation of dark and light, has been the basis of Western pictorial art, its chief means, much more important than perspective, to a convincing illusion of depth and volume; and it has also been its chief agent of structure and unity. . . . Impressionism's muffling of light and dark contrasts in response to the effect of the glare of the sky caused it to be criticized for that lack of "form" and "structure" which Cézanne tried to supply with his substitute contrasts of warm and cool color (these remained nonetheless contrasts of dark and light . . .). Black and white is the extreme statement of value contrast, and to harp on it as many of the abstract expressionists do . . . seems to me to be an effort to preserve by extreme measures a technical resource whose capacity to yield convincing form and unity is nearing exhaustion. . . .
>
> [There was, however, within Abstract Expressionism a development that is] I think, the most radical of all developments in the painting of the last two decades, and has no counterpart in Paris . . . as so many other things in American abstract expressionism have had since 1944. This development involves a more consistent and radical suppression of

value contrasts than seen so far in abstract art. We can realize now, from this point of view, how conservative Cubism was in its resumption of Cézanne's effort to save the convention of dark and light. . . . The late Monet, whose suppression of values had been the most consistently radical to be seen in painting until a short while ago, was pointed to as a warning, and the *fin-de-siècle* muffling of contrasts in much of Bonnard's and Vuillard's art caused it to be deprecated by the avant-garde for many years. . . . Recently, however, some of the late Monets began to assume a unity and power they had never had before.

This expansion of sensibility has coincided with the emergence of Clyfford Still [along with Newman and Rothko]. . . . As the Cubists resumed Cézanne, Still has resumed Monet—and Pissarro. His paintings were the first abstract pictures I ever saw that contained almost no allusion to Cubism. . . . Still's art has a special importance at this time because it shows abstract painting a way out of its own academicism. . . . A concomitant of the fact that Still, Newman, and Rothko suppress value contrasts . . . is the more emphatic flatness of their paintings. Because it is not broken by sharp differences of value or by more than a few incidents of drawing or design, color breathes from the canvas with an enveloping effect, which is intensified by the largeness itself of the picture.[28]

Greenberg valued the "modernist" or vanguard attributes of art, but this was not as important to him as its quality. He considered the urge to "good" painting as a primary motive of the Abstract Expressionists, stating that "most . . . did not set out to be 'advanced'; they set out to paint good pictures, and they 'advance' in pursuit of qualities analogous to those they admire in the art of the past." [29] To be sure, the Abstract Expressionists valued good painting, but their attitude to it was equivocal for, as Goldwater remarked, they reacted "against the well-made modern picture of the Cézanne-cubist-post-cubist lineage, reactions which include the fauves, the expressionists, the dadaists, the surrealists"—a lineage that Greenberg overlooked in his writing.[30] Greenberg argued that the main function of criticism was separating good art from bad, yet he believed that there could be no criteria for judgment, it being ultimately a matter of taste. He considered quality in art as independent of style, for it could be found in any kind of picture, no matter how retrogressive or easy to make. Yet he was ambiguous on this issue, for he tended to assume (although he denied it) that painting that is not difficult enough to challenge taste is minor or commonplace. Consequently, implicit in his criticism is the notion that "difficult" styles tend toward high quality more than any other, a reason, perhaps, for his shifting attitudes.

Despite changes of mind, Greenberg's strength as a critic was in the clarity and logic of his formal definitions of modern styles and their traditions. His major weakness was in the narrowness of his approach, which excluded all interpretations other than the formal, and even in this he was, as Goldwater remarked, fixated on "cubism . . . as the style through whose analysis and understanding all modern picture construction becomes comprehensible. . . . the whole development of the New York School is somehow reduced to a battle for freedom from cubist composition. Surrealism, in both its iconographic and structural aspects, is ignored." [31]

The refusal to consider content in art constituted a serious gap in Greenberg's criticism, notably because the formal departures made by the Abstract Expressionists issued from their need for fresh expressive meanings and could be understood only with regard to those needs. As Goldwater wrote, they

were engaged in "telling the truth" and they talked a great deal about it. This truth was an emotional truth which would emerge from themselves if they knew how to allow it (here was a strong surrealist influence), and once told would reveal to their eventual audience . . . the pretense of many of its current emotional and (yes!) social attitudes. . . . The New York group believed in the efficacy of this kind of emotional honesty. . . . This understanding is particularly important because that force of impact, that directness and discarding of finish which Greenberg rightly values in American painting has its source in this attitude and is bound up with it. . . . The quality of this expressiveness . . . is difficult to formulate. It cannot for all that be ignored, nor can it be resolved by purely formal analysis. . . . But circumspect as one must be, one must also recognize that art has meaning beyond the purely formal relation of its internal parts.[32]

20 Notes

1. The idea of mounting an exhibition—like a big salon—was raised many times at the Club but was rejected because it might indicate a trend or position and curb the Club's open character. However, in the spring of 1951, it was decided to have a show, but not under the direct auspices of the Club. With the help of Leo Castelli, a group of charter members leased an empty store at 60 East Ninth Street, chose the artists, and installed the show. Baziotes, Gottlieb, Newman, Rothko, and Still did not submit pictures.

2. Robert Motherwell and Ad Reinhardt, eds., *Modern Artists in America* (New York: Wittenborn, Schultz, 1952), p. 6.

3. Artists listed in the catalogue of Motherwell's exhibition, "The School of New York," Perls Gallery, Beverley Hills, Cal., 1951, were: William Baziotes, Willem de Kooning, Lee Gatch, Adolph Gottlieb, Morris Graves, Hans Hofmann, Matta, Robert Motherwell, Jackson Pollock, Richard Pousette-Dart, Ad Reinhardt, Mark Rothko, Theodoros Stamos, Hedda Sterne, Clyfford Still, Mark Tobey, Bradley Walker Tomlin.

4. Thomas B. Hess, *Abstract Painting* (New York: Viking Press, 1951), pp. 63–64, 99.

5. Harold Rosenberg, "The American Action Painters," *Art News*, LI, No. 8 (December, 1952), 22.

6. *Ibid.*, p. 23, 48.

7. *Ibid.*, p. 23.

8. *Ibid.*

9. Harold Rosenberg, Introduction to Marcel Raymond, "From Baudelaire to Surrealism," in *Documents of Modern Art*, X (New York: Wittenborn, Schultz, 1949), n.p.

10. Rosenberg, "The American Action Painters," p. 48.

11. Robert Goldwater, "Reflections on the New York School," *Quadrum*, No. 8 (1960), 29.

12. Rosenberg, "The American Action Painters," p. 23.

13. Harold Rosenberg, "Critic Within the Act," *Art News*, LIX, No. 6 (October, 1960), 26.

14. Irving Howe, *A World More Attractive* (New York: Horizon Press, 1963), pp. 196–97. ,

15. Clement Greenberg, "Feeling Is All," *Partisan Review*, XIV, No. 1 (January–February, 1952), 97.

16. Clement Greenberg, "The 'Crisis' of Abstract Art," *Arts Yearbook 7: New York: The Art World* (1964), p. 90.

17. *Ibid.*, p. 91.

18. Clement Greenberg, "Art," *The Nation*, CLVII, No. 20 (November 13, 1943), 535.

19. Clement Greenberg, "Art," *The Nation*, CLX, No. 16 (April 21, 1945), 469.

20. Clement Greenberg, "Art," *The Nation*, CLX, No. 18 (May 5, 1945), 526.

21. *Ibid.*

22. Clement Greenberg, "Art," *The Nation*, CLXIV, No. 1 (January 11, 1947), 54, 53.

23. *Ibid.*, p. 53.

24. Clement Greenberg, "The Decline of Cubism," *Partisan Review*, XV, No. 3 (March, 1948), 366–67.

25. *Ibid.*, p. 367.

26. *Ibid.*, p. 366.

27. Clement Greenberg, "The Situation at the Moment," *Partisan Review*, XV, No. 1 (January, 1948), 83.

28. Clement Greenberg, " 'American-Type' Painting," *Partisan Review*, XXII, No. 2 (Spring, 1955), 189–90, 192, 194.

29. *Ibid.*, p. 180.

30. Robert Goldwater, "Art and Criticism," *Partisan Review*, XXVIII, Nos. 5–6 (May-June, 1961), 692. (A review of Clement Greenberg's book *Art and Culture: Critical Essays*.)

31. *Ibid.*, p. 690.

32. *Ibid.*, pp. 693–94.

WILLIAM BAZIOTES

1912 Born Pittsburgh, Pennsylvania.
1913 Family moved to Reading, Pennsylvania.
1933 Settled in New York City.
1933–36 Studied at National Academy of Design, New York City, under Leon Kroll.
1936–38 Teacher on WPA Federal Art Project.
1938–40 Worked on WPA Easel-Painting Project.
1947 Awarded Walter M. Campana Memorial Purchase Prize, Thirty-eighth Annual Exhibition, Art Institute of Chicago.
1948 Co-founder of "Subjects of the Artist" school, New York City.
1952–62 Taught painting at Hunter College, New York City.
1963 Died New York City.

One-Man Shows: 1944, Art of This Century, New York City; 1946–58, Kootz Gallery, New York City; 1961, Sidney Janis Gallery, New York City; 1965, Solomon R. Guggenheim Museum, New York City.

JAMES BROOKS

1906 Born St. Louis, Missouri.
1911–26 Lived in Oklahoma, Colorado, and Texas.
1926 Moved to New York City.
1927–30 Studied at Art Students League, New York City, with Kimon Nicolaides and Boardman Robinson.
1936–42 Worked on WPA Federal Art Project as muralist.
1948–59 Taught at Pratt Institute, Brooklyn, New York.
1955–60 Visting critic of advanced painting at Yale University, New Haven, Connecticut.
1962–63 Artist-in-residence at American Academy, Rome.

One-Man Shows: 1949–53, Peridot Gallery New York City; 1954, Grace Borgenicht Gallery, New York City; 1956–59, Stable Gallery, New York City; 1961–66, Kootz Gallery, New York City; 1963, Whitney Museum of American Art, New York City, Rose Art Museum, Brandeis University, Waltham, Massachusetts; 1968, Martha Jackson Gallery, New York City.

WILLEM de KOONING

1904 Born Rotterdam, The Netherlands.
1916 Apprenticed to commercial art firm.
1916–24 Attended evening classes at Academie voor Beeldende Kunsten en Technische Wetenschappen, Rotterdam.
1926 Moved to United States.
1927 Moved to New York City.
1935–36 Worked on WPA Federal Art Project as muralist.

1948 Taught at Black Mountain College, Black Mountain, North Carolina.
1950 Exhibited at XXV Biennale, Venice.
1950–51 Taught at Yale University Art School, New Haven, Connecticut.
1960 Elected member of National Institute of Arts and Letters.

One-Man Shows: 1948, Egan Gallery, New York City; 1953, 1956, 1959, 1962, Sidney Janis Gallery, New York City; 1955, Martha Jackson Gallery, New York City; 1964, Allan Stone Gallery, New York City; 1967, M. Knoedler & Company, Inc., New York City; 1968–69, Museum of Modern Art, New York City.

ARSHILE GORKY
(Vosdanig Manoog Adoian)

1904 Born Armenia.
1920 Arrived in United States. Studied at Providence Technical High School, Rhode Island School of Design, and New School of Design, Boston.
ca. 1925 Changed name to "Arshele," later "Arshile," Gorky. Moved to New York City. Studied and taught at Grand Central School until 1931.
1935 Worked on WPA Federal Art Project as muralist.
1948 Committed suicide, Sherman, Connecticut.

One-Man Shows: 1934, Mellon Galleries, Philadelphia; 1938, Boyer Galleries, New York City; 1941, San Francisco Museum of Art; 1945–48, Julien Levy Gallery, New York City; 1951, Whitney Museum of American Art, New York City; 1962, Museum of Modern Art, New York City; 1969, M. Knoedler & Company, Inc., New York City.

ADOLPH GOTTLIEB

1903 Born New York City.
1920 Studied at Art Students League, New York City, with John Sloan and Robert Henri.
1921 Attended sketch classes at Académie de la Grande Chaumière, Paris, and other art schools.
1923 Studied at Parsons School of Design, Art Students League, Cooper Union, and Educational Alliance Art School, New York City.
1935 Co-founder of and annual exhibitor with The Ten.
1936 Worked on WPA Easel-Painting Project.
1958 Taught at Pratt Institute, Brooklyn, New York, and at University of California, Los Angeles.
1963 Awarded Gran Premio, VII Bienal, São Paulo, Brazil.
1967 Appointed to Art Commission, City of New York.

One-Man Shows: 1930, Dudensing Gallery, New York City; 1934, Uptown Gallery, New York City; 1940, 1942, Wakefield Gallery, New York City; 1945, 67 Gallery, New York City; 1947, 1950–54, Kootz Gallery, New York City; 1957, Martha Jackson Gallery, New York City, Jewish Museum, New York City; 1958, 1959, André Emmerich Gallery, New York City; 1960, French and Co., New York City; 1960, 1962, Sidney Janis Gallery, New York City; 1963, Walker Art Center, Minneapolis; 1964, 1966, Marlborough-Gerson Gallery, New York City; 1967, Solomon R. Guggenheim Museum, New York City, Whitney Museum of American Art, New York City.

PHILIP GUSTON

1913 Born Montreal, Canada.
1919 Moved to Los Angeles.
1934 Traveled in Mexico.
1934–35 Worked in Public Works Administration, Los Angeles.
1936 Moved to New York City.
1936–40 Worked on WPA Federal Art Project as muralist.
1938–42 Commissions from Treasury Department's Section of Fine Arts.
1945 Awarded first prize, *Pittsburgh International Exhibition of Painting and Sculpture*, Carnegie Institute.
1947 Awarded Guggenheim fellowship; moved to Woodstock, New York.
1948 Awarded Prix de Rome.
1951–59 Taught drawing, New York University.
1959 Awarded $10,000 grant from Ford Foundation.

One-Man Shows: 1944, University of Iowa, Iowa City; 1947, Munson-Williams-Proctor Institute, Utica, New York; 1956, 1958, 1959, 1960, 1961, Sidney Janis Gallery, New York City; 1962, Solomon R. Guggenheim Museum, New York City; 1966, Jewish Museum, New York City.

HANS HOFMANN

1880 Born Weissenburg, Germany.
1904–14 Lived in Paris.
1915 Opened art school in Munich.
1930–31 Taught summer sessions at University of California, Berkeley.
1932–33 Moved to United States. Taught at Art Students League, New York City.
1933 Opened art school in New York City.
1958 Stopped teaching to devote full time to painting.
1966 Died New York City.

One-Man Shows: 1931, California Palace of the Legion of Honor, San Francisco; 1941, Isaac Delgado Museum of Art, New Orleans; 1944, Art of This Century, New York City; 1947, Betty Parsons Gallery, New York City; 1948, Addison Gallery of American Art, Andover, Massachusetts; 1954, Baltimore Museum of Art; 1955, Bennington College, Bennington, Vermont; 1957, Whitney Museum of American Art, New York City; 1963, Museum of Modern Art, New York City; 1947–66, showed annually or biannually with Kootz Gallery, New York City.

FRANZ KLINE

1910 Born Wilkes-Barre, Pennsylvania.
1931–35 Studied painting at Boston University under Frank Durkee, John Grosman, and Henry Hensche.
1937–38 Studied in London with Bernard Adams, Steven Spurrier, and Frederick Whiting. Settled in New York City.
1943–44 S. J. Wallace Truman Prize, National Academy of Design.
1952–54 Taught at Black Mountain College, Black Mountain, North Carolina, Pratt Institute, Brooklyn, New York, Philadelphia Museum School of Art.
1960 Awarded prize at XXX Biennale, Venice.
1962 Died New York City.

One-Man Shows: 1950, 1951, 1954, Egan Gallery, New York City; 1956, 1958, 1960, 1961, 1963, Sidney Janis Gallery, New York City; 1962, Gallery of Modern Art, Washington, D.C.; 1967, Marlborough-Gerson Gallery, New York City; 1968, Whitney Museum of American Art, New York City.

ROBERT MOTHERWELL

1915 Born Aberdeen, Washington.
ca. 1918 Family moved to California.
1932–38 Studied at California School of Fine Arts, San Francisco, Stanford University, Harvard University.
1938–39 Visited Paris.
1940–41 Attended Graduate School of Architecture and Art, Columbia University. Studied engraving at studio of Kurt Seligmann.
1941 Spent part of year in Mexico.
1948 Co-founder of "Subjects of the Artist" school, New York City.
1950 Taught at Black Mountain College, Black Mountain, North Carolina.
1951–59 Taught at Hunter College, New York City.

One-Man Shows: 1944, Art of This Century, New York City; 1946, Kootz Gallery, New York City, San Francisco Museum of Art; 1957, 1959, 1961, 1962, Sidney Janis Gallery, New York City; 1959, Bennington College, Bennington, Vermont; 1962, Pasadena Art Museum, Pasadena, California; 1963, Smith College, Northampton, Massachusetts; 1965, Phillips Gallery, Washington, D.C., Museum of

Modern Art, New York City; 1967, San Francisco Museum of Art; 1968, Whitney Museum of American Art, New York City; 1964, 1966, 1969, Marlborough-Gerson Gallery, New York City.

BARNETT NEWMAN

1905 Born New York City.
1922–26 Studied at Art Students League, New York City with Duncan Smith, John Sloan, William von Schlegel.
1927 B.A., City College of New York.
1948 Taught at "Subjects of the Artist" school, New York City.
1959 Leader of Artist's Workshop of University of Saskatchewan, Canada.
1965 Exhibited at VIII Bienal, São Paulo, Brazil.
1970 Died New York City.

One-Man Shows: 1950–51, Betty Parsons Gallery, New York City; 1958, Bennington College, Bennington, Vermont; 1959, French and Company, New York City; 1962, Allan Stone Gallery, New York City; 1966, Solomon R. Guggenheim Museum, New York City; 1969, M. Knoedler & Company, Inc., New York City.

JACKSON POLLOCK

1912 Born Cody, Wyoming.
1929–31 Came to New York City. Studied at Art Students League with Thomas Hart Benton.
1935–43 Worked on WPA Easel-Painting Project.
1946 Moved to The Springs, East Hampton, New York.
1950 Exhibited at XXV Biennale, Venice.
1956 Died in automobile accident, East Hampton, New York.

One-Man Shows: 1943–47, Art Of This Century, New York City, San Francisco Museum of Art; 1948–51, Betty Parsons Gallery, New York City; 1952, Bennington College, Bennington, Vermont; 1952, 1954, 1955, 1957, 1958, Sidney Janis Gallery, New York City; 1956–57, 1967, Museum of Modern Art, New York City; 1964, 1969, Marlborough Gallery, New York City.

AD REINHARDT

1913 Born Buffalo, New York.
1931–35 Studied at Columbia University, New York City.
1936 Studied at National Academy of Design, New York City, with Karl Anderson.
1936–37 Studied with Carl Holty and Francis Criss.
1937–41 Worked on WPA Easel-Painting Project.
1937–47 Member of American Abstract Artists.
1946–50 Studied at Institute of Fine Arts, New York University.

1947–67 Taught at Brooklyn College, Brooklyn, New York.
1959–67 Taught at Hunter College, New York City.
1967 Died New York City.

One-Man Shows: 1944, Artists Gallery, New York City; 1946, Mortimer Brandt Gallery, New York; 1946–65, Betty Parsons Gallery, New York City; 1965, Graham Gallery, New York City; 1967, Jewish Museum, New York City; 1970, Marlborough Gallery, New York City.

MARK ROTHKO

1903 Born Dvinsk, Russia.
1913 Emigrated with family to United States and moved to Portland, Oregon.
1925 Moved to New York City. Studied at Art Students League with Max Weber.
1935 Co-founder of and annual exhibitor with The Ten.
1936–37 Worked on WPA Federal Art Project.
1948 Co-founder of "Subjects of the Artist" school, New York City.
1970 Committed suicide, New York City.

One-Man Shows: 1933, Contemporary Arts Gallery, New York City; 1945, Art of This Century, New York City; 1946–51, Betty Parsons Gallery, New York City; 1954, Rhode Island School of Design, Providence, Art Institute of Chicago; 1955, 1958, Sidney Janis Gallery, New York City; 1960, Phillips Gallery, Washington, D.C.; 1961, Museum of Modern Art, New York City; 1963, Solomon R. Guggenheim Museum, New York City.

CLYFFORD STILL

1904 Born Grandin, North Dakota.
1904–20 Lived in Spokane, Washington, and Bow Island, Alberta, Canada.
1924 Visited New York City.
1935–41 Taught at Washington State University.
1945 Moved to New York City.
1946–48 Taught at California School of Fine Arts, San Francisco.
1948 Returned to New York City; co-founder of "Subjects of the Artist" school.
1950–61 Occasional trips to San Francisco.
1961 Moved to Maryland, near Westminster.

One-Man Shows: 1943, San Francisco Museum of Art; 1946, Art of This Century, New York City; 1947, Betty Parsons Gallery, New York City; California Palace of the Legion of Honor, San Francisco; 1959, 1966, Albright-Knox Art Gallery, Buffalo, New York; 1963, Institute of Contemporary Art, University of Pennsylvania, Philadelphia; 1969, Marlborough Gallery, New York City.

BRADLEY WALKER TOMLIN

1899 Born Syracuse, New York.
1921 Moved to New York City.
1923 Studied at Académie Colarossi and Académie de la Grande Chaumière, Paris.
1925–28 Joined Whitney Studio Club and became a regular exhibitor in its annual exhibitions.
1932–41 Taught at Sarah Lawrence College, Bronxville, New York.
1953 Died New York City.

One-Man Shows: 1923, Anderson Galleries, New York City, 1926, Montross Gallery, New York City; 1931, Frank K. M. Rehn Galleries, New York City; 1950, Betty Parsons Gallery, New York City; 1955, Phillips Gallery, Washington, D.C.; 1957–58, Whitney Museum of American Art, New York City.

BOOKS

American Abstract Artists (eds.). *The World of Abstract Art*. New York: George Wittenborn, 1957.

Arnason, H. Harvard. *History of Modern Art*. New York: Harry N. Abrams, 1968.

Ashton, Dore. *The Unknown Shore: A View of Contemporary Art*. Boston and Toronto: Little, Brown, 1962.

Barker, Virgil. *From Realism to Reality in Recent American Painting*. Lincoln: University of Nebraska Press, 1959.

Baur, John I. H. *Revolution and Tradition in Modern Art*. Cambridge, Mass.: Harvard University Press, 1951.

Baur, John I. H., Lloyd Goodrich, Dorothy C. Miller, James Thrall Soby, Frederick S. Wight (eds.). *New Art in America*. Greenwich, Conn.: New York Graphic Society; New York: Frederick A. Praeger, 1957.

Blesh, Rudi. *Modern Art USA: Men, Rebellion, Conquest, 1900–1956*. New York: Alfred A. Knopf, 1956.

Calas, Nicolas. *Art in the Age of Risk and Other Essays*. New York: E. P. Dutton, 1968.

Calas, Nicolas, and Elena Calas. *The Peggy Guggenheim Collection of Modern Art*. New York: Harry N. Abrams, 1967.

Canaday, John. *Embattled Critic*. New York: Farrar, Straus & Cudahy, 1962.

Celentano, Francis. "The Origins and Development of Abstract Expressionism in the United States." Unpublished Master's thesis, New York University, 1957.

Friedman, B. H. (ed.). *School of New York. Some Younger Artists*. New York: Grove Press, 1959.

Geldzahler, Henry. *American Painting in the Twentieth Century*. New York: Metropolitan Museum of Art, 1965.

Goodrich, Lloyd, and John I. H. Baur. *American Art of Our Century*. New York: Frederick A. Praeger, 1961.

Graham, John D. *System and Dialectics of Art*. New York: Delphic Studios, 1937.

Greenberg, Clement. *Art and Culture: Critical Essays*. Boston: Beacon Press, 1961.

Guggenheim, Peggy. *Art of This Century: Informal Memoirs of Peggy Guggenheim*. New York: Dial Press, 1946.

———. *Confessions of an Art Addict*. New York: Macmillan, 1960.

Henning, Edward B. *Fifty Years of Modern Art, 1916–1966*. Cleveland: Cleveland Museum of Art, 1966.

Hess, Thomas B. *Abstract Painting: Background and American Phase*. New York: Viking Press, 1951.

Hunter, Sam. "American Art Since 1945," *New Art Around the World: Painting and Sculpture*. New York: Harry N. Abrams, 1966.

———. *Modern American Painting and Sculpture*. New York: Dell, Laurel edition, 1959.

Janis, Sidney. *Abstract and Surrealist Art in America*. New York: Reynal & Hitchcock, 1944.

Kepes, Gyorgy. *The Visual Arts Today*. Middletown, Conn.: Wesleyan University Press, 1960.

Kootz, Samuel M. *New Frontiers in American Painting*. New York: Hastings House, 1943.

Kozloff, Max. *Renderings: Critical Essays on a Century of Modern Art*. New York: Simon & Schuster, 1968.

———. "The New American Painting," *The New American Arts*, ed. Richard Kostelanetz. New York: Horizon Press, 1965.

Kuh, Katherine. *The Artist's Voice: Talks with Seventeen Artists*. New York and Evanston, Ill.: Harper & Row, 1962.

Larkin, Oliver W. *Art and Life in America* (rev. ed.). New York: Holt, Rinehart & Winston, 1960.

Levy, Julien. *Surrealism*. New York: Black Sun Press, 1936.

McCoubrey, John W. *American Tradition in Painting*. New York: Braziller, 1963.

McDarrah, Fred W. *The Artist's World in Pictures*. New York: E. P. Dutton, 1961.

Mendelowitz, Daniel M. *A History of American Art*. New York: Holt, Rinehart & Winston, 1960.

Motherwell, Robert (ed.). *Documents of Modern Art*. New York: Wittenborn, Schultz, 1947–55. Series consists of: Guillaume Apollinaire, *The Cubist Painters* (1949); Hans Arp, *On My Way* (1948); Georges Duthuit, *The Fauvist Painters* (1950); Max Ernst, *Beyond Painting* (1948); D. H. Kahnweiler, *The Cubist Painters* (1949); Wassily Kandinsky, *Concerning the Spiritual in Art* (1947); László Moholy-Nagy, *The New Vision: From Material to Architecture* (1946); Piet Mondrian, *Plastic Art and Pure Plastic Art and Other Essays* (1945); Robert Motherwell (ed.), *The Dada Painters and Poets* (1951); Marcel Raymond, *From Baudelaire to Surrealism* (1950); Louis Henri Sullivan, *Kindergarten Chats on Architecture, Education and Democracy* (1947).

Motherwell, Robert, and Ad Reinhardt (eds.). *Modern Artists in America*. New York: Wittenborn, Schultz, 1952.

Pellegrini, Aldo. *New Tendencies in Art*. New York: Crown, 1966.

Ponente, Nello. *Modern Painting: Contemporary Trends*. Lausanne: Albert Skira, 1960.

Rodman, Selden. *Conversations with Artists*. New York: Devin-Adair, 1957.

Rose, Barbara. *American Art Since 1900: A Critical History*. New York: Frederick A. Praeger, 1967.

——— (ed.). *Readings in American Art Since 1900: A Documentary Survey*. New York: Frederick A. Praeger, 1968.

Rosenberg, Bernard, and Norris Fliegel. *The Vanguard Artist: Portrait and Self-Portrait*. Chicago: Quadrangle Books, 1965.

Rosenberg, Harold. *Art Works and Packages*. New York: Horizon Press, 1969.

———. *The Anxious Object: Art Today and Its Audience*. New York: Horizon Press, 1966.

———. *The Tradition of the New*. New York: Horizon Press, 1959.

SCHAPIRO, MEYER. "Rebellion in Art," *America in Crisis*, ed. DANIEL AARON. New York: Alfred A. Knopf, 1952.

SEITZ, WILLIAM C. "Abstract Expressionist Painting in America." Unpublished Ph.D. dissertation, Princeton University, 1955.

SOBY, JAMES THRALL. *Contemporary Painters*. New York: Museum of Modern Art, 1948.

SWEENEY, JAMES JOHNSON. *Plastic Redirections in Twentieth-Century Painting*. Chicago: University of Chicago Press, 1934.

SYLVESTER, DAVID (ed). *Modern Art: From Fauvism to Abstract Expressionism*. New York: Franklin Watts, 1965.

ARTICLES

ALLOWAY, LAWRENCE. "Art in New York Today," *The Listener*, LX, No. 1543 (October 23, 1958).

———. "Background to Action: A Series of Six Articles on Post-War Painting, "I: Ancestors and Revaluations," *Art News and Review*, IX, No. 19 (October 12, 1957). "II: The Marks," IX, No. 20 (October 26, 1957). "IV: The Shifted Center," IX, No. 23 (December 7, 1957). "VI: The Words," IX, No. 26 (January 18, 1958).

———. "Iconography Wreckers and Maenad Hunters," *Art International*, III, No. 3 (April, 1961).

———. "Introduction to 'Action,'" *Architectural Design*, XXVI, No. 1 (January, 1956).

———. "Paintings From the Big Country," *Art News and Review*, XI, No. 4 (March 14, 1959).

———. "Sign and Surface: Notes on Black and White Painting in New York," *Quadrum*, No. 9 (1960).

———. "The American Sublime," *Living Arts*, I, No. 2 (June, 1963).

———. "The Biomorphic Forties," *Artforum*, IV, No. 1 (September 1965).

———. "The New American Painting," *Art International*, III, Nos. 3–4 (1959).

———. "U.S. Modern: Paintings," *Art News and Review*, No. 26 (January 21, 1956).

ARMSTRONG, RICHARD. "Abstract Expressionism Was an American Revolution," *Canadian Art*, XXI, No. 93 (September-October 1964).

ASHTON, DORE. "Abstract Expressionism Isn't Dead," *Studio*, CLXIV, No. 883 (September, 1962).

———. "Painting in New York Today," *Cimaise*, Series 4, No. 2 (November-December 1956).

———. "Some Lyricists in the New York School," *Art News and Review*, X, No. 22 (November 22, 1958).

BAIGELL, MATTHEW. "American Abstract Expressionism and Hard Edge: Some Comparisons," *Studio International*, CLXXI, No. 873 (January, 1966).

BANNARD, DARBY. "Cubism, Abstract Expressionism, and David Smith," *Artforum*, VI, No. 8 (April, 1968).

BARR, ALFRED H., JR. "7 Americans Open in Venice: Gorky, De Kooning, Pollock," *Art News*, XLIX, No. 4 (Summer, 1950).

BUTLER, BARBARA. "New York Fall 1961," *Quadrum*, No. 12 (1962).

CALAS, ELENA. "The Peggy Guggenheim Collection: Some Reflections," *Arts*, XLIII, No. 3 (December, 1968–January, 1969).

DAVENPORT, RUSSELL (ed.). "*Life* Round Table on Modern Art," *Life*, XXV, No. 5 (October 11, 1948).

DE KOONING, ELAINE. "Subject: What, How or Who?" *Art News*, LIV, No. 2 (April, 1955).

DONNELL, RADKA ZAGAROFF. "Space in Abstract Expressionism," *Journal of Aesthetics*, XXIII, No. 2 (Winter, 1964).

FERREN, JOHN. "Epitaph for an Avant-Garde: The Motivating Ideas of the Abstract Expressionist Movement as Seen by an Artist Active on the New York Scene," *Arts*, XXXIII, No. 2 (November, 1958).

———. "Stable State of Mind," *Art News*, LIV, No. 3 (May, 1955).

FINKELSTEIN, LOUIS. "New Look: Abstract-Impressionism," *Art News*, LV, No. 1 (March, 1956).

FRIEDMAN, B. H. "The New Baroque," *Art Digest*, XXVIII, No. 20 (September, 15, 1954).

GETLEIN, FRANK. "Schmeerkunst and Politics," *New Republic*, CXL, No. 6 (February 23, 1959).

———. "The Same Old Schmeerkunst," *New Republic*, CXL, No. 4 (January 26, 1959).

GOLDWATER, ROBERT. "A Surfeit of the New," *Partisan Review*, XXIX, No. 1 (Winter, 1962).

———. "A Symposium: The State of American Art," *Magazine of Art*, XLII, No. 3 (March, 1949).

———. "Art and Criticism," *Partisan Review*, XXVIII, No. 5–6 (May-June, 1961).

———. "Everyone Knew What Everyone Else Meant," *It Is*, No. 4 (Autumn, 1959).

———. "Reflections on the New York School," *Quadrum*, No. 8 (1960).

GOLUB, LEON. "A Critique of Abstract Expressionism," *College Art Journal*, Vol. 14, No. 2 (Winter, 1955).

GOOSSEN, EUGENE C. "The Big Canvas," *Art International*, Vol 2, No. 8 (1958).

GOTTLIEB, ADOLPH, and MARK ROTHKO (in collaboration with BARNETT NEWMAN). "Letter to the Editor," cited Edward Alden Jewell, "The Realm of Art: A New Platform. 'Globalism Pops Into View,'" *The New York Times*, June 13, 1943.

GREENBERG, CLEMENT. "Abstract and Representational," *Art Digest*, XXIX, No. 3 (November 1, 1954).

———. "After Abstract Expressionism," *Art International*, VI, No. 8 (October 25, 1962).

———. "'American-Type' Painting," *Partisan Review*, XXII, No. 2 (Spring, 1955).

———. "Art Chronicle: The Decline of Cubism," *Partisan Review*, XV, No. 3 (March, 1948).

———. "Case for Abstract Art," *The Saturday Evening Post*, CCXXXII (August 1, 1959).

———. "Cézanne, Gateway to Contemporary Painting," *American Mercury*, LXXIV, No. 342 (June, 1952).

———. "Feeling is All," *Partisan Review*, XIX, No. 1 (January-February, 1952).

———. "Modernist Painting," *Arts Yearbook*, No. 4 (1960).

———. "Our Period Style," *Partisan Review*, XVI, No. 11 (November, 1949).

———. "New York Painting Only Yesterday," *Art News*, LVI, No. 4 (Summer, 1956).

———. "Plight of our Culture," *Commentary*, XV, No. 6 (June, 1953); XVI, No. 1 (July, 1953).

———. "Post Painterly Abstraction," *Art International*, VIII, Nos. 5–6 (Summer, 1964).

———. "Surrealist Painting," *The Nation*, Part I, CLIX, No. 7 (August 12, 1944); Part II, CLIX, No. 8 (August 19, 1944).

———. "The Artist Speaks Out, Part VI: America Takes the Lead," *Art in America*, LIII, No. 4 (August-September, 1965).

———. "The 'Crisis' of Abstract Art," *Arts Yearbook*, No. 7 (1964).

———. "The European View of American Art," *The Nation* (November 25, 1950).

———. "The Present Prospects of American Painting and Sculpture," *Horizon*, XVI, No. 93–94 (October, 1947).

———. "The Situation at the Moment," *Partisan Review*, XV, No. 1 (January, 1948).

———. "The Venetian Line," *Partisan Review*, XVII, No. 4 (April, 1950).

———. "Towards a Newer Laocoon," *Partisan Review*, ·VII, No. 4 (July-August, 1940).

GREENE, BALCOMB. "The Artist's Reluctance to Communicate," *Art News*, LV, No. 9 (January, 1957).

HAMILTON, GEORGE. "Painting in Contemporary America," *Burlington Magazine*, CII, No. 686 (May, 1960).

HAWKINS, ROBERT B. "Contemporary Art and the Orient," *College Art Journal*, XVI, No. 2 (Winter, 1957).

HELLER, BEN. "The Roots of Abstract Expressionism," *Art in America*, XLIX, No. 4 (1961).

HERON, PATRICK. "The Americans at the Tate Gallery, Abstract Expressionism the Most Provocative," *Arts*, XXX, No. 6 (March, 1956).

HESS, THOMAS B. "A Tale of Two Cities," *Location*, I, No. 2 (Summer, 1964).

———. "American Abstract Art," *U.S. Lines Paris Reviews* (June, 1954).

———. "Editorial: The Many Deaths of American Art," *Art News*, LIX, No. 6 (October, 1960).

———. "Inside Nature," *Art News*, LVI, No. 10 (February, 1958).

———. "Introduction to Abstract," *Art News Annual*, XLIX, No. 7, Part II (November, 1950).

———. "Is Abstraction Un-American?" *Art News*, XLIX, No. 10 (February, 1951).

———. "John Graham, 1881–1961" *Art News*, LX, No. 5 (September, 1961).

———. "Seeing the Young New Yorkers," *Art News*, XLIX, No. 3 (May, 1950).

———. "The Modern Museum's Fifteen: Where U.S. Extremes Meet," *Art News*, LI, No. 2 (April, 1952).

———. "The Phony Crisis in American Art." *Art News*, LXII, No. 4 (Summer, 1963).

———. "U.S. Art, Notes from 1960," *Art News*, LVIII, No. 9 (January, 1960).

———. "U.S. Painting: Some Recent Directions," *25th Art News Annual*, XXV (1956).

HODIN, J. P. "The Fallacy of Action Painting," *Art News and Review*, X, No. 24 (December 20, 1958).

HOPKINS, HENRY T. "Abstract Expressionism," *Artforum*, II, No. 12 (Summer, 1964).

HUNTER, SAM. "Abstract Expressionism Then—and Now," *Canadian Art*, XXI, No. 93 (September-October 1964).

———. "New York, Art Capital of the East," *Art in America*, XLIII, No. 1 (February, 1955).

———. "Painting by Another Name," *Art in America*, XLII, No. 4 (December, 1954).

JARRELL, RANDALL. "The Age of the Chimpanzee; A Poet Argues as Devil's Advocate Against the Canonization of Abstract Expressionism," *Art News*, LVI, No. 4 (Summer, 1957).

KAPROW, ALLAN. "Impurity," *Art News*, LXI, No. 9 (January, 1963).

KAVOLIS, VYTANTAS. "Abstract Expressionism and Puritanism," *Journal of Aesthetics and Art Criticism*, XXI, No. 3 (Spring, 1963).

KOZLOFF, MAX. "A Letter to the Editor," *Art International*, VII, No. 6 (June, 1963).

———. "An Interview with Friedel Dzubas," *Artforum*, IV, No. 1 (September, 1965).

———. "An Interview with Matta," *Artforum*, IV No. 1 (September, 1965).

———. "The Critical Reception of Abstract-Expressionism," *Arts*, XL, No. 2 (December, 1965).

———. "The Dilemma of Expressionism," *Artforum*, III, No. 2 (November, 1964).

———. "The Many Colorations of Black and White," *Artforum*, II, No. 8 (February, 1964).

KRAMER, HILTON. "Critics of American Painting," *Arts*, XXXIV, No. 1 (October, 1959).

———. "Notes on Painting in New York," *Arts Yearbook*, No. 7 (1964).

———. "The End of Modern Painting," *The Reporter*, XXI, No. 2 (July 23, 1959).

———. "The New American Painting," *Partisan Review*, XX, No. 4 (July-August, 1953).

——— (ed.). *Paris/New York* (Arts Yearbook No. 3), 1960.

LANES, JERROLD. "Reflections on Post-Cubist Painting," *Arts*, XXXIII, No. 8 (May, 1959).

LANGSNER, JULES. "More About the School of New York," *Arts and Architecture*, LXVIII, No. 5 (May, 1951).

LAVIN, IRVING. "Abstraction in Modern Painting: A Comparison," *Metropolitan Museum of Art Bulletin*, New Series, No. 19 (Fall, 1961).

LEIDER, PHILIP. "The New York School in Los Angeles," *Artforum*, IV, No. 1 (September, 1965).

LICHTENSTEIN, GENE. "10th Street: Main Street of the Art World," *Esquire*, LII, No. 3 (September, 1959).

LIPPARD, LUCY R. "Notes on Dada and Surrealism at the Modern," *Art International*, XII, No. 5 (May 15, 1968).

283

Louchheim, Aline B. "Betty Parsons: Her Gallery, Her Influence," *Vogue*, CXVIII, No. 6 (October 1, 1951).

McCoy, Garnett. "The Artist Speaks Out; Part V: Poverty, Politics and Artists 1930–1945," *Art in American* LIII, No. 4 (August-September, 1965).

McNeil, George. "American Abstractionists Venerable at Twenty," *Art News*, LV, No. 3 (May, 1956).

——. "Spontaneity," *It Is*, No. 3 (Winter-Spring, 1959).

Meier-Graefe, Julius. "American Painting," *Arts Yearbook*, IV (1961).

Melville, Robert. "Action Painting: New York, Paris, London," *Ark*, No. 18 (November, 1956).

Myers, John Bernard. "The Impact of Surrealism on the New York School," *Evergreen Review*, IV, No. 12 (March-April, 1960).

O'Connor, Francis V. "New Deal Murals in New York," *Artforum*, VII, No. 3 (November, 1968).

O'Doherty, Brian. "Vanity Fair: The New York Art Scene," *Newsweek*, XLV, No. 1 (January 4, 1965).

O'Hara, Frank. "Art Chronicle," *Kulchur*, II, No. 5 (Spring, 1962).

——. "Nature and the New Painting," *Folder*, No. 3 (1954–55). Reprint by Tiber Press.

Pavia, Phillip. "A Manifesto-in-Progress," *It Is*, No. 1 (Spring, 1958); No. 2 (Autumn, 1958); No. 3 (Winter-Spring, 1959); No. 4 (Autumn, 1959).

——. "Polemics," *It Is*, No. 1 (Spring, 1958).

——. "The Unwanted Title: Abstract Expressionism," *It Is*, No. 5 (Spring, 1960).

Pavia, P. G. and Irving Sandler (eds.). "The Philadelphia Panel," *It Is*, No. 5 (Spring, 1960).

Possibilities 1. An Occasional Review, eds. John Cage, Pierre Chareau, Robert Motherwell, Harold Rosenberg, No. 1 (Winter, 1947–48).

Read, Herbert. "An Art of Internal Necessity," *Quadrum*, No. 1 (1956).

Read Herbert, and H. H. Arnason, "Dialogue on Modern U.S. Painting," *Art News*, LIX, No. 3 (May, 1960).

Reise, Barbara. "Greenberg and The Group: A Retrospective View," Part I, *Studio International*, CLXXV, No. 900 (May, 1968); Part II, CLXXV, No. 901 (June, 1968).

Rexroth, Kenneth. "Americans Seen Abroad," *Art News*, LVIII, No. 4 (June, 1959).

Rose, Barbara. "The Second Generation: Academy and Breakthrough," *Artforum*, IV, No. 1 (September, 1965).

Rosen, Israel. "Toward a Definition of Abstract Expressionism," *Baltimore Museum of Art News*, XXII, No. 3 (February, 1959).

Rosenberg, Harold. "Action Painting: A Decade of Distortion," *Art News*, LXI, No. 8 (December, 1962).

——. "After Next, What?" *Art in America*, LII, No. 2 (April, 1964).

——. "Art in Orbit," *Art News*, LX, No. 6 (October, 1961).

——. "Critic Within the Act," *Art News*, LIX, No. 6 (October, 1960).

——. "Introduction to Six American Artists," *Possibilities 1*, No. 1 (Winter, 1947–48).

——. "Parable for American Painters," *Art News*, LII, No. 9 (January, 1954).

——. "The American Action Painters," *Art News*, LI, No. 8 (December, 1952).

Rosenblum, Robert. "The Abstract Sublime," *Art News*, LIX, No. 10 (February, 1961).

Rubin, William. "The New York School—Then and Now," Part 1, *Art International*, II, Nos. 2–3 (1958); Part 2, II, Nos. 4–5 (1958).

——. "Toward a Critical Framework," *Artforum*, V, No. 1 (September, 1966); 1. Notes on Surrealism and Fantasy Art; 2. Georgio de Chirico; 3. A Post-Cubist Morphology.

——. "Younger American Painters," *Art International*, IV, No. 1 (1960).

Rudikoff, Sonya. "Art Chronicle: Tangible Abstract Art," *Partisan Review*, XXIV, No. 2 (Spring, 1957).

——. "Space in Abstract Painting," *Partisan Review*, XXV, No. 2 (Spring, 1958).

Russell, John. "The 'New American Painting' Captures Europe," *Horizon*, II, No. 2 (November, 1959).

Sandler, Irving. "John D. Graham," *Artforum*, VII, No. 2 (October, 1968).

——. "The Club," *Artforum*, IV, No. 1 (September, 1965).

——. "The Surrealist Emigres in New York," *Artforum*, VI, No. 9 (May, 1968).

——(ed.). "Discussion: Is There a New Academy?" *Art News*, LVIII, No. 4 (Summer, 1959; September, 1959).

Sawyer, Kenneth. "The Century Plant: A Dialogue on Current Painting," *Hudson Review*, IX, No. 3 (Autumn, 1956).

——. "The Importance of a Wall: Galleries," *Evergreen Review*, II, No. 8 (Spring, 1959).

Schapiro, Meyer. "The Liberating Quality of Avant-garde Art," *Art News*, LVI, No. 4 (Summer, 1957).

——. "The Younger American Painters of Today," *The Listener*, LX, No. 1404 (January 26, 1956).

Seeley, Carol. "On the Nature of Abstract Painting in America," *Magazine of Art*, XLIII, No. 5 (May, 1950).

Seiberling, Dorothy. "Abstract Expressionists," Part I: Baffling U.S. Art: What It is About," *Life*, XLVII, No. 19 (November 9, 1959); Part II: "The Varied Art of Four Pioneers," XLVII, No. 20 (November 16, 1959).

Seitz, William C. "Spirit, Time and Abstract Expressionism," *Magazine of Art*, XLVI, No. 2 (February, 1953).

——. "The Rise and Dissolution of the Avant-Garde," *Vogue*, CXLII, No. 1 (September 1, 1963).

Selz, Peter. "A New Imagery in American Painting," *College Art Journal*, XV, No. 4 (Summer, 1956).

Siegel, Jeanne. "The 1930's: Painting and Sculpture in America," *Arts*, XLIII, No. 2

(November, 1968).

SORZANO, MARGO. "17 Modern American Painters: A Recent Exhibition at the Frank Perls Gallery," *Arts and Architecture*, LXVIII, No. 1 (January, 1951).

STEVENS, ELIZABETH. "The Thirties Revisited: Federal Art Patronage, 1933–1943," *Artforum*, IV, No. 10 (June, 1966).

SUTTON, DENYS. "The Challenge of American Art," *Horizon*, XX, No. 118 (October, 1949).

SWEENEY, JAMES JOHNSON. "The Cat That Walks by Itself," *Quadrum*, No. 2 (1956).

———. "Recent Trends in American Painting," *Bennington College Alumnae Quarterly*, VII, No. 1 (Fall, 1955).

SYLVESTER, DAVID. "Expressionism, German and American," *Arts*, XXXI, No. 3 (December, 1956).

"Symposium: Is the French Avant-Garde Overrated?", *Art Digest*, XXVII, No. 20 (September 15, 1953). Statements by RALSTON CRAWFORD, CLEMENT GREENBERG, ROBERT MOTHERWELL, JACK TWORKOV.

TANNENBAUM, LIBBY. "Notes at Mid-Century," *Magazine of Art*, XLIII, No. 8 (December, 1950).

TILLIM, SIDNEY. "The Figure and the Figurative in Abstract Expressionism," *Artforum*, IV, No. 1 (September, 1965).

———. "What Happened to Geometry?," *Arts*, XXXIII, No. 9 (June, 1959).

TWORKOV, JACK. "Four Excerpts from a Journal," *It Is*, No. 4 (Autumn, 1959).

———. "The Wandering Soutine," *Art News*, Part I, XLIX, No. 7 (November, 1950).

TYLER, PARKER. "Nature and Madness Among the Younger Painters," *View*, Series 5, No. 2 (May, 1945).

WAGNER, GEOFFREY. "The New American Painting," *Antioch Review*, XIV, No. 1 (March, 1954); and XIV, No. 2 (June, 1954).

"The Wild Ones," *Time*, XLVII, No. 8 (February 20, 1956).

"What Abstract Art Means to Me," *Museum of Modern Art Bulletin*, XVIII, No. 3 (Spring, 1951). Statements by GEORGE L. K. MORRIS, WILLEM DE KOONING, ALEXANDER CALDER, FRITZ GLARNER, ROBERT MOTHERWELL, STUART DAVIS.

EXHIBITION CATALOGUES

ARNASON, H. HARVARD. "Abstract Expressionism in 1960," in *60 American Painters 1960: Abstract Expressionist Painting of the Fifties*, Walker Art Center, Minneapolis, Minn., April 3–May 8, 1960.

———. *American Abstract Expressionists and Imagists*, Solomon R. Guggenheim Museum, New York, October 13–December 31, 1961.

———. "Preface," *40 American Painters, 1940–1950*, University of Minnesota Gallery, Minneapolis, Minn., June 4–August 30, 1951.

ASHTON, DORE, and BERNARD DORIVAL. *New York and Paris: Painting in the Fifties*, Museum of Fine Arts, Houston, Tex., January 16–February 8, 1959.

BARR, ALFRED H., JR. *Bauhaus 1919–1928*, Museum of Modern Art, New York, 1938.

———. *Cubism and Abstract Art*, Museum of Modern Art, New York, 1936.

———. "Introduction," *The New American Painting*, Museum of Modern Art, New York, 1959. As shown in eight European countries.

———. *Picasso: Forty Years of His Art*, Museum of Modern Art, New York, 1939.

——— (ed.). *Fantastic Art, Dada, Surrealism*, Museum of Modern Art, New York, 1936.

BAUR, JOHN I. H. *Nature in Abstraction*, Whitney Museum of American Art, New York, January 14–March 16, 1958.

———. *The New Decade—35 American Painters and Sculptors*, Whitney Museum of American Art, New York, May 11–August 7, 1955.

BRETON, ANDRÉ, and MARCEL DUCHAMP. *First Papers of Surrealism*, Coordinating Council of French Relief Societies, Inc., New York, October 14–November 7, 1942.

GELDZAHLER, HENRY. *New York Painting and Sculpture: 1940–1970*, E. P. Dutton and Co., New York, 1969.

GREENBERG, CLEMENT. *Albers, De Kooning, Gorky, Guston, Kline, Motherwell, Pollock, Rothko; An Exhibition in Tribute to Sidney Janis*, Hetzel Union Gallery, Pennsylvania State University, Philadelphia, February 3–24, 1958.

———. "Preface," *Ten Years*, Betty Parsons Gallery, New York, December 19, 1955–January 14, 1956.

GUGGENHEIM, HARRY K., THOMAS M. MESSER, and PEGGY GUGGENHEIM. *Works from the Peggy Guggenheim Foundation*, Solomon R. Guggenheim Museum, New York, 1969.

GUGGENHEIM, PEGGY (ed.). *Art of This Century*, Art of This Century Gallery, New York, 1942.

HELLER, BEN. "Introduction," *Black and White*, Jewish Museum, New York, 1963. Preface by ALAN R. SOLOMON.

HESS, THOMAS B., and HAROLD ROSENBERG. "Some Points About Action Painting," *Action Painting . . . 1958*, Dallas Museum for Contemporary Arts, Dallas, Tex., March 5–April 13, 1958.

MILLER, DOROTHY C. (ed.), *Fifteen Americans*, Museum of Modern Art, New York, 1952.

———. (ed.), *Fourteen Americans*, Museum of Modern Art, New York, 1946.

———. (ed.), *Twelve Americans*, Museum of Modern Art, New York, 1956.

MOTHERWELL, ROBERT. "Introduction," *The School of New York*, Perls Gallery, Beverly Hills, Calif., January 11–February 7, 1951.

O'CONNOR, FRANCIS V. *Federal Art Patronage 1933 to 1943*, University of Maryland Art Gallery, College Park, Md., April 6–May 13, 1966.

PASLOFF, PATRICIA (ed.), *The 30's, Painting in New York*, Poindexter Gallery, New York, 1957.

PORTER, DAVID (ed.), *Personal Statement: A Painting Prophecy—1950*, Washington, D.C., David Porter Gallery, May 14–July 7, 1945.

RASMUSSEN, WALDO. "Preface," *Two Decades of*

American Painting, Museum of Modern Art, New York, 1966–69.

RITCHIE, ANDREW C. *Abstract Painting and Sculpture in America*, Museum of Modern Art, New York, 1951.

ROSENBERG, HAROLD, and SAMUEL M. KOOTZ. *The Intrasubjectives*, Kootz Gallery, New York, September 14–October 3, 1949.

RUBIN, WILLIAM. *Dada, Surrealism, and Their Heritage*, Museum of Modern Art, New York, 1968.

SEITZ, WILLIAM C., *The Art of Assemblage*, Museum of Modern Art, New York, October 2–November 12, 1961.

SELZ, PETER. *New Images of Man*, Museum of Modern Art, New York, 1959.

SWEENEY, JAMES JOHNSON. "Preface," *Younger American Painters: A Selection*, Solomon R. Guggenheim Museum, New York, May 12–July 25, 1954.

TUCHMAN, MAURICE (ed.), *New York School—The First Generation Painting of the 1940s and 1950s*, Los Angeles County Museum of Art, Los Angeles, July 16–August 1, 1965.

(The material concerning each artist in this section is arranged in chronological order.)

WILLIAM BAZIOTES

Statements

JANIS, SIDNEY. *Abstract and Surrealist Art in America.* New York: Reynal & Hitchcock, 1944.

PORTER, DAVID, (ed.). *Personal Statement: A Painting Prophecy—1950*, David Porter Gallery, Washington, D.C., May 14–July 7, 1945.

BAZIOTES, WILLIAM. "I Cannot Evolve Any Concrete Theory," *Possibilities 1*, No. 1 (Winter, 1947–48).

———. Statement in *The Tiger's Eye*, I, No. 5 (October 20, 1948).

———. "The Artist and His Mirror," *Right Angle*, Washington, D.C., III, No. 2 (June, 1949).

———. "Symposium: The Creative Process," *Art Digest*, XXVIII, No. 8 (January 15, 1954).

———. Statement in *The New Decade—Thirty-five American Painters and Sculptors*, ed. JOHN I. H. BAUR, Whitney Museum of American Art, New York, 1955.

FRANKS, PAULA, and MARION WHITE (eds.). "An Interview with William Baziotes," *Perspective No. 2*, Hunter College, New York (1956–57).

BAZIOTES, WILLIAM. Statement in *The Magical Worlds of Redon, Klee, Baziotes*, Contemporary Arts Museum, Houston, Tex., January 24–February 17, 1957.

BAUR, JOHN I. H. *Nature in Abstraction*, New York: Macmillan, 1958.

BAZIOTES, WILLIAM. "Notes on Painting," *It Is*, No. 4 (Autumn, 1959).

Articles

ROSENBERG, HAROLD. "The Shapes in a Baziotes Canvas," *Possibilities 1*, No. 1 (Winter, 1947–48.)

KEES, WELDON. "Art," *The Nation*, CLXX, No. 5 (February 4, 1950).

"William Baziotes 1912–1963," *Location*, I, No. 2 (Summer, 1964). Articles by DAVID HARE and THOMAS B. HESS.

SANDLER, IRVING. "Baziotes: Modern Mythologist," *Art News*, LXIII, No. 10 (February, 1965).

Exhibition Catalogue

ALLOWAY, LAWRENCE. *William Baziotes*, Solomon R. Guggenheim Museum, New York, 1965.

JAMES BROOKS

Statements

BROOKS, JAMES. Statement in *Contemporary American Painting and Sculpture*, University of Illinois, Urbana, 1952.

———. Statement in *Contemporary American Painting and Sculpture*, University of Illinois, Urbana, 1953.

———. Statement in *Contemporary American Painting and Sculpture*, University of Illinois, Urbana, 1955.

———. Statement in *The New Decade*, Whitney Museum of American Art, New York, 1955.

———. Statement in *Twelve Americans*, Museum of Modern Art, New York, 1956.

———. Statement in *The New American Painting*, Museum of Modern Art, New York, 1958–59.

CHAET, BERNARD. "Concept of Space and Expression: An Interview," *Arts*, XXXIII, No. 4 (January, 1959).

BROOKS, JAMES. "Interview," *Scrap*, No. 3 (January 20, 1961).

———. Statement in *Contemporary American Painting and Sculpture*, University of Illinois, Urbana, 1961.

Articles

"James Brooks," *Magazine of Art*, XLVI, No. 1 (January, 1953).

JUDD, DONALD. "Exhibition at the Whitney Museum," *Arts*, XXXVII, No. 9 (May–June, 1963).

PRESTON, STUART. "Retrospective at the Whitney Museum." *Burlington Magazine*, CV, No. 720 (March, 1963).

SANDLER, IRVING. "James Brooks and the Abstract Inscape," *Art News*, LXI, No. 10 (February, 1963).

Exhibition Catalogue

HUNTER, SAM. *James Brooks*, Whitney Museum of American Art, New York, 1963.

WILLEM DE KOONING

Statements

DE KOONING, WILLEM. Letter to the editor on Arshile Gorky, *Art News*, XLVIII, No. 9 (January, 1949).

———. "The Renaissance and Order," *trans/formation*, I, No. 2 (1951).

———. "What Abstract Art Means to Me," *Museum of Modern Art Bulletin*, XVII, No. 3 (Spring, 1951).

DE HIRSCH, STORM. "A Talk with Willem de Kooning." *Intro Bulletin*, I, No. 1 (October, 1955).

DE KOONING, WILLEM. "Is Today's Artist With or Against the Past?" (Contribution to an inquiry.) *Art News*, LVII, No. 4 (Summer, 1958).

SONNABEND, M. C. Film Script, *Sketchbook No. 1: Three Americans.* Time, Inc. (1960).

SYLVESTER, DAVID. "Content is a Glimpse . . . ," *Location*, I, No. 1 (Spring, 1963). Excerpts from BBC interview broadcast December 30, 1960.

Monographs

HESS, THOMAS B. *Willem de Kooning* ("The Great American Artists Series"). New York: Braziller, 1959.

JANIS, HARRIET, and RUDI BLESH. *De Kooning*. New York: Grove Press, 1960.

HESS, THOMAS B. *De Kooning: Recent Paintings*. New York: Walker, 1967. Issued on the occasion of an exhibition at M. Knoedler & Co., Inc., New York, November 14–December 2.

Articles

"Willem de Kooning," *Magazine of Art*, XLI, No. 2 (February, 1948).

FINKELSTEIN, LOUIS. "Marin and de Kooning," *Magazine of Art*, XLIII, No. 6 (October, 1950).

HESS, THOMAS B. "De Kooning Paints a Picture," *Art News*, LII, No. 1 (March, 1953).

STEINBERG, LEO. "Month in Review," *Arts*, XXX, No. 2 (November, 1955).

SAWYER, KENNETH B. "A Backyard on Tenth Street," *Baltimore Museum of Art News*, XX, No. 2 (December, 1956).

———. "Three Phases of Willem de Kooning," *Art News and Review*, X, No. 22 (November 22, 1958).

HAMMACHER, A. M. "Mondrian and de Kooning: A Contrast in Transformation," *Delta* (September, 1959).

ASHTON, DORE. "New York Commentary: de Kooning's Verve," *Studio*, CLXIII, No. 830 (June, 1962).

FRIED, MICHAEL. "New York Letter," *Art International*, VI, No. 10 (December 20, 1962).

HESS, THOMAS B. "Willem de Kooning," *Art News*, LXI, No. 1 (March, 1962).

KOZLOFF, MAX. "New York Letter," *Art International*, VI, No. 4 (May, 1962).

ROSENBERG, HAROLD, "Painting is a Way of Living," *New Yorker*, XXXVIII, No. 52 (February 16, 1963).

DENBY, EDWIN. "My Friend De Kooning," *Art News Annual*, No. 24 (November, 1964). Unabridged version in EDWIN DENBY, *Dancers, Buildings and People in the Streets*. New York: Horizon Press, 1965.

KOZLOFF, MAX, "The Impact of de Kooning," *Arts Yearbook*, No. 7 (1964).

HESS, THOMAS B. "De Kooning's New Women," *Art News*, LXIV, No. 1 (March, 1965).

LIPPARD, LUCY R. "Three Generations of Women; De Kooning's First Retrospective," *Art International*, IX, No. 8 (November 20, 1965).

O'DOHERTY, BRIAN. "De Kooning: Grand Style," *Newsweek*, LXV, No. 1, January 4, 1965.

BATTCOCK, GREGORY. "Willem de Kooning," *Arts*, XLII, No. 2 (November, 1967).

ROSENBERG, HAROLD. "Art of Bad Conscience," *New Yorker*, XLIII, No. 43 (December 16, 1967).

BLOK, C. "Willem de Kooning and Henry Moore," *Art International*, X, No. 10 (December, 1968).

FORGE, ANDREW. "De Kooning's Women," *Studio International*, CLXXVI, No. 609 (December, 1968).

O'DOHERTY, BRIAN. "Willem de Kooning: Fragmentary Notes Towards a Figure," *Art International*, XII, No. 10 (December 20, 1968).

BANNARD, WALTER DARBY. "Willem de Kooning's Retrospective at the Museum of Modern Art," *Artforum*, VII, No. 8 (April, 1969).

DALI, SALVADOR. "De Kooning's 300,000,000th Birthday," *Art News*, LXVII, No. 2 (April, 1969).

FORGE, ANDREW. "De Kooning in Retrospect," *Art News*, LXVII, No. 1 (March, 1969).

LICHTBLAU, CHARLOTTE. "Willem de Kooning and Barnett Newman," *Arts*, XLIII, No. 5 (March, 1969).

PERRAULT, JOHN. "The New de Koonings," *Art News*, LXVIII, No. 1 (March, 1969).

Exhibition Catalogues

XXVII Venice Biennale, American Pavilion, Venice, June, 1954. Comment by A. C. RITCHIE.

GREENBERG, CLEMENT. "Foreword," *De Kooning Retrospective*, Boston Museum School, Boston, April 21–May 8, 1956.

ODETS, CLIFFORD. "Introduction," *Willem de Kooning*, Paul Kantor Gallery, Beverly Hills, Calif., April 3–29, 1961.

HESS, THOMAS B. "Introduction," *Recent Paintings by Willem de Kooning*, Sidney Janis Gallery, New York, March 5–31, 1962.

ASHTON, DORE. "Introduction," *Willem de Kooning*, Smith College Museum of Art, Northampton, Mass., April 8–May 2, 1965.

INGE, WILLIAM. "Preface," *Willem de Kooning*, Paul Kantor Gallery, Beverly Hills, Calif., March 22–April 30, 1965.

HESS, THOMAS B. *Willem de Kooning*, Museum of Modern Art, New York, 1968.

ARSHILE GORKY

Statements

GORKY, ARSHILE. "Fetish of Antique Stifles Art Here," *New York Evening Post*, September 15, 1926.

———. "Stuart Davis," *Creative Art*, IX, No. 3 (September, 1931).

Books

SCHWABACHER, ETHEL. *Arshile Gorky*. New York: Macmillan, 1957.

ROSENBERG, HAROLD. *Arshile Gorky: The Man, The Time, The Idea*. New York: Horizon Press, 1962.

LEVY, JULIEN. *Arshile Gorky*. New York: Harry N. Abrams, 1968.

Articles

GREENBERG, CLEMENT. "Art," *The Nation*, CLX (March 24, 1945); CLXII (May 4, 1946); CLXVI (March 6, 1948); CLXVII (December 11, 1948).

———. "Art Chronicle," *Partisan Review*, XV (March, 1948); XVII (May-June, 1950); XXII (Spring, 1955).

Davis, Stuart. "Arshile Gorky in the 1930's: A Personal Recollection," *Magazine of Art*, XLIV, No. 9 (February, 1951). (Reprinted from a catalogue of the Julien Levy Gallery, March, 1945.)

De Kooning, Elaine. "Gorky: Painter of His Own Legend," *Art News*, XLIX (January, 1951).

Goodrich, Lloyd. "Notes on Eight Works by Arshile Gorky," *Magazine of Art*, XLIV, No. 9 (February, 1951).

Seitz, William C. "Arshile Gorky's *The Plough and the Song*," Oberlin College, *Allen Memorial Art Museum Bulletin*, No. 1 (1954).

Schapiro, Meyer. "Gorky: The Creative Influence," *Art News*, LVI, No. 5 (September, 1957).

Rosenblum, Robert. "Arshile Gorky," *Arts*, XXXII, No. 4 (January, 1958).

Breton, André. "The Eye-Spring: Arshile Gorky," *It Is*, No. 4 (Autumn, 1959).

Goldwater, Robert. "The Genius of the Moujik," *Saturday Review*, XLV, No. 20 (May 19, 1962).

O'Hara, Frank. "Art Chronicle," *Kulchur*, II, No. 6 (Summer, 1962).

Alloway, Lawrence. "Gorky," *Artforum*, I, No. 9 (March, 1963).

Dennison, George. "The Crisis-Art of Arshile Gorky," *Arts*, XXXVII, No. 5 (February, 1963).

Osborn, Margaret. "The Mystery of Arshile Gorky: A Personal Account," *Art News*, LXI, No. 10 (February, 1963).

Reiff, Robert. "The Late Works of Arshile Gorky," *Art Journal*, XXII, No. 3 (Spring, 1963).

Rubin, William S. "Arshile Gorky, Surrealism and the New American Painting," *Art International*, VII, No. 2 (February 25, 1963).

Sandler, Irving. "New York Letter," *Quadrum*, No. 14 (1963).

Silver, Cathy S. "Gorky, When the Going Was Rough," *Art News*, LXII, No. 2 (April, 1963).

Vaccaro, Nick Dante. "Gorky's Debt to Gaudier-Brzeska," *Art Journal*, XXIII, No. 1 (Fall, 1963).

Mooradian, K. "The Unknown Gorky," *Art News*, LXVI, No. 5 (September, 1967).

Finkelstein, Louis. "Becoming Is Meaning," *Art News*, LXVII, No. 8 (December, 1969).

Exhibition Catalogues

Schwabacher, Ethel. *Arshile Gorky, Memorial Exhibition*, Whitney Museum of American Art, New York, January 5–February 18, 1951.

Seitz, William C. *Arshile Gorky: Painting, Drawings, Studies*, Museum of Modern Art, New York, 1962.

Jordan, Jim M. *Gorky: Drawings*. New York, Walker, 1969. Issued on the occasion of an exhibition at M. Knoedler & Co., Inc., New York, November 25–December 27, 1969.

ADOLPH GOTTLIEB

Statements

Gottlieb, Adolph. "The Portrait and The Modern Artist," October 13, 1943. Mimeographed script of WNYC broadcast with Mark Rothko: "Art in New York."

———. In *Personal Statement: A Painting Prophecy —1950*. David Porter Gallery, Washington, D.C., May 14–July 7, 1945.

———. "Adolph Gottlieb," *Limited Editons— MKR's Art Outlook*, No. 6 (December, 1945).

———. Letter to Art Editor, *The New York Times*, July 22, 1945.

———. Statement in "The Ides of Art: The Attitudes of 10 Artists on their Art and Contemporaneousness," *The Tiger's Eye*, I, No. 2 (December, 1947).

———. "The Ides of Art/11 Graphic Artists Write," *The Tiger's Eye*, I, No. 8 (June 15, 1949).

———. Statement in *Selected Paintings by the Late Arshile Gorky*, Kootz Gallery, New York, March 28–April 24, 1950.

———. Statement in *American Vanguard Art for Paris*, Sidney Janis Gallery, New York, 1951.

———. Statement in *40 American Painters, 1940–1950*, University of Minnesota, Minneapolis, Minn., 1951.

———. "My Painting," *Arts and Architecture*, LXVIII, No. 9 (September, 1951).

———. Statement in *Contemporary American Painting*, University of Illinois, Urbana, 1952.

———. Statement in *Contemporary American Painting and Sculpture*, University of Illinois, Urbana, 1955.

———. Statement in *The New Decade: 35 American Painters and Sculptors*, ed. John I. H. Baur, Whitney Museum of American Art, New York, May 11–August 7, 1955.

———. "Integrating the Arts," *Interiors*, I, No. 114 (June, 1955).

———. "Artist and Society: A Brief Case History," *College Art Journal*, XIV, No. 2 (Winter, 1955).

Baur, John I. H. *Nature in Abstraction*. New York: Macmillan, 1958.

Gottlieb, Adolph. Statement in *The New American Painting*. New York: International Council of The Museum of Modern Art, 1959.

———. "Representational or Abstract?" *Junior League Magazine*, L, No. 2 (November–December, 1962).

Sylvester, David. "Adolph Gottlieb: An Interview with David Sylvester," *Living Arts*, I, No. 2 (June, 1963).

Brown, Gordon. "A New York Interview with Adolph Gottlieb," *Art Voices*, III, No. 2 (February, 1964).

Articles

Riley, Maude Kemper. "Gottlieb's Enigmas," *Art Digest*, XIX, No. 13 (April 1, 1945).

Greenberg, Clement. "Art," *The Nation*, CLXV, No. 23 (December 6, 1947).

Kees, Weldon. *The Nation*, CLXX, No. 1 (January 7, 1950).

Fitzsimmons, James. "Adolph Gottlieb," *Everyday Art Quarterly*, No. 25 (1953).

———. "Gottlieb on Land and Sea," *Art Digest*, XXVII, No. 7 (January 1, 1953).

HUXTABLE, ADA LOUISE. "Gottlieb's Glass Wall," *Art Digest*, XXIX, No. 8 (January 15, 1955).

SECKLER, DOROTHY GEES. "Adolph Gottlieb Makes a Façade," *Art News*, LIV, No. 1 (March, 1955).

RUBIN, WILLIAM. "Adolph Gottlieb," *Art International*, III, Nos. 3–4 (1959).

O'DOHERTY, BRIAN. "Adolph Gottlieb: The Dualism of an Inner Life," *The New York Times*, February 23, 1964.

ROSENSTEIN, HARRIS. "Gottlieb at the Summit," *Art News*, LXV, No. 2 (April, 1966).

ASHTON, DORE. "Adolph Gottlieb at the Guggenheim and Whitney Museums," *Studio International*, CLXXV, No. 899 (April, 1968).

CONE, JANE HARRISON. "Adolph Gottlieb," *Artforum*, VI, No. 8 (April, 1968).

HUDSON, ANDREW. "Adolph Gottlieb's Paintings at the Whitney," *Art International*, XII, No. 4 (April 20, 1968).

SIEGEL, JEANNE. "Adolph Gottlieb: Two Views," *Arts*, XLII, No. 4 (February, 1968).

WALDMAN, DIANE. "Gottlieb: Signs and Suns," *Art News*, LXVI, No. 10 (February, 1968).

Exhibition Catalogues

NEWMAN, BARNETT. *Adolph Gottlieb*, Wakefield Gallery, New York, February 7–19, 1944.

STROUP, JON. *Adolph Gottlieb*, 67 Gallery, New York, March 12–31, 1945.

WOLFSON, VICTOR. *Adolph Gottlieb*, Kootz Gallery, New York, January 6–25, 1947.

KOOTZ, SAMUEL M. *Adolph Gottlieb*, Kootz Gallery, New York, January 8–26, 1952.

GREENBERG, CLEMENT. *An Exhibition of Oil Painting by Adolph Gottlieb*, Jewish Museum, New York, November-December, 1957.

FRIEDMAN, MARTIN. *Adolph Gottlieb*, Walker Art Center, Minneapolis, Minn., April 28–June 9, 1963.

GREENBERG, CLEMENT. "Introduction," *Adolph Gottlieb*. Bennington College, Bennington, Vt., 1963.

DOTY, ROBERT, and DIANE WALDMAN, *Adolph Gottlieb*, published for the Whitney Museum of American Art and the Solomon R. Guggenheim Museum by Frederick A. Praeger. New York: 1968.

PHILIP GUSTON

Statements

GUSTON, PHILIP. Statement in *12 Americans*, Museum of Modern Art, New York, 1956.

"Art in New York," interview by SAM HUNTER, *Playbill*, I, No. 8 (November, 1957).

GUSTON, PHILIP. Statement in *Bradley Walker Tomlin*, Whitney Museum of American Art, New York, 1957.

———. Statement in *It Is*, No. 1 (Spring, 1958).

———. Statement in *Nature in Abstraction*, Whitney Museum of American Art, 1958.

———. Statement in *The New American Painting*, Museum of Modern Art, New York, 1958–59.

BERKSON, BILL. "Dialogue with Philip Guston, *Art and Literature*, No. 7 (Winter, 1965).

GUSTON, PHILIP. "Faith, Hope and Possibility," *Art News Annual*, XXXI, No. 1 (October, 1965).

———. "Piero della Francesca: The Impossibility of Painting," *Art News*, LXIV, No. 3 (May, 1965).

"Philip Guston's Object: A Dialogue with Harold Rosenberg," *Philip Guston: Recent Paintings and Drawings*, Jewish Museum, New York, 1966.

Monograph

ASHTON, DORE. *Philip Guston*. New York: Grove Press, 1959.

Articles

"Carnegie Winner's Art is Abstract and Symbolic," *Life*, XX, No. 21 (May 27, 1946).

JANSON, H. W. "Philip Guston," *Magazine of Art*, XL, No. 2 (February, 1947).

STEINBERG, LEO. "Fritz Glarner and Philip Guston Among '12 Americans' at the Museum of Modern Art," *Arts*, XXX, No. 9 (June, 1956).

ASHTON, DORE. "Art," *Arts and Architecture*, LXXIV, No. 6 (June, 1957); LXXV, No. 5 (May, 1958); LXXVII, No. 3 (March, 1960).

CANADAY, JOHN. "Philip Guston, Abstractionist . . ." *The New York Times*, December 30, 1959.

SANDLER, IRVING. "Guston: A Long Voyage Home," *Art News*, LVIII, No. 8 (December, 1959).

ASHTON, DORE. "Philip Guston," *Metro*, No. 3 (1961).

SANDLER, IRVING. "New York Letter," *Art International*, V, No. 3 (April, 1961).

ALLOWAY, LAWRENCE. "Notes on Guston," *Art Journal*, XXII, No. 1 (Fall, 1962).

BERKSON, BILL. "Art Chronicle," *Kulchur*, II, No. 7 (Autumn, 1962).

HUNTER, SAM. "Philip Guston," *Art International*, VI, No. 4 (May, 1962).

JANSON, H. W. " 'Martial Memory' by Philip Guston and American Painting Today," *Bulletin of the City Art Museum of St. Louis*, XXVII, Nos. 3–4 (December, 1942).

KOZLOFF, MAX. "Art," *The Nation*, CXCIV, No. 20 (May 19, 1962).

O'HARA, FRANK. "Growth and Guston," *Art News*, LXI, No. 3 (May, 1962).

RAYNOR, VIVIEN. "Guston," *Arts*, XXXVI, No. 10 (September, 1962).

SANDLER, IRVING. "In the Art Galleries," *New York Post*, May 27, 1962.

SYLVESTER, DAVID. "London," *New Statesman*, LXV, No. 1666 (February 15, 1963).

YATES, PETE, "Philip Guston at the County Museum," *Arts and Architecture*, LXXX, No. 9 (September, 1963).

ASHTON, DORE. "Philip Guston, the Painter as Meta-

physician," *Studio International*, CLXIX, No. 862 (February, 1965).

FELDMAN, MORTON. "Philip Guston: The Last Painter," *Art News Annual*, XXXI (1965).

BERKSON, WILLIAM. "Philip Guston: A New Emphasis," *Arts*, XL, No. 4 (February, 1966).

Exhibition Catalogues

ARNASON, H. HARVARD. *Philip Guston*, Solomon R. Guggenheim Museum, New York, May 2–July 1, 1962. Exhibition traveled to the Los Angeles County Museum, May 15–June 23, 1963.

HUNTER, SAM. Introduction to *Philip Guston: Recent Paintings and Drawings*, Jewish Museum, New York, January 12–February 13, 1966.

HANS HOFMANN

Statements

HOFMANN, HANS. "Art in America," *Art Digest*, IV, No. 19 (August, 1930).

——. "Painting and Culture" (as communicated to GLENN WESSELS), *Fortnightly*, I, No. 1 (September 11, 1931).

——. "On the aims of art," trans. ERNST STOLZ and GLENN WESSELS, *Fortnightly*, I, No. 13 (February 26, 1932).

——. "Plastic Creation," trans. from the German, *The League* (Art Students League) V, No. 2 (Winter, 1932–33).

——. Statement in *Hans Hofmann* (exhibition announcement), Art of This Century, New York, March, 1944.

——. *Search for the Real and Other Essays*, Addison Gallery of American Art, Phillips Academy, Andover, Mass., 1948.

——. Statement in *Recent Paintings by Hans Hofmann*, (exhibition announcement) Kootz Gallery, New York, November 15–December 5, 1949.

——. "Homage to A. H. Maurer," *Hartley-Maurer*, Bertha Schaefer Gallery, New York, November 13–December 2, 1950.

——. Statement in *Contemporary American Painting*, University of Illinois, Urbana, 1951.

——. "Space Pictorially Realized Through the Intrinsic Faculty of the Colors to Express Volume," in *Hans Hofmann*, Kootz Gallery, New York, November 13–December 1, 1951.

——. Statement in *Contemporary American Painting and Sculpture*, University of Illinois, Urbana, 1952.

——. Statement in *Hans Hofmann*, Kootz Gallery, New York, October 28–November 22, 1952.

——. Statement in *Contemporary American Painting and Sculpture*, University of Illinois, Urbana, 1953.

——. Statement in *Contemporary American Painting and Sculpture*, University of Illinois, Urbana, 1955.

——. "Hofmann Explains His Paintings." *Ben-*

nington College Alumnae Quarterly, VII, No. 1 (Fall, 1955).

——. "The Color Problem in Pure Painting—Its Creative Origin," in *Hans Hofmann*, Kootz Gallery, New York, November 7–December 3, 1955. Reprinted in *Arts and Architecture*, LXXIII, No. 2 (February, 1956).

——. "Nature and Art. Controversy and Misconceptions," in *Hans Hofmann*, Kootz Gallery, New York, January 7–25, 1957.

——. "Statement," *It Is*, No. 3 (Spring, 1959).

——. Statement in *Contemporary American Painting and Sculpture*, University of Illinois, Urbana, 1959.

——. "Space and Pictorial Life," *It Is*, No. 4 (Autumn, 1959).

——. Statement in *Hans Hofmann*, Kootz Gallery, New York, January 5–23, 1960.

——. Statement in *Contemporary American Painting and Sculpture*, University of Illinois, Urbana, 1961.

——. Statement in KATHERINE KUH, *The Artist's Voice. Talks with Seventeen Artists* (New York and Evanston, Ill.: Harper & Row, 1962).

——. Statement in *Contemporary American Painting and Sculpture*, University of Illinois, Urbana, 1963.

——. "Photo-Critic," in *Location*, I, No. 2 (Summer, 1964).

Monographs

GREENBERG, CLEMENT. *Hans Hofmann*. Paris: Editions Georges Fall, 1961.

HUNTER, SAM. *Hans Hofmann*. New York: Harry N. Abrams, 1964.

Articles

GREENBERG, CLEMENT. "Most Important Art Teacher of Our Time," *The Nation*, CLX, No. 4 (April 21, 1945).

WOLF, BEN. "The Digest Interviews Hans Hofmann," *Art Digest*, XIX, No. 13 (April 1, 1945).

HESS, THOMAS B. "Art News Visits the Art Schools: 3 in Provincetown," *Art News*, XLV, No. 4 (June, 1946).

MATTER, MERCEDES. "Hans Hofmann," *Arts and Architecture*, LXIII, No. 5 (May, 1946).

KEES, WELDON. "Weber and Hofmann," *Partisan Review*, XVI, No. 5 (May, 1949).

DE KOONING, ELAINE. "Hans Hofmann Paints a Picture," *Art News*, XL, No. 10 (February, 1950).

BIRD, PAUL. "Hofmann Profile," *Art Digest*, XXV, No. 16 (May 15, 1951).

SECKLER, DOROTHY. "Can Painting Be Taught? 2. Hofmann's Answer," *Art News*, L, No. 1 (March, 1951).

SAWYER, KENNETH B. "Largely Hans Hofmann," *Baltimore Museum of Art News*, XVIII, No. 3 (December, 1945).

FITZSIMMONS, JAMES. "Hans Hofmann," *Everyday Art Quarterly*, No. 28 (1953).

PLASKETT, JOE. "Some new Canadian Painters and

291

Their Debt to Hans Hofmann," *Canadian Art*, X, No. 2 (Winter, 1953).

POLLET, ELIZABETH. "Hans Hofmann," *Arts*, XXXI, No. 8 (May, 1957).

ROSENBERG, HAROLD. "Hans Hofmann: Nature into Action," *Art News*, LVI, No. 3 (May, 1957).

ASHTON, DORE. "Hans Hofmann," *Cimaise*, Series 6, No. 3 (January–March, 1959).

GREENBERG, CLEMENT. "Hans Hofmann: Grand Old Rebel," *Art News*, LVII, No. 9 (January, 1959).

ROSENBERG, HAROLD. "Hans Hofmann's 'Life' Class," *Portfolio and Art News Annual*, No. 6 (Autumn, 1962).

BULTMAN, FRITZ. "The Achievement of Hans Hofmann," *Art News*, LXII, No. 5 (September, 1963).

FRIED, MICHAEL. "New York Letter," *Art International*, VII, No. 4 (April, 1963).

KAPROW, ALLAN. "The Effect of Recent Art upon the Teaching of Art," *Art Journal*, XXXIII, No. 2 (Winter, 1963–64).

ROSENBERG, HAROLD. "Hans Hofmann and the Stability of the New," *New Yorker*, XXXIX, No. 37 (November 2, 1963).

LORAN, ERLE. "Hans Hofmann and His Work," *Artforum*, II, No. 11 (May, 1964).

KOOTZ, SAMUEL M. "The Credibility of Color," *Arts*, XLI, No. 4 (February, 1967).

ROSENBERG, HAROLD. "Homage to Hans Hofmann," *Art News*, LXV, No. 9 (January, 1967).

BANNARD, WALTER DARBY. "Hofmann's Rectangle," *Artforum*, VII, No. 10 (Summer, 1969).

Exhibition Catalogues

GREENBERG, CLEMENT. "Hans Hofmann," in *A Retrospective Exhibition of the Paintings of Hans Hofmann*, Bennington College, Bennington, Vt., 1955.

WIGHT, FREDERICK S. *Hans Hofmann*. Berkeley and Los Angeles: University of California Press, 1957.

GREENBERG, CLEMENT. "Hofmann's Early Abstract Paintings," in *Hans Hofmann*, Kootz Gallery, New York, January 6–31, 1959.

SEITZ, WILLIAM C. *Hans Hofmann*, New York: Museum of Modern Art, 1963.

FRANZ KLINE

Statements

KLINE, FRANZ. Statement in *New Decade*, Whitney Museum of American Art, New York, 1955.

———. "Is Today's Artist With or Against the Past?" *Art News*, LVII, No. 5 (September, 1958).

O'HARA, FRANK. "Franz Kline Talking," *Evergreen Review*, II, No. 6 (Autumn, 1958).

"Franz Kline 1910–1962: An Interview with David Sylvester," *Living Arts*, I, No. 1 (Spring, 1963).

KUH, KATHERINE. *The Artist's Voice: Talks With Seventeen Artists*. New York and Evanston, Ill.: Harper & Row, 1962.

Book

DAWSON, FIELDING. *An Emotional Memoir of Franz Kline*. New York: Pantheon Books, 1967.

Articles

HASEGAWA, SABRO. "The Beauty of Black and White," *Bobuki*, XII, No. 4 (1951).

GOODNOUGH, ROBERT. "Kline Paints a Picture," *Art News*, LI, No. 8 (December, 1952).

SAWIN, MARTICA. "An American Artist in Japan," *Art Digest*, XXIX, No. 19 (August, 1955).

STEINBERG, LEO. "Month in Review," *Arts*, XXX, No. 7 (April, 1956).

ASHTON, DORE. "Art," *Arts and Architecture*, LXXIII, No. 4 (April, 1956); LXXV, No. 7 (July, 1958); LXXVI, No. 3 (March, 1959).

DE KOONING, ELAINE. "Two Americans in Action: Kline and Rothko," *Art News Annual*, XXVII (November, 1957).

OERI, GEORGINE. "Notes on Franz Kline," *Quadrum*, No. 12 (1961).

DE KOONING, ELAINE. "Franz Kline: Painter of His Own Life," *Art News*, LXI, No. 7 (November, 1962).

LANGSNER, JULES. "Kline," *Artforum*, I, No. 2 (July, 1962).

BUTLER, BARBARA. "Franz Kline in Retrospect," *Arts*, XXXVII, No. 4 (January, 1963).

LANGSNER, JULES. "Franz Kline Calligraphy and Information Theory," *Art International*, VII, No. 3 (March, 1963).

ROBBINS, DANIEL, and EUGENIA ROBBINS. "Franz Kline: Rough Impulsive Gesture," *Studio*, CLXVII, No. 853 (May, 1964).

ALLOWAY, LAWRENCE. "Kline's Estate," *Arts*, XLI, No. 6 (April, 1967).

GOLDWATER, ROBERT. "Franz Kline: Darkness Visible," *Art News*, LXVI, No. 1 (March, 1967).

SCHUYLER, JAMES. "As American as Franz Kline," *Art News*, LXVII, No. 6 (October, 1968).

Exhibition Catalogues

DE KOONING, ELAINE. *Franz Kline Memorial Exhibition*, Washington Gallery of Modern Art, Washington, D.C., October 30–December 27, 1962.

O'HARA, FRANK. Introduction to *Franz Kline*, Galleria Civica d'Arte Moderna, Turin, November 5–December 1, 1963.

GOLDWATER, ROBERT. "Introduction," *Franz Kline*, Marlborough-Gerson Gallery, New York, 1967.

GORDON, JOHN. *Franz Kline: 1910–1962*, Whitney Museum of American Art, New York, October 1–November 24, 1968.

ROBERT MOTHERWELL

Statements

MOTHERWELL, ROBERT. "Notes on Mondrian and Chirico," *VVV*, No. 1 (June, 1942).

———. "The Modern Painter's World," *Dyn*, I,

No. 6 (November, 1944).

———. "Painter's Objects," *Partisan Review*, XI, No. 1 (Winter, 1944).

———. "Beyond the Aesthetic," *Design*, XLVII, No. 8 (April, 1946).

———. Statement in *Fourteen Americans*, Museum of Modern Art, New York, 1946.

———. Statement in Introduction to *Robert Motherwell*, Kootz Gallery, New York, May, 1947.

———. Statement in *Possibilities 1*, No. 1 (Winter, 1947–48). Editorial preface with HAROLD ROSENBERG.

———. "A Tour of the Sublime," *The Tiger's Eye*, I, No. 6 (December 15, 1948).

———. Statement in *Robert Motherwell Collages 1943–1949*, Kootz Gallery, New York, 1949.

———. "The Public and the Modern Artist," *Catholic Art Quarterly*, XIV, No. 2 (Easter, 1951).

———. *The School of New York*, "Seventeen Modern American Painters," Frank Perls Gallery, Beverly Hills, Calif., January 11–February 7, 1951.

———. "What Abstract Art Means to Me," *Museum of Modern Art Bulletin*, XVIII, No. 3 (Spring, 1951).

———. "The Rise and Continuity of Abstract Art," *Arts and Architecture*, LXIX, No. 9 (September, 1951).

———. Preface in *Robert Motherwell*, Kootz Gallery, New York, November 14–December 4, 1952.

———. "Is the French Avant Garde Overrated?," *Art Digest*, XXVII (September, 1953).

———. "The Painter and the Audience," *Perspectives USA*, No. 9 (Autumn, 1954).

———. Statement in *The New Decade*, Whitney Museum of American Art, New York, 1955.

———. Statement in *Bradley Walker Tomlin*. Whitney Museum of American Art, New York, 1957.

———. Statement in *It is*, No. 3 (1959).

———. "The Significance of Miró," *Art News*, LVIII, No. 4 (May, 1959).

———. "What Should a Museum Be?," *Art in America*, XLIX, No. 2 (1961).

SYLVESTER, DAVID. "Painting as Existence: An Interview with Robert Motherwell," *Metro*, No. 7 (1962).

A conversation at lunch (1962), in "Robert Motherwell," *Smith College*, (January, 1963).

KOZLOFF, MAX. "An Interview with Robert Motherwell," *Artforum*, IV, No. 1 (September, 1965).

CONANT, HOWARD (ed.). "The Motherwell Proposal," *Seminar on Elementary and Secondary School Education in the Arts*. New York: New York University, 1965.

MOTHERWELL, ROBERT. "David Smith: A Major American Sculptor," *Studio International*, CLXXII, No. 880 (August, 1966).

Articles

GREENBERG, CLEMENT. "Art," *The Nation*, CLIX, No. 20 (November 11, 1944); CLXIV, No. 22 (May 31, 1947); CLXVI, No. 22 (May 29, 1948).

KEES, WELDON. "Robert Motherwell," *Magazine of Art*, XLI, No. 3 (March, 1948).

BIRD, PAUL. "Motherwell: A Profile," *Art Digest*, XXVI, No. 1 (October 1, 1951).

FITZSIMMONS, JAMES. "Robert Motherwell," *Design Quarterly*, No. 29 (1954).

GOOSSEN, EUGENE C. "Robert Motherwell and the Seriousness of Subject," *Art International*, III, Nos. 1–2 (1959).

SANDLER, IRVING. "Robert Motherwell," *Art International*, V, Nos. 5–6 (June-August, 1961).

ASHTON, DORE. "Motherwell Loves and Believes," *Studio*, CLXV, No. 839 (March, 1963).

TILLIM, SIDNEY. "Month in Review" (Motherwell at the Janis Gallery), *Arts*, XXXVII, No. 4 (January, 1963).

ASHTON, DORE. "Robert Motherwell: Passion and Transfiguration," *Studio*, CLXVII, No. 851 (March, 1964).

EDGAR, NATALIE. "The Satisfactions of Robert Motherwell," *Art News*, LXIV, No. 6 (October, 1965).

LIPPARD, LUCY R. "New York Letter: Miró and Motherwell," *Art International*, XIV, Nos. 9–10 (December 20, 1965).

O'HARA, FRANK. "Robert Motherwell," *Art in America*, LIII, No. 5 (October-November, 1965).

ARNASON, H. HARVARD. "On Robert Motherwell and His Early Work," *Art International*, X, No. 1 (January 20, 1966).

———. "Robert Motherwell: 1948–1965," *Art International*, X, No. 4 (April 20, 1966).

BARO, GENE. "The Ethics of Risk," *Arts*, XL, No. 3 (January, 1966).

ROBERTSON, BRYAN. "From a Notebook on Robert Motherwell," *Studio*, CLXXI, No. 875 (March, 1966).

ARNASON, H. HARVARD. "Motherwell: the Wall and the Window," *Art News*, LXVIII, No. 4 (Summer, 1969).

KRAUSS, ROSALIND. "Robert Motherwell's New Paintings," *Artform*, VII, No. 9 (May, 1969).

Exhibition Catalogues

SWEENEY, JAMES JOHNSON. Preface, *Robert Motherwell*, Art of this Century, New York, October-November, 1944.

GOOSSEN, E. E. Commentary, *Motherwell. First Retrospective Exhibition*, Bennington College, Bennington, Vt., April 24–May 23, 1959.

Robert Motherwell, A Retrospective Exhibition, Pasadena Art Museum, Pasadena, Calif., February 18–March 11, 1962. Texts by T. W. LEAVITT, FRANK O'HARA, SAM HUNTER; poem by BARBARA GUEST; essay by the artist.

An Exhibition of the Work of Robert Motherwell, Smith College Museum of Art, Northampton, Mass., January 10–28, 1963. Motherwell texts, chronology, extensive bibliography (with addenda slip).

HUNTER, SAM. Preface, *Collages by Robert Mother-*

well, Phillips Collection, Washington, D.C., January 2–February 15, 1965.

O'Hara, Frank. *Robert Motherwell*, Museum of Modern Art, New York, 1965.

BARNETT NEWMAN

Statements

Newman, Barnett. "Globalism Pops into View," letter to the Editor from Gottlieb and Rothko, written by Gottlieb, Rothko, and Newman, *The New York Times*, June 13, 1943.

————. "Escultura pre-Colombina en piedra," *La Revista Belga*, I, No. 6 (August, 1944).

————. Foreword to *Adolph Gottlieb*, Wakefield Gallery, New York, February 7–19, 1944.

————. Foreword to *Pre-Columbian Stone Sculpture*, Wakefield Gallery, New York, May 16–June 5, 1944.

————. "La pintura de Tamayo y Gottlieb," *La Revista Belga*, II, No. 4 (April, 1945).

————. Foreword to *Teresa Zarnower*, Art of This Century, New York, April 23–May 11, 1946.

————. "Las formas artisticas del Pacifico," *Ambros Mundos*, I, No. 1 (June, 1946).

————. *Northwest Coast Indian Painting*, Betty Parsons Gallery, New York, September 30–October 19, 1946.

————. Foreword to *Stamos*, Betty Parsons Gallery, New York, February 10–March 1, 1947.

————. Foreword to *The Ideographic Picture*, Betty Parsons Gallery, New York, January 20–February 8, 1947.

————. "The First Man Was an Artist," *The Tiger's Eye*, I, No. 1 (October, 1947).

————. "The Ides of Art—The Attitudes of 10 Artists on Their Art and Contemporaneousness," *The Tiger's Eye*, I, No. 2 (December, 1947).

————. Foreword to *Herbert Ferber*, Betty Parsons Gallery, New York, December 15, 1947–January 3, 1948.

————. "The Ides of Art—6 Opinions on What is Sublime in Art," "The Sublime is Now," *The Tiger's Eye*, I, No. 6 (December 15, 1948).

————. "The Object and the Image," *The Tiger's Eye*, I, No. 3 (March, 1948).

————. "To Be or Not—6 Opinions on Trigant Burrow's 'The Neurosis of Man,' " *The Tiger's Eye*, I, No. 9 (October, 1949).

————. "Embattled Lamb," *Art News*, LXI, No. 5 (September, 1962).

Seckler, Dorothy Gees. "Frontiers of Space," *Art in America*, L, No. 2 (Summer, 1962).

Newman, Barnett. Foreword to *Amlash Sculpture from Iran*, Betty Parsons Gallery, New York, September 23–October 19, 1963.

————. Statement in *Recent American Synagogue Architecture*, Jewish Museum, New York, October 6–December 8, 1963.

————. "18 Cantos 1963–64," Preface to a volume of Newman's lithographs. Universal Ltd. Art Editions, West Islip, N.Y., 1964.

————. Statement in *São Paulo Bienal VIII*, São Paulo Bienal, Brazil, September 4–November 28, 1965.

————. "The New York School Question," *Art News*, LXIV, No. 5 (September, 1965). Interviewed by Neil A. Levine.

————. Statement in *The Stations of the Cross*, Solomon R. Guggenheim Museum, New York, April-May, 1966.

————. "The 14 Stations of the Cross," *Art News*, LXV, No. 3 (May, 1966).

————. "Artists on Museums—The Museum World," *Arts Yearbook*, 9 (1967).

————. "Jackson Pollock: An Artists' Symposium, Part I," *Art News*, LXVI, No. 2 (April, 1967).

————. "For Impassioned Criticism," *Art News*, LXVII, No. 4 (Summer, 1968).

————. "Charters and Jericho," *Art News*, LXVIII, No. 2 (April, 1969).

Book

Hess, Thomas B. *Barnett Newman*. New York: Walker & Co., 1969. Issued on the occasion of an exhibition at M. Knoedler & Co., Inc., New York, March 25–April 19.

Articles

Goossen, E. C. "The Philosophic Line of Barnett Newmen," *Art News*, LVII, No. 4 (Summer, 1958).

Rosenberg, Harold. "Barnett Newman: A Man of Controversy and Grandeur," *Vogue* (February, 1963). Reprinted in Harold Rosenberg, *The Anxious Object*. New York: Mentor, 1969.

Alloway, Lawrence. "Barnett Newman," *Artforum*, III, No. 9 (June, 1965).

Calas, Nicolas. "Subject Matter in the Work of Barnett Newman," *Arts*, XLII, No. 2 (November, 1967).

Alloway, Lawrence. "Barnett Newman—Some Notes on His Work," *Art International*, XIII, No. 6 (Summer, 1969).

Baker, Elizabeth C. "Barnett Newman in a New Light," *Art News*, LXVII, No. 10 (February, 1969).

Rosenberg, Harold. "The Art World: Icon Maker," *New Yorker*, XLV (April 19, 1969).

Schneider, Pierre. "Through the Louvre with Barnett Newman," *Art News*, LXVIII, No. 4 (Summer, 1969).

Exhibition Catalogues

Greenberg, Clement. *Barnett Newman: First Retrospective Exhibition*, Bennington College, Bennington, Vt., May 4–24, 1958.

Alloway, Lawrence. *The Stations of the Cross*, Solomon R. Guggenheim Museum, New York, 1966.

JACKSON POLLOCK

Statements

Pollock, Jackson. "Jackson Pollock," *Arts and Architecture*, CLXI, No. 2 (February, 1944).

————. Statement in JANIS, SIDNEY, *Abstract and Surrealist Art in America*. New York: Reynal & Hitchcock, 1944.

————. "My Painting," *Possibilities 1*, No. 1 (Winter 1947–48).

————. Excerpts from an interview taped by William Wright, 1950. *Art in America*, LIII, No. 4 (August-September 1965).

————. Excerpt from a letter to ALFONSO OSSORIO and EDWARD DRAGON, June 7, 1951. In *The New York School*, ed. MAURICE TUCHMAN, Los Angeles County Museum of Art, 1965.

Monographs

HUNTER, SAM. "Jackson Pollock: The Maze and the Minotaur," in *New World Writing*. New York: New American Library, 1956.

O'HARA, FRANK. *Jackson Pollock*. (The Great American Artists Series.) New York: Braziller, 1959.

ROBERTSON, BRYAN. *Jackson Pollock*. New York: Harry N. Abrams, 1960.

O'CONNOR, FRANCIS V. "The Genesis of Jackson Pollock: 1912 to 1943." Unpublished Ph.D. dissertation, The Johns Hopkins University, Baltimore, Md., 1965.

ROSE, BERNICE. *Jackson Pollock: Works on Paper*. New York: Museum of Modern Art, 1970.

Articles

GREENBERG, CLEMENT. Reviews in *The Nation*, CLVII, No. 22 (November 27, 1943); CLX, No. 14 (April 7, 1945); CLII, No. 15 (April 13, 1946); CLXIII, No. 26 (December 28, 1946); CLXIV, No. 5 (February 1, 1947); CLXVI, No. 4 (January 24, 1948); CLXVIII, No. 9 (February 19, 1949).

MOTHERWELL, ROBERT. "Painters' Objects," *Partisan Review*, XI, No. 1 (Winter, 1944).

FARBER, MANNY. "Jackson Pollock," *New Republic*, CXII, No. 26 (June 9, 1945).

TYLER, PARKER. "Jackson Pollock: The Infinite Labyrinth," *Magazine of Art*, XLIII, No. 3 (March, 1950).

GOODNOUGH, ROBERT. "Pollock Paints a Picture," *Art News*, L, No. 3 (May, 1951).

GREENBERG, CLEMENT. "Jackson Pollock's New Style," *Harper's Bazaar*, LXXXV, No. 2883 (February, 1952).

FRIEDMAN, B. H. "Profile: Jackson Pollock," *Art in America*, XLIII, No. 4 (December, 1955).

STEINBERG, LEO. "Month in Review . . . Fifteen Years of Jackson Pollock," *Arts*, XXX, No. 3 (December, 1955).

ASHTON, DORE. Reviews in *Arts and Architecture*, LXXIII, No. 1 (January. 1956); LXIV, No. 3 (March, 1957); LXVI, No. 1 (January, 1959).

HESS, THOMAS B. "Jackson Pollock 1912–1956," *Art News*, LV, No. 5 (September, 1956).

SAWYER, KENNETH B. "Jackson Pollock: 1912–1956," *Cimaise*, IV, No. 2 (November–December 1956).

GREENBERG, CLEMENT. "Jackson Pollock," *Evergreen Review*, I, No. 3 (1957).

KRAMER, HILTON. "The Month in Review: Pollock," *Arts*, XXXI, No. 5 (February, 1957).

TYLER, PARKER. "Hopper/Pollock. The Loneliness of the Crowd and the Loneliness of the Universe: An Antiphonal," *Art News Annual*, XXVI (1957).

TILLIM, SIDNEY. "Jackson Pollock. A Critical Evaluation," *College Art Journal*, XVI, No. 3 (Spring, 1957).

KAPROW, ALLAN. "The Legacy of Jackson Pollock," *Art News*, LVII, No. 4 (October, 1958).

KRAMER, HILTON. "Jackson Pollock and Nicolas de Staël. Two Painters and Their Myths," *Arts Yearbook*, No. 3 (1959).

RUBIN, WILLIAM. "Notes on Masson and Pollock," *Arts*, XXXIV, No. 2 (November, 1959).

GREENBERG, CLEMENT. "The Jackson Pollock Market Soars," *The New York Times Magazine*, April 16, 1961.

LAVIN, IRVING. "Abstraction in Modern Painting: A Comparison," *Metropolitan Museum of Art Bulletin*, XIX No. 6 (February, 1961).

ALLOWAY, LAWRENCE. "Notes on Pollock," *Art International*, V, No. 4 (May 1, 1961).

HESS, THOMAS B. "Pollock: The Art of a Myth," *Art News*, LXII, No. 9 (January, 1964).

TILLIM, SIDNEY. "Month in Review: Retrospective at the Marlborough-Gerson Gallery," *Arts*, XXXVIII, No. 6 (March, 1964).

VALLIERE, JAMES T. "The El Greco Influence on Jackson Pollock's Early Works," *The Art Journal*, XXIV, No. 1 (Fall, 1964).

FRIED, MICHAEL. "Jackson Pollock," *Artforum*, IV, No. 1 (September, 1965).

GLASER, BRUCE. "Jackson Pollock. An Interview with Lee Krasner," *Arts*, XLI, No. 6 (April, 1967).

GREENBERG, CLEMENT. "Jackson Pollock: 'Inspiration, Vision, Intuitive Decision,'" *Vogue*, CXLIX (April 1, 1967).

"Jackson Pollock: An Artists' Symposium, Part 1," *Art News*, LXVI, No. 2 (April, 1967). Statements by JAMES BROOKS, ADOLPH GOTTLIEB, AL HELD, ALLAN KAPROW, ALEX KATZ, ELAINE DE KOONING, ROBERT MOTHERWELL, BARNETT NEWMAN, PHILLIP PAVIA, LARRY RIVERS.

"Jackson Pollock: An Artists' Symposium, Part 2," *Art News*, LXVI, No. 3 (May, 1967). Statements by AL BRUNELLE, JANE FREILICHER, DAVID LEE, JOAN MITCHELL, KENNETH NOLAND, DAVID NOVROS, CLAES OLDENBURG, GEORGE SEGAL.

JUDD, DONALD. "Jackson Pollock," *Arts*, XLI, No. 6 (April, 1967).

O'CONNOR, FRANCIS V. "The Genesis of Jackson Pollock: 1912 to 1943," *Artforum*, V, No. 9 (May, 1967).

RAYNOR, VIVIEN. "Jackson Pollock in Retrospect— 'He Broke the Ice,'" *The New York Times Magazine*, April 2, 1967.

ROSENBERG, HAROLD. "The Art World: The Mythic Art," *New Yorker*, XLIII, No. 11 (May 6, 1967).

RUBIN, WILLIAM. "Jackson Pollock and the Modern Tradition," *Artforum*, Part I, V, No. 6 (February, 1967); Part II, V, No. 7 (March, 1967); Part III, V, No. 8 (April, 1967); Part IV, V, No. 9 (May, 1967).

"Who Was Jackson Pollock?" Interviews by FRAN-
CINE DU PLESSIX and CLEVE GRAY, *Art in
America*, LV, No. 3 (May–June, 1967).
ALLOWAY, LAWRENCE. "Pollock's Black Paintings,"
Arts Magazine, XLIII, No. 7 (May, 1969).
ASHBERY, JOHN. "Black Pollock," *Art News*, LXVIII,
No. 1 (March, 1969).

Exhibition Catalogues

SWEENEY, JAMES JOHNSON. Introduction to *Jackson
Pollock*, Art of This Century, New York, No-
vember 9–27, 1943.
DAVIS, W. N. M. Introduction to *Jackson Pollock*,
Art of This Century, New York, January 14–
February 1, 1947.
OSSORIO, ALFONSO. Introduction to *Jackson Pollock*,
Betty Parsons Gallery, New York, November
26–December 15, 1951.
GREENBERG, CLEMENT. Preface to *Retrospective
Exhibition of Jackson Pollock*, Bennington Col-
lege, Bennington, Vermont, 1952.
HUNTER, SAM. *Jackson Pollock*, Museum of Modern
Art, New York, December 19, 1956–February
3, 1957.
PIERRE, JOSÉ. "Surrealism, Jackson Pollock and Lyric
Abstraction," in *Surrealist Intrusion into the
Enchanters' Domain*, D'Arcy Galleries, New
York, May, 1960.
O'HARA, FRANK. "Jackson Pollock 1912–1956," in
SELZ, PETER (ed.), *New Images of Man*, Mu-
seum of Modern Art, New York, 1959.
ALLOWAY, LAWRENCE. Introduction and catalogue
notes to *Jackson Pollock: Paintings, Drawings
and Watercolors from the Collection of Lee
Krasner Pollock*, Marlborough Fine Art Ltd.,
London, June, 1961.
O'CONNOR, FRANCIS V. *Jackson Pollock*, Museum of
Modern Art, New York, 1967.

AD REINHARDT

Statements

REINHARDT, AD. "How Modern Is The Museum of
Modern Art?" (Broadside for the American
Abstract Artists when they picketed the mu-
seum; dated April 15, 1940.)
———. "How to Look." *PM* (1944, 1946). (A
series of cartoons on art and the art world, and
daily writings on art and other subjects.)
———. "Stuart Davis," *New Masses* (November
27, 1945).
———. Statement in *Ad Reinhardt*, Betty Parsons
Gallery, New York, October 18–November 6,
1948.
———. "Incidental Note," in *Ad Reinhardt*, Betty
Parsons Gallery, New York, October 31–No-
vember 19, 1949.
———. Statement in H. HARVARD ARNASON, *Forty
American Painters*, University of Minnesota
Gallery, Minneapolis, June 4–August 30, 1951.
———. Statement in *Contemporary American
Painting*, University of Illinois, Urbana, 1952.
REINHARDT, AD, and ROBERT MOTHERWELL. Edi-
torial statement in *Modern Artists in America*.
New York: Wittenborn, Schultz, 1952.
REINHARDT, AD. "The Artist in Search of an Acad-
emy," *College Art Journal*, XII, No. 3 (Spring,
1953); Part II: "Who Are the Artists?" XIII,
No. 4 (Summer, 1954).
———. "Cycles Through the Chinese Landscape,"
Art News, LIII, No. 8 (December, 1954).
———. Statement in *The New Decade: 35 Ameri-
can Painters and Sculptors*, Whitney Museum
of American Art, New York, May 11–August
7, 1955.
———. "The Art-Politics Syndrome: A Project in
Integration," *Art News*, LV, No. 7 (November
1956).
———. Statement in *Eleven Young Painters*, Mills
College of Education Gallery, New York, April
2–30, 1957. Exhibition selected by AD REIN-
HARDT.
———. "Twelve Rules of a New Academy," *Art
News*, LVI, No. 3 (May, 1957).
———. "Is Today's Artist With or Against the
Past?" *Art News*, LVII, No. 4 (Summer, 1958).
———. "Panel: All-Over Painting," *It Is*, No. 2
(Autumn, 1958).
———. "44 Titles for Articles for Artists Under
45." *It Is*. No. 1 (Spring, 1958).
———. "Discussion: Is There a New Academy?"
Art News, LVIII, No. 4 (June, 1959). Contri-
bution to a symposium.
———. "Seven Quotes," *It Is*, No. 4 (Autumn,
1959).
———. "Timeless in Asia," *Art News*, LVIII, No. 9
(January, 1960).
———. "Angkor and Art," in *Khmer Sculpture*,
Asia House Gallery, New York, 1961. Reprinted
in *Art News*, LX, No. 8 (December, 1961).
———. "Who is Responsible for Ugliness?," *Ameri-
can Institute of Architects Journal*, XLVII, No.
6 (June, 1962).
———. "Art-as-Art," *Art International*, VI, No. 10
(December 20, 1962).
SANDLER, IRVING. "In The Art Galleries; Interview
with Ad Reinhardt," *New York Post*, August
12, 1962.
———. "The Next Revolution in Art: Art-as-Art
Dogma, Part II," *Art International*, VIII, No. 2
(March, 1964).
———. "Reinhardt Paints a Picture," *Art News*,
LXIV, No. 1 (March, 1965) (Autointerview.)
———. "The Artists Say. . . . Ad Reinhardt: 39
Art Planks," *Art Voices*, IV, No. 2 (Spring,
1965).
GLASER, BRUCE. "Interview with Ad Reinhardt," *Art
International*, X, No. 10 (December 20, 1966).
———. "Art in Art is Art as Art," *The Lugano
Review*, I, Nos. 5–6 (Summer, 1966).
———. "Art vs. History: *The Shape of Time*, by
George Kubler," *Art News*, LXIV, No. 9
(January, 1966).
———. "Ad Reinhardt: Three Statements," *Art-
forum*, IV, No. 7 (March, 1966).

Articles

DE KOONING, ELAINE. "Pure Paints a Picture," *Art
News*, LVI, No. 4 (Summer, 1957).

296

MARTIN, JAMES. "Today's Artists: Reinhardt," *Portfolio and Art News Annual*, No. 3 (1960). Includes statements.

NORDLAND, GERALD. "Art: The Artist as Reinhardt," *Frontier*, XIII, No. 5 (March, 1962). Includes statements.

HESS, THOMAS B. "Reinhardt: The Position and Perils of Purity," *Art News*, LII, No. 8 (December, 1963).

KRAMER, HILTON. "Art," *The Nation*, CXCVI, No. 24 (June 22, 1963).

COLT, PRISCILLA. "Notes on Ad Reinhardt," *Art International*, VIII, No. 8 (October, 1964).

LIPPARD, LUCY R. "New York Letter," *Art International*, IX, No. 4 (May, 1965).

McSHINE, KYNASTON. "More than Black," *Arts*, XLI, No. 3 (December 1966–January 1967).

MICHELSON, ANNETTE. "Ad Reinhardt or the Artist as Artist," *Harper's Bazaar* (November, 1966).

ROSE, BARBARA. "Reinhardt," *Vogue*, CXLVIII, No. 8 (November 1, 1966).

ROSENSTEIN, HARRIS. "Black Pastures," *Art News*, LXV, No. 7 (November, 1966).

SANDLER, IRVING. "Reinhardt: The Purist Backlash," *Artforum*, V, No. 4 (December, 1966).

ASHTON, DORE. "Notes on Reinhardt's Exhibition," *Arts and Architecture*, LXXXIII, No. 12 (January, 1967).

Exhibition Catalogue

LIPPARD, LUCY. *Ad Reinhardt Paintings*, Jewish Museum, New York, November 23–January 15, 1967. Preface by SAM HUNTER.

MARK ROTHKO

Statements

ROTHKO, MARK. Statement in "Ides of Art," *The Tiger's Eye*, I, No. 2 (December, 1947).

———. "The Romantics Were Prompted," *Possibilities 1*, No. 1 (Winter 1947–48).

———. "A Statement on His Attitude of Painting," *The Tiger's Eye*, I, No. 9 (October, 1949).

———. Statement delivered from the floor at a symposium at the Museum of Modern Art on "How to Combine Architecture, Painting and Sculpture," published in *Interiors*, CX, No. 10 (May, 1951).

Articles

COLLIER, OSKAR. "Mark Rothko," *Iconograph* (Fall, 1947).

MacAGY, DOUGLAS. "Mark Rothko," *Magazine of Art*, XLII, No. 1 (January, 1949).

CREHAN, HUBERT. "Rothko's Wall of Light: Exhibition at the Art Institute of Chicago," *Art Digest*, XXIX, No. 5 (November 1, 1954).

KUH, KATHERINE. "Mark Rothko: Recent Paintings," *The Art Institute of Chicago Quarterly*, XLVIII, No. 4 (1954).

DE KOONING, ELAINE. "Two Americans in Action: Kline and Rothko," *Art News Annual*, XXVII (November, 1957).

ASHTON, DORE. "Art: Lecture by Rothko," *The New York Times*, October 31, 1958. Includes quotations from lecture at Pratt Institute.

———. "Art: Mark Rothko," *Arts and Architecture*, LXXIV, No. 8 (April, 1958).

OERI, GEORGINE. "Tobey and Rothko," *Baltimore Museum of Art News*, XXIII, No. 2 (Winter, 1960).

———. "Mark Rothko," *Quadrum*, No. 10 (1961).

KOZLOFF, MAX. "Mark Rothko's New Retrospective," *Art Journal*, XX, No. 3 (Spring, 1961).

GOLDWATER, ROBERT. "Reflections on the Rothko Exhibit," *Arts*, XXXV, No. 6 (March, 1961).

GOOSEN, EUGENE C. "Rothko: The Omnibus Image," *Art News*, LIX, No. 9 (January, 1961).

ALLOWAY, LAWRENCE. "Notes on Rothko," *Art International*, VI, Nos. 5–6 (Summer, 1962).

KOZLOFF, MAX. "The Problem of Color-Light in Rothko," *Artforum*, IV, No. 1 (September, 1965).

Exhibition Catalogues

ROBERTSON, BRYAN. *Rothko*, Whitechapel Gallery, London, 1961.

SELZ, PETER. *Mark Rothko*, Museum of Modern Art, New York, 1961.

CLYFFORD STILL

Statements

STILL, CLYFFORD. Statement, Betty Parsons Gallery, New York, 1950. (Telescript.)

———. Letter to Gordon Smith, in *Paintings by Clyfford Still*, Albright-Knox Art Gallery, Buffalo, N.Y., November 5–December 13, 1959.

———. "Comments," *Gallery Notes*, Albright-Knox Art Gallery, Buffalo, N.Y., XXIII, No. 2 (Summer, 1960).

TOWNSEND, BENJAMIN J. "An Interview with Clyfford Still," *Gallery Notes*, Albright-Knox Art Gallery, Buffalo, N.Y., XXIV, No. 2 (Summer, 1961).

STILL, CLYFFORD. "An Open Letter to An Art Critic," *Artforum*, II, No. 6 (December, 1963).

———. Letter to the Editor, *Artforum*, II, No. 8 (February, 1964).

Articles

"Clyfford Still," *Magazine of Art*, XLI, No. 3 (March, 1948).

ASHTON, DORE. "Clyfford Still," *The New York Times*, November 16, 1959.

CREHAN, HUBERT. "Clyfford Still: Black Angel in Buffalo," *Art News*, LVIII, No. 8 (December, 1959).

SAWYER, KENNETH B. "U.S. Painters Today: No. 1: Clyfford Still," *Portfolio and Art News Annual*, No. 2 (1960).

GOOSSEN, EUGENE C. "Painting as Confrontation: Clyfford Still," *Art International*, IV, No. 1 (1960).

SHARPLESS, TI-GRACE. "Freedom . . . Absolute and Infinitely Exhilarating," *Art News*, LXII, No. 7 (November, 1963).

KOZLOFF, MAX. "Art: Clyfford Still," *The Nation,* CXCVIII, No. 2 (January 6, 1964).

HESS, THOMAS B. "The Outsider," *Art News,* LXVIII, No. 8 (December, 1969).

SANDLER, IRVING. "Clyfford Still—Emerging from Eclipse," *The New York Times,* December 21, 1969.

Exhibition Catalogues

Paintings of Clyfford Still, Albright-Knox Art Gallery, Buffalo, N.Y., November 5–December 13, 1959.

SHARPLESS, TI-GRACE. *Clyfford Still,* Institute of Contemporary Art, University of Pennsylvania, Philadelphia, October 18–November 29, 1963.

———. Introduction to *Clyfford Still: Thirty-three Paintings in the Albright-Knox Art Gallery,* Albright-Knox Art Gallery, Buffalo, N.Y., 1966.

BRADLEY WALKER TOMLIN

Statements

TOMLIN, BRADLEY WALKER. Foreword to *Frank London,* Woodstock Art Association Gallery, Woodstock, N.Y., 1948.

———. Foreword to *Judson Smith Retrospective Exhibition,* Woodstock Art Association Gallery, Woodstock, N.Y., 1952.

Articles

"Bradley Walker Tomlin," *Magazine of Art,* XLII, No. 5 (May, 1949).

ASHBERY, JOHN. "Tomlin: The Pleasures of Color," *Art News,* LVI, No. 6 (October, 1957).

ASHTON, DORE. "Art," *Arts and Architecture,* LXXIV, No. 12 (December, 1957).

SAWIN, MARTICA. "Bradley Walker Tomlin," *Arts,* XXXII, No. 2 (November, 1957).

Exhibtion Catalogue

BAUR, JOHN I. H. *Bradley Walker Tomlin,* Whitney Museum of American Art, New York, 1957.

Additional sources on this subject are listed in the comprehensive bibliography to The New York School, *edited by Maurice Tuchman (Los Angeles County Museum; Greenwich, Conn.: New York Graphic Society, 1966).*